Key Issues

GENDER AND SCIENCE
Late Nineteenth-Century Debates
on the Female Mind and Body

T0345946

Key Issues

GENDER AND SCIENCE

Late Nineteenth-Century Debates on the Female Mind and Body

Edited and Introduced by

KATHARINA ROWOLD
Wellcome Institute

Series Editor
Andrew Pyle
University of Bristol

THOEMMES PRESS

© Thoemmes Press 1996

Published in 1996 by
Thoemmes Press
11 Great George Street
Bristol BS1 5RR
England

ISBN
Paper: 1 85506 410 3
Cloth: 1 85506 411 1

Gender and Science:
Late Nineteenth-Century Debates on the Female Mind and Body
Key Issues No. 9

British Library Cataloguing-in-Publication Data

A catalogue record of this title is available
from the British Library

Printed in Great Britain by Antony Rowe Ltd., Chippenham

CONTENTS

All the articles have been reproduced in their entirety, except for Herbert Spencer's 'The Study of Sociology: No. XV – Preparation in Psychology', of which only the part relevant to the volume has been reproduced. The pieces reprinted in this book have been taken from original copies and the different grammatical and stylistic arrangement of each has been preserved.

INTRODUCTION[1]

The emergence of the women's movement during the second half of the nineteenth century was a cause and a symptom of rethinking of ideas on the nature of the sexes. Within this process, scientific knowledge about gendered human nature occupied a privileged position. Scientists of all sorts intervened in the 'Woman Question' – the question of the nature and roles of women. Scientific notions about female nature permeated the ideas formulated in the debates surrounding changes in middle-class female educational and occupational opportunities, not least those of the women's movement. Women campaigners reconstituted and contributed to conceptions of the female mind and body.

REFORMS IN WOMEN'S EDUCATION

Educational reform was one aspect of the campaigns of the women's movement that gathered momentum during the 1860s. Female middle-class education at the time was non-vocational and non-standardized. It was administered at home by family members or governesses, and in small, privately-run schools, which tended to focus on training in 'accomplishments'. Consequently, the education girls received varied considerably in terms of form and content. Self-education was an important source of the acquisition of knowledge.

Campaigners sought educational reforms for a range of reasons. Education as a way of increasing women's capabilities and qualifications for employment was of central importance. Whereas working-class women formed part of the

[1] I am grateful to the Wellcome Trust for providing the funding for this project. I would like to thank Jo Bedford and Alison Bashford for commenting on drafts of this introduction. Thanks also to Roy Porter for his encouragement and help with the entire volume.

labour force, middle-class women were largely absent from the labour market. Although the implications of the industrial revolution for middle-class women is subject to much debate,[2] it is clear that the growth in the numbers of middle-class women made their position an issue of increasing public concern. It was particularly the situation of unmarried middle-class women which attracted attention in the earlier decades of the nineteenth century. In the census of 1851 it was found that 42 per cent of women between the ages of twenty and forty were unmarried.[3] Many middle-class families could not afford to maintain spinster daughters, yet they were not brought up to participate in the world of paid employment, nor were there many work opportunities which corresponded to good social standing. At mid-century the position of governess was the only occupation for middle-class women 'in distress' considered to be genteel. Consequently, governessing was a greatly overcrowded and underpaid field of work.[4]

The women's movement, particularly in its early stage, turned much of its energies to increasing the employment prospects of single women, such as by establishing classes to train women in skilled lower-middle-class occupations, as shop assistants, bookkeepers and clerks. During the second half of the nineteenth century growing numbers of women entered the civil service. Others earned a living by their pen as novelists, essayists and journalists. Nursing and midwifery became increasingly middle-class occupations and a high number of women went into jobs created by the expansion of girls' formal education.[5]

[2] See Leonore Davidoff and Catherine Hall, *Family Fortunes: Men and Women of the English Middle Class, 1780–1850* (London: Routledge, 1987), and Amanda Vickery, 'Golden Age to Separate Spheres? A Review of the Categories and Chronology of English Women's History', *Historical Journal*, vol. 36 (1993), pp. 383–414.

[3] Mary Poovey, *Uneven Developments: The Ideological Work of Gender in Mid-Victorian England* (London: Virago Press, 1989), p. 4.

[4] Philippa Levine, *Victorian Feminism, 1850–1900* (Tallahassee: The Florida State University Press, 1987), pp. 83–6.

[5] For a discussion of middle-class women and employment see Lee

Economic independence for unmarried women was not the only argument behind educational reforms brought forward by the women's movement. The improvements were also sought to include women into the educational ideals of the age, and thus to cultivate women's mental powers so they could attain the 'dignity of rational human beings'. Beliefs in a 'free trade of knowledge', and the right of women, no less than men, to make the best of their faculties were also formulated. Moreover, campaigners argued that a better education for women was necessary to keep up with changing times. Rather than interfering with women's domestic roles, as opponents feared, more educated women would enhance their influence in the home by becoming better companions for their husbands and mothers for their children. At the same time it would prepare them to have a greater influence on the public world. 'Ignorant' married women were said to be leading unfulfilled lives of idleness and boredom.

Changes in female middle-class education were taking place from mid-century onwards. The first moves went towards improving the educational training of governesses. In 1848 Queen's College was founded in London for this purpose. A year later, in 1849, Bedford College was opened, also in London, differing from the former in that it was founded by a woman and had a mixed governing board.

In 1850 and 1854 Frances Buss and Dorothea Beale opened secondary schools for girls, the North London Collegiate School and the Cheltenham Ladies' College. Both offered more academically oriented curricula than conventional girls' schools. In 1863, following a campaign by Emily Davies, the University of Cambridge held girls' local examinations on an experimental basis. Cambridge and Oxford local examinations had been introduced in the 1850s with the aim of providing middle-class secondary boys' schools with a general standard. In 1865 Cambridge adopted them officially also for girls. Oxford University followed suit in 1870. The sisters Emily Shirreff and Maria Grey founded the following year the

Holcombe, *Victorian Ladies at Work: Middle-Class Working Women in England and Wales, 1850–1914* (Newton Abbot: David & Charles, 1973), and Levine, *Victorian Feminism*, pp. 82ff.

National Union for the Education of Girls of All Classes, which became known as the Women's Education Union. In 1872 the Union set up the Girls' Public Day School Company to finance the establishment of girls' schools.

Higher education became gradually available to women. The University of London rejected in 1856 attempts by Jessie Meriton White and again in 1862 by Elizabeth Garrett, later Garrett Anderson, to be allowed to take its matriculation examinations. Six years later, however, in 1868, the University established special examinations for women, comparable to the local examinations. Then, in 1878, the University of London became the first to admit women to all its degrees.

The first women's college was established by Emily Davies in 1869 at Hitchin, being moved a few years later to Girton village, in close proximity of Cambridge University. In the meantime the reforming Cambridge professor Henry Sidgwick asked Anne Jemina Clough to become the head of a residence he had rented, and established what was to become Newnham College. Sidgwick and Davies had quite different approaches to women's college education. Davies rejected all ideas of treating women students differently to prove that they were capable of undergoing the same intellectual education as men. Accordingly, she insisted that Girton students should follow the same curricula as male students at Cambridge. They were also required to take the preliminary Classics examinations and the degree examinations within the three years and a term as was the case at the male colleges. Sidgwick, on the other hand, believed that most women students did not have the necessary previous preparation for the traditional Cambridge education, which he thought to be outdated anyway. He favoured a more flexible approach, adaptable to the needs of individual women students. At Newnham, students were encouraged to favour courses in the sciences and modern languages over Classics, as well as being allowed to spend as much or as little time at the College as they liked. Their different views remained a point of friction and contention between Davies and Sidgwick for years to come. In Oxford women's colleges were estab-

lished in 1879 with the opening of Lady Margaret Hall and Somerville College.

During the 1880s there was much pressure by the Cambridge women's colleges for the university to award degrees to women. However, Cambridge only gave permission to women to sit the examinations in 1881 and a year later to issue certificates stating the class of the Tripos obtained without granting official degrees. It waited until 1922 to make these attainable for women, two years after Oxford. Nonetheless, by the 1890s, it was widely perceived that higher education could be obtained by women. Although not receiving official degrees, they could attend colleges at Cambridge and Oxford, and degrees were available at a growing number of universities across Britain.[6]

WOMEN IN THE MEDICAL PROFESSION

As well as expanding particular 'female' occupations, women also began to enter traditionally male professions. This was particularly true of the medical profession. Not only was there a long history of female involvement in nursing and midwifery, but views on female nature as caring and nurturing also provided a space to argue for women's entry to medicine. Moreover, codes of decency favoured demands to make female physicians available to female patients. The precedent was set when in 1858 Elizabeth Blackwell was placed on the first British Medical Register. The British-born Blackwell had emigrated to the United States with her family at the age of eleven. In 1847 she enroled at medical school at Geneva College in New York, from which she graduated two years later. During the next twenty years she often visited Great Britain, occasionally giving lectures on the role of women in medicine, until she settled there in 1869. One of her lectures was attended by Elizabeth Garrett (later Garrett Anderson), a friend of Emily Davies, who thereupon decided to become

[6] For further information on women's education see, for example, Levine, *Victorian Feminism*, pp. 26ff.; Rita McWilliams-Tullberg, *Women at Cambridge: A Men's University – Though of a Mixed Type* (London: Victor Gollancz, 1975), and June Purvis, *A History of Women's Education in England* (Milton Keynes: Open University Press, 1991).

a physician. As a first step she trained at the Middlesex Hospital as a nurse in 1860, but was subsequently refused entry to the medical schools of the universities of London, Edinburgh and St Andrews. She then prepared in private study for the licentiate of the Apothecaries Society, which she received in 1865. In the following year she became the second woman to be put on the British Medical Register.

The next move came in 1869 when Sophia Jex-Blake and four other women were provisionally admitted by the University of Edinburgh. One of them, Edith Pechey, soon won a distinction in chemistry, the Hope Scholarship. The prize, however, was awarded to a male student on the grounds that the women were not full members of the class. When in 1870 the women were to start their practical training, male students organized a 'riot' against them. Jex-Blake alleged that the assistant of one of the professors had organized the disturbance. The assistant promptly sued Jex-Blake for libel. Matters worsened when in 1872 the Faculty refused to grant the women degrees. After prolonged legal battles, the University won a ruling that the admission of the women had been illegal and the University had no responsibility to them.

Jex-Blake now moved to London where in 1874 she established the London School of Medicine for Women with the support of Elizabeth Blackwell, Elizabeth Garrett Anderson, the scientist T. H. Huxley and Dr David Anstie, a fellow of the Royal College of Physicians. Blackwell and Garrett Anderson had both initially shown reservations to the scheme, fearing that a separate school for women would lead to women doctors being considered as subordinate and inferior to male physicians, but ultimately decided to support the project. The London School of Medicine, however, could neither offer clinical training, nor confer degrees. The turning point for women's medical qualification came when the Irish College of Physicians and the Queen's University of Ireland agreed to admit women to examinations in 1876. The following year, in 1877, the Royal Free Hospital in London admitted women students to its wards.[7]

[7] For accounts of women's entry to the medical profession see E. Moberly

These developments in middle-class women's education and occupations were accompanied by fierce debates on the nature of the sexes and how it related to their social roles. Notions of similarity and difference between men and women were brought into discussions about the rights, duties and natural aptitudes of the female sex.

EQUALITY AND DIFFERENCE

Concerns about the rights of women had been spurred by Enlightenment ideas about the rights of man. The emergence of an organized women's movement during the mid-nineteenth century can be traced back to the emancipatory claims of the Enlightenment, combined with the political, economic and social changes brought about by industrialization. The shift towards an individualistic and egalitarian philosophy opened the way for women to join the demand for enfranchisement of formerly disenfranchised groups.[8]

The emergence of claims to universal human equality and freedom, however, was paralleled by the scientifically based elaboration of ideas of differences between the sexes. The Enlightenment inaugurated a transformation of notions of the male and female body. Thomas Laqueur has argued that earlier ideas had been based on a Galenic model of physiological homology between male and female reproductive organs, in which the lesser 'vital heat' of woman made her an inferior version of man. This model was replaced by notions of the sexes as fundamentally different, but complementary by nature, which highlighted the role of the reproductive system

Bell, *Storming the Citadel: The Rise of the Woman Doctor* (London: Constable & Co., 1953), and Catriona Blake, *The Charge of the Parasols: Women's Entry to the Medical Profession* (London: The Women's Press, 1990). For a European and American comparative study see Thomas Neville Bonner, *To the Ends of the World: Women's Search for Education in Medicine* (Cambridge, MA: Harvard University Press, 1992).

8 See Ray Strachey, *'The Cause': A Short History of the Women's Movement in Great Britain* (London: G. Bell and Sons, 1928), p. 12 for a classical argument of these roots of the nineteenth-century women's movement. See Barbara Caine, *Victorian Feminists* (Oxford University Press, 1993), pp. 18–22 for a criticism of Strachey.

as the primary factor of difference.[9] Scientific notions on gender difference thus presented inequalities of rights between the sexes as reflecting prescripts of Nature.[10]

In the ascent of liberal thought, science and medicine played an important role. They occupied a 'privileged epistemological position' with regard to knowledge about gendered human nature. Their methods were believed to provide empirically based knowledge of human nature, which would guide the establishment of a secular social order in which Nature, not religious dogma or metaphysics, defined the place of humankind.[11] Thus rather than viewing it as divinely ordained, women's social position started to be thought of in terms of what was natural to the female sex.[12]

The separation of a private sphere of familial relations from a public sphere of politics, paid work and commerce was formulated in terms of biological difference. In this women were constructed as naturally finding their fullest expression in the private sphere and men in the public.[13] By the time of the emergence of the women's movement at the mid-nineteenth century, ideas about mental and physical differences between men and women were underlying a sexual division of political and legal rights, as well as social and economic roles.[14]

[9] Thomas Laqueur, 'Orgasm, Generation, and the Politics of Reproductive Biology', *Representations*, vol. 14 (1986), pp. 1–41; *idem, Making Sex: Body and Gender from the Greeks to Freud* (Cambridge, MA: Harvard University Press, 1990).

[10] Laqueur, *Making Sex*, p. 194; Londa Schiebinger, *The Mind Has No Sex? Women in the Origins of Modern Science* (Cambridge, MA: Harvard University Press, 1989), pp. 216–17.

[11] Ludmilla Jordanova, *Sexual Visions: Images of Gender and Medicine between the Eighteenth and Twentieth Centuries* (Hemel Hempstead: Harvester Wheatsheaf, 1989), p. 24; Ornella Moscucci, *The Science of Woman: Gynaecology and Gender in England, 1800–1929* (Cambridge University Press, 1990), p. 3.

[12] Jane Rendall, *The Origins of Modern Feminism: Women in Britain, France and the United States, 1780–1860* (Basingstoke: Macmillan, 1985), p. 8.

[13] Laqueur, *Making Sex*, p. 194; Moscucci, *Science of Woman*, pp. 3–4; Poovey, *Uneven Developements*, p. 52.

[14] Poovey, *Uneven Developments*, p. 8.

One pillar of nineteenth-century middle-class ideology was the exclusion of women from paid labour. The distinction of female domestic labour from male paid employment established a boundary between the private sphere of familial relations and the public sphere of commercial activity, creating an alternative to marketplace competitiveness. The home was conceptualized as a repository of moral values, as well as a shelter which offered tranquillity and security and thus tempered the effects of the outside world of competition and economic vicissitudes.[15]

The alignment of women with the domestic sphere and men with the public was supported by an articulation of natural differences between them. Man was more ruled by reason and more capable of abstraction. He was naturally more aggressive and competitive. Physically he was more apt to stand the strains of competition. In body and mind woman was more under the influence of her reproductive function. Emotion and instinct dominated over reason. Maternal instincts – 'the strongest of all influences in the determination of character'[16] – made woman naturally more nurturing, non-competitive, and underlay her moral influence.

The naturalization of gender roles mediated the tensions between the ideas of universal human equality and liberty and the inequality of rights between the sexes. Thus the evolutionist George Romanes asserted in 1887 that 'anatomical and physiological considerations...bar *a priori* any argument for the natural equality of the sexes'.[17] However, these tensions were never fully resolved. During the second half of the nineteenth century, the notion that the sexes were 'different but equal' was a dominant concept. As this phrase suggests, the debates instigated by the women's movement were located in a complex context of tensions between notions of a common humanity and differences between the sexes.

[15] Susan Kingsley Kent, *Sex and Suffrage in Britain, 1860–1914* (Princeton University Press, 1987), p. 33; Poovey, *Uneven Developments*, p. 144.

[16] See George Romanes, pp. 180–81 of the present volume.

[17] See p. 183.

Feminists put forward claims to equal rights, but operated mostly with concepts of difference in the formulation of their ideas. Notions of innate female moral superiority, for instance, were very important in nineteenth-century feminist thought. 'We do not advocate the representation of women', the suffragist Millicent Garrett Fawcett pointed out, 'because there is no difference between men and women, but rather because of the difference between them.'[18]

When the women's movement campaigned to reform middle-class women's education and to broaden the scope of employments for them, opponents voiced concerns about how this participation in the public would impact upon women's specific influence in the domestic sphere, and how it would affect its separation from the public. 'The dignity of masculine life is often lost in its feverish competitions and restless acquisitions', the lawyer Herbert Cowell was to write in 1874, '[a]nd if the life of women is to be forcibly degraded to the same level, where are we to seek the influences which are to refine and mitigate the bustling tumult which characterises modern society?'[19] Alarm was raised about the repercussions of turning the sexes into 'rivals' and 'competitors'. Since the sexual division of labour was bound up with notions of male and female nature, anxieties were expressed about the physical and mental implications for women of changes in their social roles. Considerations about the safeguarding of women's health and thus that of the future generations became important in discussions about suitable lifestyles for women. These questions were negotiated and contested by women campaigners, leaving important marks on nineteenth-century feminist thought.

DEBATES ON THE FEMALE MIND AND BODY

During the Victorian period, conceptions of the 'natural' aptitudes of classes of people formed the basis for their social roles. Hence scientists, as those who decoded Nature, often claimed the right and responsibility to be the arbiters of social

[18] See p. 282.

[19] See p. 96.

change.[20] In the issues raised by the women's movement, scientific knowledge on the nature of the sexes consequently played an important role. Scientists of all sorts contributed to the debates about the natural aptitudes and capacities of the sexes and their ensuing social roles.[21] The reforms in female education, the setting up of women colleges and the expanding occupational opportunities for middle-class women, provoked extensive discussions and debates on the nature of the female mind and body. The meaning of the differences in brain size, weight and structure was widely debated, as was also how the female mind was affected by what in medico-scientific discourse was thought of as the most important physiological difference – the female repro- ductive system. Physicians particularly raised questions about whether or not women were capable of undergoing the same continuous intellectual application as men and the strains of a professional life. The debates surrounding female education and occupations were permeated by questions about the natural aptitudes of the sexes.

By the 1870s the reforms demanded and achieved by the women's movement had obtained a high profile. Besides the changes in women's education and occupations, most noted the appearance of the first women doctors, the first Married Women's Property Act had been passed in 1870, and suffrage societies were springing up. At this point, growing numbers of scientists went public with their views by publishing in lay journals, rather than confining them to medical and scientific text books and journals. The psychiatrist Henry Maudsley thus caused a stir when he published 'Sex in Mind and in Education' in a literary journal in 1874, in which he discussed female physiology. As Herbert Cowell rebuked him, 'however appropriate to the pages of a medical publication, [this] is a

[20] Ornella Moscucci, 'Hermaphroditism and Sex Difference: The Construction of Gender in Victorian England', in Marina Benjamin (ed.), *Science and Sensibility: Gender and Scientific Enquiry, 1879–1945* (Oxford: Basil Blackwell, 1991), pp. 174–5.

[21] There exists an extensive literature on the Victorian scientific ideas on gender difference and the role of scientists in the 'Woman Question'. See the suggestions for further reading.

novelty in English current Literature'.[22] In her reply to
Maudsley, the physician Elizabeth Garrett Anderson
wondered whether 'such a subject can be fully and with
propriety discussed except in a professional journal',[23] but,
since Maudsley had done so, took him up on these issues in
the same journal.[24] As this collection of articles will show, the
education and occupation debates became a site for the
negotiation of gender difference in which male and female
scientists, laymen and laywomen, those in favour and those
against the women's movement, took up, discussed, debated
and contested each others' views.

SCIENCE AND GENDER

An important move in the formulation of ideas on gender
took place when in 1871 Charles Darwin joined the debate on
the nature and causes of differences between the sexes with
The Descent of Man, and Selection in Relation to Sex.[25] Two
years earlier, in 1869, John Stuart Mill had published *The
Subjection of Women.*[26] Mill's book was widely perceived as
arguing that female characteristics were not innate: 'What is
now called the nature of women', Mill declared, 'is an
eminently artificial thing – the result of forced repression in

[22] See p. 80.

[23] See p. 54.

[24] For responses to the Maudsley/Garrett Anderson debate, other than those
reprinted here, see 'American Women: Their Health and Education',
Westminster Review, vol. 46 (1874), pp. 456–99; [George L. Bennett], 'The
Education of Women', *Edinburgh Review*, vol. 166 (1887), pp. 89–114;
H. T., 'Sex in Education', *The Examiner* (18 April 1874), pp. 399–400;
'Sex in Mind Education', *The Lancet*, vol. 1 (1874), pp. 663–4; 'Female
Education', *The Lancet*, vol. 1 (1874), pp. 880–81; 'Sex in Education', *The
British Medical Journal*, vol. 1 (1874), pp. 530–31.

[25] 2 vols. (Princeton University Press, 1981). For a detailed discussion of
Darwin's views on gender and the woman question see Evelleen Richards,
'Darwin and the Descent of Woman', in David Oldroyd and Ian Langham
(eds.), *The Wider Domain of Evolutionary Thought* (London: D. Reidel,
1983), pp. 57–111.

[26] ed. Susan Moller Okin (Indianapolis: Hackett Publishing Company, 1988).

some directions, unnatural stimulation in others.'[27] Since
women were not free to employ their faculties, according to
Mill, it was impossible to know what was nature or nurture
in the differences between men and women.

Contrary to this view, Charles Darwin sought to establish
a biologically based theory of the physical and mental distinc-
tions between men and women. Differences between the
sexes, according to him, were constituted by the primary
sexual characters, ie. the reproductive organs, and also by the
secondary sexual characters, ie. differences between the sexes
which were not directly connected to the act of repro-
duction.[28] These secondary sexual characters had developed
through sexual and natural selection.

Whereas Darwin defined natural selection as the survival of
the better fitted in the struggle for existence, he saw sexual
selection as dependent on the 'advantage which certain
individuals have over other individuals of the same sex and
species, in exclusive relation to reproduction'.[29] Sexual
selection operated through the combat between males for the
possession of females, and, among animals, through mostly
female choice of the most attractive males.[30] Among humans,
however, according to Darwin, it was the males who had
acquired the power of selection.[31] Human evolution meant
that man in terms of mental power had 'ultimately become
superior to woman'.[32] He attained 'to a higher eminence, in
whatever he takes up, than woman can attain – whether
requiring deep thought, reason or imagination, or merely the
use of the senses and hands'.[33]

[27] Mill, *Subjection*, p. 22.

[28] Darwin, *Descent*, vol. 1, p. 253.

[29] *ibid.*, vol. 1, p. 256.

[30] *ibid.*, vol. 1, p. 296.

[31] *ibid.*, vol. 2, p. 371. For the contradictions in Darwin's argument about
the reversal in the operations of sexual selection between animals and
humans see Rosemary Jann, 'Darwin and the Anthropologists: Sexual
Selection and Its Discontents', *Victorian Studies*, vol. 37 (1994), pp. 295–6.

[32] *ibid.*, vol. 2, p. 328.

[33] *ibid.*, vol. 2, p. 327.

The causes of this mental difference were to be found in sexual and natural selection. 'Courage, perseverance, and determined energy' were of advantage in the contest of rival males for the possession of females among animals, as well as among humans in their lowest evolutionary stage. In the human male, moreover, higher mental faculties were also an asset in the successful protection of females and their young, and the provision for their joint subsistence.[34] What Darwin in effect suggested was that the female of the human species had been removed from the struggle for existence, in that she was no longer responsible for feeding and protecting herself, since this was done for her by the male.[35] Thus, women had never undergone selective pressures in the contest for the possession of males, but rather had long been selected by men for their beauty.[36] At the same time, through their dependency on men, women's mental powers were not subject to the same mechanisms of natural selection.

Darwin's evolutionary theory naturalized gender difference in ways which explained and legitimized the different roles and rights of men and women. The two human sexes had originally derived from an androgynous 'extremely remote progenitor of the whole vertebrate kingdom'.[37] Sexual differentiation was a central component of the evolutionary process.[38] Opposition to the women's movement was often rooted in the conviction that the social organization reflected evolutionary differentiation. Thus the psychiatrist Henry Maudsley, who became one of the important contributors to the theory of degeneration, that is the potential reversal of the evolutionary process, rhetorically asked 'does it not appear that in order to assimilate the female to the male mind it would be necessary to undo the life-history of mankind from

[34] Darwin, *Descent*, vol. 2, pp. 327–8, 382–3.

[35] Cynthia Eagle Russett, *Sexual Science: The Victorian Construction of Womanhood* (Cambridge, MA: Harvard University Press, 1989), p. 84.

[36] *ibid.*, vol. 2, p. 372.

[37] *ibid.*, vol. 1, p. 207.

[38] Moscucci, 'Hermaphroditism', p. 182.

its earliest commencement?'[39] Mental differences between the sexes were the product of the evolutionary process, and not to be meddled with.

Evolutionary theory supposed that gendered human nature was subject to change. As much as Victorian science focused on establishing differences between the sexes, it was also preoccupied with how these differences were mutable. Although men and women were different, this did not mean that *all* men and *all* women were the same. Thus the philosopher Herbert Spencer, for instance, declared when he discussed the mental differences between the sexes that '[o]f course it is understood that...reference is made to men and women of the same society, in the same age. If women of a more-evolved race are compared with men of a less-evolved race, the statement will not be true'.[40] The sexes among 'South American Indians', 'negroes', and the 'higher races', as well as among 'European and Eastern nations', differed 'both bodily and mentally, not quite in the same way'.[41] The concept that gendered human nature was not static enabled other distinctions to be made between groupings of people, such as those of class and race, as well as between the human species and the lower animals.[42]

But the notion that the differences between the sexes were subjected to a process of change according to transforming environment, suggested that these could be affected by a conscious modification of the environment.[43] This could be interpreted as meaning that in times to come women would be able to attain the same mental faculties and powers as men. The question was thus not whether this was possible, but rather whether it was desirable. Thus, Benjamin Ward Richardson, a physician noted for his involvement in public hygiene reforms, pointed out that:

[39] See p. 38.

[40] See p. 25

[41] See p. 27.

[42] Jill L. Matus, *Unstable Bodies: Victorian Representations of Sexuality and Maternity* (Manchester University Press, 1995), p. 25.

[43] *ibid.*, p. 38; Moscucci, 'Hermaphroditism', p. 183.

[s]ince development by evolution has become the leading scientific idea, we have been led to conceive that those peculiarities in women which admittedly have rendered them incapable of performing masculine work in equality with men, are not due to any primitive failure incident to sex, but to a failure of development incident to the mode in which the so-called gentler sex has been brought up.[44]

Following this basic assumption, in the education and occupations debates, the implications of Darwin's theories were also interpreted in ways which favoured women's demands, precisely because it postulated that although gender difference was biological, human nature was not immutable. In S. Tolver Preston's view, to keep women from developing intellectually was to hinder human mental progress, because of the transmission of traits to the offspring of both sexes.[45] For the anonymous author of 'Female Poaching on Male Preserves', the excess numbers of women over men supposed that the environment had undergone changes, ie. not all women could be looked after and maintained by men any more. And '[a]s environment changes, the organism adapts itself or perishes', the author asserted.[46] Women had to adapt to their 'surplus condition' and were justified in assailing 'the male stronghold of the professions themselves'.[47]

Frequently, however, the understanding that there existed a relationship between human nature and the environment led rather to the assumption that dire consequences would arise from the way social developments were going, a view which physicians particularly propagated. Subjecting women to a male life-environment – ie. the same intellectual application and fending for their own livelihood – was thought to interfere with the functioning of the female body and thus 'unsex' women. The female body would be deprived of its specificity, such as the workings of the reproductive system, the growth of breasts, and the capacity to breast-feed. Rather

[44] See p. 147.

[45] See pp. 124–5.

[46] See p. 234.

[47] See pp. 236–7.

than progressing in evolution, there would be regression, manifested in decreasing difference between the sexes.

At the time, the human organism was understood to be ruled by a fixed stock of vital energy, which was divided up between the different organs.[48] For the early sociologist and philosopher, Herbert Spencer, this notion formed the basis of his theory that in women individual evolution stopped earlier than in men, because an extra amount of vital energy was needed to meet 'the cost of reproduction'. This earlier arrest in individual evolution resulted in women's lesser growth and had its effects on the mind. Woman, according to Spencer, lacked the latest products of human evolution: the power of abstract reasoning and the sentiment of justice.[49]

The theory of a closed human energy system became a key issue propagated by physicians in the higher education debates. In the context of this theory it was believed that excessive use of one particular organ would weaken others. In both sexes, mismanagement of energy resources led to disorders, such as for instance, neurasthenia, a condition of nerve exhaustion.[50] Because of their smaller bodies women had a lesser amount of nerve force to draw upon than men. Thus the strains upon these resources were greater if they undertook the same intellectual work, or exposed themselves to the strains of a professional life.

Moreover, women's energy economy was dominated by the development and maintenance of a highly complex reproductive system. For females to attempt to spend as much energy on mental development and exertion as males, physicians warned, would divert energy allotted for the reproductive system to the brain. This was especially the case during puberty, when much energy was needed for the body to develop its feminine specificity to the full.

Interference with female physiological processes not only affected the individual woman, but also had implications for future generations. If women spent too much energy on the

[48] See Russett, *Sexual Science*, pp. 104ff. for a discussion of this.

[49] See pp. 24–5.

[50] Russett, *Sexual Science*, pp. 113–15.

brain, ill-health would be the outcome. This, through inheritance, would have its effects on the future race. And, in the opinion of Henry Maudsley, 'it would be an ill thing, if it should so happen, that we got the advantages of a quantity of female intellectual work at the price of a puny, enfeebled, and sickly race'.[51]

Physicians continued to express these concerns that too much mental application would interfere with the female body throughout the late nineteenth century.[52] But by the 1890s the emphasis had shifted from anxieties about the strains of higher education to the strains of a competitive professional life, particularly when it was combined with motherhood.

WOMEN AND THE FEMALE MIND AND BODY

Women's voices were not absent in the construction of the female mind and body.[53] Even before the first women doctors

[51] See p. 39.

[52] These views were not unanimously held by male physicians. The surgeon T. Spencer Wells, for instance, to whom Eliza Orme referred (see p. 159), was all in favour that the education of both sexes of the middle-class had to be expanded and that women should be given the option to engage in occupations other than those of domestic life. He was of the opinion that want of mental occupation was a much more current source of health breakdown than mental overstrain (see T. Spencer Wells, 'Inaugural Address Delivered before the Sanitary Congress', *The Lancet*, vol. 2 (1886), pp. 570–73).

[53] For an argument that women were more or less silent in nineteenth-century scientific constructions of woman see, for example, Ruth Hubbard, 'Have Only Men Evolved?', in Ruth Hubbard et al. (eds.), *Women Look at Biology Looking at Women: A Collection of Feminist Critiques* (Boston: G. K. Hall & Co., 1979), p. 16. Carroll Smith-Rosenberg in 'The New Woman as Androgyne: Social Disorder and Gender Crisis, 1870–1936', in *Disorderly Conduct* (New York: Oxford University Press, 1985), pp. 245–96 has argued that American feminists initially developed a language that differed radically from the medical model men had developed. But later they adopted a language invested with male sexual metaphors which ultimately led to the disappearance of the women's movement as a political force. For interpretations which locate women's voices within medico-scientific discourse see, for instance, Nancy M. Theriot, 'Women's Voices in Nineteenth-Century Medical Discourse: A Step Toward Deconstructing Science', *Signs*, vol. 19 (1993), pp. 1–31; Rosaleen Love, 'Darwinism and Feminism: The "Woman Question" in the

appeared, women negotiated scientific knowledge on female nature. The ideas of women campaigners were central to changes in women's social roles, and these changes were inextricably linked to the formulation of ideas on the nature of the female mind and body. Scientific ideas on gender were sites of competing definitions and interpretations, leaving members of the women's movement space to explore contradictions and alternative possibilities of these theories and to create their views on the nature and implications of gender difference. Medico-scientific construction of woman had a profound influence on feminists' ideas, establishing conceptual boundaries. Women campaigners were active, however, in reconstituting these boundaries.

Not all women, of course, supported the causes of the women's movement. Thus, Eliza Lynn Linton, the first salaried woman journalist in Britain, established her reputation by condemning just these. In 'The Higher Education of Woman' (1886), Linton did so by basing her argument against female higher education on male scientific authority. Medical men, she argued, were the 'only trustworthy judges' in the matter, and they were saying that higher education was prejudicial to the health of women and damaging their reproductive capacities.[54]

Arabella Kenealy, herself of a generation for whom higher education and medical degrees were attainable, based her argument, on the other hand, on her own authority as a trained physician. She reinforced this position by framing her arguments in a narrative of encounters with patients in her consulting room. From this vantage point she endorsed the view that women should be provided with an education which would enable them to live an economically independent life as long as they were unmarried, although she reminded her readers that this education had to be carefully administered,

Life and Work of Olive Schreiner and Charlotte Perkins Gilman', in David Oldroyd and Ian Langham (eds.), *The Wider Domain of Evolutionary Thought* (London: D. Reidel, 1983), pp. 113–31 and Susan Kingsley Kent, *Sex and Suffrage in Britain, 1860–1914* (Princeton University Press, 1987).

[54] See pp. 139–40.

so as not to 'spoil her woman-power'. Once married, however, women had to give themselves up to motherhood – the ultimate essence of womanhood – which was incompatible with an 'emancipated' lifestyle.

Expanding on contemporary ideas on degeneration and atavism, that is, evolutionary throwbacks, Kenealy argued that continuous strain upon the nervous forces through mental and physical exertion during pregnancy would be drawing on the unborn child's resources. The embryo which, as recapitulation theory postulated, in its individual development would be going through all the evolutionary stages of the human species, would be stopped short in its development. It would belong to 'an inferior type – anterior to the age in which it was born'.[55]

Members of the women's movement engaged explicitly with scientific authority on the female mind and body in varying ways. Lydia Becker, for instance, who corresponded with Charles Darwin and published an introduction to botany in 1864, maintained that although the body was sexed, the mind was not, and based this argument on her own observations of the natural world. Frances Power Cobbe, on the other hand, more typically thought that the mind as well as the body was sexed, but rather uncommonly, she dismissed the views of male physicians on the causes of female valetudinarianism, believing that doctors were deliberately keeping middle-class women in a state of ill-health in order to further their financial interests. Eliza Orme pointed out that there existed a friction between moving people 'as chess pawns, to be moved here or left there, as science dictates', and the exercise of free will,[56] and Millicent Garrett Fawcett rebuked the positivist Frederic Harrison for erroneously wanting to 'map out the whole of human life with tape measure and ruler'.[57] Henrietta Müller, on the other hand, explored the implications of evolutionary understanding of female nature in ways which justified social change. Edith Simcox, for her

[55] See p. 254.
[56] See pp. 165–6.
[57] See p. 290.

part, contested ideas of the evolutionist George Romanes by centralizing aspects of evolutionary theory which he had marginalized, that is, the notion of the changeability of human nature and the idea that the differences between the sexes were based on a common humanity. Elizabeth Garrett Anderson, on the other hand, countered the authority of the psychiatrist Henry Maudsley with her own authority as a qualified physician.

Demands for reforms in women's education were supported by claims that the natural difference between the sexes was being distorted by societal restrictions. Equal rights for women would favour the establishment of a *real* femininity, unhampered by artificial constraints and male ideals. Women campaigners highlighted the contradiction in opponents' arguments that although Nature was said to dictate the social roles of the sexes, it was so open to violation that it had to be protected.[58] Nature, Elizabeth Garrett Anderson asserted instead, would ultimately protect herself. Thus, 'when we are in doubt, we may be guided by the general principles of equality and common sense, while waiting for the light of a larger experience'.[59] Feminists argued that artificial barriers were circumscribing women's lives. These barriers were the result of male domination, a left-over from the past when the law of the strongest had reigned supreme.[60]

Concepts of innate female difference played an important role in the formulation of feminist thought, often centring on notions of female moral superiority.[61] Thus the female body left its traces on the constitution of the female psyche. Fewer related their demands to prioritizing concepts of the common humanity of men and women over the differences between them. But there was a widespread belief that women's mental

[58] See, for instance, Millicent Garrett Fawcett p. 293.

[59] See p. 68.

[60] See Lydia Becker, p. 18; Henrietta Müller, p. 208.

[61] For a dissenting voice see Edith Simcox, pp. 193ff. For a detailed discussion of feminists' endeavour to transform the relations between the sexes and the social order, and to establish a new morality see Lucy Bland, *Banishing the Beast: English Feminism and Sexual Morality, 1885–1914* (London: Penguin, 1995).

rank could be established only once women were given the opportunity to employ their mental powers freely. Restrictions upon women's intellectual occupation had been and were impeding the development of their mental powers. The contemporary female intellect was the product of the conditions of life and education, as well as inherited aptitudes.

Feminist ideas about gendered human nature incorporated evolutionary theories. In the year of the publication of *The Descent of Man*, Millicent Garrett Fawcett, who was to become one of the leading figures of the suffrage movement, in a lecture on women's education argued, by emphasizing the view that men and women were at the same level of development within the constructed racial hierarchies, that women had always moved on with the times they lived in. Had it not been so, she pointed out, 'civilization would have had no influence on them, and they would have remained savages, or else, if we accept theories contained in "The Descent of Man", jelly fish'. With everything around them changing and progressing, women had to be given the freedom to change and progress too.[62]

As time passed, Darwinian evolutionary theory began to have an important impact on the ideas of some campaigners. In her views on gender difference the writer and trade-unionist Edith Simcox thus explored the concept of evolutionary change. In 'The Capacity of Women' (1887) she responded to the assertion made by the Darwinian George Romanes in his 'Mental Differences Between Men and Women' (1887), that those mental differences were secondary sexual characters developed by the evolutionary process. Simcox reminded her readers (and Romanes) that in all the ideas about the mental differences between the sexes and their implications for the social roles of men and women, it should not be forgotten that the sexes derived from a non-sexed ancestor. Simcox argued that even if women had so far been intellectually inferior, this did not mean that, with changing conditions, this would always have to be so. She declared:

[62] Millicent Garrett Fawcett, 'The Education of Women' (1871), in Henry Fawcett and Millicent Garrett Fawcett, *Essays and Lectures on Social and Political Subjects* (London: Macmillan and Co., 1872), p. 225.

Of course, it will be said that the existing distinction has emerged and survived because of its natural fitness; that is, that it has proved favourable to the life and development of the higher vertebrates; but there is a difference between things practically useful under given material conditions and things belonging to the eternal and immutable 'nature of things'. Science teaches us that nature is eminently mutable, and that all elaborate qualities are the products of lengthy and complex processes of manufacture.[63]

It was the underlying assumption of Darwinian theory that man and woman were not static unities, but developing and evolving with changing conditions, which was explored to argue for reforms in women's social environment. The member of Karl Pearson's Men and Women's Club, Henrietta Müller thus, based her argument about the need for social change heavily upon an evolutionary framework. In the age 'which Darwin had enlightened', she said, it had become clear that 'women have become what they are' by their circumstances. This, she argued, meant that 'our present system of society is wrong and unjust, inasmuch as it still places one sex in a dependent and cramped position'.[64]

The emphasis on notions of the mutability of female nature became a way to see the present social organization as inadequate. To refuse rights to women on the grounds of the specificities of the female mind and body was indefensible because it was based on the assumption that contemporary female nature was the only possible one, rather than seeing it at the outcome of an unjust social system. '[N]o one', Müller declared, 'has the right to prejudge the question of woman's future possibilities, and this is unfortunately exactly what everyone does.'[65] Whereas the early campaigners had stressed that education was a way to draw out contemporary women's potential to enhance their feminine influence, these ideas were increasingly supplemented with notions which put the

[63] See p. 194.

[64] See p. 208.

[65] See p. 209.

emphasis on a long process of transforming biological charac-
teristics of the female mind, as well as body.

The conception that women's bodily difference disqual-
ified them from undergoing equal mental efforts as men
without injury to health, constituted an important issue in the
education campaign. With the growth and profile of the
literature from the early 1870s which raised alarm about the
effects of traditionally male education upon the health of
women and their offspring, women campaigners engaged
increasingly with the idea that female constitution was a
barrier to women's entry to the world of higher education and
self-gained economic independence. As late as 1888 the
writer Emily Pfeiffer identified it an issue which played the
primary role in retarding the satisfactory solution of the
education question,[66] although two years later Eleanor
Sigdwick, who had been involved in the establishment of
Newnham College, published a statistical survey of the health
of over 500 women who had attended college in which she
concluded that according to her data higher education was
not injurious to the constitution of women, nor to that of their
children.[67]

Women physicians, due to their own scientific authority,
played an important role in reconstituting notions of female
physiology, sometimes explicitly arguing that their knowledge
was of central importance to establish the possibilities and
limits of women's lives. Thus, Sophia Jex-Blake maintained
that women physicians had the role to encourage women to
'live full and useful lives', as well as to impart knowledge on
physiology and hygiene, so that they would not harm their
physical and mental well-being.[68]

When Henry Maudsley published his article in the
Fortnightly Review, Emily Davies, the founder of Girton
College, approached the physician Elizabeth Garret Anderson

[66] Emily Pfeiffer, *Women and Work* (London: Trübner & Co., 1888), p. 4.

[67] Mrs Henry Sidgwick, *Health Statistics of Women Students of Cambridge
and Oxford and of their Sisters* (Cambridge University Press, 1890).

[68] See pp. 70–71.

to write a reply.[69] In her response Garrett Anderson explored Maudsley's assertion that the promotion of an equal education for women opposed the teachings of physiology and constituted a rebellion by them against the 'tyranny of their organization'.[70] In her model of physiological difference, Garrett Anderson resisted the positioning of the male body as the norm. She maintained that the question could not be answered by proving that men and women were different, but that it had to be solved by looking at women in their own right. She thus argued that menstruation did not exhaust female energy resources, but rather that it got rid of a surplus of nutritive material – a margin kept ready for the demands to be made in childbearing. In adult life, when proceeding normally, menstruation did not involve any 'loss of vigour to the woman'.[71]

Garrett Anderson concurred that the development of the reproductive system taxed the nutritive powers in ways which produced a 'temporary weakness'. Allowances had to be made for it, she declared.[72] College education, however, started only at the age of eighteen or nineteen, when women's development was complete.[73]

The notion that 'the physiological difference between men and women' should interfere in adult life with women pursuing higher education and careers was met by asserting the sameness of the working-class and middle-class female body. Healthy women, Garrett Anderson thus declared, as a rule nearly completely disregarded 'their special physiological functions' in the labour of life, and that was most prominently to be observed among working-class women.[74]

Drawing on the female working-class body allowed women

[69] See Barbara Stephen, *Emily Davies and Girton College* (London: Constable & Co., 1927), pp. 290–92.

[70] See Maudsley, p. 34.

[71] See p. 58.

[72] See p. 59. See also Sophia Jex-Blake, p. 70.

[73] See p. 63.

[74] See p. 58.

campaigners to explore other causes of health breakdown than overstrain. Female ill-health, so prevalent among the middle-class, owed much to the circumscribed lives that allowed no outlet of energies. For every woman whose health was injured by too much study, there were many more whose health had deteriorated through the lack of occupation. As Garrett Anderson asserted, it was this which made women 'morbid, self-absorbed, or even hysterical'.[75] Women campaigners widely started to refer to this model in which female health was endangered by the narrowness and idleness of middle-class women's lives, rather than by the strains of traditionally male education and professional lives.[76]

Some feminists of a younger generation, however, expressed ideas that women's position of dependency had produced biological disadvantages. Women were thus constitutionally 'handicapped'. This was not the reflection of woman's original organization, but, as Henrietta Müller argued, for instance, an 'acquired weakness'. Müller believed that it would at first constitute an obstacle for women to 'go out into the world of savage competition'. However, the removal of social and legal disabilities was 'demanded by justice and is a step in the direction of progress'. The injustices women had endured in the past would 'haunt them and their descendants for many generations'. But they had to be faced to embrace the new order, a social organization in which present female nature would give way under the influence of the new environment to the mentally and physically 'truly womanly woman who develops her power that is within her freely and without reference to artificial ideals'.[77] Thus, feminist ideas embraced the perception that male dominance had biologically moulded women and that a change of social form would in turn make an impact on the bodies and minds of future women. The gendered body would not disappear, but reappear in a different form.

[75] See p. 64.

[76] See Frances Power Cobbe, p. 116.

[77] See p. 214.

CONCLUSION

The texts reprinted in this volume present an overview of periodical publications which contributed to the debates surrounding the question of women's mental and physical aptitudes and capabilities, raised by demands of the women's movement. Medico-scientific knowledge played an important role in the formulation of these ideas, and many scientists and physicians participated directly in the debates. Discussions about the mental and physical implications of changing middle-class female lifestyles raged in scientific textbooks and periodical publication, in literary and feminist journals, as well as in independent publications.

Nineteenth-century feminist thought was formulated in the context of the Victorian notion that 'Nature' was of prime importance in the definition of social roles. Demands for changes in educational and occupational opportunities were based upon analyses of the relationship between female nature and social organization. Feminist theories were formulated in the light of prevailing medico-scientific ideas on gendered human nature, debating, exploring and reinterpreting them. Thus, nineteenth-century women participated in the construction of the female mind and body.

Katharina Rowold
Wellcome Institute for the
History of Medicine, 1996

BIOGRAPHICAL NOTES
ON THE CONTRIBUTORS

Some of the reprinted articles were not signed by their authors, following a normal procedure of the time. Where the name appears in square brackets, the article was originally published anonymously, but the authorship has been established subsequently.

ANDERSON, ELIZABETH GARRETT (1836–1917)

Elizabeth Garrett was one of the first women to become a licensed physician in Britain. She was educated privately by governesses and at a boarding school. In 1860 she trained as a nurse at the Middlesex hospital, but was subsequently refused admission to medical school by the universities of London, Edinburgh and St Andrews. In 1866 she was put on the British Medical Register, having obtained the licentiate of the Society of Apothecaries for which she had prepared in private study. In 1870 she obtained a medical degree from the Medical School of Paris. Two years later she founded the New Hospital for Women in London, staffed entirely by women. She became involved in the establishment of the London School of Medicine, being appointed its dean in 1883. From 1873 to 1892 she was a member of the British Medical Association. Garrett Anderson had joined the British Women's Suffrage Committee in 1866 but soon withdrew. In 1907 she joined the militant suffragette movement. In 1908 she was elected Mayor of Aldeburgh, to become the first woman mayor in England. Elizabeth Garrett, who in 1871 married James Skelton Anderson, was a close friend of Emily Davies and the sister of Millicent Garrett Fawcett.

See Jo Manton, *Elizabeth Garrett Anderson* (1965).

BECKER, LYDIA ERNESTINE (1827–1890)

Except for a short period at a boarding school, Lydia Becker was educated at home. Her interest in botany led her to correspond with Charles Darwin and to publish *Botany for Novices: A Short Outline of the Natural System of the Classification of Plants* under her initials in 1864. In 1865 she set up a Ladies Literary Society in Manchester, which was dedicated to the study of scientific subjects. Two years later she became the secretary of the newly established Manchester Women's Suffrage Committee. She also was active on the Married Women's Property Committee. In 1870 she founded the *Woman's Suffrage Journal* which she edited for the next twenty years. She became the Secretary of the London Central Committee for Women's Suffrage.

COBBE, FRANCES POWER (1822–1904)

Educated first by a succession of governesses, Frances Power Cobbe was then sent to a boarding school. Later in life, she was to censure the emphasis on 'accomplishments' in her schooling. With the aid of a small inherited income sufficient to maintain her, she chose to remain unmarried and to pursue a career as a writer and social reformer. Power Cobbe was one of the most prolific authors of the women's movement. Some of her earlier essays were collected in *Essays on the Pursuits of Women* (1863). She took part in many campaigns of the women's movement, including suffrage, education, legal rights, and wife-abuse, as well as being involved in the anti-vivisection campaign. Power Cobbe introduced the question of women's access to university education in a paper she gave in 1862 on 'The Education of Women and How it Would be Affected by University Examinations'.

See her autobiography, *The Life of Frances Power Cobbe by Herself* (1894).

COWELL, HERBERT (b. 1836/37)

An Oxford graduate, Cowell was called to the bar in 1861. Two years later, in 1863, he was married to Alice Garrett, sister of Elizabeth and Millicent Garrett.

DAVIES, EMILY (1830–1921)

Emily Davies was the founder of the first women's college in Britain. She was educated at home. At the age of twenty-four she met Elizabeth Garrett, later Garrett Anderson, and her sisters. She supported Garrett Anderson in her attempt to be admitted by the University of London. After this failed, she successfully campaigned to have the Cambridge Local Examinations opened to girls and to have girls' schools included in the Taunton Schools' Inquiry Commission in 1864. In 1866 she published *The Higher Education of Women*. In 1869 she founded Hitchin College for women, which in 1873 was moved to Girton, in the vicinity of Cambridge University. Davies had dropped out of her involvement with the suffrage campaign when she started to establish a women's college so as not to harm the endeavour. Once she felt that the future of Girton College was secure, Davies returned to suffrage the campaign in the late 1880s.

See Barbara Stephen, *Emily Davies and Girton College* (1927).

FAWCETT, MILLICENT GARRETT (1847–1929)

Millicent Garrett Fawcett is best known for her involvement in the suffrage campaign. She was educated at home and at a boarding school. In 1867 she married the blind MP, Henry Fawcett, a Professor of Political Economy at Cambridge. Fawcett acted as a secretary for her husband, which helped her to enlarge her knowledge of political and social issues. She started her involvement in the suffrage campaign by becoming a member of the first Women's Suffrage Committee in 1867 in London. In 1897, when the various suffrage committees merged, she became the President of the resulting National Union of Women's Suffrage Societies, a position which she held until 1918. Millicent Garrett Fawcett was the younger sister of Elizabeth Garrett Anderson.

See David Rubinstein, *A Different World for Women: The Life of Millicent Garrett Fawcett* (1991).

HARRISON, FREDERIC (1831–1923)

Frederic Harrison studied at Wadham College, Oxford and was called to the bar in 1858. In 1877 he was appointed professor of jurisprudence and international law by the Council of Legal Education. Harrison is best known for becoming the leading disciple in Britain of the French positivist Auguste Comte (1798–1857). He frequently published in a number of Victorian journals.

See Martha S. Vogeler, *Frederic Harrison: The Vocations of a Positivist* (1984).

JEX-BLAKE, SOPHIA (1840–1912)

Next to Elizabeth Garrett Anderson and Elizabeth Blackwell, Sophia Jex-Blake is one of the main figures associated with the entry of women into the medical profession. She was educated by governesses and at boarding school. In 1858 she entered Queen's College, London. Jex-Blake spent three years in the United States of America, from 1865 to 1868, where she started to study medicine, until brought back to Britain by the death of her father. In America she had visited co-educational institutions of learning, publishing her views on them in 1867 in *A Visit to Some American Schools and Colleges*. In 1869 she and four other women were provisionally admitted by the University of Edinburgh to study medicine. The position of the women at the university became gradually more difficult, and in 1873 they left. The previous year in 1872, Jex-Blake had published *Medical Women: A Thesis and a History*. After leaving Edinburgh, Jex-Blake moved to London and established the London School of Medicine for Women. In 1876 she went to Bern, where she received her medical degree the following year. In 1878 Jex-Blake returned to Edinburgh where she began medical practice. In 1886 she founded the Edinburgh School of Medicine for Women.

See Shirley Roberts, *Sophia Jex-Blake: A Woman Pioneer in Nineteenth-Century Medical Reform* (1993).

KENEALY, ARABELLA (1864–1938)

Educated at home and at the London School of Medicine for women, Arabella Kenealy practised medicine between 1888 and 1894 in London and Watford. She retired from practice after a serious illness. She continued, however, to publish medical and scientific books and articles, as well as novels. In 1920 she published *Feminism and Sex Extinction*.

LINTON, ELIZA LYNN (1822–1898)

Eliza Lynn Linton was the first salaried female journalist. She published her first novel, *Azeth the Egyptian* in 1846 at the age of twenty-four. Linton created a stir when in 1868 she published 'The Girl of the Period' in the *Saturday Review*, criticizing modern women. For the next thirty years she continued to attack the ideas and actions of the women's movement in her numerous publications.

See Nancy Fix Anderson, *Woman against Women in Victorian England: A Life of Eliza Lynn Linton* (1987).

MAUDSLEY, HENRY (1835–1918)

Henry Maudsley was a prominent psychiatrist. He advocated a hereditary theory of mental disorder and was an important contributor to the idea that evolutionary progress was reversible. Maudsley was the superintendent of the Cheadle Royal Hospital, Manchester from 1858 to 1861, joint editor of the *Journal of Mental Science* from 1862 to 1878, consulting physician in mental disease to the West London Hospital from 1864 to 1874, and professor of medical jurisprudence at University College London from 1869 to 1879. He became a Fellow of the Royal College of Physicians in 1869. See Michael Collie, *Henry Maudsley, Victorian Psychiatrist: A Bibliographical Study* (1988).

MÜLLER, HENRIETTA (d. 1906)

Born in Chile, as daughter of a German businessman, Henrietta Müller became in 1873 one of the early students of

Girton College where she studied Classics. She was an active suffragist and between 1885 and 1888 she was a member of the Men and Women's Club, the brainchild of the mathematician Karl Pearson (1857–1936), founded with the aim of discussing the relations between the sexes. From 1888 onwards she edited the *Women's Penny Paper*.

ORME, ELIZA (no dates found)

Holder of a LL.D. She published *Lady Fry of Darlington* in 1898 and wrote the introduction to *The Trial of Shama Charan Pal: An Illustration of Village Life in Bengal*, published in 1894.

PRESTON, TOLVER S. (no dates found)

Author of various articles in *Natural Science* and *Nature*. He also published *Physics of the Ether* (1875) and *Original Essays: I. On the Social Relation of the Sexes, II. Science and Sectarian Religion, etc.* (1884).

RICHARDSON, BENJAMIN WARD (1828–1896)

Active in many of the reform movements of his time such as sanitation, temperance and public hygiene, Benjamin Ward Richardson was a prominent physician of his time. In 1850 he became licentiate of the Faculty of Physicians and Surgeons of Glasgow and received his MD in 1854 from the University of St Andrews. In 1865 he became a Fellow of the Royal College of Physicians of London and two years later, in 1867, he became a Fellow of the Royal Society. He was knighted three years before his death.

ROMANES, GEORGE JOHN (1848–1894)

A physiologist, evolutionary theorist, and early comparative psychologist, Romanes was educated at home until he entered Cambridge University in 1867. In the six years he spend there Romanes studied mathematics, natural sciences and physiology. Romanes became a renowned representatve of Darwinism in Britain. He particularly contributed to theories

about mental evolution. Romanes was a prolific writer, who frequently contributed to scientific journals, as well as literary reviews.

See Ethel Romanes, *The Life and Letters of George John Romanes Written and Edited by his Wife* (1896).

SIMCOX, EDITH J. (1844–1901)

Edith Simcox was a writer and a journalist, contributing for more than twenty-five years to *The Academy*, as well as writing for *The Nineteenth Century*, *The Fortnightly Review*, *Women's Union Journal* and *Labour Tribune*. In 1875 she co-founded a shirt-making co-operative in which she continued to be involved until the early 1880s. She was one of the first women delegates to the Trades Union Congress in 1875 in Glasgow. In 1872 Edith Simcox first met George Eliot with whom she was to maintain a friendship until Eliot's death, developing passionate feelings for her.

See K. A. McKenzie, *Edith Simcox and George Eliot* (1961).

SPENCER, HERBERT (1820–1903)

A philosopher, evolutionist and early sociologist, Herbert Spencer was educated privately by his father and uncle. Leaving his job as a railway engineer, Spencer became a subeditor of *The Economist* in 1848. From there he gradually established a career as an independent writer. He soon gained much popularity, particularly in the United States, establishing a reputation as an advocate of extreme laissez-faire liberalism and proponent of evolutionary philosophy. Coining the phrase 'the survival of the fittest', Spencer in his evolutionary ideas integrated Darwinian notions of natural selection with Lamarckian ideas about the inheritance of acquired traits. A life-long friend of George Eliot, Spencer favoured women's emancipation in the early 1850s, but subsequently altered his views.

See J. D. Y. Peel, *Herbert Spencer: The Evolution of a Sociologist* (1971).

CHRONOLOGY

1848 Queen's College, London, founded.

1849 Bedford College, London, founded.

1850 North London Collegiate School founded.

1854 Cheltenham Ladies' College founded.

1856 The University of London rejects a petition by Jessie Meriton White to be admitted to the matriculation examinations.

1858 Elizabeth Blackwell is placed on the British Medical Register.

1859 Society for Promoting the Employment of Women founded.

1862 Frances Power Cobbe reads a paper at the National Association for the Promotion of Social Science in which she puts forward the idea of university education and examinations for women.

1862 The University of London rejects Elizabeth Garrett's application for admission to the matriculation examinations.

1863 First, provisional, Cambridge Local Examinations for women.

1864 Schools Inquiry Commission (Taunton Commission) set up.

1865 Elizabeth Garrett receives the licentiate of the Society of Apothecaries.

1865 Cambridge Local Examinations officially opened to women.

1866 Emily Davies, *The Higher Education of Women* published.

1866 Elizabeth Garrett is placed on the British Medical Register.

1866 Durham and Edinburgh Local Examinations opened to women.

1866 *Englishwoman's Review* begins publication.

1868 University of London opens special examinations for women.

1868 Report of the Schools Inquiry Commission published.

1869 John Stuart Mill, *The Subjection of Women* published.

1869 First female medical students at Edinburgh University.

1869 Hitchin College founded.

1870 Elizabeth Garrett receives a degree from the Paris Medical School.

1870 Oxford Local Examinations opened to women.

1871 Charles Darwin, *The Descent of Man, and Selection in Relation to Sex* published.

1871 Merton Hall, later Newnham College, opened.

1871 The first Hitchin students sit the Little-go at Cambridge.

1872 New Hospital for Women founded.

1872 Girls' Public Day School Company founded.

1873 Hitchin College moved to Girton.

1873 Elizabeth Garrett Anderson is elected to the British Medical Association.

1874 London School of Medicine for Women opened.

1875 Frances Hoggan joins the British Medical Association.

1876 The Irish College of Physicians and the Queen's University of Ireland grant medical degrees to women.

1877 The Royal Free Hospital, London, admits female students to clinical instruction.

1878 The University of London approves a charter which provides that all degrees of the university should be open to women.

1879 Lady Margaret Hall and Somerville Hall, Oxford, opened.

1880 Co-educational Victoria University, Manchester, founded.

1881 Cambridge University allows women to sit the examination, but does not award them degrees.

1882 Westfield College, London, founded.

1882 Cambridge University authorizes to issue certificates to women which state the class of their tripos.

1886 At the annual meeting of the British Medical Association, its president, Dr Withers Moore, delivers an address against higher education for women.

1886 Edinburgh School of Medicine for Women founded.

1887 Agnata Ramsay of Girton receives the only first-class degree in the classics examination.

1892 The Universities of Edinburgh, Glasgow, St Andrews and Aberdeen admit women to degrees.

1890 Philippa Fawcett of Newnham is classed above the senior wrangler in the mathematics tripos.

1890 At Queen Margaret College, Glasgow, a school of medicine for women is opened.

1920 Oxford awards degrees to women.

1922 Cambridge awards degrees to women.

1947 Cambridge awards full membership to women.

SUGGESTIONS FOR FURTHER READING

Alaya, Flavia, 'Victorian Science and the "Genius" of Woman', *Journal of the History of Ideas*, vol. 38 (1977), pp. 261–80.

Bell, E. Moberly, *Storming the Citadel: The Rise of the Woman Doctor* (London: Constable & Co., 1953).

Blake, Catriona, *The Charge of the Parasols: Women's Entry to the Medical Profession* (London: The Women's Press, 1990).

Bland, Lucy, *Banishing the Beast: English Feminism and Sexual Morality, 1885–1914* (London: Penguin, 1995).

Bonner, Thomas Neville, *To the Ends of the Earth: Women's Search for Education in Medicine* (Cambridge, MA: Harvard University Press, 1992).

Burstyn, Joan N., *Victorian Education and the Ideal of Womanhood* (London: Croom Helm, 1980).

Caine, Barbara, *Victorian Feminists* (Oxford University Press, 1993).

Conaway, Jill, 'Stereotypes of Femininity in a Theory of Sexual Evolution', in Martha Vicinus (ed.), *Suffer and Be Still: Women in the Victorian Age* (Bloomington: Indiana University Press, 1972), pp. 140–54.

Davidoff, Leonore and Catherine Hall, *Family Fortunes: Men and Women of the English Middle Class, 1780–1850* (London: Routledge, 1987).

Delamont, Sara and Lorna Duffin (eds.), *The Nineteenth-Century Woman: Her Cultural and Physical World* (London: Croom Helm, 1978).

Digby, Anne, 'Women's Biological Straitjacket', in Susan Mendus and Jane Rendall (eds.), *Sexuality and Subordination: Interdisciplinary Studies of Gender in the Nineteenth Century* (London: Routledge, 1989), pp. 192–220.

Dijkstra, Bram, *Idols of Perversity: Fantasies of Feminine Evil in Fin-de-Siècle Culture* (New York: Oxford University Press, 1986).

Dyhouse, Carol, 'Social Darwinistic Ideas and the Development of Women's Education in England, 1880–1920', *History of Education* (London), vol. 5 (1976), pp. 41–58.

Fee, Elizabeth, 'Nineteenth-Century Craniology: The Study of the Female Skull', *Bulletin for the History of Medicine*, vol. 53 (1979), pp. 415–33.

——————, 'Science and the Woman Problem: Historical Perspectives', in Michael S. Teitelbaum (ed.), *Sex Differences: Social and Biological Perspectives* (New York: Anchor Books, 1976), pp. 175–223.

Geyer-Kordesch, Johanna and Rona Ferguson, *Blue Stockings, Black Gowns and White Coats* (University of Glasgow, 1995).

Harding, Sandra, *The Science Question in Feminism* (Milton Keynes: Open University Press, 1986).

Jann, Rosemary, 'Darwin and the Anthropologists: Sexual Selection and its Discontents', *Victorian Studies*, vol. 37 (1994), pp. 287–306.

Jeffreys, Sheila, *The Spinster and Her Enemies: Feminism and Sexuality, 1880–1930* (London: Pandora Press, 1985).

Jordanova, Ludmilla, *Sexual Visions: Images of Gender in Science and Medicine between the Eighteenth and Twentieth Centuries* (Hemel Hempstead: Harvester Wheatsheaf, 1989).

Kent, Susan Kingsley, *Sex and Suffrage in Britain, 1860–1914* (Princeton University Press, 1987).

Laqueur, Thomas, *Making Sex: Body and Gender from the Greeks to Freud* (Cambridge, MA: Harvard University Press, 1990).

Levine, Philippa, *Victorian Feminism, 1850–1900* (Tallahassee: The Florida State University Press, 1987).

Love, Rosaleen, 'Darwinism and Feminism: The "Woman Question" in the Life and Work of Olive Schreiner and Charlotte Perkins Gilman', in David Oldroyd and Ian Langham (eds.), *The Wider Domain of Evolutionary Thought* (London: D. Reidel, 1983), pp. 113–31.

Matus, Jill L., *Unstable Bodies: Victorian Representations of Sexuality and Maternity* (Manchester University Press, 1995).

Morantz-Sanchez, Regina Markell, *Women Physicians in American Medicine: Sympathy and Science* (New York University Press, 1985).

Moscucci, Ornella, *The Science of Woman: Gynaecology and Gender in England, 1800–1929* (Cambridge University Press, 1990).

——————, 'Hermaphroditism and Sex Difference: The Construction of Gender in Victorian England', in Marina Benjamin (ed.), *Science and Sensibility: Gender and Scientific Enquiry, 1780–1945* (Oxford: Basil Blackwell, 1991), pp. 174–99.

Mosedale, Susan Sleeth, 'Science Corrupted: Victorian Biologists Consider "The Woman Question"', *Journal of the History of Biology*, vol. 11 (1978), pp. 1–55.

Oppenheim, Janet, *'Shattered Nerves': Doctors, Patients, and Depression in Victorian England* (New York: Oxford University Press, 1991).

Pateman, Carole, *The Sexual Contract* (Cambridge: Polity Press, 1988).

Paxton, Nancy L., *George Eliot and Herbert Spencer: Feminism, Evolutionism and the Reconstruction of Gender* (Princeton University Press, 1991).

Pick, Daniel, *Faces of Degeneration: A European Disorder, c.1848 – c.1918* (Cambridge University Press, 1989).

Poovey, Mary, *Uneven Developments: The Ideological Work of Gender in Mid-Victorian England* (London: Virago Press, 1989).

Purvis, June, *A History of Women's Education in England* (Milton Keynes: Open University Press, 1991).

Rendall, Jane, *The Origins of Modern Feminism: Women in Britain, France and the United States, 1780–1860* (Basingstoke: Macmillan, 1985).

Richards, Evelleen, 'Darwin and the Descent of Woman', in David Oldroyd and Ian Langham (eds.), *The Wider Domain of Evolutionary Thought* (London: D. Reidel, 1983), pp. 57–111.

Rosenberg, Rosalind, *Beyond Separate Spheres: Intellectual Roots of Modern Feminism* (New Haven: Yale University Press, 1982).

Russett, Cynthia Eagle, *Sexual Science: The Victorian Construction of Womanhood* (Cambridge, MA: Harvard University Press, 1989).

Schiebinger, Londa, *The Mind Has No Sex? Women in the Origins of Modern Science* (Cambridge, MA: Harvard University Press 1989).

Showalter, Elaine, *The Female Malady: Women, Madness and English Culture, 1830–1980* (London: Virago Press, 1987).

Smith-Rosenberg, Carroll, *Disorderly Conduct: Visions of Gender in Victorian America* (New York: Oxford University Press, 1985).

Stepan, Nancy Leys, 'Race and Gender: The Role of Analogy in Science', in David Theo Goldberg (ed.), *The Anatomy of Racism* (Minneapolis: University of Minnesota Press, 1990), pp. 38–57.

Theriot, Nancy M., 'Women's Voices in Nineteenth-Century Medical Discourse: A Step Toward Deconstructing Science', *Signs*, no. 19 (1993), pp. 1–31.

Trecker, Janice Law, 'Sex, Science and Education', *American Quarterly*, vol. 26 (1974), pp. 352–66.

Vertinsky, Patricia, *The Eternally Wounded Woman: Women, Doctors and Exercise in the Late Nineteenth Century* (Manchester University Press, 1990).

Vicinus, Martha, *Independent Women: Work and Community for Single Women, 1850–1920* (London: Virago Press, 1985).

Vickery, Amanda, 'Golden Age to Separate Spheres? A Review of the Categories and Chronology of English Women's History', *Historical Journal*, vol. 36 (1993), pp. 383–414.

THE INFLUENCE OF UNIVERSITY DEGREES ON THE EDUCATION OF WOMEN

Victoria Magazine, Vol. 1 (1863)

[Emily Davies]

In considering the education of women in connexion with recent proposals for its improvement by means of examinations for University Degrees, it may be well to inquire at the outset, what *is* a Degree? In what does its value consist?

A University degree is neither more nor less than a certificate. At Oxford and Cambridge it certifies that the graduate has lived during a certain number of terms in a college or hall, has been devoting his time chiefly to study, and has passed divers examinations, which were meant to test his ability and knowledge. The degrees of the University of London also certified in the beginning, that graduates in Arts and Laws had been students during two years, at one or other of the affiliated institutions, which were to the University of London what the colleges are to the Universities of Oxford and Cambridge. Few will deny the advantages of residence for two or three years in a college; and it may be easily seen how such residence, and the intercourse between students which it implies, may be made very greatly to lessen the dangers and disadvantages from which mere examination, taken alone, can scarcely be wholly free. It is possible that a young man, preparing at home for his degree, may be sufficiently crammed to pass, and may even find his name somewhere in a list of honours; and yet mistake knowledge for wisdom, and a retentive memory for genius. But in a college, such a man would be pretty sure to find his real level. He would find among his companions some, who with far less than his own powers of memory or application, would still unquestionably be his superiors. He would be made to feel quite easily, and almost without knowing how useful a lesson he was learning, that processes are almost as valuable as results; that what a

man is, is of far more importance than what at any given time he can do, and that there are a thousand excellences that can find no room for display in any University examination whatever. Moreover, residence for two or three years in a college, implies comparatively easy circumstances, and ought, therefore, to imply all that society expects from gentlemen: and though many of the colleges connected with the University of London required no extravagant expenditure, and were, perhaps, not half so costly as those of Oxford and Cambridge, yet the term of residence was generally longer, being in many of them as long as five years.

The University of London, however, was intended to promote the education, not only of gentlemen, and of persons who could afford to live for several years at a college, but of all classes of her Majesty's subjects, without any distinction whatever; and accordingly in the new Charter it was provided, that persons not educated in any of the institutions connected with the University, should be admitted as candidates for matriculation, and degrees, "other than degrees in medicine or surgery, on such conditions as the Chancellor, Vice-Chancellor, and Fellows by regulations in that behalf should from time to time determine; such regulations being subject to the provisoes and restrictions contained in the Charter." This change was regarded with considerable disfavour by many of those who had graduated under the old regulations, and who imagined that the value of their degrees would be reduced when similar degrees were conferred upon those who had never been to a college at all. It is obvious, however, that the colleges must look for their prosperity to their own intrinsic worth; and that the University should confer degrees upon all those who could pass the examinations prescribed, wherever they might have been educated, was clearly in harmony with the original intention of the University. The want of college training, and especially of the indirect advantage of association with men whose favourite studies lie in different directions, and who possess very different kinds of ability, was partly counteracted by the wide range of subjects in which candidates for degrees were required to pass. Nor has the change as yet done much more than recognise a right which it would have been invidious to withhold. Scarcely any of those who have taken honours during the last few years, have come to their examinations from "private study," and sixteen out of the twenty who have

taken the degree of Bachelor of Science are from the colleges connected with the University. But after all, if a man can read Livy or Thucydides, Plato's Republic or Aristotle's Ethics, it really matters little how he obtained his knowledge of Greek and Latin; and if it be expedient to found a University at all, and if degrees are of any use, then the man who can prove that he possesses the requisite knowledge, has a fair claim to have that fact certified.

But if the want of money, and, what amounts to very much the same thing, the want of leisure, are to be no impediment to the recognition of a man's real worth and attainments, so far as examination can test them, why should any impediments whatever be allowed to remain? Why especially should difference of sex be an impediment?

This question was raised so early as 1856, in which year a lady applied for admission to the examinations of the University of London. The advice of counsel was taken, and an opinion was given that such admission could not legally be granted. No further steps were taken until April, 1862, when another lady preferred a request to be admitted as a candidate at the next Matriculation Examination. On that occasion a resolution was passed: "That the Senate, as at present advised, sees no reason to doubt the validity of the opinion given by Mr. Tomlinson, July 9th, 1856, as to the admissibility of females to the Examinations of the University." The matter was not allowed to rest here. On April 30th, the following Memorial was laid before the Senate.

"GENTLEMEN, – An application having been made by my daughter for admission to the Examinations of your University, and refused on legal grounds, we beg respectfully to request that the question may receive further consideration.

"It appears to us very desirable to raise the standard of female education, and that this object can in no way be more effectually furthered than by affording to women an opportunity of testing their attainments in the more solid branches of learning. It is usually admitted that examinations are almost essential as a touchstone of successful study, and as a stimulus to continuous effort. Such a touchstone, and such a stimulus, are even more necessary to women than to men; and though we should be most unwilling to obtain these advantages by the sacrifice of others still more precious, we are of opinion that in the University of London our object might be obtained without

any contingent risk. Many of the candidates for degrees would probably be furnished by the existing Ladies' Colleges, and as the University requires no residence, and the examinations involve nothing which could in the slightest degree infringe upon feminine reserve, we believe that by acceding to our wishes you would be conferring an unmixed benefit.

"We are informed that a new Charter of the University is about to be submitted to Parliament. We beg therefore to suggest that the technical legal objection, which appears to be the only obstacle to the admission of women, may be removed by the insertion of a clause expressly providing for the extension to women of the privileges of the University. I beg to enclose a list of ladies and gentlemen who have given their sanction to the proposal.

"I have the honour to be, Gentlemen,
"Your obedient Servant,
"NEWSON GARRETT."

On May 7th, a resolution was moved by the Vice-Chancellor, Mr. Grote, and seconded by the Right Hon. R. Lowe, M.P., to the effect "That the Senate will endeavour, as far as their powers reach, to obtain a modification of the Charter, rendering female students admissible to the Degrees and Honours of the University of London, on the same conditions of examination as male students, but not rendering them admissible to become Members of Convocation." After an earnest and protracted discussion, the Senate divided. The numbers being equal, ten on each side, the motion was negatived by the casting vote of the Chancellor. The following reply to the Memorial was addressed to Mr. Garrett.

"SIR, - I am directed to inform you that, after a full consideration of your Memorial, the Senate have come to the conclusion that it is not expedient to propose any alteration in the Charter, with a view of obtaining power to admit females to the Examinations of the University.

"I think it well to add, that this decision has not been the result of any indisposition to give encouragement to the higher education of the female sex - a very general concurrence having been expressed in the desire stated in your Memorial, that an opportunity should be afforded to women of testing their attainments in the more solid branches of learning; but it has been based on the conviction entertained by the majority of the Senate, that it is not desirable that the constitution of this

University should be modified for the sake of affording such opportunity.

> "I remain, Sir,
> "Your obedient Servant,
> "W. B. CARPENTER."

The matter has since been brought forward in the Convocation of the University. On the 26th March, a Resolution was passed by the Annual Committee, and afterwards embodied in the Report to Convocation, to the following effect: "That this Committee, recognising the desirableness of elevating the standard of female education, recommend Convocation to represent to the Senate the propriety of considering whether it might not forward the objects of the University, as declared in the Charter, to make provision for the examination and certification of women." After a lengthened discussion the resolution was negatived by a considerable majority.

The question having thus been fairly raised – a definite application having been made – it clearly becomes the duty of those who decline to accede to a request which appears so reasonable, to show cause for their refusal. The *onus probandi* undoubtedly rests with the opponents of the measure. And it must be confessed that they have not been backward in accepting the challenge, whatever may be thought of the quality of the arguments brought forward. They resolve themselves, for the most part, into an "instinct," a prejudice, or an unproved assertion that women ought not to pursue the same studies as men; and that they would become exceedingly unwomanly if they did. A woman so educated would, we are assured, make a very poor wife or mother. Much learning would make her mad, and would wholly unfit her for those quiet domestic offices for which Providence intended her. She would lose the gentleness, the grace, and the sweet vivacity, which are now her chief adornment, and would become cold, calculating, masculine, fast, strongminded, and in a word, generally unpleasing. That the evils described under these somewhat vague terms are very real and do actually exist at this moment, cannot be denied by any one who is at all conversant with English society. That any scheme of education which might tend to foster them, ought to be energetically resisted, will scarcely be disputed by any – least of all by the advocates of extended mental culture for women.

It may be well to examine first that theory of the difference

between manhood and womanhood which underlies most of the objections commonly brought against the thorough culture of women; and which, if it were true, would render all further argument superfluous. The differences between a man and a woman are either essential or conventional, or both. In any case it is difficult to understand how they affect the right of a woman to pass an examination and to take a degree. The differences themselves are often exaggerated, both by women and by men. So far as they are manifested by any external acts, they are almost entirely conventional; and of those which are essential, and which belong to the inmost being of woman or man, if seems difficult to understand how any information can be obtained, or comparison instituted. For how can things be compared, which *ex-hypothesi* are wholly unlike? How can we possibly know or learn that, to which there is nothing analogous in ourselves? We understand the nature of animals, because, and in so far as, we are animals ourselves. To the same extent possibly a dog might understand a man; but no ingenuity could ever impart to an animal the knowledge of the human spirit, with all its endless resources, its freedom, its aspirations, its power to "look before and after." Nothing could make a brute religious, or explain to a brute what religion is; and, on the other side, are we not taught that we can know God only so far as we are partakers of the Divine nature; only because God created man in His own image? If there be then in woman a mystic something, to which nothing in a man corresponds; if woman has what man wants, or wants what man has; if this difference be natural, essential, and therefore for ever unalterable, it simply marks out a region of utter unlikeness which is protected by that unlikeness from intrusion, or visitation. Perhaps then we may leave altogether out of the question those mystic differences, which can give no clear proof of their own existence, which have no faculty of speech, no means of expressing what they are.

But at any rate, there are differences, we are told, which can manifest themselves. The strength of the woman, we are told, is in the heart; the strength of the man, in the head. The woman can suffer patiently; the man can act bravely. The woman has a loving care for the individual; the man an unimpassioned reverence for the general and universal. These, and such as these, are represented as the outward tokens of essential differences, which cannot be mistaken, and ought

never, in any system of education, or work of life, to be overlooked.

If these are natural differences, it is idle to ask whether we should praise or blame them, for the nature of a thing has no moral qualities whatever. A tiger may be dangerous, but is certainly not cruel; a fox may be cunning, but cannot be dishonest; and if dogs delight to bark and bite, because God hath made them so, who shall find fault with them? But natural differences should certainly guide our systems of education; and if it is really in the nature of a woman to have very much feeling and very little sense, were it not a kind of fighting against Providence, to attempt to rescue her from this very dangerous form of insanity? Yet, surely, it may be affirmed with the utmost confidence, that a woman's affections ought to be as well regulated as a man's; that she should know how to give as well as to receive, and be prompt to act as well as patient to suffer. She should not sacrifice the many for the one, not the long endless future for the passing moment. And do we really wish to people the world with male creatures, devoid of all gentleness and affection, losing sight of the individual in the mass, irritable and impatient under the irremediable discomforts and reverses of life? Does religion include no tender affections for the man, no intellectual strength for the woman? And do we not read that God created man in His own image, in the image of God created He him, male and female created He them? Should not a man's thoughts of God be a woman's thoughts also? And why should that compassion of the Almighty, which is spoken of in Scripture as womanly, be strange to the heart of man? A woman surely ought to have a sense of the law of justice, and a man, of the law of love. Moreover a genius for detail is quite worthless, if the parts are not fittingly arranged and subordinated to the whole.

In truth, it is exactly in this subordinating of the whole to its parts, that even the charity and affection of women has often done great mischief; and is capable of doing any amount of mischief, if it were not restrained by that power of generalisation, and order, which now women sometimes find in men, and ought to find in themselves. A beggar dying in the streets of starvation, should be relieved by anybody who is able to relieve him; his individual life is not to be sacrificed for any theory or system, however comprehensive. If it is a man who sees him perishing with want, he would be bound, and we may fairly

hope he would be willing, to save him. On the other hand, the majority of street-beggars are impostors, and certainly ought not to be relieved. To relieve them is a direct encouragement of idleness and vice. Even the little children, who will certainly be cruelly flogged unless they take home a fair amount of money, after a day's suffering and shame, would never be employed in so shameful a business as begging, if ill-regulated kindness had not make it profitable. Individually they may be as greatly in need of assistance as any sufferers whatever; the reasons why they are not to receive alms are reasons derived from the careful combination and comparison of very many facts of very different kinds. Is it really thought desirable then, that women should be ignorant of those facts, and the general rules deduced from them? Is the wisdom of the male sex to be for ever fighting against the tender-heartedness of the female sex? And is the thought of man to form wise and useful rules of conduct, only that the impulsiveness of woman may break them? But why do women look to the individual rather than to the many, and deal with separate examples rather than with general rules? It is surely not necessary to look for any recondite and essential ground of this difference if we can find one obvious and conventional, which will account equally well for the pheno-menon. Women, in fact, have never been instructed in general principles. A man talks to a man about the statistics of poverty or crime; they carefully consider together what are the causes, which, in the majority of cases, have produced either of these gigantic evils; causes, such as ignorance, drunkenness and the like. They do their best, therefore, not to collect money to give away in alms to any beggar who may ask their assistance, but they establish a school, provide places of refreshment and amusement, orderly and well-conducted, and where, by satisfying natural desires, the temptation to unnatural excesses may be reduced to a minimum. They take care, or at least they know that they *ought* to take care, that the relief of poverty shall be of a kind to remove as far as possible the causes of poverty, and every new experiment they make for the relief of misery and the prevention of crime, widens their theories and improves their rules of practice. But it has not been the habit of men to talk with women, and act with them, after this manner. Without a word of instruction about the reasons for what they are about to do, they are asked to visit some poor man's cottage, and administer what relief they may think necessary;

or to visit some school or workhouse, or to collect money, or to make clothes, like Dorcas. It is surely not very surprising that women confine themselves to that sort of work which alone has been entrusted to them from generation to generation. It is not wonderful that they do that sort of work well, nor does it require any mystic difference between the sexes to account for the fact that they do not know what, through hundreds of generations, they have neither been required nor encouraged to learn.

We are told, however, that the course of study required for obtaining a degree in the University of London is altogether unfit for women. "Do the advocates of the Burlington House degrees know," asks a writer on female education, "what is actually required by the London University for ordinary graduates? Why, the candidate is required to pass in nearly the whole range of pure arithmetical science, – in geometry, plane and solid; in simple and quadratic equations; in the elements of plane trigonometry; in elementary Latin; in the history of Rome to the death of Augustus; in English composition, and English history to the end of the seventeenth century; in either French or German; in statics and dynamics treated with elementary mathematics; in an experimental knowledge of physics and optics, and a general conception of plane astronomy; in animal physiology; in elementary Greek, and Greek history to the death of Alexander; and in the elements of logic and moral philosophy. Does any one in his (or her) senses suppose that the understanding of average young ladies would be the better for passing this examination well, or for trying to pass it anyhow, as the proper aim of their education? We might get one or two clever women, several Miss Cornelia Blimbers, and many Miss Tootses – if we may suggest an intellectual sister to Mr. Toots – out of such a system, but certainly not an improved standard for ordinary women. I believe that we should have half the young women in the country in brain fever or a lunatic asylum, if they were to make up their minds to try for it."

It is perhaps equally probable that we should have half the young *men* in the country in brain fever or a lunatic asylum, if they were to make up *their* minds to try for it. Graduates are a very small minority of the men of England, and yet their education has determined the education of the great majority who are not graduates. It is by no means obvious that it would

do women any harm to know enough for the B.A. (London) pass-examination. They are already expected to learn not much less at Queen's College, in Harley Street; and a degree would be to women, in their present stage of cultivation, what honours are to men.

Women are expected to learn *something* of arithmetical science, and who shall say at what point they are to stop? Why should simple equations brighten their intellects, and quadratic equations drive them into a lunatic asylum? Why should they be the better for the three books of Euclid, which they are required to master at Queen's College, and "stupefied" by conic sections or trigonometry? Why should Latin give them a deeper insight into the philosophy of language, and introduce them to a literature and history which may raise them above the narrowness or the extravagance of their own age, and the language of the New Testament be forbidden, as too exhausting a labour, a toil fruitful only of imbecility or death? Is it really necessary that women should be shut out from the knowledge of the physical sciences? Would a knowledge of physiology make them worse mothers, and an acquaintance with the chemistry of food less fit to superintend the processes of cooking? It is not asked, be it remembered, that one single woman should be compelled to take a degree, or held disgraced for being without one; but simply, that she may try if she chooses, and that if she chooses and succeeds, then she shall receive that certificate of her strength and culture, which will be fairly her due.

But the value of degrees in female education would be far greater indirectly than directly; they would raise the standard of excellence by a sure process, even though it might be slow, of every school and every teacher in the kingdom. A very small proportion of girls would attempt to take them; fewer still would succeed; fewer still would take honours. But every school-girl in the land would very soon become aware of the fact, that women might hope and strive for a thorough culture, which has never yet been generally offered to them. The Arts regulations of the University of London would guide the studies of women as gently and effectually as they now guide the studies of boys and men. A very simple example of this may be given. There is an increasing neglect of the Greek and Latin Classics in ordinary education. The reason why these languages are still taught in the majority of middle-class

schools, is neither more nor less than this: that some knowledge of them is required for the B.A. degree, and even for matriculation in the University of London. That which in the case of boys seems drawing near to death, is, in the case of girls, just beginning to live; and the classic languages in girls' schools and colleges have to force their way to general acceptance through many difficulties and prejudices. The same influence which arrests the decay in one case, would favour the growth in the other case. Whether the reasons for the study of the classical languages be understood or not, reasons of the utmost cogency do actually exist. They have been considered and reconsidered over and over again, and in all variety of circumstances, by those who are best qualified to judge; and they still retain their place of highest honour and prime necessity, in thorough human culture. The study of them justifies itself in every case where they are really studied, and not simply acquired as accomplishments. It would be a very great advantage, and especially in a country so devoted to commerce as our own, that they should be studied, even though very few might perceive the reasons why. That they were necessary for a certificate of merit, or for a University degree, would be a satisfactory answer for teachers to give to that large class of parents who really know nothing about genuine education, but who feel that they must obtain for their children what other children have, and a reputation for knowledge at any rate, if not knowledge itself.

In the foregoing observations it is not intended to assert that the curriculum of the London University is absolutely the best that could possibly be devised for women. There are differences of opinion as to whether it is absolutely the best that could be devised for men. But in the meantime, here it is, ready made to our hands. Men accept it, admitting it to be imperfect, as the best at present attainable. Women are desirous of sharing its advantages and disadvantages. They need, even more than men, "an encouragement for pursuing a regular and liberal course of education" *after* the period at which their school education ceases. To found a separate University for them would be a work of enormous difficulty and expense, and one which the existence of the University of London renders unnecessary. If indeed there were no University having the power to examine and confer degrees without collegiate residence, a new institution would undoubtedly be required. As

it happens, however, that quite irrespective of the claims of women, the constitution of the University of London has already been so modified as exactly to meet their requirements, the suggestion to found a new University may be regarded as simply a device for getting rid of the question.

Those who entertain the fear that an enlarged course of study would, by overworking the female brain, eventually produce wide-spread idiocy, should remember that mental disease is produced by want of occupation as well as by an excess of it. It has been stated to us by a physician at the head of a large lunatic asylum near London, having under his charge a considerable number of female patients of the middle-class, that the majority of these cases were the result of mental idleness. It is a well-known fact that in those most melancholy diseases known by the names of hysteria, and nervous affections, under which so large a proportion of women in the well-to-do classes are, more or less, sufferers, the first remedy almost invariably prescribed is, interesting occupation, change of scene, anything in fact, that may divert the mind from the dull monotony of a vacant life.

The strongest arguments which can be used in favour of offering some stimulus to the higher intellectual culture of women are in fact those which have been thoughtlessly advanced on the other side. Amazons have never been persons of high intellectual attainments, nor have the most learned women shown any tendency to rush into Bloomerism and other ugly eccentricities. It is true, indeed, and a fact of the utmost significance, that women with great natural force of character, do, when denied a healthy outlet for their energy, often indulge in unhealthy extravagances, simply because it is a necessity of their nature to be active in some way or other. But the fast women and the masculine women are not those who sit down to their books and devote themselves to an orderly course of study. It may be asserted with still greater emphasis, that the hard and cold women are precisely those whom a consciousness of their unimportance to the world in general has made callous to everything but their own petty, personal interests, and in whom the sense of duty and responsibility, or in other words, the conscience, has been deadened and seared by fashionable frivolity.

Great stress has been laid on the alleged fact that women do not themselves want University examinations and degrees. It is

always difficult to ascertain the "sense" of women on any given subject. Many shrink from even affixing their names to a memorial, and there is no other recognised method by which they can, in any corporate manner, express their opinions. There can be no doubt that among the more thoughtful, there are many who are eager to obtain for younger women educational aids of which they cannot themselves enjoy the benefit. The cordial support given to this proposal by Mrs. Somerville, Mrs. Grote, Mrs. Gaskell, Mrs. Mary Howitt, &c., and by a large proportion of the ladies concerned in the management of Queen's College and Bedford College, sufficiently attest the fact.

It is probably equally true that there are many others who are not very anxious for any alteration in existing systems of education. This ought not to be surprising to a reflecting mind. It is perfectly natural that people who do not know by experience the value of learning, and who are pretty well satisfied with themselves as they are, should not care much about securing to others advantages which they are incapable of appreciating. The tendency, almost the professed object, of their education, has been to make them unreasonable. It would be strange indeed, if on this one subject, they should be able to reason and judge. *Their* indifference is much less astonishing than that of men, who willingly forego for their daughters, opportunities of intellectual advancement which they well know how to appreciate, and which they consider of the highest importance for their sons.

There is one part of this subject which is of special practical importance, and also of peculiar difficulty: the right of women to take degrees in Medicine. This, if should be remembered, is wholly distinct from the general question, which it has been the object of this paper to discuss. The course of study and of practice necessary for the M.B. or M.D. degree, is by no means a necessary part of that human culture, which every man and every woman should be encouraged and urged to seek. But the right to practise as a physician would be valuable as opening the way for useful and remunerative employment to those ladies who do not wish to be governesses, or to engage in ordinary trade; and as affording to all women the alternative of being attended by physicians of their own sex. It cannot be denied that a large number of women find very great satisfaction in some kind or other of doctoring, and do actually

practise it, whether they know anything about it or not; yet this is so grave a matter that it has been thought necessary, quite recently, to bring the practice of medicine more completely under legal control. The want of skill or care may so easily and quickly produce fatal mischief, and even murder itself may be so easily hidden under the disguise of the unskilfulness of a physician, that it has been thought necessary to require the surest guarantees of competency from all those to whose professional attention, the health and lives of their patients are so often entrusted. Here, however, as in Arts, what has been asked on the part of women is, not a lower standard of medical skill, not easier examinations, but that they should be allowed, in medical schools of their own, to acquire such knowledge as would enable them to pass the examinations and acquire the skill which are now thought necessary and sufficient in the case of men.

The holding of degrees by women is not without precedent. In the Italian Universities and in that of Göttingen, women have held high positions. Towards the end of the last century a female physician graduated at Montpelier. In 1861, the degree of *Bachelier des-Lettres* was conferred on Mdlle. Daubié, by the Academy of Lyons, and within the last few months, another French lady, Mdlle. Chenu, passed her examination for the degree of *Bachelier des-Sciences* at the University of the Sorbonne. It appears not unreasonable to hope that before many years have elapsed, Englishwomen will be placed in a not less favourable position than their continental neighbours, and that whatever advantages may belong to University examinations and degrees, will be thrown freely open to them.

IS THERE ANY SPECIFIC DISTINCTION BETWEEN MALE AND FEMALE INTELLECT?

Paper read at a meeting of the Manchester Ladies' Literary Society, *Englishwoman's Review* (1868)

Lydia E. Becker[1]

The superiority in muscular strength of the male to the female sex in the human species is a fact beyond all dispute. Many persons, reasoning from analogy, maintain that there is a difference in the minds of men and women corresponding to the difference in their bodily organisation – that because women are weaker in body than men they must be weaker in mind; and in order to soften this rude assertion of superiority, men have endeavoured to make out that to compensate women for the intellectual powers denied to their sex, they are gifted with a certain fineness of perception, an intuitive apprehension of truths, to be reached by the slower minds of the other sex only by a cumbrous process of reasoning. The persons who believe that the distinction of sex extends to mind are accustomed to maintain that the intellects of men and women should be cultivated in a different fashion and directed in different ways, and that there is a "sphere" or "province" assigned to each, within which it is the bounden duty of one sex, at least, to confine erratic genius. There would seem more reason for this division of intellectual labour if the terms imposed affected both sexes alike. But while men have been permitted to wander at will over the whole range of human thoughts and capacities without danger of being warned off any region, as "beyond the province of their sex," women have been pent in a small corner, and though they have lately succeeded in considerably enlarging the boundary of what is considered their legitimate sphere of exertion, they have not yet been able to obtain the recognition of the principle that the boundary itself, in so far as it is a restriction on natural tastes and capacities, ought not to be imposed on one sex more than

on the other. Men have been left free to think and act according to their natural bent, while women have been and are subjected to artificial restraint; and this circumstance has produced the same inevitable result as would have arisen from a corresponding difference in the training of two classes of men. Suppose all dark-haired boys were encouraged to join in athletic sports and exhilarating games, and trained to strive for all the honours and rewards of active life, and all light-haired ones were kept chiefly indoors, allowed exercise only in the shape of walking, set to quiet occupations, and instructed that their vocation in life consisted mainly in being useful to the others, there would arise a difference between the mental and moral complexion of the two sets, quite as striking as that which subsists between girls and boys, or men and women.

The propositions to which I invite your assent this afternoon are –

1. That the attribute of sex does not extend to mind, and that there is no distinction between the intellects of men and women corresponding to and dependent on the organisation of their bodies.

2. That any broad marks of distinction that may exist at the present time between the minds of men and women collectively, are fairly traceable to the influence of the different circumstances under which they pass their lives, and cannot be proved to inhere in each class in virtue of sex.

3. That in spite of the external circumstances which tend to cause divergence in tone of mind, habits of thought, and opinions, between men and women, it is a matter of fact that these do not differ more among persons of opposite sexes than they do among persons of the same; that comparing any one man and any one women, the difference between them in these points will not be greater than what may be found between two men or two women.

In illustration of the first of my propositions, I would observe that sex is an attribute common to all organised beings who rise above the very lowest forms of animal or vegetable life. The higher vegetables, though possessing the attribute of sex, have never manifested any signs of consciousness or intelligence. They do possess a certain amount of sensitiveness to external impressions not strictly mechanical, and a capacity for spontaneous movement till they find the support or nourishment they need. Yet these appearances, curious and

interesting as they are, do not warrant us in ascribing any degree of intellect to plants. These cannot therefore afford us any assistance in the inquiry as to the effect of sex upon mind, but they may help to disabuse us of the notion that superiority in strength is necessarily masculine – every botanist being aware that female plants are quite as strong and big as male ones of the same species.

When we turn to the animal kingdom, we do not proceed far up the scale from the lowest organisms before detecting the existence of mind in the creatures whose habits we observe. Mind of a very low order, it may be, still we observe signs of consciousness, of pleasure and pain, of voluntary action, and of ingenious adaptation of means to ends, long before we quit the kingdoms of the invertebrata. And I am not aware that any naturalist has reported that there is a greater development of intellect in one sex than in the other, as a general rule. Exceptions there are, certainly. In the hive bee, the ingenuity to work and the power to govern are vested in actual or potential females, while the males, kept within their "sphere," are ignominiously hustled out of existence, whenever they are tempted to step beyond it, or unreasonable enough to ask for a share of the good things of the hive. But it seems fair to conclude that this subordination is not due to any inherent inferiority in masculinity, as such, but simply to the fact that their bodily organisation leaves them defenceless against the terrible weapons of the superior sex. Had nature gifted the males with stings, they would assuredly assert their right to live on equal terms with other members of the community.

In another class of invertebrata we are presented with the view of numerous species of animals having the sexes united in the same individual; a puzzling anomaly for those who maintain that difference of sex extends to mind. They may try to escape by denying that snails and oysters have any intellect, and certainly their mental powers seem greatly below those of ants and bees – still, we are not justified in saying they have none at all.

Passing to the kingdom of which man is a member, we do not find universal among vertebrate animals the rule as to feminine subordination deduced from the relative strength of the sexes in the human species. Where there is inequality in this respect among brutes, the difference is not always in favour of the male. Whichever sex is stronger will have the mastery, but

there is no ground for the assertion that the male is necessarily the superior. In the birds of prey, from the eagle to the sparrow-hawk, the female exceeds her mate in size, strength, and courage; the male bird is an inferior creature, who was always rejected by the falconers on account of his comparative deficiency in these qualities. The lordly eagle, the monarch of the peak, is the female bird, and should not be spoken of by names denoting the masculine gender.

If the birds of prey were to reason, from experience in their own species, that there was any inherent superiority of one sex over the other they would unquestionably assign the palm of dominion to the female. But the eagles would undoubtedly be mistaken if they affirmed that the dominant sex reigned among them by any more recondite title than that of an accidental superiority of physical strength. The male is bodily weaker among eagles, the female among men, therefore there is no ground for the assumption that one sex is naturally and inherently superior, even in strength, to the other.

But in animals, and in the lower stages of civilization among human beings, superiority in physical strength counts for, and brings in its train, superiority in everything else; the weakest go to the wall – the strong oppress and enslave the less powerful. In the long dark night of ignorance and superstition which represents the past history of our race, brute force has been the one thing worshipped. Men have bowed down in adulation before the conquerors who came with sword in hand to oppress them, and put to death those who came with intellect to enlighten and free them. Now the dawn of a brighter day is breaking, and we rejoice in the promise of the light to come. It is true, we have not ceased to idolize military despotism, but we have at least learned not to put to death the philosophers. We still seem, however, a long way off the time when he will not be considered the greatest man who boasts the "greatest faculty for coercing mankind."

The second proposition to which I ask your assent is, that any broad marks of distinction existing at the present time between the minds of men and women collectively are fairly traceable to the influence of the different circumstances under which they pass their lives, and cannot be proved to inhere in each class in virtue of sex.

In illustration of this assertion, I point to the fact, that when minds are classified into groups, the male and the female mind

are not the only species recognised. Whenever a class of persons are united by similarity of profession or pursuits, there is generated among them a peculiar tone of thought, distinguishing them from men engaged in other occupations.

We have the legal mind, the military mind, the clerical mind, the commercial mind, the scientific mind, the scholastic mind, and others. Suppose a company of soldiers, another of lawyers, another of priests, another of artists were gathered together, the conversation of each assemblage would have a marked tone peculiar to the members of the profession of which it was composed; and suppose the separate parties then gathered into one, and a conversation to take place on general subjects – the lawyer, the doctor, the artist and the soldier would each bring into the discussion, not only his own individual peculiarities of thought and feeling, but something of the influence exerted on these by the exigencies of his calling in life.

We do not attribute this result to any inherent natural distinction in the minds of those who pursue each profession, but entirely to education, and circumstances. Men are not born soldiers, lawyers, or doctors, and though some are undoubtedly predisposed by natural bent to one vocation, in which only they can excel, the great majority would make indifferently good members of any trade or profession which circumstances caused them to embrace.

Now I believe that a similar reason accounts for all the differences that may be observed to exist between men and women. The difference in their vocation in life, in their daily habits, in the things each has got to do, would tend to make a divergence between men and women, even if their education and training had been in common.

But how far is this from being the case! Boys are encouraged to develop their bodily powers, to mix with the world, to regard personal distinction in their calling in life as an object of honourable ambition. Girls are usually discouraged from hard play, or exercise calculated to develop bodily strength; their natural aspirations for a career or pursuit in life by which they may win their way in the world are repressed as unbecoming, and they are told that the highest reward of any excellence they may attain consists in living unrecognized and unknown.

The one thing to be sedulously and religiously shunned is publicity. When boys or men do a thing worthy of approbation their friends think it something to be proud of, and give honour

where honour is due, their names are given that others may be encouraged to persevere in the good work.

But if a girl or a woman renders a public service, or distinguishes herself in any way, it seems to be regarded as something to be ashamed of; it is considered wrong to give honourable public distinctions to women, and that they ought to deprecate rather than desire them. This principle is acted on by the University of Cambridge, which admits boys and girls on exactly equal terms to its local examinations. But the boys who pass honourably have their names published, while the girls who pass honourably have their names suppressed. It is just as natural for a girl as for a boy to be pleased to see her names in a list of those who have done well. This desire is thought praiseworthy in a boy and worthy of encouragement – it is thought blameworthy in a girl and to be sternly reproved. An artificial distinction is made where nature has made none.

No one would wish to see either girls or boys ostentatiously putting themselves forward. But there may be just as much egotism and self-consciousness in ostentatiously hiding their heads. Arrogance is a very unpleasant quality. But a man who is "'umble" may be more trying to deal with. At least we give the first credit for honesty.

With this and other marked differences in the mental training and moral code imposed on the two sexes, it is only wonderful that the distinction between men and women is not greater than we find it; and this brings me to my third proposition, namely – That in spite of the circumstances which tend to cause divergence in the tone of mind, the habits of thought, and the opinions of men and women, it is a matter of fact that these do not differ more among persons of opposite sexes than they do among persons of the same – that comparing any one man with any one woman, the difference between them will not be greater than may be found between two men or two women.

One of the most natural and obvious divisions of labour between the two sexes, is that which assigns to men the occupations of soldiers and sailors. Women would seem to be unfitted physically to engage in them. But do we find a corresponding mental or moral disability? On the contrary, instances are by no means uncommon of the natural taste of a woman leading her so decidedly to one or other of these professions that she has overcome all obstacles and actually engaged in them. Disguised as men, women have more than

once been detected as soldiers and sailors, some having performed their duties creditably, and maintained the secret of their sex for years.[1] We may assume that all have not been detected, and that a careful scrutiny might possibly reveal others scattered among the ships and armies of the world.[2] These instances are not adduced with a view of proving that it is desirable to open such professions to women, but merely in support of my proposition that sex does not extend to mind. As these military and naval heroines were feminine in body they would have had minds to correspond if it were truly a law of nature that there was such a thing as sex in taste and intellect.

Needlework is a trade seemingly peculiarly adapted to the powers and tastes of women. Yet surely it is not hard necessity which leads so many men to embrace it. Men can do it, and do it well, and as there is no legal nor social restraint on them, they set to work to make clothes, I presume with satisfaction to themselves, as well as to those who employ them.[3]

Many professions are common to both sexes; and the votaries of art and literature are taken from the ranks of men and women indiscriminately, though the opportunities of study and the prospect of reward are greatly in favour of the dominant sex.

[1] The following extract appeared in the *Morning Star* of March 31, a few days after the reading of this paper:– "A woman named Mary Walker, found begging in man's attire in Whitechapel, was yesterday brought before Mr. Benson. She has long been known to the police, not so much as a bad as an eccentric character. For many years she has dressed as a man, and obtained men's situations. At one time she was stoker on a Cunard boat, at another a porter on the Great Western Railway. She was once a "barman" and once a sailor. In answer to a question from the magistrate, she said she did not know why she had changed her dress; she left her native village seven years ago; and had ever since worn male attire. As she was very ill and weak, in consequence of the excessive hardships she had undergone in doing men's work, she was remanded for a week to the House of Detention, to regain her strength."

[2] A CRETAN JOAN OF ARC. The *Indépendance Hellénique* states that a young Cretan lady has just arrived in Athens dressed in masculine attire, which she assumed for the purpose of preserving her *incognito* whilst heroically fighting against the Turks in Crete. She has been photographed in her military costume and equipment. June 1st, 1868.

[3] Miss M. B. Edwards, in giving an account of the famous reformatory at Mettray, says – "Each boy is at liberty to follow the trade he likes best, and, oddly enough, the favourite one seems to be that of tailoring." "Through Spain to the Sahara," Page 6. Note Ed. E. R.

If we take an assemblage of persons of opposite sexes and test the difference of thought and opinion existing among them by putting before them any proposition on which opposite views can be held, I believe it would be impossible to find one which would range all the men on one side, and all the women on the other. If it were true that there is a specific difference, however slight, between the minds of men and women, it would be possible to find such a proposition, if we took one which corresponded to this distinction. When a naturalist seeks to group a number of individuals into a distinct class, he fixes on some character, or set of characters, common to them all, and distinguishing them from other individuals. When he finds such a group distinctly defined he calls it a species. But when he finds two individuals differing very widely from each other, yet so connected by numerous intermediate forms that he can pass from one extreme to the other without a violent break anywhere in the series, he considers them to be of one and the same kind. Taking the conventional masculine type of mind as one end of the scale, and the conventional feminine type as the other, I maintain that they are connected by numerous intermediate varieties distributed indiscriminately in male and female bodies; that what is called a masculine mind is frequently found united to a feminine body, and sometimes the reverse; and that there is no necessary, nor even presumptive connexion between the sex of a human being, and the type of intellect and character he possesses.

Excerpted from
THE STUDY OF SOCIOLOGY:
NO. XV. – PREPARATION IN PSYCHOLOGY
The Contemporary Review, Vol. 22 (1873)
Herbert Spencer

. . .

One further instance of the need for psychological inquiries as
guides to sociological conclusions, may be named – an instance of
quite a different kind, but one no less relevant to questions of the
time. I refer to the comparative psychology of the sexes. Women,
as well as men, are units in a society; and tend by their natures to
give that society certain traits of structure and action. Hence the
question – Are the mental natures of men and women the same? –
is an important one to the sociologist. If they are, an increase of
feminine influence is not likely to affect the social type in a
marked manner. If they are not, the social type will inevitably be
changed by increase of feminine influence.

That men and women are mentally alike, is as untrue as that
they are alike bodily. Just as certainly as they have physical
differences which are related to the respective parts they play in
the maintenance of the race, so certainly have they psychical
differences, similarly related to their respective shares in the
rearing and protection of offspring. To suppose that along with
the unlikenesses between their parental activities there do not
go unlikenesses of mental faculties, is to suppose that here
alone in all Nature, there is no adjustment of special powers to
special functions.[1]

[1] The comparisons ordinarily made between the minds of men and women
are faulty in many ways, of which these are the chief:-
 Instead of comparing either the average of women with the average of men,
or the *élite* of women with the *élite* of men, the common course is to compare
the *élite* of women with the average of men. Much the same erroneous
impression results as would result if the relative statures of men and women
were judged by putting very tall women side by side with ordinary men.
 Sundry manifestations of nature in men and women, are greatly perverted
by existing social conventions upheld by both. There are feelings which,

Two classes of differences exist between the psychical, as between the physical, structures of men and women, which are both determined by this same fundamental need – adaptation to the paternal and maternal duties. The first set of differences is that which results from a somewhat-earlier arrest of individual evolution in women than in men; necessitated by the reservation of vital power to meet the cost of reproduction. Whereas, in man, individual evolution continues until the physiological cost of self-maintenance very nearly balances what nutrition supplies, in woman, an arrest of individual development takes place while there is yet a considerable margin of nutrition: otherwise there could be no offspring. Hence the fact that girls come earlier to maturity than boys. Hence, too, the chief contrasts in bodily form: the masculine figure being distinguished from the feminine by the greater relative sizes of the parts which carry on external actions and entail physiological cost – the limbs, and those thoracic viscera

under our predatory *régime*, with its adapted standard of propriety, it is not considered manly to show; but which, contrariwise, are considered admirable in women. Hence repressed manifestations in the one case, and exaggerated manifestations in the other; leading to mistaken estimates.

The sexual sentiment comes into play to modify the behaviour of men and women to one another. Respecting certain parts of their general characters, the only evidence which can be trusted is that furnished by the conduct of men to men, and of women to women, when placed in relations which exclude the personal affections.

In comparing the intellectual powers of men and women, no proper distinction is made between receptive faculty and originative faculty. The two are scarcely commensurable; and the receptivity may, and frequently does, exist in high degree where there is but a low degree of originality, or entire absence of it.

Perhaps, however, the most serious error usually made in drawing these comparisons is that of overlooking the limit of normal mental power. Either sex under special stimulations is capable of manifesting powers ordinarily shown only by the other; but we are not to consider the deviations so caused as affording proper measures. Thus, to take an extreme case, the mammæ of men will, under special excitation, yield milk: there are various cases of gynæcomasty on record, and in famines infants whose mothers have died have been thus saved. But this ability to yield milk, which, when exercised, must be at the cost of masculine strength, we do not count among masculine attributes. Similarly, under special discipline, the feminine intellect will yield products higher than the intellects of most men can yield. But we are not to count this as truly feminine if it entails decreased fulfilment of the maternal functions. Only that mental energy is normally feminine which can coexist with the production and nursing of the due number of healthy children. Obviously a power of mind which, if general among the women of a society, would entail disappearance of the society, is a power not to be included in an estimate of the feminine nature as a social factor.

which their activity immediately taxes. And hence, too, the physiological truth that throughout their lives, but especially during the child-bearing age, women exhale smaller quantities of carbonic acid, relatively to their weights, than men do; showing that the evolution of energy is relatively less as well as absolutely less. This rather earlier cessation of individual evolution thus necessitated, showing itself in a rather smaller growth of the nervo-muscular system, so that both the limbs which act and the brain which makes them act are somewhat less, has two results on the mind. The mental manifestations have somewhat less of general power or massiveness; and beyond this there is a perceptible falling-short in those two faculties, intellectual and emotional, which are the latest products of human evolution – the power of abstract reasoning and that most abstract of the emotions, the sentiment of justice – the sentiment which regulates conduct irrespective of personal attachments and the likes or dislikes felt for individuals.[2]

After this quantitative mental distinction, which becomes incidentally qualitative by telling most upon the most recent and most complex faculties, there come the qualitative mental distinctions consequent on the relations of men and women to their children and to one another. Though the parental instinct, which, considered in its essential nature, is a love of the helpless, is common to the two; yet it is obviously not identical in the two. That the particular form of it which responds to infantile helplessness is more dominant in women than in men, cannot be questioned. In man the instinct is not so habitually excited by the very helpless, but has a more generalized relation to all the relatively-weak who are dependent upon him. Doubtless, along with this more specialized instinct in women, there go special aptitudes for dealing with infantile life – an adapted power of intuition and a fit adjustment of behaviour. That there is here a mental specialization, joined with the bodily specialization, is undeniable; and this mental specialisation, though primarily related to the rearing of offspring, affects in some degree the conduct at large.

2 Of course it is to be understood that in this, and in the succeeding statements, reference is made to men and women of the same society, in the same age. If women of a more-evolved race are compared with men of a less-evolved race, the statement will not be true.

The remaining qualitative distinctions between the minds of men and women are those which have grown out of their mutual relation as stronger and weaker. If we trace the genesis of human character, by considering the conditions of existence through which the human race passed in early barbaric times and during civilization, we shall see that the weaker sex has naturally acquired certain mental traits by its dealings with the stronger. In the course of the struggles for existence among wild tribes, those tribes survived in which the men were not only powerful and courageous, but aggressive, unscrupulous, intensely egoistic. Necessarily, then, the men of the conquering races which gave origin to the civilized races, were men in whom the brutal characteristics were dominant; and necessarily the women of such races, having to deal with brutal men, prospered in proportion as they possessed, or acquired, fit adjustments of nature. How were women, unable by strength to hold their own, otherwise enabled to hold their own? Several mental traits helped them to do this. We may set down, first, the ability to please, and the concomitant love of approbation. Clearly, other things equal, among women living at the mercy of men, those who succeeded most in pleasing would be the most likely to survive and leave posterity. And (recognizing the predominant descent of qualities on the same side) this, acting on successive generations, tended to establish, as a feminine trait, a special solicitude to be approved, and an aptitude of manner to this end. Similarly, the wives of merciless savages must, other things equal, have prospered in proportion to their powers of disguising their feelings. Women who betrayed the state of antagonism produced in them by ill-treatment, would be less likely to survive and leave offspring than those who concealed their antagonism; and hence, by inheritance and selection, a growth of this trait proportionate to the requirement. In some cases, again, the arts of persuasion enabled women to protect themselves, and by implication their offspring, where, in the absence of such arts, they would have disappeared early, or would have reared fewer children. One further ability may be named as likely to be cultivated and established – the ability to distinguish quickly the passing feelings of those around. In barbarous times a woman who could from a movement, tone of voice, or expression of face, instantly detect in her savage husband the passion that was rising, would be likely to escape dangers run into by a woman

less skilled in interpreting the natural language of feeling. Hence, from the perpetual exercise of this power, and the survival of those having most of it, we may infer its establishment as a feminine faculty. Ordinarily, this feminine faculty, showing itself in an aptitude for guessing the state of mind through the external signs, ends simply in intuitions formed without assignable reasons; but when, as happens in rare cases, there is joined with it skill in psychological analysis, there results an extremely-remarkable ability to interpret the mental states of others. Of this ability we have a living example never hitherto paralleled among women, and in but few, if any, cases exceeded among men. Of course, it is not asserted that the specialities of mind here described as having been developed in women by the necessities of defence in their dealings with men, are peculiar to them: in men also they have been developed as aids to defence in their dealings with one another. But the difference is that, whereas, in their dealings with one another, men depended on these aids only in some measure, women in their dealings with men depended upon them almost wholly – within the domestic circle as well as without it. Hence, in virtue of that partial limitation of heredity by sex, which many facts throughout Nature show us, they have come to be more marked in women than in men.[3]

3 As the validity of this group of inferences depends on the occurrence of that partial limitation of heredity of sex here assumed, it may be said that I should furnish proof of its occurrence. Were the place fit, this might be done. I might detail evidence that has been collected showing the much greater liability there is for a parent to bequeath malformations and diseases to children of the same sex, than to those of the opposite sex. I might cite the multitudinous instances of sexual distinctions, as of plumage in birds and colouring in insects, and especially those marvellous ones of dimorphism and polymorphism among females of certain species of Lepidoptera, as necessarily implying (to those who accept the Hypothesis of Evolution) the predominant transmission of traits to descendants of the same sex. It will suffice, however, to instance, as more especially relevant, the cases of sexual distinctions within the human race itself, which have arisen in some varieties and not in others. That in some varieties the men are bearded and in others not, may be taken as strong evidence of this partial limitation of heredity; and perhaps still stronger evidence is yielded by that peculiarity of feminine form found in some of the negro races, and especially the Hottentots, which does not distinguish to any such extent women of other races from the men. There is also the fact, to which Agassiz draws attention, that among the South American Indians males and females differ less than they do among the negroes and the higher races; and this reminds us that among European and Eastern nations the men and women differ, both bodily and mentally, not quite in the same ways and to the same

One further distinctive mental trait in women, springs out of the relation of the sexes as adjusted to the welfare of the race. I refer to the effect which the manifestation of power of every kind in men, has in determining the attachments of women. That this is a trait inevitably produced, will be manifest on asking what would have happened if women, had by preference attached themselves to the weaker men. If the weaker men had habitually left posterity when the stronger did not, a progressive deterioration of the race would have resulted. Clearly, therefore, it has happened (at least, since the cessation of marriage by capture or by purchase has allowed feminine choice to play an important part), that, among women unlike in their tastes, those who were fascinated by power, bodily or mental, and who married men able to protect them and their children, were more likely to survive in posterity than women to whom weaker men were pleasing, and whose children were both less efficiently guarded and less capable of self-preservation if they reached maturity. To this admiration for power, caused thus inevitably, is ascribable the fact sometimes commented upon as strange, that women will continue attached to men who use them ill, but whose brutality goes along with power, more than they will continue attached to weaker men who use them well. With this admiration of power, primarily having this function, there goes the admiration of power in general; which is more marked in women than in men, and shows itself both theologically and politically. That the emotion of awe aroused by contemplating whatever suggests transcendent force or capacity, which constitutes religious feeling, is strongest in women, is proved in many ways. We read that among the Greeks the women were more religiously excitable than the men. Sir Rutherford Alcock tells us of the Japanese that "in the temples it is very rare to see any congregation except women and children; the men, at any time, are very few, and those generally of the lower classes." Of the pilgrims to the temple of Juggernaut, it is stated that "at least five-sixths, and often nine-tenths, of them are females." And we are also told of the Sikhs, that the women believe in more gods than the men do. Which facts, coming from different races and times, sufficiently show us that the like fact, familiar to us in Roman Catholic countries and to some extent

degrees, but in somewhat different ways and degrees – a fact which would be inexplicable were there no partial limitation of heredity by sex.

at home, is not, as many think, due to the education of women, but has a deeper cause in natural character And to this same cause is in like manner to be ascribed the greater respect felt by women for all embodiments and symbols of authority, governmental and social.

Thus the *à priori* inference, that fitness for their respective parental functions implies mental differences between the sexes, as it implies bodily differences, is justified; as is also the kindred inference that secondary differences are necessitated by their relations to one another. Those unlikenesses of mind between men and women, which, under the conditions were to be expected, are the unlikenesses we actually find. That they are fixed in degree, by no means follows: indeed, the contrary follows. Determined as we see they some of them are by adaptation of primitive women's natures to the natures of primitive men, it is inferable that as civilization re-adjusts men's natures to higher social requirements, there goes on a corresponding re-adjustment between the natures of men and women, tending in sundry respects to diminish their differences. Especially may we anticipate that those mental peculiarities developed in women as aids to defence against men in barbarous times, will diminish. It is probable, too, that though all kinds of power will continue to be attractive to them, the attractiveness of physical strength and the mental attributes that commonly go along with it, will decline; while the attributes which conduce to social influence will become more attractive. Further, it is to be anticipated that the higher culture of women, carried on within such limits as shall not unduly tax the *physique* (and here, by higher culture, I do not mean mere language-learning and an extension of the detestable cramming-system at present in use), will in other ways reduce the contrast. Slowly leading to the result everywhere seen throughout the organic world, of a self-preserving power inversely proportionate to the race-preserving power, it will entail a less-early arrest of individual evolution, and a diminution of those mental differences between men and women, which the early arrest produces.

Admitting such to be changes which the future will probably see wrought out, we have meanwhile to bear in mind these traits of intellect and feeling which distinguish women, and to take note of them as factors in social phenomena – much more important factors than we commonly suppose. Considering

them in the above order, we may note, first, that the love of the helpless, which in her maternal capacity woman displays in a more special form than man, inevitably affects all her thoughts and sentiments; and this being joined in her with a less-developed sentiment of abstract justice, she responds more readily when appeals to pity are made, than when appeals are made to equity. In foregoing chapters we have seen how much our social policy disregards the claims of individuals to whatever their efforts purchase, so long as no obvious misery is brought on them by the disregard; but when individuals suffer in ways conspicuous enough to excite commiseration, they get aid, and often as much aid if their sufferings are caused by themselves as if they are caused by others – often greater aid, indeed. This social policy, to which men tend in an injurious degree, women tend to still more. The maternal instinct delights in yielding benefits apart from deserts; and being partially excited by whatever shows a feebleness that appeals for help (supposing antagonism has not been aroused), carries into social action this preference of generosity to justice, even more than men do. A further tendency having the same general direction, results from the aptitude which the feminine intellect has to dwell on the concrete and proximate rather than on the abstract and remote. The representative faculty in women deals quickly and clearly with the personal, the special, and the immediate; but less rapidly grasps the general and the impersonal. A vivid imagination of simple direct consequences mostly shuts out from her mind the imagination of consequences that are complex and indirect. The respective behaviours of mothers and fathers to children, sufficiently exemplify this difference: mothers thinking chiefly of present effects on the conduct of children, and regarding less the distinct effects on their characters; while fathers often repress the promptings of their sympathies with a view to ultimate benefits. And this difference between their ways of estimating consequences, affecting their judgments on social affairs as on domestic affairs, makes women err still more than men do in seeking what seems an immediate public good without thought of distant public evils. Once more, we have in women the predominant awe of power and authority, swaying their ideas and sentiments about all institutions. This tends towards the strengthening of governments, political and ecclesiastical. Faith in whatever presents itself with imposing accompaniments, is,

for the reason above assigned, especially strong in women. Doubt, or criticism, or calling-in-question of things that are established, is rare among them. Hence in public affairs their influence goes towards the maintenance of controlling agencies, and does not resist the extension of such agencies: rather, in pursuit of immediate promised benefits, it urges on that extension; since the concrete good in view excludes from their thoughts the remote evils of multiplied restraints. Reverencing power more than men do, women, by implication, respect freedom less – freedom, that is, not of the nominal kind, but of that real kind which consists in the ability of each to carry on his own life without hindrance from others, so long as he does not hinder them.

As factors in social phenomena, these distinctive mental traits of women have ever to be remembered. Women have in all times played a part, and, in modern days, a very notable part, in determining social arrangements. They act both directly and indirectly. Directly they take a large, if not the larger share in that ceremonial government which supplements the political and ecclesiastical governments; and as supporters of these other governments, especially the ecclesiastical, their direct aid is by no means unimportant. Indirectly they act by modifying the opinions and sentiments of men – first, in education, when the expression of maternal thoughts and feelings affects the thoughts and feelings of boys, and afterwards in domestic and social intercourse, during which the feminine sentiments sway men's public acts, both consciously and unconsciously. Whether it is desirable that the share already taken by women in determining social arrangements and actions should be increased, is a question we will leave undiscussed. Here I am concerned merely to point out that, in the course of a psychological preparation for the study of Sociology, we must include the comparative psychology of the sexes; so that if any change is made, we may make it knowing what we are doing.

. . .

SEX IN MIND AND IN EDUCATION
The Fortnightly Review, Vol. 15 (1874)
Henry Maudsley

Those who view without prejudice, or with some sympathy, the movements for improving the higher education of women, and for throwing open to them fields of activity from which they are now excluded, have a hard matter of it sometimes to prevent a feeling of reaction being aroused in their minds by the arguments of the most eager of those who advocate the reform. Carried away by their zeal into an enthusiasm which borders on or reaches fanaticism, they seem positively to ignore the fact that there are significant differences between the sexes, arguing in effect as if it were nothing more than an affair of clothes, and to be resolved, in their indignation at woman's wrongs, to refuse her the simple rights of her sex. They would do better in the end if they would begin by realising the fact that the male organization is one, and the female organization another, and that, let come what come may in the way of assimilation of female and male education and labour, it will not be possible to transform a woman into a man. To the end of the chapter she will retain her special functions, and must have a special sphere of development and activity determined by the performance of those functions.

It is quite evident that many of those who are foremost in their zeal for raising the education and social status of woman, have not given proper consideration to the nature of her organization, and to the demands which its special functions make upon its strength. These are matters which it is not easy to discuss out of a medical journal; but, in view of the importance of the subject at the present stage of the question of female education, it becomes a duty to use plainer language than would otherwise be fitting in a literary journal. The gravity of the subject can hardly be exaggerated. Before sanctioning the proposal to subject woman to a system of

mental training which has been framed and adapted for men, and under which they have become what they are, it is needful to consider whether this can be done without serious injury to her health and strength. It is not enough to point to exceptional instances of women who have undergone such a training, and have proved their capacities when tried by the same standard as men; without doubt there are women who can, and will, so distinguish themselves, if stimulus be applied and opportunity given; the question is, whether they may not do it at a cost which is too large a demand upon the resources of their nature. Is it well for them to contend on equal terms with men for the goal of man's ambition?

Let it be considered that the period of the real educational strain will commence about the time when, by the development of the sexual system, a great revolution takes place in the body and mind, and an extraordinary expenditure of vital energy is made, and will continue through those years after puberty when, by the establishment of periodical functions, a regularly recurring demand is made upon the resources of a constitution that is going through the final stages of its growth and development. The energy of a human body being a definite and not inexhaustible quantity, can it bear, without injury, an excessive mental drain as well as the natural physical drain which is so great at that time? Or, will the profit of the one be to the detriment of the other? It is a familiar experience that a day of hard physical work renders a man incapable of hard mental work, his available energy having been exhausted. Nor does it matter greatly by what channel the energy be expended; if it be used in one way it is not available for use in another. When Nature spends in one direction, she must economise in another direction. That the development of puberty does draw heavily upon the vital resources of the female constitution, needs not to be pointed out to those who know the nature of the important physiological changes which then take place. In persons of delicate constitution who have inherited a tendency to disease, and who have little vitality to spare, the disease is apt to break out at that time; the new drain established having deprived the constitution of the vital energy necessary to withstand the enemy that was lurking in it. The time of puberty and the years following it are therefore justly acknowledged to be a critical time for the female organization. The real meaning of the physiological changes which constitute

puberty is, that the woman is thereby fitted to conceive and bear children, and undergoes the bodily and mental changes that are connected with the development of the reproductive system. At each recurring period there are all the preparations for conception, and nothing is more necessary to the preservation of female health than that these changes should take place regularly and completely. It is true that many of them are destined to be fruitless so far as their essential purpose is concerned, but it would be a great mistake to suppose that on that account they might be omitted or accomplished incompletely, without harm to the general health. They are the expressions of the full physiological activity of the organism. Hence it is that the outbreak of disease is so often heralded, or accompanied, or followed by suppression or irregularity of these functions. In all cases they make a great demand upon the physiological energy of the body; they are sensitive to its sufferings, however these be caused; and, when disordered, they aggravate the mischief that is going on.

When we thus look the matter honestly in the face, it would seem plain that women are marked out by nature for very different offices in life from those of men, and that the healthy performance of her special functions renders it improbable she will succeed, and unwise for her to persevere, in running over the same course at the same pace with him. For such a race she is certainly weighted unfairly. Nor is it a sufficient reply to this argument to allege, as is sometimes done, that there are many women who have not the opportunity of getting married, or who do not aspire to bear children; for whether they care to be mothers or not, they cannot dispense with those physiological functions of their nature that have reference to that aim, however much they might wish it, and they cannot disregard them in the labour of life without injury to their health. They cannot choose but to be women; cannot rebel successfully against the tyranny of their organization, the complete development and function whereof must take place after its kind. This is not the expression of prejudice nor of false sentiment; it is the plain statement of a physiological fact. Surely, then, it is unwise to pass it by; first or last it must have its due weight in the determination of the problem of woman's education and mission; it is best to recognise it plainly, however we may conclude finally to deal with it.

It is sometimes said, however, that sexual difference ought not to have any place in the culture of mind, and one hears it affirmed with an air of triumphant satisfaction that there is no sex in mental culture. This is a rash statement, which argues want of thought or insincerity of thought in those who make it. There is sex in mind as distinctly as there is sex in body; and if the mind is to receive the best culture of which its nature is capable, regard must be had to the mental qualities which correlate differences of sex. To aim, by means of education and pursuits in life, to assimilate the female to the male mind, might well be pronounced as unwise and fruitless a labour as it would be to strive to assimilate the female to the male body by means of the same kind of physical training and by the adoption of the same pursuits. Without doubt there have been some striking instances of extraordinary women who have shown great mental power, and these may fairly be quoted as evidence in support of the right of women to the best mental culture; but it is another matter when they are adduced in support of the assertion that there is no sex in mind, and that a system of female education should be laid down on the same lines, follow the same method, and have the same ends in view, as a system of education for men.

Let me pause here to reflect briefly upon the influence of sex upon mind. In its physiological sense, with which we are concerned here, mind is the sum of those functions of the brain which are commonly known as thought, feeling, and will. Now the brain is one among a number of organs in the common-wealth of the body; with these organs it is in the closest physiological sympathy by definite paths of nervous communication, has special correspondence with them by internuncial nerve-fibres; so that its functions habitually feel and declare the influence of the different organs. There is an intimate consensus of functions. Though it is the highest organ of the body, the co-ordinating centre to which impressions go and from which responses are sent, the nature and functions of the inferior organs with which it lives in unity, affect essentially its nature as the organ of mental functions. It is not merely that disorder of a particular organ hinders or oppresses these functions, but it affects them in a particular way; and we have good reason to believe that this special pathological effect is a consequence of the specific physiological effect which each organ exerts naturally upon the constitution and function of mind. A disordered liver gives rise to gloomy feelings; a

diseased heart to feelings of fear and apprehension; morbid irritation of the reproductive organs, to feelings of a still more special kind – these are familiar facts; but what we have to realise is, that each particular organ has, when not disordered, its specific and essential influence in the production of certain passions or feelings. From of old the influence has been recognised, as we see in the doctrine by which different passions were located in particular organs of the body, the heart, for example, being made the seat of courage, the liver the seat of jealousy, the bowels the seat of compassion; and although we do not now hold that a passion is aroused anywhere else than in the brain, we believe nevertheless that the organs are represented in the primitive passions, and that when the passion is aroused into violent action by some outward cause, it will discharge itself upon the organ and throw its functions into commotion. In fact, as the uniformity of thought among men is due to the uniform operation of the external senses, as they think alike because they have the same number and kind of senses, so the uniformity of their fundamental passions is due probably to the uniform operation of the internal organs of the body upon the brain; they feel alike because they have the same number and kind of internal organs. If this be so, these organs come to be essential constituents of our mental life.

The most striking illustration of the kind of organic action which I am endeavouring to indicate is yielded by the influence of the reproductive organs upon the mind; a complete mental revolution being made when they come into activity. As great a change takes place in the feelings and ideas, the desires and will, as it is possible to imagine, and takes place in virtue of the development of their functions. Let it be noted then that this great and important mental change is different in the two sexes, and reflects the difference of their respective organs and functions. Before experience has opened their eyes, the dreams of a young man and maiden differ. If we give attention to the physiology of the matter, we see that it cannot be otherwise, and if we look to the facts of pathology, which would not fitly be in place here, they are found to furnish the fullest confirmation of what might have been predicted. To attribute to the influence of education the mental differences of sex which declare themselves so distinctly at puberty, would be hardly less absurd than to attribute to education the bodily

differences which then declare themselves. The comb of a cock, the antlers of a stag, the mane of a lion, the beard of a man, are growths in relation to the reproductive organs which correlate mental differences of sex as marked almost as these physical differences. In the first years of life, girls and boys are much alike in mental and bodily character, the differences which are developed afterwards being hardly more than intimated, although some have thought the girl's passion for her doll evinces even at that time a forefeeling of her future functions; during the period of reproductive activity, the mental and bodily differences are declared most distinctly; and when that period is past, and man and woman decline into second childhood, they come to resemble one another more again. Furthermore, the bodily form, the voice, and the mental qualities of mutilated men approach those of women; while women whose reproductive organs remain from some cause in a state of arrested development, approach the mental and bodily habits of men.

No psychologist has yet devoted himself to make, or has succeeded in making, a complete analysis of the emotions, by resolving the complex feelings into their simple elements and tracing them back from their complex evolutions to the primitive passions in which they are rooted; this is a promising and much-needed work which remains to be done; but when it is done, it will be shown probably that they have proceeded originally from two fundamental instincts, or – if we add consciousness of nature and aim – passions, namely, that of self-preservation, with the ways and means of self-defence which it inspires and stimulates, and that of propagation, with the love of offspring and other primitive feelings that are connected with it. Could we in imagination trace mankind backwards along the path stretching through the ages, on which it has gone forward to its present height and complexity of emotion, and suppose each new emotional element to be given off at the spot where it was acquired, we should view a road along which the fragments of our high, special and complex feelings were scattered, and should reach a starting-point of the primitive instincts of self-preservation and propagation. Considering, then, the different functions of the sexes in the operation of the latter instinct, and how a different emotional nature has necessarily been grafted on the original differences in the course of

ages,[1] does it not appear that in order to assimilate the female to the male mind it would be necessary to undo the life-history of mankind from its earliest commencement? Nay, would it not be necessary to go still farther back to that earliest period of animal life upon earth before there was any distinction of sex?

If the foregoing reflections be well grounded, it is plain we ought to recognise sex in education, and to provide that the method and aim of mental culture should have regard to the specialties of women's physical and mental nature. Each sex must develope after its kind; and if education in its fundamental meaning be the external cause to which evolution is the internal answer, if it be the drawing out of the internal qualities of the individual into their highest perfection by the influence of the most fitting external conditions, there must be a difference in the method of education of the two sexes answering to differences in their physical and mental natures. Whether it be only the statement of a partial truth, that "for valour he" is formed, and "for beauty she and sweet attractive grace," or not, it cannot be denied that they are formed for different functions, and that the influence of those functions pervades and affects essentially their entire beings. There is sex in mind and there should be sex in education.

Let us consider, then, what an adapted education must have regard to. In the first place, a proper regard to the physical nature of women means attention given, in their training, to their peculiar functions and to their foreordained work as mothers and nurses of children. Whatever aspirations of an intellectual kind they may have, they cannot be relieved from the performance of those offices so long as it is thought necessary that mankind should continue on earth. Even if these be looked upon as somewhat mean and unworthy offices in comparison with the nobler functions of giving birth to and developing ideas; if, agreeing with Goethe, we are disposed to hold – Es wäre doch immer hübscher wenn man die Kinder von den Bäumen schüttelte; it must still be confessed that for the great majority of women they must remain the most important offices of the best period of their lives. Moreover they are work

[1] The instinct of propagation is what we are concerned with here, but it should not be overlooked, that, in like manner, a difference of character would grow out of the instinct of self-preservation and the means of self-defence prompted by it.

which, like all work, may be well or ill done, and which, in order to be done well, cannot be done in a perfunctory manner, as a thing by the way. It will have to be considered whether women can scorn delights, and live laborious days of intellectual exercise and production, without injury to their functions as the conceivers, mothers, and nurses of children. For it would be an ill thing, if it should so happen, that we got the advantages of a quantity of female intellectual work at the price of a puny, enfeebled, and sickly race. In this relation, it must be allowed that women do not and cannot stand on the same level as men.

In the second place, a proper regard to the mental nature of women means attention given to those qualities of mind which correlate the physical differences of her sex. Men are manifestly not so fitted mentally as women to be the educators of children during the early years of their infancy and childhood; they would be almost as much out of place in going systematically to work to nurse babies as they would be in attempting to suckle them. On the other hand, women are manifestly endowed with qualities of mind which specially fit them to stimulate and foster the first growths of intelligence in children, while the intimate and special sympathies which a mother has with her child as a being which, though individually separate, is still almost a part of her nature, give her an influence and responsibilities which are specially her own. The earliest dawn of an infant's intelligence is its recognition of its mother as the supplier of its wants, as the person whose near presence is associated with the relief of sensations of discomfort, and with the production of feelings of comfort; while the relief and pleasure which she herself feels in yielding it warmth and nourishment strengthens, if it was not originally the foundation of, that strong love of offspring which, with unwearied patience, surrounds its wayward youth with a thousand ministering attentions. It can hardly be doubted that if the nursing of babies were given over to men for a generation or two, they would abandon the task in despair or in disgust, and conclude it to be not worth while that mankind should continue on earth. But "can a woman forget her sucking child, that she should not have compassion on the son of her womb?" Those can hardly be in earnest who question that woman's sex is represented in mind, and that the mental qualities which spring from it

qualify her specially to be the successful nurse and educator of infants and young children.

Furthermore, the female qualities of mind which correlate her sexual character adapt her, as her sex does, to be the helpmate and companion of man. It was an Eastern idea, which Plato has expressed allegorically, that a complete being had in primeval times been divided into two halves, which have ever since been seeking to unite together and to reconstitute the divided unity. It will hardly be denied that there is a great measure of truth in the fable. Man and woman do complement one another's being. This is no less true of mind that it is of body; it is true of mind indeed as a consequence of its being true of body. Some may be disposed to argue that the qualities of mind which characterize women now, and have characterized them hitherto, in their relations with men, are in great measure, mainly if not entirely, the artificial results of the position of subjection and dependence which she has always occupied; but those who take this view do not appear to have considered the matter as deeply as they should; they have attributed to circumstances much of what unquestionably lies deeper than circumstances, being inherent in the fundamental character of sex. It would be a delusive hope to expect, and a mistaken labour to attempt, to eradicate by change of circumstances the qualities which distinguish the female character, and fit woman to be the helpmate and companion of man in mental and bodily union.

So much may be fairly said on general physiological grounds. We may now go on to inquire whether any ill effects have been observed from subjecting women to the same kind of training as men. The facts of experience in this country are not such as warrant a full and definite answer to the inquiry, the movement for revolutionizing the education of women being of recent date. But in America the same method of training for the sexes in mixed classes has been largely applied; girls have gone with boys through the same curriculum of study, from primary to grammar schools, from schools to graduation in colleges, working eagerly under the stimulus of competition, and disdaining any privilege of sex. With what results? With one result certainly – that while those who are advocates of the mixed system bear favourable witness to the results upon both sexes, American physicians are beginning to raise their voices in earnest warnings and protests. It is not that girls have not

ambition, nor that they fail generally to run the intellectual race which is set before them, but it is asserted that they do it at a cost to their strength and health which entails lifelong suffering, and even incapacitates them for the adequate performance of the natural functions of their sex. Without pretending to endorse these assertions, which it would be wrong to do in the absence of sufficient experience, it is right to call attention to them, and to claim serious consideration for them; they proceed from physicians of high professional standing, who speak from their own experience, and they agree moreover with what perhaps might have been feared or predicted on physiological grounds. It may fairly be presumed that the stimulus of competition will act more powerfully on girls than on boys; not only because they are more susceptible by nature, but because it will produce more effect upon their constitutions when it is at all in excess. Their nerve-centres being in a state of greater instability, by reason of the development of their reproductive functions, they will be the more easily and the more seriously deranged. A great argument used in favour of a mixed education is that it affords adequate stimulants to girls for thorough and sustained work, which have hitherto been a want in girls' schools; that it makes them less desirous to fit themselves only for society, and content to remain longer and work harder at school. Thus it is desired that emulation should be used in order to stimulate them to compete with boys in mental exercises and aims, while it is not pretended they can or should compete with them in those outdoor exercises and pursuits which are of such great benefit in ministering to bodily health, and to success in which boys, not unwisely perhaps, attach scarcely less honour than to intellectual success. It is plain then that the stimulus of competition in studies will act more powerfully upon them, not only because of their greater constitutional susceptibility, but because it is left free to act without the compensating balance of emulation in other fields of activity. Is it right, may well be asked, that it should be so applied? Can woman rise high in spiritual development of any kind unless she take a holy care of the temple of her body?[2]

2 Of all the intellectual errors of which men have been guilty, perhaps none is more false and has been more mischievous in its consequences than the theologico-metaphysical doctrine which inculcated contempt of the body as the temple of Satan, the prison-house of the spirit, from which the highest

A small volume, entitled "Sex in Education," which has been published recently by Dr. Edward Clarke of Boston, formerly a Professor in Harvard College, contains a somewhat startling description of the baneful effects upon female health which have been produced by an excessive educational strain. It is asserted that the number of female graduates of schools and colleges who have been permanently disabled to a greater or less degree by improper methods of study, and by a disregard of the reproductive apparatus and its functions, is so great as to excite the gravest alarm, and to demand the serious attention of the community. "If these causes should continue for the next half-century, and increase in the same ratio as they have for the last fifty years, it requires no prophet to foretell that the wives who are to be the mothers in our republic must be drawn from Transatlantic homes. The sons of the New World will have to re-act, on a magnificent scale, the old story of unwived Rome and the Sabines." Dr. Clarke relates the clinical histories of several cases of tedious illness, in which he traced the cause unhesitatingly to a disregard of the function of the female organization. Irregularity, imperfection, arrest, or excess occurs in consequences of the demand made upon the vital powers at times when there should rightly be an intermission or remission of labour, and is followed first by pallor, lassitude, debility, sleeplessness, headache, neuralgia, and then by worse ills. The course of events is something in this wise. The girl enters upon the hard work of school or college at the age of fifteen years or thereabouts, when the function of her sex has perhaps been fairly established; ambitious to stand high in class, she pursues her studies with diligence, perseverance, constancy, allowing herself no days of relaxation or rest out of the school-days, paying no attention to the periodical tides of her organization, unheeding a drain "that would make the stroke oar of the University crew falter." For a time all seems to go well with her studies; she triumphs over male and female competitors, gains the front rank, and is stimulated to continued exertions in order to hold it. But in the long run nature, which cannot be ignored or defied with impunity, asserts its power; excessive losses occur; health fails, she

aspiration of mind was to get free. It is a foolish and fruitless labour to attempt to divorce or put asunder mind and body, which nature has joined together in essential unity; and the right culture of the body is not less a duty than, is indeed essential to, the right culture of the mind.

becomes the victim of aches and pains, is unable to go on with her work, and compelled to seek medical advice. Restored to health by rest from work, a holiday at the sea-side, and suitable treatment, she goes back to her studies, to begin again the same course of unheeding work, until she has completed the curriculum, and leaves college a good scholar but a delicate and ailing woman, whose future life is one of more or less suffering. For she does not easily regain the vital energy which was recklessly sacrificed in the acquirement of learning; the special functions which have relation to her future offices as woman, and the full and perfect accomplishment of which is essential to sexual completeness, have been deranged at a critical time; if she is subsequently married, she is unfit for the best discharge of maternal functions, and is apt to suffer from a variety of troublesome and serious disorders in connection with them. In some cases the brain and the nervous system testify to the exhaustive effects of undue labour, nervous and even mental disorders declaring themselves.

Such a picture, painted by an experienced physician, of the effects of subjecting young women to the method of education which has been framed for young men. Startling as it is, there is nothing in it which may not well be true to nature. If it be an effect of excessive and ill-regulated study to produce derangement of the functions of the female organization, of which so far from there being an antecedent improbability there is a great probability, then there can be no question that all the subsequent ills mentioned are likely to follow. The important physiological change which takes place at puberty, accompanied, as it is, by so great a revolution in mind and body, and by so large an expenditure of vital energy, may easily and quickly overstep its healthy limits and pass into a pathological change, under conditions of excessive stimulation, or in persons who are constitutionally feeble and whose nerve-centres are more unstable than natural; and it is a familiar medical observation that many nervous disorders of a minor kind, and even such serious disorders as chorea, epilepsy, insanity, are often connected with irregularities or suppression of these important functions.

In addition to the ill effects upon the bodily health which are produced directly by an excessive mental application, and a consequent development of the nervous system at the expense of the nutritive functions, it is alleged that remoter effects of an

injurious character are produced upon the entire nature, mental and bodily. The arrest of development of the reproductive system discovers itself in the physical form and in the mental character. There is an imperfect development of the structure which Nature has provided in the female for nursing her offspring.

"Formerly," writes another American physician, Dr. N. Allen, "such an organization was generally possessed by American women, and they found but little difficulty in nursing their infants. It was only occasionally, in case of some defect in the organization, or where sickness of some kind had overtaken the mother, that it became necessary to resort to the wet-nurse, or to feeding by hand. And the English, the Scotch, the German, the Canadian, the French, and the Irish women who are living in this country, generally nurse their children: the exceptions are rare. But how is it with our American women who become mothers? It has been supposed by some that all, or nearly all of them, could nurse their offspring just as well as not; that the disposition only was wanting, and that they did not care about having the trouble or confinement necessarily attending it. But this is a great mistake. This very indifference or aversion shows something wrong in the organization, as well as in the disposition: if the physical system were all right, the mind and natural instincts would generally be right also. While there may be here and there cases of this kind, such an indisposition is not always found. It is a fact that large numbers of our women are anxious to nurse their offspring, and make the attempt: they persevere for a while – perhaps for weeks or months – and then fail. . . . There is still another class that cannot nurse at all, having neither the organs nor nourishment necessary to make a beginning."

Why should there be such a difference between American women and those of foreign origin residing in the same locality, or between them and their grandmothers? Dr. Allen goes on to ask. The answer he finds in the undue demands made upon the brain and nervous system to the detriment of the organs of nutrition and secretion.

In consequence of the great neglect of physical exercise, and the continuous application to study, together with various other influences, large numbers of our American

women have altogether an undue predominance of the nervous temperament. If only here and there an individual were found with such an organization, not much harm comparatively would result; but when a majority, or nearly a majority have it, the evil becomes one of no small magnitude.

To the same effect writes Dr. Weir Mitchell, an eminent American physiologist.

Worst of all, to my mind, most destructive in every way, is the American view of female education. The time taken for the more serious instruction of girls extends to the age of eighteen, and rarely over this. During these years they are undergoing such organic development as renders them remarkably sensitive. . . . To-day the American woman is, to speak plainly, physically unfit for her duties as a woman, and is, perhaps, of all civilised females, the least qualified to undertake those weightier tasks which tax so heavily the nervous system of man. She is not fairly up to what Nature asks from her as wife and mother. How will she sustain herself under the pressure of those yet more exacting duties which nowadays she is eager to share with man?

Here there is no uncertain testimony as to the effects of the American system of female education: some women who are without the instinct or desire to nurse their offspring, some who have the desire but not the capacity, and others who have neither the instinct nor the capacity. The facts will hardly be disputed, whatever may finally be the accepted interpretation of them. It will not probably be argued that an absence of the capacity and the instinct to nurse is a result of higher development, and that it should be the aim of woman, as she advances to a higher level, to allow the organs which minister to this function to waste and finally to become by disuse as rudimentary in her sex as they are in the male sex. Their development is notably in close sympathy with that of the organs of reproduction, an arrest thereof being often associated with some defect of the latter; so that it might perhaps fairly be questioned whether it was right and proper, for the race's sake, that a woman who has not the wish and power to nurse should indulge in the functions of maternity. We may take note, by the way, that those in whom the organs are wasted invoke the dressmaker's aid in order to gain the appearance of them; they

are not satisfied unless they wear the show of perfect womanhood. However, it may be in the plan of evolution to produce at some future period a race of sexless beings who, undistracted and unharassed by the ignoble troubles of reproduction, shall carry on the intellectual work of the world, not otherwise than as the sexless ants do the work and the fighting of the community.

Meanwhile, the consequences of an imperfectly developed reproductive system are not sexual only; they are also mental. Intellectually and morally there is a deficiency, or at any rate a modification answering to the physical deficiency; in mind, as in body, the individual fails to reach the ideal of a complete and perfect womanhood. If the aim of a true education be to make her reach *that*, it cannot certainly be a true education which operates in any degree to unsex her; for sex is fundamental, lies deeper than culture, cannot be ignored or defied with impunity. You may hide nature, but you cannot extinguish it. Consequently it does not seem impossible that if the attempt to do so be seriously and persistently made, the result may be a monstrosity – something which having ceased to be woman is yet not man – "ce quelque chose de monstrueux," which the Comte A. du Gasparin forebodes, " cet être répugnant, qui déjà paraît à notre horizon."

The foregoing considerations go to show that the main reason of woman's position lies in her nature. That she has not competed with men in the active work of life was probably because not having had the power she had not the desire to do so, and because having the capacity of functions which man has not she has found her pleasure in performing them. It is not simply that man being stronger in body than she is, has held her in subjection, and debarred her from careers of action which he was resolved to keep for himself; her maternal functions must always have rendered, and must continue to render, most of her activity domestic. There have been times enough in the history of the world when the freedom which she has had, and the position which she has held in the estimation of men, would have enabled her to assert her claims to other functions, had she so willed it. The most earnest advocate of her rights to be something else than what she has hitherto been would hardly argue that she has always been in the position of a slave kept in forcible subjection by the superior physical force of men. Assuredly, if she has been a slave, she has been a slave content

with her bondage. But it may perhaps be said that in that lies the very pith of the matter – that she is not free, and does not care to be free; that she is a slave, and does not know or feel it. It may be alleged that she has lived for so many ages in the position of dependence to which she was originally reduced by the superior muscular strength of man, has been so thoroughly imbued with inherited habits of submission, and overawed by the influence of customs never questioned, that she has not the desire for emancipation; that thus a moral bondage has been established more effectual than an actual physical bondage. That she has now exhibited a disposition to emancipate herself, and has initiated a movement to that end, may be owing partly to the easy means of intellectual intercommunication in this age, whereby a few women scattered through the world, who felt the impulses of a higher inspiration, have been enabled to co-operate in a way that would have been impossible in former times, and partly to the awakened moral sense and to the more enlightened views of men, which have led to the encouragement and assistance, instead of the suppression, of their efforts.

It would be rash to assert that there is not some measure of truth in these arguments. Let any one who thinks otherwise reflect upon the degraded condition of women in Turkey, where habit is so ingrained in their nature, and custom so powerful over the mind, that they have neither thought nor desire to attain to a higher state, and "nought feel their foul disgrace:" a striking illustration how women may be demoralised and yet not know nor feel it, and an instructive lesson for those who are anxious to form a sound judgment upon the merits of the movement for promoting their higher education and the removal of the legal disabilities under which they labour. It is hardly possible to exaggerate the effects of the laws and usages of a country upon the habits of thought of those who, generation after generation, have been born, and bred, and have lived under them. Were the law which ordains that when a father dies intestate, all the real property of which he is possessed shall be inherited by his eldest son, his other children being sent empty away, enacted for the first time, there is no one, probably, who would not be shocked by its singular injustice; yet the majority of persons in this country are far from thinking it extraordinary or unjust, and a great many of them would deem it a dangerous and wicked doctrine to question its justice. Only a few weeks ago, a statesman who has

held high offices in a Conservative ministry, in an address to electors, conjured them not to part with the principle of primogeniture, and declared that there was no change in the law which he would so vehemently oppose as this: "let them but follow the example of a neighbouring nation in this respect, and there was an end of their personal freedom and liberty!" So much do the laws and usages of a country affect the feelings and judgments of those who dwell therein. If we clearly apprehend the fact, and allow it the weight which it deserves, it will be apparent that we must hesitate to accept the subordinate position which women have always had as a valid argument for the justice of it, and a sufficient reason why they should continue for ever in it.

But may we not fairly assert that it would be no less a mistake in an opposite direction to allow no weight to such an argument? Setting physiological considerations aside, it is not possible to suppose that the whole explanation of woman's position and character is that man, having in the beginning found her pleasing in his eyes and necessary to his enjoyment, took forcible possession of her, and has ever since kept her in bondage, without any other justification than the right of the strongest. Superiority of muscular strength, without superiority of any other kind, would not have done that, any more than superiority of muscular strength has availed to give the lion or the elephant possession of the earth. If it were not that woman's organization and functions found their fitting home in a position different from, if not subordinate to, that of men, she would not so long have kept that position. If she is to be judged by the same standard as men, and to make their aims her aims, we are certainly bound to say that she labours under an inferiority of constitution by a dispensation which there is no gainsaying. This is a matter of physiology, not a matter of sentiment; it is not a mere question of larger or smaller muscles, but of the energy and power of endurance of the nerve-force which drives the intellectual and muscular machinery; not a question of two bodies and minds that are in equal physical conditions, but of one body and mind capable of sustained and regular hard labour, and of another body and mind which for one quarter of each month during the best years of life is more or less sick and unfit for hard work. It is in these considerations that we find the true explanation of what has been from the beginning until now, and what must

doubtless continue to be, though it be in a modified form. It may be a pity for woman that she has been created woman, but, being such, it is as ridiculous to consider herself inferior to man because she is not man, as it would be for man to consider himself inferior to her because he cannot perform her functions. There is one glory of the man, another glory of the woman, and the glory of the one differeth from that of the other.

Taking into adequate account the physiology of the female organization, some of the statements made by the late Mr. Mill in his book on the subjection of women strike one with positive amazement. He calls upon us to own that what is now called the nature of women is an eminently artificial thing, the result of forced repression in some directions, of unnatural stimulation in others; that their character has been entirely distorted and disguised by their relations with their masters, who have kept them in so unnatural a state; that if it were not for this there would not be any material difference, nor perhaps any difference at all, in the character and capacities which would unfold themselves; that they would do the same things as men fully as well on the whole, if education and cultivation were adapted to correcting, instead of aggravating, the infirmities incident to their temperament; and that they have been robbed of their natural development, and brought into their present unnatural state, by the brutal right of the strongest which man has used. If these allegations contain no exaggeration, if they be strictly true, then is this article an entire mistake.

Mr. Mill argues as if when he has shown it to be probable that the inequality of rights between the sexes has no other source than the law of the strongest, he had demonstrated its monstrous injustice. But is that entirely so? After all there is a right in might – the right of the strong to be strong. Men have the right to make the most of their powers, to develop them to the utmost, and to strive for, and if possible gain and hold, the position in which they shall have the freest play. It would be wrong to the stronger if it were required to limit its exertions to the capacities of the weaker. And if it be not so limited, the result will be that the weaker must take a different position. Men will not fail to take the advantage of their strength over women: are no laws then to be made which, owning the inferiority of women's strength, shall ordain accordingly, and so protect them really from the mere brutal tyranny of might?

Seeing that the greater power cannot be ignored, but in the long run must tell in individual competition, it is a fair question whether it ought not to be recognised in social adjustments and enactments, even for the necessary protection of women. Suppose that all legal distinctions were abolished, and that women were allowed free play to do what they could, as it may be right they should – to fail or succeed in every career upon which men enter; that all were conceded to them which their extremest advocates might claim for them; do they imagine that if they, being in a majority, combined to pass laws which were unwelcome to men, the latter would quietly submit? Is it proposed that men should fight for them in war, and that they, counting a majority of votes, should determine upon war? Or would they no longer claim a privilege of sex in regard to the defence of the country by arms? If all barriers of distinction of sex raised by human agency were thrown down, as not being warranted by the distinctions of sex which Nature has so plainly marked, it may be presumed that the great majority of women would continue to discharge the functions of maternity, and to have the mental qualities which correlate these functions; and if laws were made by them, and their male supporters of a feminine habit of mind, in the interests of babies, as might happen, can it be supposed that, as the world goes, there would not soon be a revolution in the State by men, which would end in taking all power from women and reducing them to a stern subjection? Legislation would not be of much value unless there were power behind to make it respected, and in such case laws might be made without the power to enforce them, or for the very purpose of coercing the power which could alone enforce them.

So long as the differences of physical power and organization between men and women are what they are, it does not seem possible that they should have the same type of mental development. But while we see great reason to dissent from the opinions, and to distrust the enthusiasm, of those who would set before women the same aims as men, to be pursued by the same methods, it must be admitted that they are entitled to have all the mental culture and all the freedom necessary to the fullest development of their natures. The aim of female education should manifestly be the perfect development, not of manhood but of womanhood, by the methods most conducive thereto: so may women reach as high a grade of development

as men, though it be of a different type. A system of education which is framed to fit them to be nothing more than the superintendents of a household and the ornaments of a drawing-room, is one which does not do justice to their nature, and cannot be seriously defended. Assuredly those of them who have not the opportunity of getting married suffer not a little, in mind and body, from a method of education which tends to develope the emotional at the expense of the intellectual nature, and by their exclusion from appropriate fields of practical activity. It by no means follows, however, that it would be right to model an improved system exactly upon that which has commended itself as the best for men. Inasmuch as the majority of women will continue to get married and to discharge the functions of mothers, the education of girls certainly ought not to be such as would in any way clash with their organization, injure their health, and unfit them for these functions. In this matter the small minority of women who have other aims and pant for other careers, cannot be accepted as the spokeswomen of their sex. Experience may be left to teach them, as it will not fail to do, whether they are right or wrong in the ends which they pursue and in the means by which they pursue them: if they are right, they will have deserved well the success which will reward their faith and works; if they are wrong, the error will avenge itself upon them and upon their children, if they should ever have any. In the worst event they will not have been without their use as failures; for they will have furnished experiments to aid us in arriving at correct judgments concerning the capacities of women and their right functions in the universe. Meanwhile, so far as our present lights reach, it would seem that a system of education adapted to women should have regard to the peculiarities of their constitution, to the special functions in life for which they are destined, and to the range and kind of practical activity, mental and bodily, to which they would seem to be foreordained by their sexual organization of body and mind.

<div align="right">HENRY MAUDSLEY.</div>

NOTE. – It is fair to say that other reasons for the alleged degeneracy of American women are given. For example, a correspondent writes from America:– "The medical mind of the United States is arrayed in a very ill-tempered opposition,

on assumed physiological grounds, to the higher education of women in a continuous curriculum, and especially to that co-education which some colleges in the Western States, Oberlin, Antioch, inaugurated twenty years ago, and which latterly Cornell University has adopted. The experience of Cornell is too recent to prove anything; but the Quaker college of Swarthmore claims a steady improvement on the health of its girl-graduates, dating from the commencement of their college course; and the Western colleges report successful results, mentally, morally, and physically, from their co-education experiment. Ignoring these facts, the doctors base their war-cry on the not-to-be-disputed fact that American women are growing into more and more of invalidism with every year. Something of this is perhaps due to climate. I will not say to food; for the American *menu*, in the cities at least, has improved since Mr. Dickens's early days, and has learned to combine French daintiness, very happily, with the substantial requirements of an English table.

"American men, as a rule, 'break down' between forty and fifty, when an Englishman is but beginning to live his public and useful life. The mad excitement of business you have, as well as we; so it must be the unrest of the climate, and their unphilosophical refusal of open-air pleasures and exercise, which are to blame in the case of the men.

"There are other reasons which go to make up the languid young-ladyhood of the American girl. Her childhood is denied the happy out-door sports of her brothers. There is a resolute shutting out of everything like a noisy romp; the active games and all happy, boisterous plays, by field or roadside, are not *proper* to her! She is cased in a cramping dress, so heavy and inconvenient that no boy could wear it for a day without falling into gloomy views of life. All this martyrdom to propriety and fashion tells upon strength and symmetry, and the girl reaches womanhood a wreck. That she reaches it at all, under these suffering and bleached-out conditions is due to her superior elasticity to resist a method of education which would have killed off all the boys years before. * * * There are abundant statistics to prove that hard study is the discipline and tonic most girls need to supplant the too great sentimentality and useless day-dreams fostered by fashionable idleness and provocative of 'nerves,' melancholy, and inanition generally, and, so far as statistics can, that the women-graduates of

these colleges make as healthy and happy wives and mothers as though they had never solved a mathematical problem, nor translated Aristotle."

SEX IN MIND AND EDUCATION: A REPLY
The Fortnightly Review, Vol. 15 (1874)
Elizabeth Garrett Anderson

The April number of the *Fortnightly Review* contains an article under the heading of Sex in Mind and in Education, by Dr. Maudsley. It is a reproduction of a lecture on the same subject by Dr. Clarke, formerly a Professor at Harvard College, United States, with such additions and comments as the circumstances of English life seemed to Dr. Maudsley to warrant. Dr. Clarke's lecture was originally addressed to an audience of women, and, whether we agree with its conclusions or not, we cannot blame him that with his view of the evil effects of continuous mental work on women's health he thought himself justified in speaking with a degree of frankness that would have been out of place under other circumstances. In applying Dr. Clarke's arguments to the question of the education of women in England, Dr. Maudsley pleads the importance of the subject as an excuse for placing medical and physiological views before the readers of a literary periodical. It is possible he was right in thinking the excuse adequate, though we cannot but suggest that there is grave reason for doubting whether such a subject can be fully and with propriety discussed except in a professional journal. As, however, the usual reserve has been broken through, it would be out of place for those who approve the changes against which Dr. Maudsley's argument is directed to be silent in obedience to those considerations which he has disregarded. We will therefore venture to speak as plainly and directly as he has spoken.

Dr. Maudsley's paper consists mainly of a protest against the assimilation of the higher education of men and women, and against the admission of women to new careers; and this protest is founded upon a consideration of the physiological peculiarities of women. It derives much of its importance from the assumption that what is now being tried in England has

already been tried in America, and that it has there produced the results which Dr. Maudsley thinks are inevitable. When, however, we turn to Dr. Clarke's book (from which the American evidence quoted by Dr. Maudsley is taken) we find that the American system is, in many important features, and especially in those most strongly condemned by Dr. Clarke and the other witnesses, widely different from that now being advocated in England. Even if what Dr. Maudsley urges could be admitted as a correct inference from physiological fact, the result of a very different experiment in America could not fairly be used to support his argument. We shall show later on in what the difference between the American and English systems consists, but it is necessary, first of all, to warn readers of Dr. Maudsley's article that his use of American evidence is misleading and is not confirmed by reference to Dr. Clarke's book.

One other preliminary statement needs to be made before entering upon the consideration of Dr. Maudsley's argument. In the beginning of his paper he brings a serious charge against those who are advocating the changes he disapproves. He says, and in one form or another he repeats the charge again and again, that their aim is to change women into men, or, as he puts it, "to assimilate the female to the male mind." Much pains is taken to convince them that this is impossible; they are assured that "women cannot choose but to be women; cannot rebel successfully against the tyranny of their organization," and much more to the same effect. To meet such charges is difficult on account of their vagueness. We can but ask with unfeigned surprise what ground Dr. Maudsley can conceive that he has for them? We ask, what body of persons associated together in England for the purpose of promoting the education of women has made any statement, in any form or degree, implying such aims? That no injudicious advocate has ever made a remark which might bear such an interpretation we are not prepared to assert, but we can confidently challenge the production of any manifesto possessing a fair claim to authority in which anything of the kind is said or implied. The single aim of those anxious to promote a higher and more serious education for women is to make the best they can of the materials at their disposal, and if they fail, it assuredly will not be from thinking that the masculine type of excellence includes all that can be desired in humanity.

The position Dr. Maudsley has undertaken to defend is this, that the attempt now being made in various directions to assimilate the mental training of men and women is opposed to the teachings of physiology, and more especially, that women's health is likely to be seriously injured if they are allowed or encouraged to pursue a system of education laid down on the same lines, following the same method, and having the same ends in view, as a system of education for men.

He bases his opinion on the fact that just at the age when the real educational strain begins, girls are going through an important phase of physiological development, and that much of the health of their after-life depends upon the changes proper to this age being effected without check and in a normal and healthy manner. Moreover, the periodical recurrence of the function thus started, is attended, Dr. Maudsley thinks, with so great a withdrawal of nervous and physical force, that all through life it is useless for women to attempt, with these physiological drawbacks, to pursue careers side by side with men.

We have here two distinct assertions to weigh and verify: 1st, that the physiological functions started in girls between the ages of fourteen and sixteen are likely to be interfered with or interrupted by pursuing the same course of study as boys, and by being subjected to the same examinations; and, 2nd, that even when these functions are in good working order and the woman has arrived at maturity, the facts of her organization interfere periodically to such an extent with steady and serious labour of mind or body that she can never hope to compete successfully with men in any career requiring sustained energy. Both with girls and women, however, it is the assimilation of their education and the equality of their aim with those of boys and men which, in Dr. Maudsley's eyes, call for special condemnation. And in each case he grounds his objection on the fact that physiologically important differences are found in the two sexes. He says, "It would seem plain that as women are marked out by nature for very different offices from those of men, the healthy performance of her special functions renders it improbable she will succeed, and unwise for her to persevere in running over the same course at the same pace with him." But surely this argument contains a *non sequitur*. The question depends upon the nature of the course and the quickness of the pace, and upon the fitness of both for women; not at all on the

amount of likeness or unlikeness between men and women. So far as education is concerned it is conceivable, and indeed probable that, were they ten times as unlike as they are, many things would be equally good for both. If girls were less like boys than the anthropomorphic apes, nothing but experience would prove that they would not benefit by having the best methods and the best tests applied to their mental training. And if the course of study which Dr. Maudsley is criticising be one as likely to strengthen the best powers of the mind as good food is to strengthen the body, if it tend to develope habits as valuable to women as to men, and if the pace is moderate, there would seem to be no good reason why the special physiological functions of women should prevent them from running it, any more than these same functions prevent them from eating beef and bread with as much benefit as men. The question is not settled by proving that both in mind and body girls are different from boys.

The educational methods followed by boys being admitted to be better than those hitherto applied to girls, it is necessary to show that these better methods would in some way interfere with the special functions of girls. This Dr. Maudsley has not done. He has not attempted to show how the adoption of a common standard of examination for boys and girls, allowing to each a considerable range in the choice of subjects, is likely to interfere more with a girl's health than passing an inferior examination for girls only. Either would hurt her if unwisely pressed, if the stimulus of competition were unduly keen, or if in the desire for mental development the requirements of her physical nature were overlooked.

What we want to know is what exactly these requirements are, and especially how much consideration girls and women ought to show to the fact of the periodic and varying functions of their organization. In considering this point, we ought not to overlook the antecedent improbability of any organ or set of organs requiring exceptional attention; the rule certainly being that, when people are well, their physiological processes go on more smoothly without attention than with it. Are women an exception to this rule? When this is settled we shall be in a position to speculate upon how far in education or in after-life they will be able to work side by side with men without overtaxing their powers.

And first, with regard to adults. Is it true, or is it a great exaggeration, to say that the physiological difference between

men and women seriously interferes with the chances of success a woman would otherwise possess? We believe it to be very far indeed from the truth. When we are told that in the labour of life women cannot disregard their special physiological functions without danger to health, it is difficult to understand what is meant, considering that in adult life healthy women do as a rule disregard them almost completely. It is, we are convinced, a great exaggeration to imply that women of average health are periodically incapacitated from serious work by the facts of their organization. Among poor women, where all the available strength is spent upon manual labour, the daily work goes on without intermission, and, as a rule, without ill effects. For example, do domestic servants, either as young girls or in mature life, show by experience that a marked change in the amount of work expected from them must be made at these times unless their health is to be injured? It is well known that they do not.

With regard to mental work it is within the experience of many women that that which Dr. Maudsley speaks of as an occasion of weakness, if not of temporary prostration, is either not felt to be such or is even recognised as an aid, the nervous and mental power being in many cases greater at those times than at any other. This is confirmed by what is observed when this function is prematurely checked, or comes naturally to an end. In either case its absence usually gives rise to a condition of nervous weakness unknown while the regularity of the function was maintained. It is surely unreasonable to assume that the same function in persons of good health can be a cause of weakness when present, and also when absent. If its performance made women weak and ill, its absence would be a gain, which it is not. Probably the true view of the matter is this. From various causes the demand made upon the nutritive processes is less in women than in men, while these processes are not proportionately less active; nutrition is thus continually a little in excess of what is wanted by the individual, and there is a margin ready for the demand made in childbearing. Till this demand arises it is no loss, but quite the reverse, to get rid of the surplus nutritive material, and getting rid of it involves, when the process is normal, no loss of vigour to the woman.

As to the exact amount of care needed at the time when this function is active and regular, individual women no doubt vary

very much, but experience justifies a confident opinion that the cases in which it seriously interferes with active work of mind or body are exceedingly rare; and that in the case of most women of good health, the natural recurrence of this function is not recognised as causing anything more than very temporary *malaise*, and frequently not even that.

The case is, we admit, very different during early womanhood, when rapid growth and the development of new functions have taxed the nutritive powers more than they are destined to be taxed in mature life. At this age a temporary sense of weakness is doubtless much more common than it is later in life, and where it exists wise guardians and teachers are in the habit of making allowance for it, and of encouraging a certain amount of idleness. This is, we believe, as much the rule in the best English schools as it is in private schoolrooms and homes. No one wishes to dispute the necessity for care of this kind; but in our experience teachers, as a rule, need a warning on the point even less than parents. Fathers especially are apt to be thoughtless in expecting their girls to be equally ready at all times to ride or take long walks, and so far as individual experience may be used as a guide, we venture to think that far more harm is done to young women in ways of this kind while they are at home, than when they are protected by the quiet routine of school life. While, too, we would not deny that very great pressure of mental work at this age is to be deprecated, we believe that practically the risk of injury from undue or exceptional physical fatigue at an inopportune moment is much greater. Riding, long standing, lifting heavy weights, – *e.g.* young brothers and sisters – dancing, and rapid or fatiguing walks, are, we believe, the chief sources of risk to delicate girls at these times, and of them all riding is probably much the most serious. The assertion that, as a rule, girls are unable to go on with an ordinary amount of quiet exercise or mental work during these periods, seems to us to be entirely contradicted by experience. Exceptional cases require special care, and under the arrangements of school life in England, whatever may be the case in America, they get it. But does it follow from this, that there is any ground for suspecting or fearing that the demands made by the special functions of womanhood during the time of development are really more in danger of being overlooked, or inadequately considered, under the new system of education than they were under the old? Dr. Maudsley

seems to think there is, but he brings no evidence in support of his opinion. He is apparently not aware that most important improvements in physical training are being introduced alongside with other reforms. The time given to education is being prolonged, and the pressure in the early years of womanhood, when continuous work is less likely to be well borne, is being lightened; girls are no longer kept standing an hour or more at a time, or sitting without support for their backs; school hours and school terms are shortened; and, above all, physical exercise is no longer limited to the daily monotonous walk which was thought all-sufficient in old-fashioned schools and homes. In spite of these undeniable facts, Dr. Maudsley charges the reformers with having neglected the physical requirements of girls, in order to stimulate their mental activity. "It is quite evident," he says, "that many of those who are foremost in their zeal for raising the education of women, have not given proper consideration to the nature of her organization." In another place he blames them for having neglected physical training and exercise. To those in a position to know the facts, such a charge as this seems peculiarly misplaced and unjust. It is no doubt true, that twenty years ago the physical training of girls was deplorably neglected, and that it still is so in homes and schools of the old-fashioned type. But the same people who during recent years have been trying to improve the mental training of girls, have continually been protesting in favour also of physical development, and to a great extent their protests have been successful. The schoolmistresses who asked that girls might share in the Oxford and Cambridge Local Examinations, were the first also to introduce gymnastics, active games, daily baths, and many other hygienic reforms sorely needed in girls' schools. The London Association of Schoolmistresses, which was formed expressly "to promote the higher education of women," took so comprehensive a view of what this included, that the first paper issued by them was one upon "Physical Exercises and Recreation," in which it was laid down as a maxim that "good results are not obtained by sacrificing any one part of our nature to another. If study takes up so much time that there is not enough left for play, there must be too much study going on. The lessons must be too many or too long, and ought to be curtailed." What more could Dr. Maudsley himself say? The same body also applied itself in the very infancy of its existence

to the study of School Hygiene, and took particular trouble to ascertain in what way the health and vigour of the girls in their schools could be improved. So far from their deserving censure, all who are interested in advancing the education of girls feel themselves deeply indebted to these ladies for the zeal and self-sacrifice they have shown in adopting, at great cost often to themselves, hygienic reforms not expected from them, and often indeed in advance of the sense of the parents of their pupils.

But it may still be urged, that admitting the advantage to girls of assimilating their play-ground hours to those of boys, of substituting outdoor games for worsted work or crouching over the fire with a story-book, yet that when it comes to school work the case is different, and that to make girls work as hard as boys do, and especially to allow them to work for the same examinations, would be to press unfairly upon their powers. In answer to this, we must take note of some facts about boys.

It must not be overlooked, that the difficulties which attend the period of rapid functional development are not confined to women, though they are expressed differently in the two sexes. Analogous changes take place in the constitution and organiza-tion of young men, and the period of immature manhood is frequently one of weakness, and one during which any severe strain upon the mental and nervous powers if productive of more mischief than it is in later life. It is possible that the physiological demand thus made is lighter than that made upon young women at the corresponding age, but on the other hand it is certain that, in many other ways unknown to women, young men still further tax their strength, *e.g.* by drinking, smoking, unduly severe physical exercise, and frequently by late hours and dissipation generally. Whether, regard being had to all these varying influences, young men are much less hindered than young women in intellectual work by the demands made upon their physical and nervous strength during the period of development, it is probably impossible to determine. All that we wish to show is that the difficulties which attend development are not entirely confined to women, and that in point of fact great allowance ought to be made, and has already been made, for them in deciding what may reasonably be expected in the way of intellectual attainment from young men. It is not much to the point to prove that men

could work harder than women, if the work demanded from either is very far from overtaxing the powers of even the weaker of the two. If we had no opportunity of measuring the attainments of ordinary young men, or if they really were the intellectual athletes Dr. Maudsley's warnings would lead us to suppose them to be, the question, "Is it well for women to contend on equal terms with men for the goal of man's ambition?" might be as full of solemnity to us as it is to Dr. Maudsley. As it is, it sounds almost ironical. Hitherto most of the women who have "contended with men for the goal of man's ambition" have had no chance of being any the worse for being allowed to do so on equal terms. They have had all the benefit of being heavily handicapped. Over and above their assumed physical and mental inferiority, they have had to start in the race without a great part of the training men have enjoyed, or they have gained what training they have been able to obtain in an atmosphere of hostility, to remain in which has taxed their strength and endurance far more than any amount of mental work could tax it. Would, for instance, the ladies who for five years have been trying to get a medical education at Edinburgh find their task increased, or immeasurably lightened, by being allowed to contend "on equal terms with men" for that goal? The intellectual work required from other medical students is nothing compared with what it has been made to them by obliging them to spend time and energy in contesting every step of their course, and yet in spite of this heavy additional burden they have not at present shown any signs of enfeebled health or of inadequate mental power. To all who know what it is to pursue intellectual work under such conditions as these, Dr. Maudsley's pity for the more fortunate women who may pursue it in peace and on equal terms with men sound superfluous. But Dr. Maudsley would probably say that, in speaking of the pace at which young men at the Universities work as being dangerously rapid for average women, he was not referring to anything less ambitious than the competition for honours. No one denies that in some cases this is severe; many men knock up under it, and it would doubtless tax the strength of women. But it must be borne in mind that that element in the competition which incites men to the greatest effort, and increases the strain to its utmost, is one which, for the present at least, would not operate upon women. Pecuniary rewards, large enough to affect a man's

whole after-life, are given for distinction in these examinations; and it is the eager desire for a Fellowship which raises the pressure of competition to so high and, as many think, to so unwholesome a point. As there are at present no Fellowships for women, this incentive does not operate upon them.

It must always be remembered, too, that University work does not come at the age when Dr. Maudsley and Dr. Clarke think it is likely to be too exciting. No one is proposing that girls of seventeen or eighteen should be allowed to try for a place in the Cambridge Honours' Lists. What is proposed is that after a girlhood of healthful work and healthful play, when her development is complete and her constitution settled, the student, at the age of eighteen or nineteen, should begin the college course, and should be prepared to end it at twenty-two or twenty-three. As we shall see later on, this is a very different plan from that pursued in America, and censured by Dr. Clarke.

In estimating the possible consequences of extending the time spent in education and even those of increasing somewhat the pressure put upon girls under eighteen, it should be borne in mind that even if the risk of overwork, pure and simple, work unmixed with worry, is more serious than we are disposed to think it, it is not the only, nor even the most pressing, danger during the period of active physiological development. The newly developed functions of womanhood awaken instincts which are more apt at this age to make themselves unduly prominent than to be hidden or forgotten. Even were the dangers of continuous mental work as great as Dr. Maudsley thinks they are, the dangers of a life adapted to develope only the specially and consciously feminine side of the girl's nature would be much greater. From the purely physiological point of view, it is difficult to believe that study much more serious than that usually pursued by young men would do a girl's health as much harm as a life directly calculated to over-stimulate the emotional and sexual instincts, and to weaken the guiding and controlling forces which these instincts so imperatively need. The stimulus found in novel-reading, in the theatre and ball-room, the excitement which attends a premature entry into society, the competition of vanity and frivolity, these involve far more real dangers to the health of young women than the competition for knowledge, or for scientific or literary honours, ever has done, or is ever likely to do. And even if, in

the absence of real culture, dissipation be avoided, there is another danger still more difficult to escape, of which the evil physical results are scarcely less grave, and this is dulness. It is not easy for those whose lives are full to overflowing of the interests which accumulate as life matures, to realise how insupportably dull the life of a young woman just out of the schoolroom is apt to be, nor the powerful influence for evil this dulness has upon her health and morals. There is no tonic in the pharmacopœia to be compared with happiness, and happiness worth calling such is not known where the days drag along filled with make-believe occupations and dreary sham amusements.

The cases that Dr. Clarke brings forward in support of his opinion against continuous mental work during the period of development could be outnumbered many times over even in our own limited experience, by those in which the break-down of nervous and physical health seems at any rate to be distinctly traceable to want of adequate mental interest and occupation in the years immediately succeeding school life. Thousands of young women, strong and blooming at eighteen, become gradually languid and feeble under the depressing influence of dulness, not only in the special functions of womanhood, but in the entire cycle of the processes of nutrition and innervation, till in a few years they are morbid and self-absorbed, or even hysterical. If they had had upon leaving school some solid intellectual work which demanded real thought and excited genuine interest, and if this interest had been helped by the stimulus of an examination, in which distinction would have been a legitimate source of pride, the number of such cases would probably be indefinitely smaller than it is now. It may doubtless be objected that even if this plan were pursued, and young women were allowed and expected to continue at tolerably hard mental work till they were twenty-one or twenty-two, it would only be postponing the evil day, and that when they left college they would dislike idleness as much, and be as much injured by it as when they left school. This is true; but by this time they would have more internal resources against idleness and dulness, and they would have reached an age in which some share in practical work and responsibility – the lasting refuge from dulness – is more easily obtained than it is in girlhood. Moreover, by entering society at a somewhat less immature age, a young woman is more able to take an

intelligent part in it; is prepared to get more real pleasure from the companionship it affords, and, suffering less from *ennui*, she is less apt to make a hasty and foolish marriage. From the physiological point of view this last advantage is no small or doubtful one. Any change in the arrangements of young women's lives which tends to discourage very early marriages will probably do more for their health and for the health of their children than any other change could do. But it is hopeless to expect girls, who are at heart very very dull, to wait till they are physiologically fit for the wear and tear consequent upon marriage if they see their way to it at eighteen or nineteen. There is always a hope that the unknown may be less dull than the known, and in the mean time the mere mention of a change gives life a fillip. It is also hopeless to expect them to be even reasonably critical in their choice. Coleridge says, "If Ferdinand hadn't come, Miranda *must* have married Caliban;" and many a Miranda finds her fate by not being free to wait a little longer for her Ferdinand.

But Dr. Maudsley supports his argument by references to American experience. He says in effect, "That which the English educational reformers advocate has been tried in America and has failed; the women there go through the same educational course as the men, and the result is that they are nervous, specially prone to the various ailments peculiar to their sex, not good at bearing children, and unable to nurse them." These are grave charges, and we can scarcely wonder at Dr. Maudsley's thinking "it is right to call attention to them." But it is also right to see if they are true. One fact certainly seems to be plain, and that is, that American women are frequently nervous, and do too often break down in the particular ways described in the quotation, though, if we may judge at all from those whom we have an opportunity of seeing in Europe, it may be hoped that the race is not quite in such a bad plight as Dr. Maudsley's quotations would lead us to fear. But granting that the facts are stated correctly, the doubtful point is, what causes this condition of things? Dr. Clarke says that, among other causes, it is due to an education which is at once too continuous, too exciting, too much pressed, and which is taken at too early an age. But against this we have to notice the testimony of many independent witnesses to the effect that the evils complained of are seen to a much greater extent among the fashionable and idle American women – those

guiltless of ever having passed an examination – than they are among those who have gone through the course of study complained of. Then, again, it is notorious that the American type in both sexes is "nervous." The men show it as distinctly, if not even more distinctly than the women; and not those men only who have any claim to be considered above the average in intellect or culture. If Dr. Clarke's explanation of the existence of this type in women is correct, what is its explanation in men?

Dr. Clarke himself gives us some valuable hints as to possible causes, other than study. He says: "We live in a zone of perpetual pie and doughnut;" "our girls revel in these unassimilable abominations." He also justly blames the dress of American women, "its stiff corsets and its heavy skirts;" but somewhat inconsequently, as it seems to us, he says, "these cannot be supposed to affect directly the woman's special functions." If one thing more than another is likely to do a woman harm in these directions, we should say it is heavy skirts; and it certainly shakes our faith in Dr. Clarke's acumen to find him attributing less direct influence to them than to mental occupation. Our own notion would be that till American girls wear light dresses and thick boots, and spend as much time out of doors as their brothers, no one knows how many examinations they could pass not only without injury but with positive benefit to their health and spirits. We find, however, no mention made by Dr. Clarke of the influence of the stove-heated rooms in which American women live, nor of the indoor lives they lead. These two things only would, we believe, suffice to explain the general and special delicacy of which he complains, and the inferiority in point of health of American to English women.

But the truth is, that the system against which Dr. Clarke protests, and to which his arguments are directed, is, in some of the very points upon which he most insists, essentially different from that which is now being gradually introduced in England. Dr. Maudsley has, with what we must call some unfairness, applied what was written against one plan, to another which is unlike it in almost every important point. Whether the system in America deserves all that Dr. Clarke says against it, Americans must determine. We are not in a position at this distance to weigh conflicting evidence, or to determine which out of many causes is the most potent in producing the ill-health he deplores. But we can speak of the

conditions under which English girls work, and we are able to say distinctly that on many vital points they are just those which Dr. Clarke and the other American doctors urge as desirable.

For instance, the stress of educational effort comes in America before eighteen. Graduation takes place at that age. At our own college for women at Girton, girls under eighteen are not admitted, and the final examinations take place three years or more later. Dr. Weir Mitchell's evidence on this point, as quoted by Dr. Clarke, is very emphatic. He says: "Worst of all is the American view of female education. The time taken for the more serious instruction of girls extends to the age of eighteen, and rarely over this." There is nothing that the English advocates of a change of system have striven more heartily to effect, than an extension of the time given to education; and what they have urged is in complete agreement with the opinions of Dr. Clarke and Dr. Mitchell. Then, again, Dr. Clarke distinguishes very clearly between girls learning the same subjects as boys, and sharing the same final examinations (which he does not disapprove), and identical co-education, where they are subjected to exactly the same rules and daily system, and where emulation between the two is constantly at work. He says (p. 135): "It is one thing to put up a goal a long way off – five or six months, or three or four years distant – and to tell girls and boys, each in their own way, to strive for it; and quite a different thing to put up the same goal, at the same distance, and oblige each sex to run their race for it side by side on the same road, in daily competition with each other, and with equal expenditure of force at all times. Identical co-education is racing in the latter way." Now, there is no organized movement in England for identical co-education in this sense. What is advocated is just what Dr. Clarke approves, viz. setting up the same goal, and allowing young men and young women to reach it each in their own way, and without the stimulus of daily rivalry. The public recitations, and the long hours of standing they involve, so much blamed by Dr. Clarke, are unknown in England, except in schools of the most old-fashioned and unenlightened type. The number of hours per day spent in mental work seems also to be much greater than that which is usual or even allowed in the best English schools. Eight or ten hours is said to be the usual time given to study in the American schools. In England, six hours is the time

suggested by the Schoolmistresses' Association, and this is to include time given to music and needlework. Naturally, there is no time in America for physical exercise or outdoor games.

Dr. Maudsley appends to the physiological argument others which do not press for immediate attention. They are already familiar to all who are interested in noticing what can be said in support of the policy of restriction, whether as applied to negroes, agricultural labourers, or women. They remind us more of an Ashantee fight than of a philosophical essay; so abundant is the powder used in their discharge, and so miscellaneous and obsolete are the projectiles. Happily, too, like the Ashantee slugs, though they wound, they are not very deadly. However, even Dr. Maudsley seems to relent when he comes to the end of the subject, and he goes so far as to allow that if the women whose policy he has been opposing fail, they will still be useful as failures, and that therefore they may go on their way, not too much discouraged by his disapproval. We will venture to draw another conclusion from the discussion, and it is this; that those who wish to give a fair hearing to all that is urged in support of a higher education for women must examine the evidence for themselves, not saying to themselves loosely that medical men seem to be afraid of this higher education, or that it seems to have been tried in America, and to have failed. Let them inform themselves thoroughly of what is proposed, and of the difference between the new system and the old; and if the result be, that, by improvement in the training and education of women, as much may be hoped for their physical as for their mental development, let them, in the interests not of women only, but of the children who claim from their mothers so much more than mere existence and nurture, give to those who are labouring at this difficult work, not languid approval, but sustained and energetic support.

And to those who share Dr. Maudsley's fears, we may say, that though under any system there will be some failures, physiological and moral, neither of which will be confined to one sex, yet that experience shows that no system will live from which failure in either of these directions as a rule results. Nature in the long run protects herself from our mistakes: and when we are in doubt, we may be guided by the general principles of equity and common sense, while waiting for the light of a larger experience.

SEX IN EDUCATION
The Examiner (May 2nd 1874)
Sophia Jex-Blake

Sir, – I have not seen Dr Maudsley's article, and therefore cannot offer any opinion upon it. I remember, however, reading in a former work of his a very touching passage in which he ascribes a large proportion of insanity among women to the vapid and purposeless lives that so many of them are condemned to lead; and I trust that he himself has not forgotten to bear this aspect of the subject in mind.

I venture to advise those of your readers to are interested in the question to read a very excellent letter which appeared in the *British Medical Journal* of April 18, wherein the writer, after acknowledging that a caution to regard physiological laws can never be ill-timed, goes on to remark that, in point of fact, such cautions are more needed with reference to the present occupations of thousands of women who are literally overwhelmed with bodily toil, than they are ever likely to be in regard to the mental efforts of their wealthier sisters. I think nothing is more curious than the placid way in which a certain class of male writers constantly assume that no labour is severe except that usually allotted to men, and that it is only when women venture to invade *that* field that they are likely to be overtasked, and yet it may, perhaps, fairly be questioned if any man in Great Britain ever works to anything like the point of exhaustion that is, I fear, but too faithfully pictured in Hood's world-famous "Song of the Shirt."

Perhaps the richest illustration ever afforded of such absurd inconsistency was furnished by a letter of Dr Henry Bennet's, which appeared in the *Lancet* of June 18th, 1870. In this he urged, with a view to excluding women from the study of medicine, that women are "sexually, constitutionally, and mentally unfitted for hard and incessant toil," and then went on with delicious *naïveté* to allow that they may

properly be employed in midwifery (or, at least, as he distinctly stipulated, "in guinea and half-guinea cases"), on the very ground that medical men would thus be relieved from what he himself described as the "most arduous, most wearing, and most unremunerative" part of the profession! Was ever a neater or more perfect *reductio ad absurdum*?

In conclusion I am anxious to say a few words in defence, or rather in explanation, of Dr Clarke's book, which seems to me to have been very seriously misunderstood, and its purpose gravely misrepresented, both in this country and in America. I have often had the pleasure of meeting Dr Clarke personally, and I know that he holds wide and liberal views with reference to the education of women, and indeed sets no limit to what they may do in any department of literature or science. He has, ever since I have known him, approved of the education of women as physicians for their own sex, and he is, I believe, one of the consulting staff of the Women's Hospital in Boston, which is managed exclusively by women doctors. I know that he constantly meets my friend, Dr Lucy Sewall, in consultation, and has repeatedly sent her patients whose cases he considered more suitable for treatment by her than by himself. I think, therefore, he may fairly be acquitted of any illiberality towards women, and I am sure that 'Sex in Education' was never written with a view to discourage them from literary or scientific study. Its sole aim, as I understand it, was to urge two cautions on those concerned with the education of girls: (1) that physiological laws can never be safely disregarded, and that especially in girlhood *incessant* strain must always be a serious evil; and (2) that, in his opinion, women do not come to their full strength of mind and body before the age of twenty-five, and that much which may most safely be done subsequently will be very perilous in earlier years. On both these points I think his cautions extremely valuable, although it is to be regretted that his book is so full of professional details and also that the "alarmist" element is so very predominant.

I sincerely trust that one of the greatest services which women doctors may render to their own sex is, on the one hand, to encourage other women to live full and useful lives, and to cultivate every power that God has given them; and, on the other, by spreading a greater knowledge of physiology and hygiene to warn them where lie the dangers which they

must avoid, and what are the reasonable precautions they must take, if they are to enjoy to the full the greatest of all earthly blessings, the *"mens sana in corpore sano."*

I am, &c. SOPHIA JEX BLAKE

SEX IN EDUCATION

The Saturday Review, Vol. 37 (1874)

The discussion opened by Dr. Maudsley in the *Fortnightly Review* has been taken up by Mrs. Anderson, a lady who is certainly well qualified to express an opinion on the subject. We do not desire to discuss the physiological questions involved; and we therefore cannot pronounce a definite opinion as to the merits of one part of the discussion. The only test, indeed, is experience; and probably Dr. Maudsley and Mrs. Anderson would both admit that we are as yet scarcely in possession of the information necessary for a trustworthy decision. Meanwhile, however, we may venture to make some remarks upon the general tendency of the discussion; and especially we would point out that, after all, there seems to be much less difference between the disputants than might at first sight be supposed; and therefore very little reason, except the irritating nature of all disputes about women's rights, for the importation of any hostile spirit into the matter. Mrs. Anderson, though she writes temperately and sensibly, seems to disapprove of Dr. Maudsley for giving what, even on her showing, appears to be a seasonable warning, and one which might very well be accepted by all parties without any display of sensibility. A good deal is admitted on all hands. The dispute was originated by certain American observers who thought, rightly or wrongly, that some part of the delicacy of American women was attributable to the system of female education. Mrs. Anderson remarks upon this that, assuming the facts, many other causes may be alleged. If American women are more delicate than Europeans, which scarcely seems to be disputed, much must be set down to habits of life, to the want of out-of-door exercise, to the worries of housekeeping in a country where good servants are an extinct luxury, and to the general state of nervous excitement in which American men, not less than American women, are accustomed to live. All this is true and indeed obvious. It would be an absurd exaggeration

to set down all the evils which afflict American women exclusively to a cause which affects but a small proportion of the population, and has only affected it lately. We will merely observe that the fact of the men suffering equally with the women is not a conclusive argument, as Mrs. Anderson seems to assume, against some part of the evil being attributable to the alleged cause. Men have mothers, and a woman with ruined nerves is likely to have sickly sons. We quite agree, however, with her view that too much is probably attributed to this single cause. Every little clique of reformers is always convinced that its own pet object of antipathy is answerable for every evil in existence; and it would be contrary to all experience if the doctors did not exaggerate the mischief which they are for the time denouncing. This, however, though it suggests the propriety of making some allowances, does not prove that the warning is altogether without foundation. We must not take the conclusions for granted, but we regard the alarm raised as at least a useful hint. Mrs. Anderson herself admits that the feminine constitution requires special care during the early years of education; and if that fact has been overlooked in America, we see no reason to doubt that evil consequences may have resulted.

On another point we entirely agree, and we do not see why Dr. Maudsley should not agree, with Mrs. Anderson. It is highly desirable that women should receive the best education possible. The evils of the present superficial and often most foolish system of education, if it deserves the name, are manifold and grievous. It is perfectly true that young women's minds are often so imperfectly developed that they are incapable of taking a rational interest in intellectual work; and that they frequently find refuge in mere frivolities, or in unhealthy sources of excitement. The same remarks indeed apply in a considerable degree to the education of men; but, in spite of the evils produced by an exaggerated athleticism and by the degradation of study due to excessive competition, a certain number of men do in fact receive a more solid training of their faculties than can often fall to the lot of women. Women ought to learn more, and to learn more systematically. Nor, we may add, is there any part of a man's education from which a woman should be debarred. Women may or may not be the equals of men in originating power; but at least they are capable of acquiring all the knowledge which is supposed to be

imparted at our Universities. And therefore, when Mrs. Anderson argues for making the course of feminine studies wider and more thorough, we entirely agree with her, and should only refrain from expressing our views more fully because we are not aware that anybody would seriously dispute them.

What, then, is the point really at issue? Dr. Maudsley asserts that sanitary considerations are too much neglected because the reformers of feminine education are apt to lay down the same course for men and for women; and he holds that the severe competition which may have no injurious effect upon male students may be prejudicial to their sisters. To this statement Mrs. Anderson seems to oppose two replies. She tells us that these reformers have, in fact, attended to sanitary considerations. The schoolmistresses, she says, who asked for the admission of their pupils to the University examinations also introduced gymnastics, baths, and various hygienic appliances. We are very glad to hear it, and we hope that they will carry out the system as thoroughly as possible. We suspect indeed that, whatever has been done, a great deal more remains to do; and that the physical needs of English schoolgirls by no means receive the amount of attention which they deserve. That, however, is a question of fact. If due provision is already made for all the wants to which Dr. Maudsley calls attention, there is no more to be said. If it is not, his caution is merely a useful one, and should be received in a friendly spirit, instead of being regarded as necessarily indicating a hostile *animus*. But there is obviously something more behind. Dr. Maudsley says that, as boys and girls have different physical needs, they should have different careers cut out for them. The difference raises a presumption that it is unwise for a woman "to persevere in running over the same course at the same speed with" a man. This presumption certainly seems to us to be a very modest one, and Mrs. Anderson's attempt to meet it are, to our thinking, the weakest part of her case. Her chief argument, indeed, contains a palpable begging of the question. "If the course of study," she says, ". . . be one as likely to strengthen the best powers of the mind as good food is to strengthen the body, if it tend to develop habits as valuable to women as to men, and if the pace is moderate, there would seem to be no good reason why the special physiological functions of women should prevent them from running it any more than these same

functions prevent them from eating beef and bread with as much benefit as men." If Mrs. Anderson merely means to say that experience must decide in both cases, we agree with her. But she says herself that young girls are frequently encouraged by ignorant parents to indulge in exercises (she specially mentions riding) which are injurious to them, though they would be healthy for boys. If this be so, it is plain that a purely physical system of training would have to be modified according as it was intended for boys or for girls; and there is at least a presumption that a similar difference would be required in the case of intellectual training. Boys and girls should both eat beef and bread, and should both learn classics and mathematics. Nobody disputes either proposition. The only question is whether they should both eat the same food in the same quantities and at the same time, and should both go through the same course of study independently of any consideration of their different physical constitutions. Experience may possibly show that the differences of constitution are not of such a nature as to require a corresponding difference in habits of life; we can only say that the presumption appears to us to be the other way; and that the tendency of feminine reformers is generally to overlook this obvious and very important fact.

Mrs. Anderson indeed disavows any such tendency, and declares that only "injudicious advocates" have made remarks capable of being interpreted as expressing a wish to assimilate the female to the male mind. We are afraid that her cause has a good many injudicious advocates, and it is precisely against them that Dr. Maudsley's remarks are valuable. She incidentally suggests a pertinent analogy. She contemptuously dismisses some of Dr. Maudsley's arguments on the ground that they have already been advanced in regard to negroes and agricultural labourers. Does the fact that they have been urged and disregarded prove that they were valueless? People objected very rightly to negro slavery on the ground that a system was a bad one which deprived certain human beings, capable of better things, of rights to property, to their wives, and to education, and which allowed other men to flog them as much as they pleased. In short, it was said that slavery was a bad thing, because it tended to lower a negro to the state of a brute. But then other people, not content with these very forcible arguments, proceeded to assert that, because a negro

was a man, he was in all respects as good as another man. They resolved entirely to overlook all physiological and intellectual differences, and to treat the emancipated slave exactly as if he were a white man. Their motives were excellent; but their arguments had the weakness of neglecting the true facts of the case. The result of acting upon them may be seen by anybody who will examine into the present condition of South Carolina. Because the inferiority of the negro race had been turned to account for purposes of tyranny, it was denied that the inferiority existed; and no reasonable abolitionist will deny that very grave evils to both races have been the result. To apply the parallel, we will admit that women have hitherto been treated, if Mrs. Anderson pleases, as slaves. Their inferiority in physical, we may not say in intellectual, strength has led to their being grievously oppressed by our social and legislative arrangements. This is the explanation, indeed the only explanation, of their grievances given by Mr. Mill and other advocates of female rights. Now, however, women are to be emancipated, and we are immediately told that women are so nearly equal to men that we need pay no attention at all in educational matters to the difference of physical constitution. Women have been bullied and ill treated through all the ages of history simply because they were weaker than men; but, now that we are to cease to take advantage of our superior strength, we are suddenly to assume that it does not exist, or at least that it is a matter not worth taking into serious account. We must say that, to our thinking, the argument should be inverted. If the weaker vessels are to be elevated by being exposed to open competition with the strong, surely the most obvious conclusion would be that some precautions should be taken to neutralize the inequality which has hitherto been so disastrous. Women should be allowed to join in the struggle on such terms as to relieve them from the strain to which the stronger race is recklessly exposed.

Indeed, without dwelling upon this argument, we cannot but think that, in spite of Mrs. Anderson's disavowals, the warning is one which may well be taken by the more ardent supporters of woman's cause. The tendency is, if not to assimilate the female to the male mind, at least to expose women as much as possible to the same conditions of education. Their teachers have been very anxious for permission to send in their pupils to the same examinations as those which their brothers undergo.

As women have had the disadvantage of being last in the field, they should have the advantage of avoiding some of the errors which have been committed. Now few people will deny that the competitive system, pushed to the extremes, is the weakest part of a male education. Dr. Maudsley seems to us to give good reasons for thinking that the evils are likely to be felt more injuriously by the weaker sex; and Mrs Anderson makes admissions which at least go very far to support his case. If so, we do not see what cause any one has to object to the modest conclusion that great care should be taken by the advocates of an improved system of feminine education when they are seeking to introduce an element which has already produced questionable results upon men, and which is certainly not likely to be less injurious to the more docile and less vigorous sex. Experience undoubtedly must be the ultimate test; but we should try experiments on such precious material with every possible care, and should guard against the danger – not an imaginary danger, whatever Mrs. Anderson may think – of being carried away by abstract theories about human equality. It is a pity that warnings should cause resentment when they might more properly be taken in a friendly spirit by those who have the success of female education most at heart.

SEX IN MIND AND EDUCATION:
A COMMENTARY[1]

Blackwood's Edinburgh Magazine, Vol. 115 (1874)

[Herbert Cowell]

A movement has been set on foot in this country in recent years which deserves every sympathy and encouragement, so far as it is directed towards improving the education of women, widening their interests in life, and of facilitating their admission to careers in which, as women, they may be useful, and in which the modesty of womanhood is not forgotten. But unfortunately, in this, as in all other matters in which there is social or popular movement, the air is poisoned with foolish theories, and fantastic tricks are perpetrated in which moderation and good sense are laughed to scorn. One frantic feminine orator, who is a married woman of some position and a champion of advanced female education, is reported, in the 'Times' of 17 January 1874, thus to have amused and instructed a Sheffield audience. Remarking that women's plea for suffrage was a plea for their very lives, asking that they might not be wholly annihilated, she proceeded: "The woman slave had arisen and looked her ruler in the face, and from that hour he had been troubled, uneasy, and unsettled on his throne. (Great cheering.) When the working man rose and said, 'I also am a man,' it was the death-knell of the aristocracy of birth. (Cheers.) When the woman said, 'I also am a human being,' it was the death-knell of the aristocracy of sex." (Loud cheers.)

Greater nonsense was never talked upon any platform. If hysterics be, as some women of advanced views tell us, the normal condition of unemployed young ladies, their admission to new careers, indiscreetly effected, does not appear to

[1] Sex in Education, by Edward H. Clarke, M.D. – Boston: 1874. Sex in Mind and Education, by Henry Maudsley, M.D. – 'Fortnightly Review,' April 1874. Sex in Mind and Education; A Reply, by Elizabeth Garrett Anderson, M.D. – 'Fortnightly Review,' May 1874.

provide a remedy. And society apparently has lost one safeguard in the undue decline or timid exercise of marital authority.

But female education, and the principles upon which it is to proceed, are of such infinite importance to society, that their discussion must not be prejudiced in any way by the vagaries of what are called exceptional women. The ladies who have earned that title have, no doubt, succeeded in calling attention to the subject, but they have also succeeded in investing it, by their language and their conduct, with a considerable amount of prejudice, for which, as applied to themselves instead of their cause, we think there is, and we tell them so frankly, a fair foundation. Much of their singular sentiment is due to the influence and writings of the late Mr Mill, whose social theories are destined to live in the affections of exceptional women, long after they have been rejected by the deliberate judgment of the rest of society.

So much has been said recently in the newspapers, and in the 'Fortnightly Review,' upon the subject of sex in mind and education, that we think it right to bring it to the notice of our readers. Its practical importance in America is enormous, for in that country the rage for equality – that spirit which, if we remember right, was recently said at Glasgow to be rising like a moaning wind in Europe – has led to the identical co-education of the sexes, regardless of their physiological needs and differences, to an extent which (combined with other causes) threatens, according to American physicians of repute and experience, chronic invalidism to women, and speedy degeneracy to the race. Its practical importance in England is at present not nearly so great, for co-education of the sexes, in the sense in which it exists in America, has not yet been tried in this country; and we have that confidence in the good sense of our countrymen and countrywomen that we believe it never will, at least to any appreciable extent. Nevertheless, it has seemed good to the 'Fortnightly' to introduce the discussion of this subject in a manner more remarkable for its fulness than its delicacy. The two medical combatants who have handled it in that journal have treated it in great detail, and with some acrimony. But they have never succeeded in bringing it to an intelligible or practical issue, as we will show further on. One has denounced the American system; the other has defended the English one, which is totally different. Both have discussed

the extent to which women are "handicapped" by their physical constitution; and though one is inclined to exaggerate and the other to make light of female disabilities, the arguments of both will justify the English and condemn the American system of higher female education.

Dr. Maudsley, who is one of the combatants, has in the April number of the 'Fortnightly' placed before its readers a paper, in which he treats, in a manner which leaves nothing to the imagination, the subject of female organisation, and the demands which its special functions make upon its strength. He has observed no reticence of any sort or kind upon what he calls the physiology of the matter, his intention being "to look the matter honestly in the face." The consequence is, we are treated to a discussion which, however appropriate to the pages of a medical publication, is a novelty in English current literature. And a collateral question of some importance arises, whether the necessity for so much frankness is made out, or whether the writer is not amenable to grave censure for having needlessly introduced an objectionable and disagreeable inquiry? The decision of that question depends upon whether we consider that the topics so obtruded upon our attention are of any immediate practical importance in this country. Considerations of delicacy and decency are usually held to impose some reserve both upon editors and authors, and it is not in the interest of English literature and the English public that any violations of them should pass unnoticed and unchallenged. A reply to Dr Maudsley's article by Mrs Garrett Anderson, M.D., appeared in the May number of the 'Fortnightly.' Fairness compels us to except her paper from the same censure which is justly due to Dr Maudsley; for if women are to be made the subject of discussions of that nature to their disadvantage, real or supposed, they may be expected to reply. They cannot, so they say, be silent, in obedience to considerations which are disregarded by their opponents. After weighing the subjects of practical controversy – both those which are ostensibly treated, and those which are obviously suppressed – it seems to us that the medical discussion, however necessary in America, was premature and unjustifiable here. There being no attempt in this country to introduce the system of early co-education of the sexes, so prevalent in America, and so fiercely denounced by medical authorities there, the only relevancy of such a discussion to anything which

exists here is as regards those who are seeking to enter a medical career, or who may seek degrees at London University, provided its charter be remodelled; or who desire to work in factories untrammelled by the restrictive rules of factory legislation. The objectionable details, however, refer not to grown women, but to growing girls at the educational period of life, rather than at that of operative or professional or even university work. It is not pretended that English girls are likely to fall victims while still children to any senseless system of education existing or suggested. Under these circumstances, much as we may need a warning on the subject of unduly stimulating feminine rivalry and competition, the laws of nature have not yet been openly defied, or even threatened with neglect; and until a writer can demonstrate that they have, he will do well to observe some delicacy. The minute details in which Dr Maudsley has indulged were not merely unnecessary; they are the weakest part of an otherwise powerful article, and have laid him open to the charge of exaggeration, which it would have been prudent to avoid.

As the question in this country is still principally one of theory, the application of which is remotely possible, we will first state the theory and trace its origin, and then refer to America, where it has been reduced to practice. It is well known that the advocates of what are called Women's Rights, as well here as in America, insist upon the equality of the sexes, without limitation. Regardless of the uniform teaching of history in all ages, races, and climates – and regardless, the doctors tell us, of the most elementary rules of physiological science – they insist upon the equal rights of the sexes, and that unrestricted competition between them should be permitted and fostered. Mr Mill started the doctrine in this country. He declared, in his own confident way, that the nature of woman was eminently artificial, whereas physiologists say it has a scientific and complete explanation. Mr Mill said that that "artificial nature" (sic) was the result of forced repression in some directions, unnatural stimulation in others; physiologists tell us that that nature is not artificial, that it demands its own special development, and cannot be contradicted or disregarded with impunity. Mr Mill denied that there was any radical inequality between the sexes, and that their general relations in all affairs of life, even in marriage, are those of absolute equality. "Standing on the ground of common-sense

and the constitution of the human mind," he denied "that any one knows, or can know, the nature of the two sexes, as long as they have only been seen in their present relations to one another." Physiologists are apparently agreed that there is sex in mind as well as in body, and that the mental qualities of the sexes correlate their physical differences.

Identical co-education of the sexes, unrestricted competition between them, the reduction of marriage to the state of partnership at will, with equal rights and limited liability, follow from Mr Mill's theory; but are alike opposed to the teachings of physiology, religion, common-sense, and experience. He was bitterly opposed to "the Subjection of Women" in any of its forms. It is right to draw attention to the position and surroundings of the authors of the book which is known by that title. They are disclosed to us in his 'Autobiography'. It was the result of that "partnership of thought, feeling, and writing," which existed between him and Mrs Taylor for twenty years of their lives, and which was succeeded, on the death of Mr Taylor, by the "partnership of their entire existence." The book emanated "from the fund of thought which had been made common to them both, by their innumerable conversations and discussions on a topic which filled so large a place in their minds." We have already in these pages reviewed Mr Mill's account of his career, and endeavoured to do justice to his eminent character and achievements. And therefore we shall the more readily say that his relations to Mrs Taylor during her husband's life were the great blot upon his career; and that the social theories which he elaborated with her, as a weapon of defence against adverse social opinion, are a stain upon his philosophic system. The rights of women were, on Mr Mill's own showing, pushed by them to an extreme which precluded in principle any duties in a wife, and in practice denied to the unfortunate husband even a title to divorce. Such a relationship between them, and such dereliction of duty on the part of one of them to her husband, were defensible only upon theories which are better know than approved. They might have enabled Mr Mill and Mrs Taylor to reconcile their conduct to their consciences. But they cannot be generally accepted without upsetting the relations between the sexes, and overturning the foundations of domestic morality.

With these theories partially afloat in England, attention is drawn to the circumstance that identical co-education of the

sexes – which is the first step towards enforced equality – is being tried in America; that the physicians denounce it, and are in their turn assailed by exceptional women, who in that country as well as this seem to think that anything appertaining to the education of their sex is their own special property, forthwith to take a place in the programme of the rights of women. The subject, however, if allowed to be managed on American principles, will soon become of transcendent importance to the human race. Amongst Americans the subject has become menacing and dangerous to the last degree. The first observation of a European landing amongst them is, that their women are a feeble race; and their physicians emphatically declare that one of the causes, which has been recently aggravated in its intensity, is the educational method adopted in their schools and colleges. "If these causes," they say, "should continue for the next half-century, and increase in the same ratio as they have for the last fifty years, it requires no prophet to foretell that the wives who are to be mothers in our Republic must be drawn from Transatlantic homes. The sons of the New World will have to react, on a magnificent scale, the old story of unwived Rome and the Sabines."

Dr Edward Clarke, a physician of some repute in America, and who was at one time a professor in Harvard College, has published a small book which endeavours to solve the problem of woman's sphere by the aid of physiological science. It is entitled 'Sex in Education;' and is devoted to prove the obvious truth that the educational capacities of boys and girls correlate the differences in their sex, and that the actual training both of mind and body must do the same. "The cerebral processes," he says, "by which the acquisition of knowledge is made, are the same for each sex; but the mode of life which gives the finest nurture to the brain, and so enables those processes to yield their best result, is not the same for each sex."

He discusses, as in that country under existing circumstances he was well entitled to do, the whole physiology of the subject, and fills it with earnest and emphatic warnings. He begins by observing that there are three primary divisions of the human frame – viz. the nutritive, nervous, and reproductive systems. The first two are alike in each sex, and the machinery of them is the same. The scientific inference from this is, that intellectual power is capable of equal development in both

sexes; and with this verdict in their behalf, women ought to be conciliated in favour of his earnest warnings as to the mode in which that development should be effected. With regard to the reproductive system, the case is altogether different. The educational life of a girl is shown with great minuteness of detail, which it is unnecessary here to follow, to stretch over several very critical years of her life. An extraordinary task calling for rapid expenditure of force, the building up a delicate and extensive mechanism, is said to be imposed upon her by her sex during these critical years; while the organisation of a male grows steadily, gradually, and equally from birth to maturity. And he goes on to show that if that task is not completed at the proper time, it is never perfectly accomplished afterwards, the result being that the foundation is laid of disease and weakness. He enumerates a host of ills which are induced by modes of early life which disregard this task, and by stimulating competition between boys and girls, which the latter are physiologically unfitted to sustain, not so much in the long-run as at the same time, by the same method, and according to the same regimen. He adds, that fortunate is the girls' school or college that does not furnish abundant examples of these sad cases. He says that the growing period or formative epoch extends from birth to the age of twenty or twenty-five years: its duration is shorter for a girl than for a boy; she ripens quicker than he. In the four years from fourteen to eighteen, he says – though other physicians dispute his statement in its actual and numerical detail – that a girl accomplishes an amount of physiological change and growth which nature does not require of a boy in less than twice that number of years.

Guided by these threefold laws of development, he passes on to the principles which limit and control education. Some are obviously common to both sexes. But supreme attention must be paid to physiological differences, which necessitate different modes of life, and forbid, as a general rule, identity in their training and pursuits. He gives numerous instances of the utter breakdown of American girls under the system of American co-education, which he describes to be, not a mere mode of utilising the same building and the same instructors for the purpose of giving appropriate education to the two sexes, as well as to the different ages of the same sex (which he does not object to); but a system of teaching boys and girls the same things at the same time, in the same place, by the same faculty,

with the same methods, and under the same regimen. This he protests against. It is a system which admits age and proficiency, but not sex, as a factor in classification. Such identity of education, with the undue stimulus to competition, is one of the causes, and a most important one, which has led to the admitted degeneracy of American women. Identity of training, he says, is what many in America at the present day seem to be praying for and working for. But, in his view, "appropriate education of the two sexes, carried as far as possible, is a consummation most devoutly to be desired: identical education of the two sexes is a crime before God and humanity that physiology protests against, and experience weeps over."

"The error," he adds, " which has led to the identical education of the two sexes, and which prophesies their identical co-education in colleges and universities, is not confined to technical education. It permeates society. It is found in the home, the workshop, the factory, and in all the ramifications of social life. The identity of boys and girls, of men and women, is practically asserted out of the school as much as in it, and it is theoretically proclaimed from the pulpit and the rostrum. Woman seems to be looking up to man and his development as the goal and ideal of womanhood. The new gospel of female development glorifies what she possesses in common with him, and tramples under her feet, as a source of weakness and badge of inferiority, the mechanism and functions peculiar to herself. In consequence of this widespread error, largely the result of physiological ignorance, girls are almost universally trained in masculine methods of living and working, as well as of studying. The notion is practically found everywhere, that boys and girls are one, and that the boys make the one."

There are two reasons, however, assigned why female operatives of all sorts are likely to suffer less, and actually do suffer less, from such persistent work than female students – why Jane in the factory can work more steadily with the loom than Jane in college with the dictionary. The first reason is, that the female operative, of whatever sort, has as a rule passed through the first critical epoch of woman's life – she has got fairly by it. The second reason is, that the former work their brains less. Give girls, he says, a fair chance for physical development at school, and they will be able in after-life, with reasonable care of themselves, to answer the demands that will

be made upon them. The gist of his discussion is, that as no education for boys is worthy of the name which does not provide for the development of muscular power and animal vigour, for proficiency in the exercises of the playground and athletic sports – so no education for girls is worthy of the name which does not specially (and in a manner distinct from boys) provide for her physical health and growth. He proves that nature punishes neglect by inflicting upon her serious physical evils and ultimate degeneracy, and the evils are the more serious that they involve in their effects future generations.

In this way a very strong case is made out in theory against the identical education of the sexes, even when carried on separately, though without discrimination between their relative powers; but when carried on, as it is in America, side by side, the element of emulation is introduced, and the evils are intensified. It is not the competition merely of separately striving for the same ultimate goal. Each sex runs its race side by side on the same road, in daily competition with the other, with equal expenditure of force at all times; and the inevitable results are such as he describes and deplores in America. The experiment of the identical co-education of the sexes has not been tried long enough to show much more than its first-fruits – viz., its results while the pupils are in college. It is, and is described to be, "intellectually a success, physically a failure." Two or three generations must come and go before any sufficient idea can be formed of the harvest it will yield. "The physiologist dreads to see the costly experiment tried. The urgent reformer, who cares less for human suffering and human life than for the trial of this theories, will regard the experiment with equanimity, if not with complacency."

Dr Clarke sums up his discussion with the following wise and judicious remarks: "The intimate connection of mind and brain, the correlation of mental power and cerebral metamorphosis, explains and justifies the physiologist's demand that in the education of girls as well as of boys, the machinery and methods of instruction should be carefully adjusted to their organisation. If it were possible, they should be adjusted to the organisation of each individual. None doubt the importance of age, acquirement, idiosyncrasy, and probable career in life, as factors in classification. Sex goes deeper than any or all of these. To neglect this is to neglect the chief factor of the problem."

The subject is a hot one in America, and no wonder; and in England the medical profession introduce its discussion through the pages of the 'Fortnightly." In order to give it a more comprehensive character than it had under Dr Clarke's handling, it is pointedly divided in that magazine into two branches; and apparently, if we wish to get clear views, it is necessary to keep them quite distinct. The first is – Is there such a thing as sex in mind; and, if so, what mental characteristics correlate the differences in sex? The second is – Ought sex to be recognised, and to what extent, in educational plans and methods, both with respect to mental and physical training? Both articles suffer from a good deal of obscurity and confusion by not sufficiently maintaining throughout the distinction which they have pointedly drawn. Knowing that the subject is one which fills a large place in the attention of the New World, and is of growing interest in the Old, we were curious to ascertain what light medical science, investigated from two opposite points of view, conducted by members of the medical profession of different sexes, could throw upon the subject. Candour obliges us to confess that the discussion falls short of our expectations, and is, in fact, much ado about nothing. The prudence of two or three sanitary rules is established beyond dispute. But so far as the generic differences of sex in mind are concerned, and the corresponding differences in mental and physical training, we are very much where we were before. We have the satisfaction of discovering that medical authorities are agreed that those differences exist. Dr Maudsley has striven, as far as the existing state of physiology and psychology will allow him, to reduce them within scientific classification, and to trace their origin. The reply is confined to a mere sanitary discussion and the details of a particular system of education, which, admitting the existence of those differences, does not help to classify or describe them. So far as they are contentious, the two articles are more in the nature of rival prescriptions than of contributions to the solution of a scientific problem.

Now, upon the subject of sex in mind, which is the really, perhaps we may say the only, valuable part of Dr Maudsley's paper, his theory, which we are obliged to extract from different parts of his article, where it is confused and embedded with other matter, is this: He first discusses the bodily organisation of the two sexes. Then he points out that mind is the sum of those functions of the brain commonly known as

thought, feeling, and will. The brain is in the closest physiological sympathy with all the organs of the body. It communicates with them by definite paths of nervous communication. There are internuncial nerve-fibres which keep up that communication. There is an intimate consensus of functions, so that the brain habitually feels and declares the influence of the different organs. These organs react upon it, and essentially affect its nature as the organ of mental functions. Each organ possesses its own special influence on the brain, and is an essential constituent of mental life, the influence of the reproductive organs being the strongest, producing at maturity a great mental revolution which is of a widely different character in the two sexes, and is the source of marked mental differences between them.

Having thus explained the existence and origin of sex in mind, he proceeds, confusing his subject again with sex in education, to unfold its distinguishing characteristics. And here, where we might have hoped for some valuable light from an expert writing in a journal of high scientific pretensions, we are to a considerable extent disappointed. He says that regard must be had to the specialities of woman's nature. What are those specialties? First, he says, they are manifestly endowed with qualities of mind which specially fit them to stimulate and foster the first growths of intelligence in children. They have the intimate and special sympathies which a mother has with a child, the mental "qualities which qualify" her specially to be the successful nurse and educator of infants and young children. Further, she has qualities of mind which adapt her to be the helpmate and companion of man. This is all somewhat vague and indefinite. We have no doubt that it is perfectly true; but a scientific writer who descends upon us from the heights of the medical profession, might have told us something new as well as something true, and given us a better glimpse of a scientific classification of the sexual qualities of mind.

He tells us that the female qualities of mind are not the artificial results of their subjection and dependence. They lie, he adds, deeper than circumstances, being inherent in the fundamental character of sex, and are ineradicable. Women are marked out by nature for different offices in life from men; they have totally different functions, the influence of which pervades and affects essentially their entire being, mental as well as physical. The vital energy which, in a growing boy, may

be directed to the growth of muscle and physical strength and brain-power, cannot be unduly diverted in a growing girl from the formation of a physical mechanism, which taxes all the resources of her constitution. She has, moreover, less "energy and power of endurance of the nerve-force which drives the intellectual and muscular machinery." That, again, is a subject upon which we should like to have heard more. Dr Maudsley again and again refers to it, but he does not give a scientific account of it. He tells us in one place that certain important physiological changes which take place may easily produce serious disorders when the nerve-centres are more unstable than is natural. When the nerve-centres are in a state of greater irritability, by reason of the development of these reproductive functions, they will be the more easily and the more serious deranged. And so on.

The result of Dr Maudsley's scientific analysis is, that those who seek to improve the education of women must recognise simply what we all knew before, – that it is impossible to transform a woman into a man; that women cannot have the same aims as men, pursued by the same methods; and that it is injurious to attempt to assimilate the female to the male mind.

The reply to this discussion, which appeared in the next number of the 'Review,' does not contravene this position – viz., the existence of sex in mind – in the slightest degree. Although Dr Maudsley has failed to keep it distinct from the rest of his article, which bears upon the subject of sex in education, and has not dealt with it with such minute completeness as one could have wished, having reserved all his power of detail for quite a subordinate branch of his subject, – it is nevertheless the prominent portion of his paper, and challenged direct contradiction, if such were forthcoming. But the reply is totally silent upon the only scientific portion of the discussion; in respect of which, Dr Maudsley's article is pointedly distinguished from the American treatise. "The single aim," it says, "of those anxious to promote a higher and more serious education for women, is to make the best they can of the materials at their disposal." It does not deny that these materials differ essentially in the two sexes, as Dr Maudsley asserts. But it asks with unfeigned surprise what ground Dr Maudsley can conceive that he has for imputing any wish to change women into men, or to assimilate the female to the male mind. It asserts that no one with the slightest authority, but

only an occasional indiscreet advocate, has ever said or implied anything of the sort.

Here, therefore, is a distinct admission on the part of "the reformers," made apparently with the necessary authority and discretion, that there is sex in mind, and that any attempt to assimilate the mind of the one sex to the mind of the other, is an attempt which no one of any authority or discretion would dream of making. And as for the special mental characteristics which distinguish the sexes, Dr Maudsley's enumeration of them is nowhere disputed, or even cavilled at. He has, in truth, limited himself to such as were too obvious to be disputed by any one who admits that there is sex in mind. There are mental qualities, therefore, which correlate the differences of sex, which from the time of Eve to the present day have determined the relation of the sexes. With that point clearly understood, the discussion is at once limited to the question whether there should also be sex in education, which is the sole point to which the reply addresses itself.

When we come to this latter question, it is obvious that if stands upon a totally different footing in this country from that which it occupies in America. Not merely is it admitted that there is sex in mind, but it is also admitted that there is sex in training. Both articles in the 'Fortnightly' agree upon that point also.

Dr Maudsley asserts that woman must have a special sphere of development and activity. Before she is subjected to a system of mental training adapted for men, "it is needful to consider whether this can be done without serious injury to her health and strength." He explicitly admits "the right of woman to the best mental culture." But because there is sex in mind, he denies that woman can be transformed into a man, and denies that "a system of female education should be laid down on the same lines, follow the same method, and have the same ends in view, as a system of education for men." He insists that a proper physical education of girls must recognise "their peculiar functions and their fore-ordained work as mothers and nurses of children" And a proper mental education requires attention "to those qualities of mind which correlate the physical differences of her sex;" that is, it should recognise the special mental qualities which are closely connected with physical organisation,

and are manifestly intended by nature to fit a woman for maternal duties, and "to be the helpmate and companion of man in mental and bodily union."

He objects to the American system of training the sexes in mixed classes, to the stimulus of competition being unduly applied, and to girls disdaining any privilege of sex. Experienced physicians assert that this system works at a cost to girls of their health and strength, which entails lifelong suffering. Stimulated to compete with boys in mental labour, unable to do so in outdoor and physical exercise, they break down not merely on account of their "greater constitutional susceptibility," but because there is "no compensating balance of emulation in other fields of activity." He objects also to the production "of a race of sexless beings who, undistracted and unharassed by the ignoble troubles of reproduction, shall carry on the intellectual work of the world, not otherwise than as the ants do the work and fighting of the community." He points out that the consequences of an imperfectly developed reproductive system are not sexual only, they are also mental.

He protests against men and women having "the same type of mental development." He admits "that they are entitled to have all the mental culture and all the freedom necessary to the fullest development of their natures." "The aim of female education should manifestly be the perfect development, not of manhood but of womanhood, by the methods most conducive thereto, so that woman may reach as high a grade of development as man, though it be of a different type. A system of education which is framed to fit them to be nothing more than the superintendents of a household and the ornaments of a drawing-room, is one which does not do justice to their nature, and cannot be seriously defended. Assuredly those of them who have not the opportunity of getting married suffer not a little in mind and body from a method of education which tends to develop the emotional at the expense of the intellectual nature, and by their exclusion from appropriate fields of practical activity."

It is quite impossible to state in stronger terms than this the right of women to the highest attainable culture, so long as it is obtained by appropriate training; their right to enter new fields of activity, so long as they are appropriate to the sex. What is "appropriate training," and what are "appropriate fields," are subjects which are omitted from consideration. The article

re-echoes the attack of the American doctors upon the training in that country. It denounces the theories of Mr Mill in this, and the arguments of all other "injudicious advocates" who ignore the differences between the sexes. But it is silent upon the details of any educational system reduced to practice in this country.

The essence of the reply, when separated from the polemical expressions with which it is studded and enlivened, is a substantial agreement with the real scope of Dr Maudsley's article, barring some of the medical details, which, as we have before shown, were beside and beyond the subject. It admits that in early womanhood, guardians and teachers are rightly and necessarily in the habit of making allowance for temporary weakness, and of encouraging a certain amount of idleness. Both teachers and parents are said to need warning on the subject; and those warnings are usefully pressed upon their attention in great detail, both with regard to mental and physical exertion. And a circumstantial account is given, which justifies alike the plans of "the reformers" and the advice of Dr Maudsley, of the arrangements made to meet the special requirements of girls, and to secure them their "appropriate" training. And the authoress asks triumphantly, What more can Dr Maudsley want? The work is shown not to come at an age when Dr Clarke and Dr Maudsley think it "likely to be too exciting." And the pressure of competition is shown not to operate unduly; for the prizes are not sufficient to insure it. The amount of mental work involved in reaching the attainments of ordinary young men is certainly not likely to overtax strength, or to be out of due proportion to the rest of the educational system.

The conditions under which English girls work are shown, on many vital points to be those which Dr Clarke and the other American doctors urge as desirable, and to differ essentially from what they denounce. As for the pressure of work at too early an age, it is shown, that "the reformers" in England have striven to effect, and have succeeded in effecting, an extension of time given to education; and that here girls are not allowed to begin their higher education till the age at which American girls have completed it. There is no identical coeducation in England, and there is no organised movement to effect it. What is done here is to set up the same goal, which neither Dr Clarke nor Dr Maudsley disapproves, and "to allow young men and

young women to reach it, each in their own way, and without the stimulus of daily rivalry."

Under these circumstances we are tempted to ask, what is the occasion for raising this discussion in England in a tone of manifest hostility in a manner which is unusual and objectionable? The combatants never come to a distinct issue. They are agreed on the subject of sex in mind, sex in physical training, sex in mental training. And when they talk of assimilating the mental training of men and women, one denounces it in one sense – viz., that which prevails in America; and the other defends it in another and totally different sense – viz., that which prevails in England. Both seem to aim at the same results, which Dr Maudsley has expressed in the passage quoted above more fully and completely than is to be found in any passage of Mrs Anderson's paper.

The dispute, therefore, is all in the air, and the necessity for the discussion is not made out. What the combatants, who are introduced in the pages of the 'Fortnightly' as medical experts, really have in their minds is, that Dr Maudsley is thinking of Mr Mill's theories, the efforts of women to obtain access to the medical profession, and the wild talk of some of the feminine orators, of whose utterances we have already given a sample; and not in the slightest degree of the plan of higher feminine education pursued in England, of the details of which, so far as appears from his article, he is totally ignorant. What Mrs Anderson has in her mind is, the five ladies in Edinburgh who are striving to enter "a new career," the asserted equality of men and women under all circumstances and for all careers, and the restrictions, legal and social, under which, it is said, they, in common with "agricultural labourers" and "negroes," unjustly suffer. These are the real elements of strife. Consequently, the really scientific part of the inquiry soon falls to the ground, and even the practical and sanitary part of it has nothing to do with any system of education practised or attempted in England. It would unduly lengthen this paper to attempt to discuss the subjects which are included within the range of suppressed controversy; which open a variety of considerations, and can readily be determined without the aid of medical science. We are satisfied with the admitted elementary principle, that there is sex in mind, sex in mental

and physical training, as well as sex in body; and we can infer for ourselves that there is also sex in rights as well as in duties, which must in either case be "appropriate," but not "identical."

But in this, as well as in all other disputes of a like nature, it must be admitted that the modest dignity of English womanhood receives very scant respect. Let Americans do what they please, why should English ladies be subjected to such a discussion as that which has recently taken place in the 'Fortnightly'? Why should the growing habit be encouraged of classing them, contrary to the dictates of moderation and good sense, with negroes and agricultural labourers? To listen to their medical friends in the 'Fortnightly,' one would think that Englishwomen have only two alternative prospects before them – one, to become sexless beings, whose womanhood has been shattered by mathematics; the other, to suffer from hysteria brought on by intolerable dulness, unless intercepted by the wear and tear of marriage to the wrong man, before they are physiologically fit for it. We have shown that, in regard to the practical subject of education, there is considerable agreement of opinion, not merely between the writers in the 'Fortnightly,' and in the press, but, as we believe, generally throughout society. It is only when the imagination breaks loose, and people begin to discuss ideal woman as she ought to be, and actual woman as she is fancied to be, that the rein is given to considerable bitterness of feeling, and a good deal of sentimental foolishness on both sides. The tendency on the one side is to describe a being good for nothing but to attend to her physiological "functions;" on the other, to describe the victim of masculine tyranny, determined to assert an equality which, it is considered, the platform and the dissecting room can most readily yield. We must remark that, in dealing with this subject, anything which treats of the relations between the sexes stirs some amount of passion and irritation; and that large deductions must be made from angry advocacy on either side before we can arrive at rational views. Exceptional women have, with singular indiscretion, succeeded in connecting the subject of higher female education with a type of feminine excellence which, in its most aggravated form, does not commend itself to the historic conscience or the æsthetic sentiment in either sex. But the subject is not on that account to be either prejudged or depreciated. A movement to develop the real capacities and worth of true womanhood is one well

worthy of national approval and support. While one school of thought inveighs against any system which will turn first-rate women into third-rate men, the other retorts with something in the nature of a good-humoured *tu quoque* (and a *tu quoque* ought to be good-humoured, for it has nothing else to recommend it), that the masculine type of excellence does not include all that can be desired in humanity. It is deeply to be regretted that women who are taking an active part in a social movement of considerable importance, should not be content to show that they desire the elevation of womanhood, not merely as an end in itself, but also because of its inestimable advantages (collateral if you will) to men and to children. There is too much disposition to adopt the attitude of leaders of "a strike;" too much the spirit of setting sex against sex; too eager a desire to show that the "spheres" of the two sexes are "identical" and not merely "appropriate." And if it would not emasculate the female sex too much, we would suggest that they would have much more chance of attaining medical diplomas, if instead of asserting identical claims with men, to study in the same dissecting and lecture rooms, and an identical right to practise, they would limit themselves to claiming women and children as their appropriate patients. We should suggest that they should recognise in practice, as it appears that they do in theory, that there is sex in mind as well as sex in education; that they should give up the equality or identity theory, both as regards aims, *status*, and rights, and substitute the theory of appropriateness; that they should eschew the late John Stuart Mill and some of his works, including the 'Subjection of Women;' and that they should have in view as the ultimate aim of female development, not merely the success of a vulgar self-assertion, but improved relations to man and his descendants.

But on every ground of justice and expediency, we protest against the question of admission of women to the medical profession, which is of limited interest, being fought out over the subject of female education, which is of universal interest. Let the medical profession fight it in the newspapers, in the medical universities, in Parliament, and in society: the question of education, either of young children or of early womanhood, is a battlefield which they have no right to select. The tendency of such a discussion as that in the 'Fortnightly' is simply to invest with a party and acrimonious feeling a subject which it is

highly desirable should be entirely free from it. The actual result of it is simply to enforce, by consent of the combatants, two very obvious precautions, which may be thus enumerated: First, that girls, at least before eighteen, should be protected from mental strain, the stimulus of undue competition, and from the requirements of their physical nature being overlooked in the desire for mental development; second, that a school system for girls requires to be more carefully guarded in these respects than one for boys, partly because they themselves physically require more care and attention, and partly because intellectual competition in their case has fewer distractions. The total outcome for all practical purposes of this wonderful discussion may be compressed into those two very obvious precautionary maxims, which are enforced, as it seems to us, with quite unnecessary detail. And as for the standard of excellence which each sex may attain, each may fix it for itself. If girls, in the opinion of their teachers, can reach the same standard as boys (no very wonderful achievement if they can), we understand that both authorities will sanction their doing so, provided, as both insist, they reach it each in their own way, by paths appropriate to each, without the stimulus of daily rivalry.

And as regards the working of undue competition, no sensible people can wish to see that principle fostered and extended. In the tumult of the present day, life seems to be reduced to a mere daily routine of a doing and a getting. The late Mr Mill raised his warning voice against it, and declared that mankind should pay more attention to the cultivation of their natures and human faculties, and devote to the mere money-getting part of their lives "fewer hours in the day, fewer days in the week, fewer weeks in the year, and fewer years of life." The dignity of masculine life is often lost in its feverish competitions and restless acquisitions. And if the life of women is to be forcibly degraded to the same level, where are we to seek the influences which are to refine and mitigate the bustling tumult which characterises modern civilisation? We are not yet, with all our progress, advanced far enough to dispense with the civilising influences of women. And we learn with great satisfaction that there is no intention of introducing into this country the American system of their education. There is no necessity for embarking in a scheme which is chiefly directed to develop in woman the special and unlovely qualities which

fit her to take a keen and engrossing interest in the mere conflicts of life. It is forcibly argued that her physical degeneracy and that of her offspring result; and it certainly tends to lower those refining and elevating influences which society cannot afford to lose, and which women hold in trust for both sexes at all ages. As Dr Maudsley's article, in its essential teaching, has, as we have shown, received the stamp of general consent and approval, we may conclude with quoting the principle which he has forcibly and eloquently expressed, and which it is impossible to gainsay: "Each sex must develop after its kind; and if education in its fundamental meaning be the external cause to which evolution is the internal answer; – if it be the drawing out of the internal qualities of the individual into their highest perfection, by the influence of the most fitting external conditions, – there must be a difference in the *method* of education, answering to differences in their physical and mental natures." This is all that Dr Maudsley contends for, and all that is in any way established by the discussion. It is and has been generally conceded; and we hope that any further elucidation of it will be free from the objectionable details which are fit only for a medical publication.

THE LITTLE HEALTH OF LADIES[1]
The Contemporary Review, Vol. 31 (1878)
Francis Power Cobbe

In the following pages I propose to speak, not of any definite
form of disease, but of that condition of *petite santé*,
valetudinarianism, and general readiness to break down under
pressure, wherein a sadly large proportion of women of the
higher classes pass their years. It is unnecessary, I think, to
adduce any evidence of the prevalence of this semi-invalidism
among ladies in England, or its still greater frequency abroad,
and (emphatically) in America. In a very moderate circle of
acquaintance every one knows a score of cases of it, of that
confirmed kind which has scarcely any analogue in the physical
condition of men. If we take a state of perfect soundness to be
represented by 100, the health of few ladies will be found to
rise above 80 or 90 – that of the majority will be I fear about 75
– and a large contingent, with which we are now specially
concerned, about 50 or 60. In short, the health of women of
the upper class is, I think, unquestionably far *below par*.
Whatever light their burners were calculated to shed on the
world, *the gas is half turned down* and cannot afford anything
beyond a feeble glimmer.

Of the wide-extending wretchedness entailed by this *petite
santé* of ladies it would be easy to speak for hours. There are
the husbands whose homes are made miserable by unsettled
habits, irregular hours, a cheerless and depressed, or else,
perhaps, an hysterically excitable or peevish companion; the
maximum of expenditure in their households, with the
minimum of enjoyment. I think men, in such cases, are most
sincerely to be pitied, and I earnestly wish that the moans
which they, and also their mothers and sisters, not unnaturally
spend over their hard lot, could be turned into short, sharp

[1] To avoid misapprehension, it may be well to say that this word is here used
in its older sense of the "*Loaf-givers*." The ill-health of women who are
Loaf-winners is, alas! another and still more sorrowful subject.

words, resolutely providing that their daughters should not adopt the unhealthful habits and fall into the same miserable state, perpetuating the evil from generation to generation.

As to the poor children of a feeble mother, their case is even worse than that of the husband, as any one may judge who sees how delightful and blessed a thing it is for a mother to be the real, cheerful, energetic companion of her sons and daughters. Not only is all this lost, but the presence of a nervous, *exigeante* invalid in the dwelling-room of the family is a perpetual damper on the healthful spirits of the children; and, in the case of the girls, the mother's demands on their attention (if she be not a miracle of unselfishness) often break up their whole time for study into fragments too small to be of practical use. The *desultoriness* of a home wherein the mistress spends half the day in bed is ruinous to the young, unless a most unusual degree of care be taken to secure them from its ill effects.

Pitiable, however, as are the conditions of the husband and children of the Lady of Little Health, her own lot – if she be not a mere malingerer – is surely still more deserving of sympathy. She loses, to begin with, all the keen happiness of health, the inexplicable, indefinable *bien-être* of natural vigour,

> "the joy of morning's active zeal,
> The calm delight, blessing and blest,
> To sink at night to dreamless rest."

She knows nothing of the glorious freedom of the hills and woods and rocky shore; she misses all the relief which lonely rides and walks afford from those petty worries which, like the wasps and ants in the dreadful old Persian torture, are sure to fasten on the poor wretch pinned to the ground. "To be weak is to be miserable." There is no truer maxim; and when we reflect how many women are weak – not merely in comparison to men, which is nothing to the purpose, but weak absolutely and judged by the standard of nature, – we have before us a vast low-lying field of dull wretchedness profoundly mournful to contemplate. Out of it, what evil vapours of morbid feelings, jealousies, suspicions, hysterical passions, religious terrors, melancholy, and even insanity are generated, who shall estimate? To preserve the *mens sana* otherwise than in the *corpore sano* is a task of almost superhuman wisdom and conscientiousness. The marvel is, not that so many fail, as that a few succeed in performing it.

Be it noted further, that it is the chronic *petite santé* much more than any positive disease, which is morally so injurious to the sufferer and all around her. I have heard one whose long years of pain seem each to have lifted her nearer to heaven remark with a smile, that "actual pain is always, in a sense, *entertaining!*" She intended, no doubt, to say that it tasked the powers of will and religious trust to bear it firmly. Out of such contests and such triumphs over either bodily or mental suffering, spring (as we all recognize) that which is most precious in human experience – the gold purified in the furnace, the wheat threshed with the flail.

"Only upon some cross of pain and woe
 God's son may lie,
Each soul redeemed from self and sin must know
 Its Calvary."

But the high moral results of positive pain and danger seem unattainable by such a mere negation of health as we are considering. The sunshine is good and the storm is good, but the grey, dull, drizzle of November – how is anyone to gain much from it? Some beautiful souls do so, no doubt; but far more often chronic *petite santé* leads to self-indulgence; and self-indulgence to selfishness; and selfishness (invariably) to deceit and affectation, till the whole character crumbles to pieces with dry rot.

Now I must say at once that I consider the frequency of this valetudinarianism among women to be a monstrous state of things, totally opposed to any conception I can form of the intentions of Providence or the laws of beneficent Nature; and the contented way in which it is accepted, as if it were a matter of course, by society and the poor sufferers themselves, and even by such well meaning friends of women as M. Michelet, strikes me as both absurd and deplorable. That the Creator should have planned a whole sex of Patients – that the normal condition of the female of the human species should be to have legs which walk not, and brains which can only work on pain of disturbing the rest of the ill-adjusted machine – this is to me simply incredible. The theory would seem to have been suggested by a study, not of the woman's *body*, framed by the great Maker's wisdom, but from that of her silly *clothes* sent home from the milliner, with tags, and buttons, and flounces, meant for show, not use; and a feather and an artificial flower by way of a head-gear.

Nay, my scepticism goes further, even into the stronghold of the enemy. I do not believe that even the holy claims of Motherhood ought to involve – or, if women's lives were better regulated, *would* involve – so often as they do, a state of invalidism for the larger part of married life; or that a woman ought to be disabled from performing the supreme moral and intellectual duties of a parent towards her first-born children, when she fulfils the lower physical part of her sacred office towards those who come afterwards. Were this to be inevitably the case, I do not see how a woman who has undertaken the tremendous responsibilities of a mother towards the opening soul of a child could venture to burden herself with fresh duties which will incapacitate her from performing them with all her heart and soul, and strength.

One of the exasperating things about this evil of female valetudinarianism is that the women who are its victims are precisely the human beings who of our whole mortal race seem naturally most exempt from physical want or danger, and *ought* to have enjoyed immunity from disease or pain of any kind. Such ladies have probably never from their birth been exposed to hardship, or toil, or ill-ventilation, or bad or scanty food, fuel, or raiment. They have fed on the fatness of the earth, and been clothed in purple and fine linen. They are the true Lotus-eaters whom the material cares of the world reach not. They

"live and lie reclined,"

in a land where (in a very literal sense)

"It seemeth always afternoon,"

and where they find a certain soothing æsthetic emotion in reading in novels the doleful tale of wrong of the "ill-used race of men that cleave the soil," – without dreaming of going down amongst them to make that tale less dismal.

That these women, these Epicurean goddesses of the drawing-room, should be so often the poor, fragile, suffering creatures we behold them, unable to perform half the duties of life, or taste a third part of its pleasures – this is a pure perversity of things which ought surely to provoke revolt.

What are the causes of the valetudinarianism of ladies?

First, of course, there is a considerable class of inherited mischief, feeble constitutions, congenital tendencies to chronic

troubles, gout, dyspepsia, and so on, due to the errors of either parent, or to *their* evil heritage of the same. All that need be said here on this topic is that such cases must necessarily go on multiplying *ad infinitum* till mothers regain the vigour which alone permits them to transmit a healthy constitution to their children.

Next to hereditary *petite santé*, we come to cases where the habits of the sufferers themselves are the cause of the mischief; and these are of two kinds – one resulting from what is good and unselfish, and one from what is bad and frivolous, in the disposition of women.

Women are generally prudent enough about their money; that is, of their own money, not that of their husbands. I have heard an observant man remark that he never knew a well-conducted woman who, of her own fault, became bankrupt. But as regards their health, the very best of women have a propensity to *live on their capital*. Their nervous energy, stimulated either by conscience or affection or intellectual interests, suffices to enable them to postpone perpetually the calls of their bodies for food, sleep, or exercise. They draw large drafts on their physical strength, and fail to lodge corresponding sums of restoring rest and nutriment. Their physical instincts are not imperious, like those of men; and they habitually disregard them when they make themselves felt, till poor Nature, continually snubbed when she makes her modest requests, ceases to press for daily settlement of her little bill, and reserves herself to put in an execution by-and-by. The vegetative and the spiritual part of these women flourish well enough; but (as Kingsley's Old Sandy says) "There is a lack of healthy animalism," between the two. They seem to consider themselves as fire-flies issuing out of a rose, flitting hither and thither to brighten the world, not creatures of flesh and blood, needing to go to bed and eat roast mutton.

If we study the condition of Mr. John Bull in his robust middle age, we shall notice that for forty years, with few interruptions, he has enjoyed those "reg'lar meals," on which Tennyson's Northern Farmer lays such stress as the foundation of general stability of character. He has also walked, ridden, rowed, skated, smoked his cigar, and gone to bed (as nearly as circumstances permitted) when the inclination seized him. If now and again he has omitted to gratify his

instincts, it has been for a business-like reason, and not merely because somebody did not happen to wish to do the same thing at the same time. He has not often waited for an hour, half-fainting for want of his breakfast, from motives of mere domestic courtesy; nor sat moped in a hot room through a long bright day to keep some old person company; nor resolved his dinner into tea and muffins because he was alone and it was not worth while to trouble the servants; nor sat up cold and weary till three in the morning to hear about a Parliamentary debate wherein he took only a vicarious interest. At the end of the forty years of wholesome indulgence, the man's instincts are more imperious and plain-spoken than ever, and as a reward for his obedience to them, his organs perform their respective offices with alacrity, to the great benefit of himself and of all dependent upon him. Pretty nearly the reverse of this has happened in the case of Mrs. Bull. Almost her first lesson in childhood was to check, control, and conceal her wants and miseries; and by the time she has grown up she has acquired the habit of postponing them, as a matter of course, to the smallest convenience of A, B, C, and D, father, mother, brothers, even servants, whom she will not "put out of their way" for herself, though no one would so much as think whether they had a way to be put out of, for her brothers. The more strain there is upon her strength, by sickness in the house or any misfortune, the more completely she effaces and forgets herself and her physical wants, recklessly relinquishing sleep and neglecting food. When the pressure is relieved, and the nervous tension which supported her relaxed, the woman breaks down, as a matter of course, perhaps never to enjoy health again.

It must be borne in mind, also, in estimating a woman's chances of health, that if she neglect to think of herself, there is seldom anybody to do for her what she does for her husband. Nobody reminds her to change her boots when they are damp; nobody jogs her memory as to the unwholesomeness of this or that beverage or comestible, or gives her the little cossetings which so often ward off colds and similar petty ills. Unless the woman live with a sister or friend, it must be scored one against her chances as compared to a man, that she *has no wife*.

There must, of course, be set against all this the two facts, that the imperiousness of men's wishes and wants leads them

often not *only* to do such wholesome things as those of which we have been speaking, but into sundry unwholesome excesses beside, for which in due time they pay by various diseases, from gout up to *delirium tremens*. And correspondingly, women's comparative indifference to the pleasures of the table keeps them clear of the ills to which gormandising and bibulous flesh is heir. We all know scores of estimable gentlemen who can scarcely be prevailed on, by the prayers and tears of their wives, to refrain from drinking a glass of beer or port wine which will in all probability entail a fit of the gout next day; but in my whole life I have never known a woman who consciously ate or drank things likely to make her ill, save one mild, and sweet old lady, whose predilection for buttered toast overcame every motive of prudence, and, alas! even of religion, which I have reason to believe she endeavoured to bring to bear against the soft temptation. But for the purpose we have now in hand, namely, that of tracing the origin, not of acute diseases, but of general *petite santé*, this aspect of the subject is unimportant. It is precisely *petite santé* which comes of the perpetual neglect of nature's hints – that she wants air, bread, meat, fruit, tea, wine, sleep, a scamper or a canter. It is definite *disease* which results from over-exercise, over-feeding, and over-drinking.

Would it not be possible, I venture to ask, to cut off *this* source of feminine invalidism, at all events, by a somewhat more respectful attention to the calls of healthful instinct? I am very far from wishing that women should grow more selfish, or less tenderly regardful of the convenience and pleasure of those around them. Even sound health of body – immeasurable blessing that it is – would be purchased too dearly if this should happen. But there ought surely to be an adequate reason, not a mere excuse of whim and caprice of her own or of anybody else, why a woman should do herself hurt or incapacitate herself for future usefulness?

Another source of *petite santé*, I fear, may be found resulting from a lingering survival amongst us of the idiotic notion that there is something peculiarly "lady-like" in invalidism, pallor, small appetite, and a languid mode of speech and manners. The very word "delicacy," properly a term of praise, being applied vulgarly to a valetudinary condition, is evidence that the impression of the "dandies" of sixty years ago that refinement and sickliness were convertible terms, is not yet

wholly exploded. "Tremaine" thought *morbidezza* – a *"charming morbidezza"* – the choicest epithet he could apply to the cheek of beauty; and the heroines in all the other fashionable novels of the period drank hartshorn almost daily, and died of broken hearts, while the pious young Protestants who converted Roman Catholics in the religious tales, uniformly perished of consumption. Byron's admiring biographer records how, at a large dinner-party, he refused all viands except potatoes and vinegar (horrid combination!), and then retired to an eating-house to assuage with a beefsteak those cravings which even Childe Harold could not silence with "chameleon's food" of "light and air."

We have advanced indeed somewhat beyond this wretched affectation in our day, and young ladies are not required by *les bienséances* to exhibit at table the public habits of a ghoul. In a few cases perhaps we may opine that women have gone to the opposite extreme, and both eat and drink more than is desirable. But yet we are obviously not wholly free from the "delicacy" delusion. We are not so clear as we ought to be on the point that, though Beauty includes *other* elements, yet Health is its *sine quâ non*, and that no statuesque nobility of form (much less a pinched waist and a painted face) can constitute a beautiful living human creature, who lacks the tokens of health – clear eyes, clear skin, rich hair, good teeth, a cool soft hand, a breath like a bunch of cowslips, and a free and joyous carriage of the head and limbs.

Have we not, in the senseless admiration of feebleness and pallor (to obtain which a fashionable lady not long ago literally bled herself by degrees to death), an illustration of the curious fact pointed out by Miss de Rothschild in her admirable essay on the "Hebrew Woman,"[2] namely, that the homage which Christianity won for weakness has tempted women to cultivate weakness to secure the homage? Just as Christian Charity to the Poor has fostered Mendicancy, so has chivalrous Tenderness to the Feeble inspired a whole sex with the fatal ambition of becoming Feeble (or of simulating feebleness) to obtain the tenderness. The misconstruction and abuse of the Beatitudes of the gospel, as manifested in the rise of the mendicant Orders of Friars, is notoriously a sad chapter of history. I do not think it a less sorrowful one that an analogous abuse has led to a sort of

2 New Quarterly Magazine, No. X.

canonization of bodily and mental feebleness, cowardice, and helplessness among women. Can we question which is the nobler idea, – the modern, nervous, pallid, tight-laced, fine lady of Little Health, – or the "Valiant Woman" (as the Vulgate calls her) of whom King Lemuel saith, "She girdeth her loins with strength, and strengtheneth her arms. Strength and honour are her clothing; and she shall rejoice in time to come?"[3]

We have now touched on the subject of Dress, which plays so important a part in the health of women that it must here be treated somewhat at length. A little girl in a London Sunday-school, being asked by a visitor "why God made the flowers of the field?" replied (not unconscious of the gorgeous paper poppy in her own bonnet), "Please, ma'am, I suppose for patterns for artificial flowers." One might anticipate some answer scarcely less wide of the mark than that of this sophisticated little damsel, were the question to be put to not a few grown women, "Why do you wear clothes?" Their most natural response would obviously be, "To be in the fashion." When we have visibly wandered a long way from the path of reason, the best thing we can do is to look back to the starting-point and find out, if possible, where we have diverged. In the matter of raiment that starting-point is not hard to find – indeed, to mark it is only to state a series of truisms.

Human clothing has three *raisons d'être*, which, in order of precedence, are these:–

 I. – HEALTH.
 II. – DECENCY.
 III. – BEAUTY.
 HEALTH demands –

 1. Maintenance of proper temperature of the body by exclusion of excessive heat and cold.

 2. Protection from injury by rain, snow, dust, dirt, stones to the feet, insects, &c.

 3. Preservation of liberty of action to all the organs of the body and freedom from pressure.

 DECENCY demands –

 4. Concealment of some portions of the human frame.

 5. Distinction between the habiliments of men and women sufficient to avert mistake.

3 Proverbs xxxi.

6. Fitness to the age and character of the wearer.

7. Concealment, when possible, of any disgusting personal defect.

BEAUTY demands –

8. Truthfulness. The dress must be genuine throughout, without any false pads, false hair, or false anything.

9. Graceful forms of drapery.

10. Harmonious colours.

11. Such moderate consistency with prevailing modes of dress as shall produce the impression of sociability and suavity, and avoid that of self-assertion.

12. Individuality, – the dress suiting the wearer as if it were an outer body belonging to the same soul.

(Be it noted that the fulfilment of this highest condition of tasteful dress necessarily limits the number of costumes which each person should wear on similar occasions. No one body can be adorned in several *equally suitable* suits of clothes, any more than one soul could be fittingly housed in twenty different bodies.)

Glancing back over the above table, we find this curious fact. The dress of *men* in all Western nations meets fairly all the conditions of Health and Decency, and fails only on the side of Beauty. The dress of *women*, on the contrary, ever variable as it is, persistently misses the conditions of Health; frequently violates the rules of Decency; and instead of securing Beauty, at which it aims first instead of last, achieves usually – ugliness.

It is to be remembered for our consolation and encouragement that men have arrived at their present good sense in dress only within two or three generations. A hundred years ago the lords of creation set Beauty above Health or convenience, just as the ladies do now, and peacocked about in their peach-blossom coats and embroidered waistcoats, surmounted by wigs, for whose stupendous discomfort even a seat on the judicial bench can scarcely reconcile the modern Englishman. Now, when the men of every European nation have abjured such fantastic apparel, we naturally ask, Why have not the women followed their example? Why is the husband, father, and brother habited like a being who has serious interests in life, and knows that his personal dignity would be forfeited were he to dress himself in parti-coloured, be-ribboned garments, and why is the wife, mother, or sister bedizened like

a macaw, challenging every observer to note how much of her time, thoughts, and money must have been spent on this futile object? The answer is one which it is not pleasant to make, discreditable as it is to both sexes. The women who set the fashions dress for admiration; and men like women who dress to be admired; and the admiration given and received is a very poor and unworthy admiration, not much better than a salmon gives to a glittering artificial fly, and having very little more to do with any real æsthetic gratification, – as is proved too clearly by the thoroughly un-beautiful devices to which fashion has recourse. It is the *well-got-up* woman (to borrow a very expressive phrase), not the really well-dressed woman, who receives by far the largest share of homage.

And now let us see how all this concerns the Health of Women – how much of their *petite santé* is due to their general neglect to make Health the first object of dress, or even an object at all compared to fashion.

Tight-lacing among habits resembles Envy among the passions. We take pride in all the rest, even the idlest and worst, but tight-lacing and an envious heart are things to which no one ever confesses. A small waist, I suppose, is understood to belong to that order of virtues which Aristotle decides ought to be natural and not acquired, and the most miserable girl who spends her days in a machine more cruel (because more slowly murderous) than the old "Maiden" of Seville, yet always assures us, smiling through her martyrdom, that her clothes are "really hanging about her!" It would be a waste of time to dwell on this supreme folly. Mrs. Haweis, in her very noteworthy new book, the "Art of Beauty," has given some exceedingly useful diagrams, showing the effects of the practice on the internal organs and skeleton[4] – diagrams which I earnestly

[4] Pp. 49 and 50. The preceding pages on what I conceive to be the *raisons d'être* of dress were written before I had seen this exceedingly clever, brilliant, and learned little book. While giving the authoress thanks for her most sensible reprobation of many senseless fashions, and not presuming for a moment to question her judgment in the matters of taste, on which she speaks with authority, I must here enter my humble but earnest protest against the over-importance which, I think, she is inclined to attach to the art of dress, among the pursuits of women; and (most emphatically) against her readiness to condone – if it be only committed in moderation – the offence against both truth and cleanliness of wearing false hair (see p. 173). It seems to me quite clear, that here the whole principle of honesty in attire is sacrificed. If no woman would wish it to be known that the hair on her head never grew there, but on the scalp of some poor French girl, so poor as

recommend to the study of ladies who may feel a "call" to perform this sort of English Suttee for a *living* husband. Mrs. Haweis says that sensible men do not love wasps, and have expressed to her their "overallishness" when they behold them. Considering how effectively they have hitherto managed to display their disapproval whenever women have attempted to introduce rational attire, it is a pity, I think, that they do not "pronounce" a little more distinctly against this, literally mortal, folly.

I have already alluded to the brain-heating chignons, just gone out of fashion after a long reign of mischief; and along with them should be classed the bonnets which expose the forehead to the cold, while the back of the head is stewed under its cushion of false hair, and which have the still more serious disadvantage of affording no shelter to the eyes. To women to whom the glare of the sun is permanently hurtful to the sight, the necessity for wearing these bonnets on pain of appearing singular, or affectedly youthful, constitutes almost a valid reason against living in London. And the remedy, forsooth, is to hold up perpetually a parasol! – a yet further incumbrance to add to the care of the draggling train, so that both arms may be occupied during a whole walk, and of course all natural ease of motion rendered impossible. In this as in a dozen other silly fashions, the women who have serious concerns in life are hampered by the practice of those who think of nothing but exhibiting their persons; and ladies of limited fortune, who live in small rooms, and go about the streets on foot or in cabs, are compelled (if they wish to avoid being pointed at) to adopt modes of dress whose sole *raison d'être* is that they suit wealthy *grandes dames* who lounge in their barouches or display their trains over the carpets of forty-feet-long drawing-rooms. What *snobbery* all this implies in our whole social structure! Some ten millions of women dress, as nearly as they can afford, in the style fit at the most for five thousand!

to be bribed to part with it, or of some unkempt Russian peasant who rarely used a comb in her life, – then the wearing of that false hair is an act of *deception*, and in so far, I hold, both morally, and even æsthetically wrong. I cannot conceive why the *Lamp of Truth*, which we are now perpetually told must shine on our architecture and furniture, so that nothing must appear stone that is iron, and so on *ad infinitum*, should not shine equally lucidly over the dress of women. Where no deception is meant, and where the object is to supply a want, not to forge a claim to beauty – *e.g.*, in the case of artificial teeth – there is no harm involved.

The practice of wearing *décolletée* dresses, sinning equally as it does against Health and Decency, seems to be gradually receding – from ordinary dinners, where it was universal twenty years ago, to special occasions, balls, and court drawing-rooms. But it dies hard, and it may kill a good many poor creatures yet, and entail on others the life-long bad health so naturally resulting from the exposure of a large surface of the skin to sudden chills.

The thin, paper-soled boots which leave the wearer to feel the chill of the pavement or the damp of the grass wherever she may walk, must have shortened thousands of lives in Europe, and even more in America. Combined with these, we have now the high heels, which, in a short period, convert the foot into a shapeless deformity, no longer available for purposes of healthful exercise. An experienced shoemaker informed the writer that between the results of tight boots and high heels, he scarcely knew a lady of fifty who had *what he could call a foot at all* – they had mere clubs. And this is done, all this anguish endured, for the sake of – Beauty!

Bad as stays, and chignons, and high heels, and paint, and low dresses, and all the other follies of dress are, I am, however, of opinion that the culminating folly of fashion, the one which has most wide-spread and durable consequences, is the mode in which for ages back women have contrived that their skirts should act as drags and swaddling clothes, weighing down their hips and obstructing the natural motion of the legs. Two hundred years ago the immortal Perrette, when she wanted to carry her milk-pail swiftly to market, was obliged to dress specially for the purpose.

"Légère et court vêtue, elle allait à grands pas,
 Ayant mis ce jour-là, pour être plus agile,
 Cotillon simple et souliers plats."

From that time to this the "cotillon simple," – modest, graceful, and rational, – has been the rare exception, and every kind of flounce and furbelow, hoops and crinolines, panniers and trains, "tied back" costume, and *robe collante* has been successively the bane of women's lives, and the slow destroyer of their activity.

It has been often remarked that the sagacity of Romish seminarists is exhibited by their practice of compelling boys destined for the priesthood to flounder along the streets in their

long gowns, and never permitting them to cast them aside or play in the close-fitting clothes wherein English lads enjoy their cricket and football. The obstruction to free action, though perhaps slight in itself, yet constantly maintained, gradually tames down the wildest spirits to the level of ecclesiastical decorum. But the lengthiest of *soutanes* is a joke compared to the multitudinous petticoats which, up to the last year or two, every lady was compelled to wear, swathing and flowing about her ancles as if she were walking through the sea. Nor is the fashion of these later days much better, when the scantier dress is "tied back" – as I am informed – with an elastic band, much on the principle that a horse is "hobbled" in a field; and to this a tail a yard long is added, which must either be left to draggle in the mud or must occupy an arm exclusively to hold it up. In youth these skirts are bad enough, as exercising a constant check on free and healthful movement; but the moment that the elastic steps begin to give place to the lassitude of middle life, the case is desperate. There is no longer energy to overcome the impediments created by the ridiculous *spancels*; and the poor donkey of a woman hobbles daily round a shorter and shorter course till at forty or fifty she tells her friends with a sigh that she finds (she cannot imagine why) that she cannot walk at all!

Does Decency require such a sacrifice as this? Does the utmost strain of feminine modesty ask for it? If it were so, I, for one, should leave the matter with a sigh, as not to be remedied. But who in their senses dreams that such is the case? Who, in the age of *robes collantes* and *décolletée* dresses, can pretend that a reasonably full, simply cut silk or cloth skirt, reaching to the ancles and *no longer*, would not fulfil immeasurably *better* than any fashion we have seen for many a day the requirements of true womanly delicacy? It is for *Fashion*, not Decency, that the activity of women is thus crushed, their health ruined, and (through them) the health of their children. I hold it to be an indubitable fact that if twenty years ago a rational and modest style of dress had been adopted by English women and encouraged by English men, instead of being sneered down by fops and fools, the health not only of women, but of the sons of women, *i.e.*, of the entire nation, would now be on altogether a different plane from what we find it.[5]

[5] The inquiry, How fashions originate and *with whom?* would lead us too far

Reviewing all these deplorable follies, we may learn to make excuses for legislators who classify women with "Criminals, Lunatics, Idiots, and Minors." It needs all a woman's knowledge of the pernicious processes to which the opening minds of girls are commonly subjected, – the false and base aims in life set before them, the perverse distribution towards them of approval and blame, admiration and neglect, and even of love and dislike, from parents, teachers, servants, brothers, and finally from the ball-room world into which they are now launched in childhood, – to enable us to make allowances for them, and retain faith that there sometimes beats a real woman's heart under the ribs of a tightly laced corset, and that a head surmounted by a pile of dead women's hair is not invariably devoid of brains.

How is the remedy for this dreary round of silly fashions ever to be attained? No woman who knows the world and how severe is the penalty of eccentricity in attire, will ever counsel her sisters to incur it for any motive short of a distinct duty. But if the hundreds of ladies who recognize the tyranny of senseless and unhealthful fashions were to combine forces to obey those fashions *just as little as may be*, to go as near the wind in the direction of simplicity, wholesomeness, and ease in their dress, as they dare, there would by degrees be formed a public opinion, rising year by year with the numbers and social standing of the representatives of common sense. It must have been in some such way that our great-grandfathers dropped their swords and bag wigs and ruffles and embroidery, and took to dressing – as even the silliest and vainest men do in these days – like rational beings.

Next to unhealthful dress, women may lay their *petite santé* at the door of their excessive addiction to pursuits giving

from the subject in hand, but some light is thrown on the way in which complicated arrangements of dress are maintained under every variation and in defiance of the true principles of taste, as well as of health and economy, by the reflection that it would never pay drapers and dressmakers that their customers should readily calculate how much stuff they require for each garment. For further criticism of the follies of female dress – the *torrid and frigid* zones of body and limbs – the "panniers" or "bustles" creating kidney disease; the skewering down of the arms by tight armholes; the veils which cause amaurosis, &c., &c. – and also for some excellent suggestions of reform, see *Dress and Health*, a little book printed by Dougall & Son, Montreal, to be obtained in London for the present only by sending 1s. 6d. in stamps to B., 15, Belsize Square, N.W.

exercise neither to the brain nor yet to the limbs. If the problem had been set to devise something, the doing of which would engage the very fewest and smallest powers of the mind or body, I know not whether we should give the prize for solving it to the inventor of knitting, netting, crochet, or worsted work. Pursued for a reasonable period in the day, these employments are no doubt quite harmless, and even perhaps, as some have urged, may be useful as sedatives. But that a woman who is driven by no dire necessity to "stitch, stitch, stitch," who has plenty of books to read, and two legs and feet to walk withal, should voluntarily limit the exercise of her body to the little niggling motion of the fingers required by these works, and the labour of her mind to counting stitches, is all but incomprehensible. That the consequences should be sickliness and feebleness seems to follow of course. In old times the ever-revolving spinning-wheel had its full justification in its abundant usefulness, and also in the dearth of intellectual pursuits for women. But it is marvellous that a well-educated Englishwoman, not yet sinking into the natural indolence of age, should choose to spend about a fifth or fourth of the hours God has given her on this beautiful earth in embroidery or worsted work. A drawing-room crammed with these useless fads – chairs, cushions, screens, and antimacassars – is simply a mausoleum of the wasted hours of the female part of the family. Happily there is a sensible diminution in this perpetual needling, and no future Mrs. Somerville will be kept for the best hours of her girlhood "sewing" her daily seam. More intelligent and more active pursuits are multiplying, and the great philanthropist who invented lawn-tennis has done more to remedy the Little Health of Ladies than ten thousand doctors together.

We have now glanced over a number of causes of *petite santé*, for which the sufferers themselves are more or less responsible. Let us turn to some others regarding which they are merely passive.

It is many years since in my early youth, I was struck by a singular coincidence. Several of my married acquaintances were liable to a peculiar sort of headache. They were obliged, owing to these distressing attacks, to remain very frequently in bed at breakfast-time, and later in the day to lie on the sofa with darkened blinds and a considerable exhibition of Eau-de-Cologne. A singular immunity from the seizures seemed to be

enjoyed when any pleasant society was expected, or when their husbands happened to be in a different part of the country. By degrees, putting my little observations together, I came in my own mind to call these the "Bad-Husband Headaches," and I have since seen no reason to alter my diagnosis. On the contrary, I am of opinion that an incalculable amount of feminine invalidism arises from nothing but the depressing influences of an unhappy home. Sometimes, of course, it is positive unkindness and cruelty which the poor creatures endure. Much more often it is the mere lack of the affection and care and tenderness for which they pine as sickly plants for sunshine. Sometimes it is the simple oppression of an iron will over them which bruises their pleasant fancies, and lops off their innocent whims, till there is no sap left in them to bud or blossom any more. Not seldom the misery comes of frequent storms in the household atmosphere, – for which the woman is probably as often to blame as her companion, but from which she suffers doubly, since, when they have passed, he goes out to his field or his merchandise with what spirit he can muster, poor fellow! while she sits still where the blighting words fell on her, to feel all their bitterness. Of course it is not only unkind *husbands* who make women down-hearted. There are unkind people in every relation, and the only speciality of a woman's suffering from unkindness is, that she is commonly almost like a bed-ridden creature, for whom a single thorn or even a hard lump in her bed, is enough to create a soreness. To those who can get up and walk away, the importance which she attaches to the thorn or the lump seems inexplicable.

This balking of the heart is, I suppose, the worst evil in life to nine women out of ten, whether it take place after marriage in finding an uncongenial husband, or before marriage when a lover leaves them in the lurch and causes them a "Disappointment." This word, I observe, is always significantly used with reference to such events among a certain class of women, as *the* Disappointment *par éminence*. When a lady fails to get her book published or her picture hung at the Academy, nobody speaks of her as having undergone a "disappointment." I have no doubt the grief of losing the lover is generally worse than these, but I wish that pride would teach every woman under such circumstances not to assume the attitude of an Ariadne, or settle down after a course of sal volatile into languor and Little Health till she is found at sixty, as M. About deliciously

describes an English Old Maid, "tant soit peu desséchée par les langueurs du célibat." Of this kind of thing I would fain hope we might soon see the end, as well as of the Actions for Breach of Promise, which are a disgrace to the whole womanhood of the country.

But beside heart sorrows, real and imaginary, there are other departments of women's natures wherein the balking of their activities has a deplorable effect on their physical as well as mental condition. Dr. Bridges once gave an admirable lecture at the Royal Institution, concerning the labouring and pauper class of Englishmen. He made the remark (which was received with emotion by the audience) that it was not enough to supply a human being with food and shelter. "Man," he said, "does not live by bread alone, he must have *Hope*." May we not say likewise, "Woman does not live by bread alone – nay, nor by the richest *cake*?" She, too, must have Hope – something to live for, something which she may look to accomplish for herself or others in God's world of work, ere her night shall fall. A Hindoo lady, lately speaking at a meeting in India, compared Mary Carpenter's beneficent existence to a river bearing fertility to many lands, while the life of a woman in the Zenana, she said, resembled rather a pond. Surely every woman worthy of the name would desire to be something more than the pool, were it only a little trickling rill! But in endless cases she is *damned up* on all sides, and none the less effectually that the soft mud of affectionate prejudice forms the dam. If her friends be rich, she is sickened with excess of luxury, but prohibited from stooping down out of the empyrean of her drawing-room to lend a finger to lift the burdens of a groaning world. If the family income be small, and the family pride proportionately great, she is required to spend her life – not in inspiriting, honourable money-*earning*, but in depressing, heart-narrowing money-*saving*. When the poor soul has borne this sort of pecuniary stay-lacing for a dozen years, and her forehead has grown narrow, and her lips pinched, and her eyes have acquired a certain anxious look (which I often fancy I recognize) as if of concern about sixpences, then, forsooth, the world laughs at her and says, "Women are so stingy!" How gladly, in a hundred cases, would that poor lady have toiled to *earn* – and not to *save* – and have been nobly generous with the proceeds of her industry!

We have heard a great deal of late of the danger to women's

health of over mental strain or intellectual labour. I do not say there is never danger in this direction, that girls never study too much or too early, or that the daughters of women who have never used their brains may not have inherited rather soft and tender organs of cogitation to start with. I am no enthusiast for excessive book-learning for either women or men, though in books read and books written I have found some of the chief pleasures of a happy life. Perhaps if it were my duty to supervise the education of girls I should be rather inclined to say, like the hero of Locksley Hall,

> "They shall ride and they shall run,
> . . . Leap the rainbows of the brooks,
> Not with blinded eyesight poring over miserable books."

But of one thing I am sure, and that is, that for one woman whose health is injured by excessive study (that is, by *study itself*, not the baneful anxiety of examinations superadded to study), there are hundreds whose health is deteriorated by *want* of wholesome mental exercise. Sometimes the vacuity in the brains of girls simply leaves them dull and spiritless. More often into those swept and empty chambers of their skulls enter many small imps of evil omen. "The exercise of the intellectual powers," says an able lady M.D., "is the best means of preventing and counteracting an undue development of the emotional nature. The extravagances of imagination and feeling engendered in an idle brain have much to do with the ill-health of girls." Another observer, an eminent teacher, says, "I am persuaded, and my experience has been confirmed by experienced physicians, that the want of wholesome occupation lies at the root of the languid debility, of which we hear so much, after girls have left school."[6] And another, the Principle of one of the largest Colleges for women in England, adds, "There is no doubt whatever that sound study is an eminent advantage to young women's health; provided, of course, that the general laws of health be attended to at the same time."

Let women have larger interests and nobler pursuits, and their affections will become, not less strong and deep, but less sickly, less craving for demonstrative tenderness in return, less variable in their manifestations. Let women have sounder mental culture, and their emotions – so long exclusively

[6] The Education of American Girls, p. 229.

fostered – will return to the calmness of health, and we shall hear no more of the intermittent feverish spirits, the causeless depressions, and all the long train of symptoms which belong to the Protean-formed Hysteria, and open the way to madness on one side and to sin on the other.

And now, in conclusion, I must touch on a difficult part of my subject. Who is to blame for all the misery resulting from the Little Health of Ladies?

Of course a large portion of the evil must be impartially distributed throughout society, with its false ideals of womanhood. Another portion rests on parents and teachers; and of course no inconsiderable part on the actual sufferers, who, in many cases, might find healthful aims in life if they had the spirit to look for them, and certainly need not carry the destructive fashions of dress to the climax they reach in the red-hot race of vanity. There remains yet a share of guilt with the childish and silly men who systematically sneer down every attempt to make women something better than the dolls they play with (just as if they would be at a loss for toys, were the dolls to be transformed into rational creatures), and those others, even more cruelly selfish, who deliberately bar every door at which women knock in search of honourable employment. After all these, I find one class more.

There is no denying the power of the great Medical Order in these days. It occupies, with strangely close analogy, the position of the priesthood of former times, assumes the same airs of authority, claims its victims for torture (this time among the lower animals), and enters every family with a latch-key of private information, only comparable to that obtained by the Confessional. If Michelet had written for England instead of for France, he should have made a book, not on "Priests, Women, and Families," but on "Doctors, Women, and Families." The influence of the family medical man on wives and mothers, and, through them, on husbands and children, is almost unbounded, and if it were ever to be exerted uniformly in any matter of physical education, there is little doubt that it would be effective.

What, then, we may reasonably ask, have these omnipotent doctors done to prevent the repetition of deadly follies in the training of girls generation after generation? Now and then we have heard feeble cautions, given in an Eli-like manner, against tight-lacing, late hours, and excitement; and a grand display of

virtuous indignation was, if I remember rightly, exhibited about a year ago in a medical round-robin, against feminine dram-drinking – a vice for which the doctor's own prescriptions are in too many cases responsible. But the steadily determined pressure on mothers and young women, the insistence on free, light petticoats, soundly shod feet, loose stays, and well-sheltered heads – when has it been exercised? An American medical lady says that at a *post-mortem* examination of several women killed by accident in Vienna, she found the internal organs of nearly all affected by tight-lacing. "Some ribs overlapped each other; one had been found to pierce the liver; and almost without exception that organ was displaced below the ribs. . . . The spleen in some cases was much enlarged, in others it was atrophied."[7] and so on. Do the male doctors, who behold these and other hideous sights continually, go out to warn the mothers who encourage girls to this ghastly self-destruction, as they do denounce the poor, misguided Peculiar People and Anti-Vaccinators who cheat Science of her dues?

At last, after the follies of luxury and fashion have gone on in a sort of *crescendo* like the descent of Vathek into the Hall of Eblis, till we seem nearly to have reached the bottom, a voice of warning is heard! It has pealed across the Atlantic, and been re-echoed on the shores of England with a cordiality of response which our men of science do not often give to American "notions." "Women, beware!" it cries: "Beware! you are on the brink of destruction! You have hitherto been engaged only in crushing your waists; now you are attempting to cultivate your minds! You have been merely dancing all night in the foul air of ball-rooms; now you are beginning to spend your mornings in study! You have been incessantly stimulating your emotions with concerts and operas, with French plays and French novels; now you are exerting your understanding to learn Greek and solve propositions in Euclid! Beware, oh beware! Science pronounces that the woman who – *studies* – is lost!"

Perhaps there are some women, now alive, who did study a little in youth, who even spent their nights occasionally over their books while their contemporaries were running from one evening party to another – who now in middle and advanced

7 Dress and Health, p. 20.

life enjoy a vigour which it would be very well for their old companions if they could share. These women know precisely *à quoi s'en tenir* concerning these terrific denunciations.

There is another point on which it seems to me that a suspicion of blame must attach to the medical profession. We all believe that our doctors do the utmost in their power to cure *acute* diseases. When any patient has scarlet fever or small pox or bronchitis, he may be sure that his medical attendant will exert all his skill and care to pull him through. But is it equally certain that out of the 20,000 men, or thereabouts, who are qualified to practise medicine and surgery in this kingdom, there are not a few who feel only a modified interest in the perfect recovery of chronic sufferers who represent to them an annual income of £50 or perhaps £200? A few months ago there appeared an article in one of the magazines expounding the way in which *legal* business was made to grow in hydra fashion. We have all heard similar accusations against slaters and plumbers, who mend one hole in a roof and leave another. In short, we unhesitatingly suspect almost every other trade and profession of *making work for itself*. Is it clearly proved that doctors are in this respect quite different from lawyers and other men, or that the temptation to keep a wealthy patient coddling comfortably with an occasional *placebo* for twenty years is invariably resisted? The question is not easy to answer unhesitatingly in the affirmative – "Suppose a really radical cure were discovered whereby all the neuralgic and dyspeptic and gouty patients could be made in an hour as sound as so many trivets, do we believe implicitly and *au fond du cœur* that that heaven-sent remedy would be rapturously welcomed by the whole medical profession?" Is there no truth at all in the familiar legend of the elderly lady whose physician, after many years of not unprofitable attendance, advised her to go to Bath, promising to give her a letter to the most eminent local doctor, his intimate friend, to whom he would thoroughly explain her case? The lady, armed with the introductory letter, it is said, proceeded on her way; but the curiosity of a daughter of Eve unhappily overcame her discretion. "It is only about myself after all," she said to pacify her scruples; "and once for all I will learn what dear Dr. D– *does* think is my complaint. If I am doomed to die, it is better than this prolonged uncertainty." The seal was broken, and the lady read: "Keep the old fool for

six weeks, and be sure to send her back to me at the end. Yours truly."

There are at this day in Mayfair and Belgravia, in Bayswater and South Kensington, a dozen houses in every street and square at the doors of which a doctor's carriage stops as regularly as the milkman's cart; and apparently there is just as little likelihood that either should cease to stop. If the old Chinese custom were introduced amongst us, and patients were to pay their physicians a salary *so long as they were in health*, and ceased to pay whenever they required medical attendance, I very much question whether we should see quite so many of those broughams about those doors. I cannot help fancying that if the clockmakers who undertake to wind up our domestic timepieces were to keep them in the same unsatisfactory and perpetually running-down condition as the inner machineries of these doctors' patients, we should in most cases bring our contract with the clockmaker to a close, and wind up our timepieces in future for ourselves.

But more, and in a yet more serious way, the doctors have, I conceive, failed, not only as guardians of the health of women, but as having (as a body) opposed with determined and acrimonious resistance an innovation which – *if medical science be good for anything* – they could scarcely doubt would have been of immense benefit to them.

No one is ignorant how often the most agonizing diseases to which female nature is liable follow from the neglect of early premonitory symptoms, and how often, likewise, lifelong invalidism results from disregard of the ailments of youth. It is almost equally notorious how often these deplorable catastrophes are traceable directly to the poor victim's modest shrinking from disclosing her troubles to a male adviser. When such events are spoken of with bated breath among friends, it is sometimes said that it was the sufferer's own fault – that she *ought not* to have felt any shyness about consulting a doctor – and that it is proper for everybody to "look on a doctor as an old woman." I confess I do not understand precisely such playing fast and loose with any genuine sentiment of modesty. The members of the Royal College of Physicians and Surgeons and of the Society of Apothecaries are *not* "old women." They are not even all old, nor all good men. A few months before they begin to practise – while they are in the "Bob Sawyer"

stage – they are commonly supposed to be among the least steady or well-conducted of youths; and where a number of them congregate together – as in Edinburgh, for example – they are apt to obtain an unenviable notoriety for "rowdyism." I have more than once myself witnessed conduct on the part of these lads at public meetings which every man on the platform denounced as disgraceful. I could not but reflect as I watched them: "And *these* youths a year hence will be called to the bedsides of ladies to minister at hours of uttermost trial when the extremest refinement of tact and delicacy must scarce make the presence of a man endurable! Nay, they *now* attend in crowds the clinical instructions in the female wards of the hospitals, and are invited to inspect miseries of disease and horrible operations on women, who, if of humbler class, are often as sensitive and modest as the noblest lady in the land!"

The feelings of Englishwomen on all matters of delicacy are probably keener than those of the women of any other Western Country, and in some particulars may possibly be now and then overstrained. But who could wish them to be changed? Who questions their almost infinite value? In every instance, except the one we are discussing, they receive from Englishmen the respect which they deserve. To propose deliberately to teach girls to set those sacred feelings aside on one point, and that point the one where they are necessarily touched immeasurably more closely than anywhere else, is simply absurd. They could not do it if they would, and they ought not to do it if they could. A girl who would willingly go to a man-doctor and consult him freely about one of the many ills to which female flesh is heir, would be an odious young woman. Violence must be done to her natural instincts, either by the pressure of the mother's persuasion (who has undergone the same *peine forte et dure* before her), or else by unendurable anguish, before she will have recourse to aid which she thinks worse than disease, or even death. And so the time when health and life might be saved is lost by delay, and when the sacrifice is made at last, the doctor observes compassionately, "If you had come to me long ago I might have restored you to health, – or an operation could have been performed which might have saved your life. Now, I grieve to say, it is too late."

That the admission of qualified women to practise medicine is the proper and only effectual remedy for this evil is of course obvious to all. In opposing such admission relentlessly, as they

have generally done, medical men have incurred a responsibility which to me seems nothing short of tremendous. Whatever motive we may be willing to assign to them above mere pitiful rivalry for practice and profit it is scarcely possible to suggest one which is not grossly injurious and insulting to women, or which ought for a moment to weigh in the balance against the cruel woes to which I have referred, or the just claim of all women to receive, if they prefer them, the ministrations of their own sex in their hours of suffering and weakness.

Doctors are wont to speak – apparently with profound feeling – of the sympathy they entertain for their patients, and to express their readiness (in a phrase which has passed into cant) "to sacrifice a hecatomb of brutes to relieve the smallest pain of a human being." May not women justly challenge them to sacrifice something a little nearer to themselves, – their professional pride, their trades-unionism, and a certain fraction of their practice, – to relieve their entire sex of enormous pain, mental and physical?

I rejoice to believe that the long contest draws to a close, and that, thanks to men like Mr. Stansfeld and Mr. Cowper Temple, there will soon be women-doctors, and women's hospitals attended by women-doctors, in every town in the kingdom. I rejoice to know that we possess already a few qualified ladies who every day, without wound to feelings of the most sensitive, receive the full and free confidence of girls and women, and give in return counsels to which many attribute the preservation of life and health; and which – if medical science have any practical value – must afford the rising generation a better chance than ever their mothers have had of escaping the endless miseries to themselves and all belonging to them attendant on the Little Health of Ladies.

EVOLUTION AND FEMALE EDUCATION
Nature, Vol. 22 (1880)
S. Tolver Preston]

One of the most remarkable features of the advance of science is perhaps the increasing facility afforded for bringing under the grasp of *physical* treatment questions formerly thought to be within the range of abstract reasoning alone. These two methods, if correct, will of course run parallel to each other, and at the same time tend reciprocally to confirm their truth:– the *physical* method being often the more easily followed, and therefore perhaps considered on that account the more certain of the two. Many instances may no doubt readily present themselves of conclusions formerly reasoned out on abstract grounds (more especially by the ancient philosophers), and subsequently confirmed by physical reasoning. As a modern example of this *double* treatment of the same subject we might mention the very important question of the higher mental training of women, dealt with by the late John Stuart Mill on substantially abstract grounds, and touched on by the theory of evolution on physical grounds. As we propose solely to notice the *physical* side of the question here, perhaps this brief essay may not be thought unsuited to the columns of NATURE. We do not expect to bring forward anything especially new, but we may perhaps exhibit the case in some novel aspects; at the same time we may avoid elements of uncertainty by carefully separating the facts supported by scientific evidence from the question of the desirability or undesirability of the measures to be taken upon these facts as a basis, and thus the paper may hope to attain that degree of reliability or solidity which is usually looked for in a journal of natural science.

Perhaps the most valuable characteristic of the doctrine of evolution (or the history of the past rise of man) is the lesson it gives for future progress. It will be apparent that an inquiry into the conditions affecting the progress of mankind would

want one of its primary elements if the conditions bearing on the advancement of woman (as one half of the race) were excluded therefrom; and the fact of this point being popularly underrated may be considered as rather in favour of its value and significance than not, inasmuch as all great reforms consist in the conquest of popular prejudice. That the value attached to this reform by Mill, which occupied a great part of his life, was not overestimated by him will, we think, become all the more evident when the subject is brought under the test of the theory of evolution.

Mr. Darwin in his work, "The Descent of Man" (second edition), remarks:– "It is indeed fortunate that the law of the equal transmission of characters to both sexes prevails with mammals, otherwise it is probable that man would have become as superior in mental endowment to woman as the peacock is in ornamental plumage to the peahen" (p. 565).

This therefore puts the question of the education of woman in a somewhat new light: though in a light probably suspected by some (including, it may be said, the writer) beforehand, on abstract grounds. For this would show, on a reliable physical basis, that one of the chief arguments for the intellectual training of woman must be for the direct benefit of *man*. For the above deduction, grounded on the evidence of natural science, would indicate clearly that man, by opposing the intellectual advance of woman for countless generations, has enormously injured his own advance – by inheritance. In other words, while man has been arbitrarily placing restrictions in the way of the mental progress of woman, nature has stepped in, and by the laws of inheritance has (to a large extent) corrected, at his expense, the injury which would otherwise have been inflicted, and which, without this interposition of natural law, would have made itself transparently obvious, centuries ago. Man, by hindering woman from performing her natural share in the work of brain development, has been compelled by nature to do the work for her, and valuable brain tissue (accumulated by mental discipline), which would have been man's own property as the fair reward of intellectual labour, has gone over by the rigorous laws of inheritance[1] to

[1] Possibly (and we believe this may have been suggested by others) the less stability, or sometimes almost hysterical character of the female intellect may be naturally due to the brain qualities being gained mainly by *inheritance* instead of by hard practice, as in the case of man's brain

the female side, to fill up the gap artificially created by man through his persistent hindrance of woman from doing her part in the progressive development of the brain. The probable extent of the gap by accumulation (from all causes, including the very important factor of man's obstruction) is apparently roughly indicated by the comparison employed in the above quotation. It would seem, therefore, that it could scarcely be said to be altogether fortunate (in *one* sense at least) that "the law of equal transmission of characters to both sexes prevails with mammals;" for this fact has served to conceal an evil which in reality exists in all its magnitude, and which otherwise it would not have required the intellect of a Mill to detect, but which must have become glaringly apparent long ago. Physical science would therefore appear to show a remarkable confirmation of Mill's magnificent theoretic analysis, and of the reality of those evils, the clear exposure of which by him looked to some like exaggeration. In fact it would result from the scientific evidence that however monstrously women might have been treated, however much idleness might have been enforced, or healthy brain exercise prevented, nature would have infallibly corrected the irregularity *at the expense of man*, entailing of course the partial extinction of the progress of the race (as a whole). Possibly the not uncommon popular ridicule which (at first, at least) accompanied Mill's protests, the conceited independence of some men in ignoring the fact that they are descended from women, and their failure even now to realise so obvious a truth as the desirability of clearing away all obstacles to the intellectual advance of woman (by facilitating education, by removing the bars to healthy exercise of the brain in suitable professions, &c., in place of idleness) may itself be in part a consequence of the deficiency of brain tissue caused by the drain through inheritance which goes to counteract their efforts of obstruction. Some of the reasons urged against the higher mental training of woman are of so superficial a

attributes. While the faculties of man have acquired the steadiness produced by centuries of healthy intellectual discipline and exercise, the field for this has been closed to woman to a large extent. In fact the scientific evidence would appear to show that the common brain (*i.e.* the brain common to the race) has been built up mainly by man's efforts, while woman has to a great extent *inherited* her share at his expense, though no doubt if left entirely unfettered she would have largely contributed to the common good; and it may be inferred with tolerable safety that the race would then have been elevated far above its present *status*.

character as themselves to show the extensive magnitude of the evil. One notoriously not uncommon ground adduced is that woman already are, as a rule, somewhat inferior in mental power to men, forgetting that they were precisely made inferior by the obstacles thrown for centuries in the way of their advance (some of these specially fixed by legal enactment), and which are sometimes of such a kind as almost to amount to a tax on liberty. It may well be conceivable that the law of inheritance, though it has achieved a vast amount, may not have been able to combat these artificial conditions for producing inferiority with entire success. The above plea of existing inferiority in mental power, therefore, so far from being an argument *against* female education, ought, when justly viewed, to be regarded as the strongest reason the other way. For if obstruction has produced – in spite of the powerful countervailing influence of the law of inheritance – a certain degree of inferiority: so (conversely) by equally reliable casual sequence encouragement would produce an effect in the opposite direction. Moreover, precisely on account of the fact that woman is already somewhat handicapped by nature in the race of progress, would there be all the more reason why every encouragement should be given; *à fortiori*, all artificial hindrances in the way of advancement removed. It would be a great mistake if the idea were for one moment entertained that progress can be accomplished by letting matters generally drift under the influence of prevailing custom. If there is one thing more certain than another it is that man can never hope to progress with satisfactory rapidity without having a sharp eye to the conditions necessary for this object, and examining (by the light of reason and knowledge gradually acquired) all his customs, to see if they are desirable or not. To facilitate this end the history of past progress, unfolded in the theory of evolution, may afford some valuable instruction. The increasing appreciation of the value of co-operating with the weak, instead of domineering over them, may be perhaps regarded as one of the most pleasing accompaniments to the advance of science.

THE HIGHER EDUCATION OF WOMAN
The Fortnightly Review, Vol. 40 (1886)
E. Lynn Linton

On all sides the woman question bristles with difficulties, and the Higher Education is one of them. The excess of women over men – reaching to not far from a million – makes it impossible for all to be married – Mormonism not being our way out of the wood. At the same time, this paucity of husbands necessitates the power of self-support for those women of the unendowed classes who are left penniless on the death of the bread-winner, and who must work if they would eat. This power of self-support, again, must be based on broad and honourable lines, and must include something that the world really wants and is content to pay for. It must not be a kind of well-masked charity if it is to serve the daughters of the professional class – women who are emphatically gentle, not only by birth, but by that refinement of habit and delicacy of sentiment which give the only true claim to the comprehensive term of lady. These women must be able to do something which shall not lower their social status and which shall give them a decent income. They must keep in line with their fathers and brothers, and be as well-considered as they. Certainly, they have always had the office of teachers; but all cannot be schoolmistresses or governesses, and the continual addition made to the number of candidates for work demands, and has already opened, other avenues and fresh careers. And – but on this no one can help save women themselves – as teachers and governesses they are not generally treated as on an equality with their employers, and are made to feel that to gain money, even by their brains, lowers their social status and reduces them perilously near to the level of the servants. As authoresses or artists they may hold their own; the glamour of "fame" and "genius" gilding over the fact that they make their incomes and do not draw them, and have nothing capitalised – not even their own reputations.

Of late years this question of woman's work has passed into another phase, and the crux now is, not so much how they can be provided with work adequately remunerated, but how they can fit themselves for doing it without damage to their health and those interests of the race and society which are bound up with their well-being. This is the real difficulty, both of the Higher Education and of the general circumstances surrounding the self-support of women. For the strain is severe, and must be, if they are to successfully compete with men – undeniably the stronger, both in mind and body, in intellectual grasp and staying power, in the faculty of origination, the capacity for sustained effort, and in patient perseverance under arduous and it may be distasteful labour. But the dream and the chief endeavour of women now is to do the same work as men alone have hitherto done; – which means that the weaker shall come into direct competition with the stronger – the result being surely a foregone conclusion. This is the natural consequence of the degradation by women themselves of their own more fitting work; so that a female doctor, for the present, holds a higher social position than does the resident governess, while a telegraph-girl may be a lady, but a shop-girl cannot.

For well-paid intellectual work a good education is naturally of the first necessity, and the base on which all the rest is founded. Wherefore, the Higher Education has been organised more as a practical equipment than as an outcome of the purely intellectual desire of women to learn where they have nothing to gain by it. For all this, many girls go to Girton and Newnham who do not mean to practically profit by their education – girls who want to escape from the narrow limits of the home, and who yearn after the quasi-independence of college life – girls to whom the unknown is emphatically the magnificent, and who desire novelty before all things; with the remnant of the purely studious – those who love learning for its own sake only, independent of gain, kudos, freedom or novelty. But these are the women who would have studied as ardently, and with less strain, in their own homes; who would have taken a longer time over their education, and would not have hurt their health and drained their vital energies by doing in two or three years what should have taken five or six; who would have gathered with more deliberation, not spurred by emulation nor driven by

competition; and who, with energy superadded to their love of knowledge, would have made the Mrs. Somervilles or Caroline Herschells, the Miss Burneys or Harriet Martineaus, of history. But such women are not many; voluntary devotion, irrespective of self-interest, to art, literature, science, philosophy, being one of the rarest accidents in the history of women – as, indeed, must needs be if they are to fulfil the natural functions of their sex.

Three important points come into this question of the Higher Education of women. These are (1) the wisdom or unwisdom for a father of limited means and uncapitalised income to send to college, at great expense, girls who may marry, and so render the whole outlay of no avail; (2) the effect which this Higher Education has on the woman and the individual; (3) the physical results on her health and strength, especially in relation to her probable maternity.

To give a good education to a boy is to lay the foundations, not only for a successful individual life, but also those for a well-conditioned family. It is the only thing a man can do who has no fortune to leave his son, and is, in fact, a fortune under another form. With a good education, and brains to profit by it, nothing is impossible. From the Prime Minister to the Lord Chancellor, from the Archbishop of York to the leader of the House of Commons, a clever lad, well educated, has all professional possibilities before him – as the French private has the marshals' *bâton* in his knapsack. But to go to the like expense for the education of a daughter is by no means the same investment, nor can it be made to produce the same return. Where the man's education enables him to provide for his family, a woman's may be entirely thrown away for all remunerative results to herself and others. Indeed, it may be hurtful rather than beneficial. At the best – taking things by their rule and not by their exceptions – it is helpful to herself only; for the women of the professional class, like those of the labouring, support only themselves. For which cause, we may say parenthetically, they are able to undercut the men, and can afford to work for less than can those who have wives and children to support. And this is the reason – again parenthetically – why men try to keep them out of certain trades; seeing in them not so much honest competitors for so much work, as the ultimate destroyers of the home and the family itself. In the education, too, of his sons a father discriminates and

determines according to their future. The boy intended for commerce he does not usually send to college; nor is stress laid on Latin or Greek or art or literature at school. For the one destined to the law or the church he stipulates for a sound classical training, and ultimately sends him to the university. For the artist he does not demand science; for the engineer he does not demand music – and so on. Almost all boys who have their own way to make are educated with a distinct reference to their future work; and wise men agree on the folly of wasting time and force on useless acquirements, with corresponding neglect of those which are useful. But how can girls be educated in this special manner? What professions are open to them as to men? The medical alone of the three learned, public opinion not yet being ripe for barristers in petticoats or for women preachers regularly ordained and beneficed; while the army and navy are still more closely shut against those ambitious amazons who think there should be no barriers against them in the barrack-yard or on the quarter-deck, and that what any individual woman can do she should be allowed to do, general rules of prohibition notwithstanding. The Higher Education gives us better teachers, more accurate writers, and our scantling of medical women. But if a girl is not to be one of these three things, the money spent on her college career will be emphatically wasted, so far as relates to the wise employment of funds in reference to a remunerative future.

And then there is always that chance of marriage, which knocks the whole thing to pieces; save in those exceptional cases where two students unite their brains as well as their fortunes, and the masculine M.A. marries the feminine, for the better perfecting of philosophical literature. Even in this rare instance the fact of marriage nullifies the good of the education; and, after a father has spent on his daughter's education the same amount of money as would have secured the fortune of a capable son, it cannot give him retrospective satisfaction to see her married to some one who will make her the mother of a family, where nothing that she has gained at so much cost will tell. Her knowledge of Greek and German will not help her to understand the management of a nursery; nor will her ability to solve all the problems of Euclid teach her to solve that ass's bridge of domestic economy – the co-ordination of expenditure with means, and the best way of extracting the

square root of refinement out of that appalling x of insufficiency.

To justify the cost of her education a woman ought to devote herself to its use, else does it come under the head of waste; and to devote herself to its use she ought to make herself celibate by philosophy and for the utilisation of her material, as nuns are celibate by religion and for the saving of their souls. As things are, it is a running with the hare of self-support and hunting with the hounds of matrimony – a kind of trusting to chance and waiting on the chapter of accidents, which deprives this Higher Education of anything like noble stability in results, making it a mere cast of the die which may draw a prize or throw blank. But very few women would elect to renounce their hope of marriage and maternity for the sake of utilising their education, or would voluntarily subordinate their individual desire to that vague thing, the good of society. On this point I shall have something to say further on. Yet this self-dedication would be the best answer to those who object to the Higher Education for the daughters of struggling professional men, because of the large chance there is of its ultimate uselessness. It would give, too, a social purpose, a moral dignity, a philosophic purity, and a personal earnestness to the whole scheme which would make it solid and organic, instead of, as now, loose and accidental.

So far as we have yet gone, has this Higher Education had a supremely beneficial effect on the character of women themselves? As intelligences, yes; as women, doubtful. We are not now taking the individual women who have been to Girton or Newnham, but the whole class of the quite modern advanced women. These are the direct product of the movement which has not only given us female doctors and superior teachers, but female orators, female politicians, and female censors all round – women who claim for themselves the leadership of life on the ground of a superior morality and clearer insight than have men. In dealing with the woman question, we can never forget the prominent characteristics of the sex – their moral vanity, coupled with their love of domination. The great mass of women think they know better than they can be taught; and on all moral questions claim the highest direction and the noblest spiritual enlightenment. Judging from sentiment and feeling, they refuse the testimony of facts; the logic of history has no lesson for them, nor has any unwelcome science its rights or its

truths. They are Anglo-Israelites, but not the products of evolution; and ghosts are real where germs are imaginary. This sentiment, this feeling, is like some other things, a good servant but a bad master. When backed by religious faith it stops at no superstition; when backed by moral conviction, it is a tyranny under which the free energies of life are rendered impossible; when backed by a little knowledge, it assumes infallibility. Scarcely a week passes without some letter in the papers, wherein an imperfectly-educated woman attacks a master in his profession, on the ground of her sentiment as superior to his facts – her spiritual enlightenment the Aaron's rod which swallows up his inferior little serpents of scientific truths. This restless desire to shoot with all bows – Ulysses', Nestor's, whose one will – may be, and probably is, the first effervescence of a ferment which will work itself clear by time and use. It is to be hoped so; for the pretensions to supremacy, by reason of their superiority, of women in these later times is not one of the most satisfactory results of the emancipation movement. And they cannot be too often reminded that the Higher Education, with all that this includes, is not meant to supersede their beautiful qualities, but only to strengthen their weak intellectual places and supply their mental deficiencies.

It would not be for the good of the world were the sentiment and tenderness of women to be lost in their philosophical calmness. But as little is it for the advantage of society when that sentiment rules rather than influences, shapes rather than modifies. That old adage about two riding on horseback together, when one must ride behind, is getting a new illustration. Hitherto the man was in front. It was thought that he was the better fitted to both discern the dangers ahead and receive the first brunt of such blows as might be about, while the woman crouched behind the shield of his broad body; and in return for that protection left the reins in his hands and did not meddle with the whip – or if she did, then was she censured while he was ridiculed. Now, things are changing; and on all sides women are seeking to dispossess the men of their places to take them for themselves. In the home and out of the home woman's main desire is for recognised leadership, so that man shall live by their rule. The bed of Procrustes was no myth; we have it in full working activity at this present time.

We come now to the third and most important point, the physical results of the educational strain in relation to

maternity. On this head we will take Dr. Withers-Moore as our guide, in his speech made at the British Association on the 11th of August. The pith of his position is in this sentence, "Bacon's mother (intellectual as she was) could not have produced the *Novum Organum*, but she, perhaps she alone, could and did produce Bacon." The same may be said of Goethe's mother. She could not have written *Faust*, but she formed and moulded and influenced the man who did. In almost all the histories of great men it is the mother, not the father, whose influence and teaching are directly traceable; and it is a remark as trite as the thing is common, that great men do not often produce great sons, but almost all great men have had notable mothers. As the "Oxford tutor," quoted by Dr. Withers-Moore, said: "A man's fate depends on the nursing – on the mother, not the father. The father has commonly little to do with the boy till the bent is given and the foundation of character laid. All depends on the mother." And his means not only her moral influence, but the actual shaping and moulding force of her physical condition reacting on his. Following this are the opinions of experts and philosophers who have given time and thought to the subject; and in all the authorities quoted – fourteen in number – there is the same note of warning against over-study in girls who are one day to be mothers. It is an unwelcome doctrine to those who desire above all things to be put on an absolute equality with men; who desire to do man's special work, while leaving undone their own; who will not recognise the limitations of sex nor the barriers of nature; who shut their eyes to the good of society and the evil which may be done by individuals; and who believe that all who would arrest a movement fraught with danger to the whole, are actuated by private motives of a base kind, and are to be treated as enemies wilfully seeking to injure, rather than as friends earnestly desirous of averting injury. Dr. Withers-Moore's summary of the whole question bearing on the physical condition of women as mothers is this:–

"Excessive work, especially in youth, is ruinous to health, both of mind and body; excessive brain-work more surely so than any other. From the eagerness of woman's nature, competitive brain-work among gifted girls can hardly but be excessive, especially if the competition be against the superior brain weight and brain strength of man. The

resulting ruin can be averted – if it be averted at all – only by
drawing so largely upon the woman's whole capital stock of
vital force and energy as to leave a remainder quite
inadequate for maternity. The Laureate's 'sweet girl graduate
in her golden hair' will not have in her the fulfilment of his
later aspiration –

'May we see, as ages run,
The mother featured in the son.'

The human race will have lost those who should have been
her sons. Bacon, for want of a mother, will not be born. She
who should have been his mother will perhaps be a very
distinguished collegian. That one truism says it all - women
are made and meant to be, not men, but mothers of men. A
noble mother, a noble wife – are not these the designations in
which we find the highest ideal of noble womanhood?
Woman was formed to be man's helpmate, not his rival;
heart, not head; sustainer, not leader."

The ideal mother is undoubtedly a woman more placid than
nervous in temperament, more energetic than restless in habits,
and with more strength of character and general good sense
than specialized intellectual acquirements. Strong emotions,
strained nerves, excitement, anxiety, absorption, are all hurtful
to the unborn child. They tend to bring on premature birth;
and if not this, then they create sickly offspring, whom the
mother cannot nourish when they are born. And, speaking of
this, I may as well state here that the number of women who
cannot nurse their own children is yearly increasing in the
educated and well-conditioned classes; and that coincident
with this special failure is the increase of uterine disease. This I
have from one of our most famous specialists. The mental
worries and the strain of attention inseparable from pro-
fessional life, make the worst possible conditions for
satisfactory child-bearing; while the anxiety bound up with the
interruption to her work, consequent on her health and
changed condition, must tell heavily on the nerves and mind of
the woman whose professional income counts in the family.
Her physical troubles, of themselves quite enough to bear, have
thus extra weight; and mind, nerves, work, and condition act
and react in a vicious circle all round. Even where her
profession is one that does not take her out of doors, and does

not involve any great personal fatigue – as literature or art – the anxiety of her work and the interruption which must needs result from her state are more disastrous to the unborn than to herself; and the child suffers as much from the relaxation as from the strain. As one of the wisest and best-trained women I know said to me the other day: "How much of all the grand force and nervous power, the steadiness and courage of Englishmen, may not be owing to the fact of the home life and protection of women; and how much shall we not lose when the mothers of the race are rendered nervous, irritable, and overstrained by the exciting stimulus of education carried to excess, and the exhausting anxieties of professional competition!"

This does not say that only the "stupid women" are therefore to be wives and mothers. Specialized education does not necessarily create companionable nor even sensible women; else, by parity of reasoning, would all professional men be personally charming and delightful, which undoubtedly they all are not. A girl may be a sound Grecian, a brilliant mathematician, a sharp critic, a faultless grammarian, yet be wanting in all that personal tact and temper, clear observation, ready sympathy, and noble self-control which make a companionable wife and a valuable mother. Nor is unprofessional or unspecialized instruction necessarily synonymous with idleness and ignorance; while a good all-round education is likely to prove more serviceable in the home and in society than one or two supreme accomplishments. Many of us make the mistake of confounding education with acquirements, and of running together mental development and intellectual specialization. The women of whom we are most proud in our own history were not remarkable for special intellectual acquirements so much as for general character and the harmonious working of will and morality. The Lady Fanshawes and Elizabeth Frys, the Mary Carpenters and Florence Nightingales, whose names are practically immortal, were not noted for their learning, but they were none the less women whose mark in history is indelible, and the good they did lives after them, and will never die. And taking one of the, at least, partially learned ladies of the past – is it her Latinity or her bookishness that we admire so much in Lady Jane Gray? or is it her modesty, her gentleness, her saintly patience, her devotion? – in a word, is it her education or her character? – the

intellectual philosopher, or the sweet and lovely and noble woman?

Modern men want intelligent companions in their wives. But the race demands in its turn healthy, wise, and noble mothers of vigorous children. Only a few of the less worthy men desire simply an upper servant for domestic use, or a mistress for personal pleasure, or both in one, with whom they, the husbands, feel no true comradeship. But do the mass of men want the specialized companionship of a like education? Does not human nature rather desire a change – the relaxation of differences? – and do specialists want to be always talking to their wives of literature, art, science, medicine, law – whatever may be their own assigned work? Would they not rather forget the shop, even though that shop be the library or the studio, and pass into a fresh intellectual atmosphere when they lay aside their MSS. or fling down their brushes? We must always remember, too, that the conduct and management of the house and family belong to women; and that if the wife and mother does not actively superintend those departments which the fitness of things has apportioned to her, subordinates must – subordinates who will not put into their work either the love or the conscience of the wife, whose interests are identical with her husband's – of the mother, with whom reason and instinct, education and affection, create that half-divine power to which most great men have owed the chief part of their greatness.

Not going all the length of the Turkish idea that women are born into the world only to be the wives and mothers of men – as mothers of women simply keeping up the supply; and that for themselves they are of no account outside their usefulness to, and relations with, men – it is yet undeniably better that they should be unnoted as individuals and perfect as mothers, rather than famous in their own persons and the mothers of abortive and unsatisfactory children. In this lies the soul of the controversy; for the whole question is contained in the relative importance of individual rights and social duties – freedom for self-development in such direction as may suit ourselves, or subordinating our personal desires to the general and unindividualized good.

We are in the midst of one of the great revolutions of the world. The old faiths are losing their hold and the new are not yet rooted; the old organization of society is crumbling to pieces and we have not even founded, still less created, the

new. In this revolution, naturally one of the most prominent facts is the universal claim for individual freedom, outside the elemental laws which hold the foundations together, made by every one alike. We preach the doctrine of rights everywhere, that of duties straggles in where it can; and the one crying need of the world at this moment is for some wise and powerful organizer who shall recombine these scattered elements and reconstruct the shattered edifice. Women, who always outstrip their leaders, are more disorganized, because at this time they are even more individualized than are men. Scarcely one among them takes into account the general good. Even in those questions where they have made themselves the leaders, individual victories are of greater value than general policy, and they would always subordinate the practical welfare of the majority to the sentimental rights of the minority. An individual sorrow moves them where the massed results of a general law leave them cold. This characteristic is perfectly sound and righteous in those to whom have been confided the care of the family and the arrangement of details. Women ought to be individual, not for themselves but for others; and in that individualism there ought to be the injustice inseparable from devotion. An altruistic mother who would sacrifice her one child for the sake of her neighbour's two, does not exactly fulfil our ideas of maternal care; on the other hand, a mother who would rather her son was disgraced as a coward than that he should run the dangers of courage – or the partisan of her own sex who would sacrifice twenty men to save one woman inconvenience or displeasure, is as little fit to be the leader of large movements involving many and varied interests, as is that other to be a mother. In their own persons women carry out to a very remarkable degree this principle of individualism, the general good notwithstanding. Speak to an ordinary woman of the evil economic effects of her actions, and you speak a foreign language. She sees only the individual loss or gain of the transaction, and a public or social duty to creatures unknown and unseen does not count. In the cruel vicissitudes of fashion and the ruin of thousands brought about by simple change of material – in the selfish greed for bargains, no matter at whose cost obtained – in the complete ignoring of and indifference to all the results to others of her own example, a woman of the ordinary type is essentially individual and unsocial. In America – whence, however, we have received so many grand and noble

impulses – this female individualism, with its corresponding indifference to the public good or to public duty, is even more pronounced than here; and the right of woman to her own development, though that should include what is called "the painless extinction of man," is the very heart and soul of the new creed.

Women, seeking to rule, have forgotten how to obey. Wishing to reorganize society according to their own desires, they have at the same time thrown off all sense of discipline in their own lives; and the former feminine virtues of devotion, patience, self-suppression, and obedience are flung aside as so much tarnished finery of a decayed and dishonoured idol. The ordinary woman cannot be got to see that she is not only herself but also a member of society and part of an organization; and that she owes, as a duty to the community, the subordination of her individualism to that organization. She understands this only in religious communities, where she obeys her director as one divinely commissioned. Outside religious discipline she refuses obedience to general principles. Society has grown so large and its disorganization is so complete, that, she says to herself, her own example does not count. She is but a fractional part of a grain added to a ton weight; and by the law of psycho-dynamics she is undiscerned and without influence. It was all very well in small communities, like those of Greece for instance, or when the one grand lady of the village was the mirror for all to dress by. Then, the individual example was of value; but now – who cares for one out of the tens of thousands crowded in London? and what duty has she to the community comparable to that which she owes herself?

And this brings us round once more to the subject-matter of this paper:– the effect on the community of the Higher Education of women, in its good and evil results on mothers and their offspring, and their own indifference to these results.

It is impossible not to sympathize with a bright girl anxious to go on with her education, and petitioning for leave to study higher matters than have been taught her at her school. It is as impossible not to feel a sense of indignation at the injustice when parents say frankly, the education of their girls does not count with them; and, so long as these know how to read and write and can play the piano and are able to dance and perhaps to sew, there is nothing more necessary. We do battle then for

the right of the individual to know, to learn, to perfect itself to the utmost of its ability, irrespective of sex. But if we are wise we stop short of such strain as would hurt the health and damage the reproductive energies, if marriage is to come into one of the chances of the future. A girl is something more than an individual; she is the potential mother of a race; and the last is greater and more important than the first. Let her learn by all means. Let her store her mind and add to her knowledge, but always with quietness and self-control – always under restrictions bounded by her sex and its future possible function. Or, if she disregards these restrictions, and goes in for competitive examinations, with their exhausting strain and feverish excitement – if she takes up a profession where she will have to compete with men and suffer all the pain and anxiety of the unequal struggle – let her then dedicate herself from the beginning as the Vestal of Knowledge, and forego the exercise of that function the perfection of which her own self-improvement has destroyed. We cannot combine opposites nor reconcile conflicting conditions. If the mental strain consequent on this higher education does waste the physical energies, and if the gain of the individual is loss to the race, then must that gain be sacrificed or isolated.

Of course it all depends on that If; and of this experts are the only trustworthy judges. We must be guided by the better knowledge of specialists and those who have studied in all its bearings a subject of which we know only one side, and that side the one turned to our own desire. If one examiner[1] reports: "That of the boys 29 per cent., and of the girls 41 per cent., were found to be in a sickly state of health;" if another,[2] in confirmation says, "That 11.6 per cent. of boys and girls in St. Petersburg schools suffer from headache," we must suppose there is something to be taken note of in the opposition of most medical men to this Higher Education of Women. For we must put out of court, as unworthy of serious consideration, that old well-worn accusation of man's opposition to woman's advancement from jealousy, tyranny, the desire of domination, and the preference of slaves and mistresses over companions and wives. We must accept it as part of all sane argument that

[1] Dr. Hertel, speaking of over-pressure in the high schools of Denmark.

[2] Professor J. N. Bystroff. Both quoted by Dr. Withers-Moore in his speech at the British Association.

people desire the best – ideas as to what is the best differing according to the point of view; as now in this very question under consideration, where the individual gain clashes with the good of the community, and the personal advantage of the woman hurts her usefulness as a mother. We must acknowledge, too, that experts know better than the unlearned; and that in matters of health and the wisest rules for physical well-being, medical men are safer guides than girls ambitious for their own distinction, or women ambitious for their sex – holders, too, of the doctrine of absolute equality in mental strength with men, and of free trade in all employments and careers.

A great deal of the difficulty surrounding the question of woman's employment could be got over by women themselves. If, instead of degrading their own more natural work by the social ostracism of the workers, they would raise it by respect and honour, large fields of productive usefulness would be opened and much cause for heart-burning would cease. The greater democracy of the present age makes it possible for great ladies to earn money. Even a queen throws her books into the market, and sells them all the same as others. A generation or so ago no lady could have made money, save by the two methods of painting and writing – both done within the sacred seclusion of the four walls of home. Actresses were what we call in the north "chancey." Some were thoroughly respectable and came to good ends and high positions; but the bulk were best left alone by women who wished to keep alive anything like veneration for virtue. Now, however, we have opened all gateways, and made it possible for ladies of condition, repute, and birth to do what they will in the way of money-making and still retain both character and position. A princess opens a milliner's shop; a lady of rank is a cowkeeper and profits by her dairy-farm; women of title go on the stage; ladies of gentle birth and breeding are storekeepers and horse-breeders. But as yet these are only the showy – we had almost said theatrical – and quasi-romantic vanguard; and what we want is a stable condition of self-support for women whose inherited position is not of that high class which no work can degrade, but who, ladies as they are, stand or fall according to the arbitrary estimation of their work.

In this, we repeat, no one can help women save women. Certain tailors and certain shopkeepers are received in London

society as among its favourite and most honoured guests. Do we meet with a milliner, a lady shopkeeper? Do we not all know milliners and dressmakers who are well-educated, pleasant-mannered, honourable ladies; yet would the countesses and dames for whom they devise their dainty costumes agree to meet them on equal terms at balls and dinners? Why not? Surely it cannot be on the ground of making their own money. The highest ladies in the land do not disdain to turn an honest penny if they can; and where, pray, is the essential difference between the clergyman's daughter who sells mantels or laces in a shop for her living, and the young duchess who sells pincushions and button-holes at a bazaar for her vanity, masked as charity? Here, if we will, the principle of individualism would work with advantage. If we could get rid of all caste feeling, and judge of people by themselves and not by their work – if we would allow that a milliner could be a lady, and a shop-girl on a level with her sister the governess, and both on an equality with their brother the clergyman and their aunt the physician's wife – we should have done more for the question of the employment of women than we have done by the establishment of colleges and the creation of educational standards, the attainments of which are inimical to the best interests of society because hurtful to women themselves. We must do what we can in this life, not always what we would; and the general interests of society are to be considered before those of a special section, by whose advancement will come about the corresponding degeneracy of the majority.

In these two propositions, then, we think the whole thing lies – in voluntary celibacy for those who overtax their vital energies by an intellectual strain that hurts the offspring; and in the honouring of those lighter and easier methods of making money which have hitherto condemned a woman to social ostracism, and denied her the status she deserves and has inherited.

WOMAN'S WORK IN CREATION
Longman's Magazine, Vol. 8 (1886)
Benjamin Ward Richardson

We discussed in the School Board of London some years ago the question whether it was to the interests of education for married women to be mistresses of schools.

A section of the Board, in which more than one lady member was included, expressed the opinion that married women should not be employed as teachers. The argument on this side of the question was that married women, on becoming mothers year after year, were prevented by that event from performing the duties of the teacher so continuously as to be worth the full value of teaching power. Added to this, it was urged, the result was bad for the teacher herself, and for her offspring. An expectant mother ought not to be subjected to the cares and anxieties of teaching. It was a tax upon her vital powers which impaired her health, and through her inflicted an injury on her child. Even when she returned from her enforced absences from the school, she was still unequal to the full performance of her public duty, if she carried out also the complete maternal duty of nursing her child and giving to it the attention that was necessary for its healthy development, with due protection from the various dangers which lead up to the current unnecessary infantile mortality.

On the other side, it was contended that the woman who was herself a mother, was, of necessity, the best teacher of the young of both sexes. She, it was said, had most correct knowledge of children, of their wants and their capacities. She was most likely to be gentle, yet prudent, decisive, yet considerate, sound in discipline without severity. As to her own part, it was held that the loss of time for teaching which she might require was compensated for by the better teaching which she could supply when at work; that with care her own health would not suffer; and that the effect of occupation

amongst the young was more likely to be conducive to the health of her own children than the monotony of indolence or the pursuit of other and more exacting pursuits.

The contest was very finely balanced, and opened up a variety of important points. But that which struck me as the most important, was the broad question of the natural work of women in creation, and whether woman is as free as man for all manner of physical and mental labour? It is to this question I propose to direct attention in the present essay.

If we admit that it is the necessary part of the life of a woman that she shall become a mother, we at once place her in a position altogether different from man in regard to the work which she is born to perform, even apart from that belonging to motherhood.

The extremely logical, who assume that women not only can but ought to perform the work of men, boldly meet this and every other difficulty by saying that women who are able to work need not accept the anxieties and responsibilities of marriage and motherhood. They would leave such anxieties and affectionate cares to those of the female sex who have no minds for other cares, and no ambitions extending beyond the little magic centre which is called the home.

From this stand-point there is much to be said. If women may be divided safely and discriminately into two sects, one of those who are to be mothers, and another of those who are not to be, then the difficulty is, from the physiological aspect of a subject singularly physiological, practically settled. One set of women, that is to say, are in the same position as men for general work, and ought to have the same privileges for obtaining work.

In the days when I was a student of medicine, it was professed that women were entirely different from men in regard to capacity for physical and for mental exercise. One of my professors, an anatomist of considerable and well-deserved reputation, systematically taught that the anatomical disposition of the muscles in woman was such that certain acts which boys and men could easily perform could never be carried out by girls or women. He gave, as an illustration, the muscular mechanism that is employed in the act and art of throwing a ball. Girls and women could never learn to play at cricket because they never could throw a cricket-ball with

any force or any precision. The muscles required for the work were not developed for such a purpose. The deltoid was too attenuated and too fan-shaped; the biceps and triceps were too long for their breadth; the pectorals were altogether inadequate, and the subscapularis and other muscles which act against them were equally deficient. The leverage and mechanism of the skeleton was also imperfect; the bones were too light and feeble, and the shoulder-joint was so shallow in its receiving part that dislocation would be constantly imminent even if the muscular capacity were sufficient.

As these various deficiencies were made matters of direct demonstration during dissections of the parts involved, the evidence seemed to be full and satisfactory in support of the theory that was advanced upon the evidence, and we were content to believe what we had seen and heard. For my own part, when I, in turn, became a teacher on the same subjects, I taught the same doctrine and illustrated it in precisely the same way, in which proceedings I was entirely supported by my colleague, the late Amédée Deville, certainly one of the cleverest anatomists that France ever lent to England; and, to the best of my recollection, the most perfect anatomical demonstrator I have ever known.

In like strain, when the position of the representatives of the two sexes was studied in respect to mental as distinct from physical exercises, we were taught to look upon women as again differing in degree of capacity from men. I had the privilege of hearing George Combe deliver an introductory discourse to a course of lectures on the Henderson trust, at Anderson's University, in 1845–6. In that discourse Combe expressed decisive views as to the sexual differences of mental power. He compared the cast of the head of the so-called 'Infant Sappho' with the head of the Calculating Boy, and he argued that each head was so organically different in construction, as the result of sex, that one could never approach the other in detail of work. The Infant Sappho could never have learned to calculate, although she had the best head of the two, and although she came nearer to a calculator than any other on the female side of humanity. But in this particular she merely resembled all other women, who from time immemorial could never calculate or become great arithmeticians. Once more I, for one, followed my master as a teacher and repeated what I

fully believed to be true, in dealing with the topic of female capacity for mental labour.

I recall another similar argument. I recall a discussion in which several able and learned men were engaged, and in which it was debated whether women possess any trace of inventive power or skill. 'See,' said one of the debaters, 'one astounding fact. Women in all times have acquired the arts of knitting, spinning, weaving, and sewing. In these arts they have been far more employed than men. They were always proficients in these arts, and, as one would suppose, knew all that was wanted to secure rapidity, neatness, and durability. Yet, where is there to be found, in history, a woman who made the faintest improvement in these arts? The stocking-frame, who invented that? The spinning jenny, who invented that? The stocking-loom, who invented that? The sewing-machine, of all machines a woman's, who invented that? Did a woman ever invent anything?' I ventured to suggest that Hypatia was credited with the invention of the hydrometer, and of being one of the most distinguished professors of mathematical science. If that be true, was the answer – and what proof is there of its truth? – it were an exception, and the exception proves the rule.

I do not altogether accept the belief that exceptions must prove the rule. I know a great number of instances in which the exception disproves the rule utterly and confoundedly; but I let it pass for gospel at the time, and I believe all of us, the lords of the creation at that meeting, went to bed under the full and satisfactory impression that woman has no inventive powers whatever; that in every art and science she is the mere imitator of man; and, that the longer she is kept to the imitating department of human work in all that is useful and of good report, the better for them and the better for us all.

But the clenching argument against women was *the brain*. The weight of the brain and the size of the convolutions – they were the tests. For was it not beyond question that the brain of the female in all living families, and signally in the human family, is of less weight than the brain of the male sex, and less convolutionary in respect to the size of the convolutions?

M. Parachappe's investigations were considered as demonstrative that the brain of the women, all reasonable excuses being allowed in its favour, is nine per cent., on the average, under the weight of the brain of man.

Altogether the case stood very bad against women as the rivals of men; unless it were said – and who could say the contrary? – that the motherhood business governed everything that relates to organisation. In further proof it was inculcated that the portion of the nervous system which, since the time of the illustrious Bichat, has been called the organic, vegetative, or sympathetic system, that system the centres or ganglions of which are placed, chiefly, within the trunk of the body, away from the centres of intelligence, the brain and spinal cord, and in close connection with the great organic viscera in or near the cavities of the chest and the abdomen, – that this system is more fully developed in women than in men. Hence in women the sympathetic mind is more active than in men. The woman rushes readily into tears, into excitement, into paroxysms of fear, and love, and hope, and sympathy; while the man remains calm, firm, less sympathetic, and most easily desponding. Hence the sign of disturbance in the highly toned organic nervous system of woman is hysteria; the sign of disturbance in the lower toned organic nervous system of man is hypochondriasis.

The state and condition of thought and belief which I have here sketched was the current article three decades ago. Women accepted it with as much credence as men; some men, and still more women, hold to it at the present hour.

A change of thought on this subject has, nevertheless, occurred of late years – a change so extreme as to be quite phenomenal. For it two distinct reasons, one practical, the other theoretical, may justly be assigned.

The practical has come first – a circumstance not common in the development of great social revolutions. It commenced, if my observation be correct, entirely by and through the study of medicine. A few women of unusual character and strength of mind determined to win their way into the field of medical industry. What they went through to attain that object; how they fought; by what strait and narrow ways and byeways they conflicted, until they reached the goal they had in view, would call for another and longer essay than the present; would call up, indeed, a page of the social history of the latter part of this century that would form a picture of itself, without any other interrupting matter.

The result has been victory for women in medicine, which, like many other victories, has led to collateral progressions

similar in kind. If one woman can obtain the degree of Doctor of Medicine or the Membership of a College of Surgeons, why should not another woman win as a wrangler, or a physicist, or a classic? Why, in any competitive mental trial, should not a woman enter the arena? Medicine is good as showing a field in which some women have won their first prizes; but medicine is not all the world, although it has to be gratefully named as the first opening for women's activity away from the fireside and the domestic drudgery. By it the spell was broken which Hector fixed on his Antromache and her sex:-

No more, but hasten to thy tasks at home,
There guide the spindle and direct the loom.
Me glory summons to the martial scene,
The field of combat is the sphere for men.

But with the breaking of that spell, women have forced themselves into almost every sense of competition in which their brothers engage, except martial engagement, for which some, probably, are ready.

While this purely practical change has been in progress, there has sprung up the new theoretical variation of opinion to which some reference was made a few lines above. Since development by evolution has become the leading scientific idea, we have been led to conceive that those peculiarities in women which admittedly have rendered them incapable of performing masculine work in equality with men, is not due to any primitive failure incident to sex, but to failure of development incident to the mode in which the so-called gentler sex has been brought up. If men were brought up in the same way as women have been; if men were made to move hedged about with petticoats and dragging long trains in the mire; if men were nipped in corsets; if men were found to live within doors; if men were forbidden to play or work at active muscular exercises; if men were not permitted to follow science, art, literature, then men would be as incapable as their sisters. Just as the Prince Charlie dogs, by back evolutionising, have, as Herbert Spencer has shown, lost their once powerful jowls by being fed on soft foods, so a race of Hercules would become effeminate if they were trained, generation upon generation, to effeminate pursuits.

Is it so? Is it true that women have been rendered small in skeleton, muscle, brain, because in them these parts have not

been permitted to develop? If this be true, then the incompetency of women is due, not to natural primitive design, but to natural result of conservative saving of developmental life and activity.

Reviewing by modern light this theory, it seems clear that the theory is correct; that it tallies with the practice; and that women, equally with men, are capable of developing into physical and mental capacity for any kind of skill, invention, strength, or endurance.

Returning to practical proofs as superior to theoretical inferences, all the evidence which has recently been acquired points in the one direction, in favour of the new belief. Without the advantage of a generation for preparation, the women of this generation have, I believe, solved the problem in their own favour.

One woman has shown such mathematical learning as to put male wranglers themselves on their best mettle; another, in a mixed examination of the most excruciating kind, has come out against her male competitors with what are called 'honours of the first class;' a third, competing in feats of strength, skill, and endurance, such as tricycling, has carried herself over country roads a hundred and sixty miles in a single day; and thousands of women have shown, since the introduction of games like lawn tennis, that the idea of the deficiency of women, anatomically, was a delusion of the past.

Moreover, in certain forms of inventive skill many women have proved themselves quite the equals of men. They have proved it in the construction and in the arrangement of subjects of works of fiction; in the art of painting; in the laying out of furniture within the house; in the planning of grounds and gardens, large and small. It may be, therefore, that if in purely mechanical arts, such as the invention of engines and other machines, and if in some fine arts, as the composition of music, women up to this time have been wanting in originality, the defect has arisen from the simple circumstance that they have not had the training and opportunity necessary for proficiency in these kinds of inventive talent, while there may fairly be adduced for them, as a set off, the fact that under extreme emergencies they have been equal to men in mechanical dexterity, fortitude, and endurance. Grace Darling is a ready illustration in proof of this last-named fact; while, occasionally, under circumstances peculiar rather than emergent, a

woman has played the part of a man for a number of years without being suspected, not to say detected, of being a woman. I know of an instance in which a woman, disguised as a man, got, in her early years, into the fighting service, as a surgeon; pursued the vocation she had chosen in the same disguise until the end of a long and active life; fought two duels; rose to eminent position in the service; and died, keeping her curious secret up to her last breath.

Women of the modern school, fighting their own battles without any disguise or eccentricity, have proved themselves the equals of men in many branches of labour which, through the past ages, have been considered as pertaining to men alone. At the same time they have richly improved themselves in other vocations, in which they have been allowed to have a limited qualification. In histrionic art; in almost every art that may be called imitative, such as telegraph work, copying, cooking, cleaning, decorating, they have advanced with rapid strides; and, in industries where repetition is the order of the day, have become, I believe, in the end, quite as automatically perfect as their male compeers. In the course of the present year I visited a factory where women were at work before the lathe, the vice, the anvil, making parts of important and delicate machinery in steel, iron, and brass. They were whitesmiths, turners, and brass-finishers. Struck with so novel a sight, I spent an hour in the shops with them, looking at the works they carried out, and I am bound to say that better and truer workmanship I never beheld. The dexterity with which those who worked with the hammer used that instrument; their correctness of eye in measuring minute distances and irregularities; the rapidity with which they turned out work from the lathe; and, the ease and accuracy with which they collected and put the various parts together in order to complete the instruments they were producing, was a new study, to me sufficient of itself to correct the early and incorrect impressions I had acquired, if nothing else in the way of evidence had been brought under my observation. There was no exhibit in these workers of any deficiency of muscular perception or skill. Everything done was decisively done, quickly done, accurately done, and strongly done.

I have noticed also, since I have got on the right tack for observing correctly, that in some muscular work women have the advantage of men. Women do not stand so firmly as men,

but they sit more firmly. In turning the pedals at the lathe, in working the pedals of the tricycle, and in working the pedals of the organ in organ playing, women have more decisive and firmer control than men, because they sit so much firmer and have the power of using their lower limbs, in the sitting posture, to greater advantage.

The reason for the advantage in this way gained is anatomical. The woman sits more firmly than the man because of the larger size of the pelvis. She rests, when she is sitting, on a broader basis than a man, and for sedentary work is more firmly balanced.

But this, if I may so put it, is a temporary advantage, and one which might soon be lost under a modification of social rules and habits. The larger pelvis of the woman is the evolutionary outcome of child-bearing, and as that has been an evolution confirmed over and over again since women first took on themselves to have children, it has become so natural a condition, according to the common modes of assigning fixed conditions to nature, that we might apply to women the attribute of a special natural advantage in the use of the lower limbs for sedentary work. The idea, however, would be as true as it would be false, because the condition is dependent altogether on circumstance totally distinct from sedentary occupation.

Summing up the whole of the argument so far submitted to the reader, it seems to me that we are driven, by the facts of practice and by the light of theory, to the unavoidable conclusion that women can, if they like, and if they are permitted to have their likings, become as men in relation to all manner of work. There is no reason whatever why, as in the old days, they should not be Spartan women once more under a new name; there is no reason why they should not become athletes and win races and wrestlings and other matches similar in kind. There is not the slightest reason why a female eleven at Lord's should not be ready to play and sometimes beat the All England eleven, the eleven of Players, the Australian eleven, or any other eleven that could be put in the field.

My friend Dr. Withers Moore will, I think, if he reads the above, consider that I am running very far away from the beat he has lately chosen to take as one of the guardians of the

public. Not so. I am now about to enter on the beat he has chosen, and on which I have long been a traveller and student.

I stand by the statement that women could, by training and change of social custom, rival men. I am ready to admit that a race of women could be trained by whom – leaving out the faculty of invention in mechanical construction, about which there may be some reservation – all the labours of men could be performed. But I admit as fully, that for such an end to be attained certain modifications would be necessary which all persons might not enjoy nor feel inclined to patronise. It is only fair to point out, without bias, what these modifications would introduce into the civilised human family.

The first necessary modification would have relation to dress. A petticoated generation could never do the full work of a generation whose limbs were free of petticoat encumbrance. The practice on the stage tells us that. In long petticoats women could neither climb, race, drive engines, walk, ride, work at the bench, nor work at the lecture-table, the school, or the laboratory, with the facility of men as men are attired. Whatever, therefore, there is of elegance in the present form of female attire, that must be sacrificed to the necessities of competition with men, in the work common to men. It may be that there is not much to be said against this change. It may be argued, even by women, that the pulling along of pounds' weight of clothes, which lie on the ground, and require, for comfort, a page or waiting-maid to carry them, is a tax of the worst kind on human endurance; to women a plague, to men a joke. It may be that the modern woman's absurd fashionable dress, which turns her into a semi-erect dromedary, is not all that could be desired; but for her to play her part as the rival of man in work she must change dress altogether, and be left as free of limb as men. If she is not to be so far emancipated, then she bids fair to remain as she has been all along the course of time, a woman; a human being, by the common consent of mankind in relation to dress, restrained by dress; a woman proud of her grand robes, content to bear the weight of them, content to tolerate the inconvenience of them, and content to suffer herself to be admired under all such unnecessary pains and penalties.

To many women it would be a great sacrifice to give up these outward and visible signs of women's dignity and women's destiny; for dignity and destiny in her case combine. The dress

she wears under the *régime* of woman, the mother of men and women, is the sign of the destiny which holds her from the active work of men, and which affords her the opportunity for bedecking herself, so as to fulfil her destiny with elegance and fascination. But at work in creation to compete with men, the flowing and embarrassing dress must go; the milliner must seek a new trade; the books of fashion must be consigned to the fashion of books, they must be placed on the shelf; and, ingenuity of a new order must invent a new style of picturesque female clothing adapted to the new kind of life.

If women are to spend their lives in occupations commonly followed by men, they and the world must submit to another modification. They must compromise also in the matter of what is called personal beauty. The occupations of men are very soon stamped on them in the expression of the visage, in the tone of voice, in the carriage of the body, in the shape and size of the hands, in the attitudes of standing and sitting, and in the combination of all those peculiarities which make up the man after his calling. A well-known inspector who once sat by me at a masonic banquet, and who proved to be one of the most interesting talkers I ever met, told me that when he wanted to find out who a man was, he 'began by getting at his business habits, which were far better than his clothes to go by, though they weren't without their true value; because a man can change his clothes, but his business habits never, so that when you know them well they are certain guides as to what he is about when he is at home.'

Through all the pursuits followed by men, some peculiarities are, in fact, developed which impress their marks on the man; and if woman finds it to be her work in creation to follow these same pursuits, she must be content to assume the same peculiarities. Already, in the short and fitful experience which we have had in the transference of the work of men on to the shoulders of women, the striking and inevitable peculiarities incident to the work assumed have become most manifest, someone told me the other day 'grotesquely' manifest; and although I decline to endorse the adjective employed – because whatever belongs by necessity to a great profession cannot be grotesque unless the profession be so too – I admit the fact of change and foresee its immense influence on the future life of womankind. In plain words, we have to inquire whether, for the happiness of men and of women, any of our women ought

to accept the fate of man in respect to personal attributes of expression, form, manner, derived from occupation. As my grotesque friend put it, shall beauty die on the altar of female independence?

I need not try to answer a question which is already beginning to answer itself, but shall seize the present as the most fitting place for saying something more about motherhood and its incompatibility with work of the kind that now pertains to men.

Granting that women may be divided into two classes, we solve all difficulties. We say then that women who do not want to be mothers of children may become mothers of any profession or industry. The solution is most satisfactory if the division be not carried too far. If it become the fashion to have too many mothers of industry, serious complications will soon arise. Men are admittedly a selfish and jealous-minded race when interfered with too severely; and if their industries are seriously menaced, they may turn round and give ground for dangerous opposition. In one instance they have done so. The printers, I remember, in an establishment where women printers were introduced, held a 'chapel,' and even in that sacred precinct leagued themselves against the invasion into their calling. The doctors are as yet not altogether reconciled to the raid of the women on their field of labour. The lawyers obstinately refuse them all rights. The Church, willing to have them as handmaids and helpers, forbids them the pulpit with no hesitating voice. And, in one of the large manufacturing towns the men all rose to a man quite recently, when it was proposed in their workshops to let women do the work at the anvil, the vice, and the lathe, which, as I have shown, they can do so neatly, quickly, and dexterously.

This danger, however, is not so great as another. It is provoking and yet true, that for women to exist there must be mothers, and as mothers are not capable of performing the work of men in full competition, either a large number of women who are not competitors in men's work must remain, or mothers must go out altogether, and then what will become of both women and men? The catastrophe suggested by such social puzzles is happily not likely to happen in our time, and we may be content at present to give to every woman who has the fixed resolution to enter on the sphere of labour usually allotted to man full freedom to follow her own course. At the

same time the advice which Dr. Withers Moore has tendered is a wise warning to the most hazardous and most self-sacrificing of the earnest class of women who feel they ought to be abreast with, if not in advance of, men in learned and professional pursuits at least. They, like men, want to be told the truth, and to many of them who are ambitious to distinguish themselves as great students and great workers, the truth cannot be told too plainly. Whatever they may do or desire to do, they are but women, and as women they must at least be as cautious as men, a point they are overlooking altogether. If they do more than men it is because they work more than men, and that is often mere insanity of competitive ambition.

It adds to the dangers by which these female aspirants are beset, that the forms of competition to which they subject themselves are those which are least conducive to health. Were the competitive work more decidedly physical than it is, the risks would be less than they are. But the extreme mental labour amongst women which we now see, the submission to examinations of the severest kind on subjects of the most intricate nature, is bringing about evils which to my mind are of the solemnest import. The rush now made by women is towards what is called graduation. A woman must have a degree of some kind, and must obtain it by an ordeal of examination on a variety of subjects, which, as a common rule, she must undergo before she has reached maturity. To the physician this course is so obviously injurious, that he cannot avoid challenging it. I challenge it for two reasons; first, because it frequently leads to direct impairment of the physical well-being; and, secondly, because it is a worthless exhibition of labour as a part of the career of the young of either of the sexes. The practice is called one of graduation, but in truth there is no graduation in it. Graduation in its old, natural, and legitimate sense, means the slow and steady progression of the student, step by step, from one branch of knowledge or skill to another. In the University, where every branch of knowledge is taught, the student of a past day went through a systematic course of training in each subject, and was simply examined by the professor from day to day or week to week on the progress made in that one particular branch. After a few years spent in learning by this method, step by step, the graduate, if he desired to proceed from the

University accomplished and accredited in some direction
which led to a profession, submitted himself to a conclave of
the professors under whom he had studied, and after
satisfying them that he was sufficiently learned by a moderate
further proof of his knowledge, obtained his degree or
diploma. I do not deny that some evils crept into this system.
Important degrees were, occasionally, conferred too loosely.
The professor became content with the observation of the
work of the student in class, and, for his own repose as well
as for the ease of those be taught, made the final examination
too easy. The University also became under this system too
exclusive; the learner must learn within four particular walls,
or his progress towards the distinction of the degree was
impossible. Yet, on the whole, when anything like a liberal
admission into the College or University was permitted,
when it was allowed that the poor as well as the rich could
enter the four walls, and when it was permitted that studies
might proceed without residence within the four walls as part
of the curriculum, the system answered, in regard to men, in
the most satisfactory manner. The history of the four great
Scottish Universities teems with evidence of the grand
national results for good which have been rendered by the
step-by-step method. The success of the Scotchman in getting
on so successfully in all parts of the world into which he has
been imported has been due to the advantages afforded him
by his nearly free University system, coupled with the life at
home, which saved him on the one side from monkish
severity of life, and on the other side from the riotous levity
of the fast members of the college-room and cloister.

No kind of passage to a degree by mere examination,
however rigid, could ever have done for Scotland what her
true system of graduation has done for her. By it she
grounded her sons in knowledge, honoured them with her
mark of approval, stamped them with he own seal, and let
them go forth into the world to develop the knowledge they
had gained, and apply it to their own wants and natural
progress in the paths they had chosen as their own. Had
Scotland admitted her daughters to the same privileges from
the first, what an incalculable boon she would have
conferred on humanity. She would have proved by the best
experiment to what extent woman may rival men, and what
is the true part of woman in the work of the world when she

is left free to learn as she may will. The present system, alike injurious to men and women, might then never have been developed nor the insane rivalry born of it.

The present system is not graduation. The degree obtained under it is not, strictly, a degree at all. It is mere conveyance in a rapid, dangerous, and whirligig sort of manner to the crest of the mountain of learning, not a steady journey to that crest by well-known paths, with good guides as conductors through every step of the way. To women this rapid mode of ascent would be hazardous if they could become, by long training, of the same strength and capacity with men; if, that is to say, they could divide into two distinct classes of their own sex – the one determining to be masters out and out in any department they may choose: the other giving up all such exclusive desires, and resolved to follow the old, old task of linking themselves to the already stronger sex, and becoming the nursing mothers of the generations that are to succeed them.

Under any circumstances, under any determinations, the present strain after extreme learning is mortal. Women, though they may give up every thought of matrimony, are unequal to the strain, and had better remain unequal. For men to strive, in a few short months, to attain as much knowledge as will enable them to satisfy a body of specialist examiners, every one of whom would on his own subject pluck the other, is mad enough. For a woman to get ready to meet these examiners, and satisfy each examiner so perfectly, that the whole shall combine to say she is perfect, she shall have a degree, she shall have honours, she shall be supplied with proof that she has gone through an ordeal which we might not have gone through ourselves had we come up for it, is madness extending into sin.

There are a few women of orderly and systematic minds, women who have passed into full womanhood, who can face such an ordeal without apparent injury. I admit the fact from knowledge of the truth. But to the majority there is no such immunity from danger. The majority or women who try it are left fitted neither to be masters nor mothers. Their work in creation has not been discovered by it, and they have no settled plans derived from it. By some strange fatality, which they themselves cannot explain, they often drift, after all has been said and done, into matrimony, and when the domestic

anxieties press on them, find that their servants, who have had no elaborate education at all, may be better fitted for the duties of domestic life than they are. They have lost their true place in creation.

And what is still more embittering is the fact, that what they seemed to have learned, while they were struggling through the rapid journey to the top of the mountain of knowledge, has become of no service to them whatever. They often cannot so much as communicate any part of it to their own children. I have had an instance before me where the admission was full and free, that every portion of the supposed knowledge, gained under extremest labour, and brilliant to a fault when it was at its best, has within a few years – I had almost said months – passed entirely away, its ashes on the head of a feeble offspring that had better not have been born.

The reader will, I trust, gather from this essay, as an expression of my own observation, three indications: (1) That, physiologically, there is nothing to be advanced against the rising belief, that women may, under systematised training, attain to the same faculty and power of work as men. (2) That in order to reach this position of vantage, if it be one, women must train after the manner of men, must be content to remain a powerful and free caste of women, without maternal ties or domestic responsibilities connected with families of their own blood and nurture. (3) That for such women to attain to perfect power in mental learning and attribute, they must proceed by graduation, step by step, slowly, patiently, evenly, persistently, and must ignore altogether the current temptation of appearing before a band of professional experts, in order to prove themselves equally great on any subject which any expert may choose to employ as a test of proficiency in his particular department.

While I venture to offer these indications, I do not feel prepared to say that I think the world would be better if they were acted upon. There is an old proverb which says that 'two persons are good company, but three are no company at all,' and on this question it is doubtful whether the existence of what would practically be three sexes, would be good company for the world at large. It would have a powerful tendency for leaving the responsibilities of maternity to the weakest mothers, about as bad an evil as could befall the

human race; and I fear it would not make the working hives of women satisfied and happy.

Far better, it seems to me, will it be for our women to proceed, as far as they like, step by step, towards the best and most useful general knowledge; to keep together in one common bond as women; and, to let the love and care of the mother be, after all, the crowning joy and ambition of woman's work in creation.

WOMAN'S WORK IN CREATION:
A REPLY

Longman's Magazine, Vol. 9 (1886)

Eliza Orme

Dr. B. W. Richardson, in an interesting paper under the above title in the October number of this journal, took up a subject which has often called forth strong expressions of opinion from members of his profession and which seems lately to have rankled in the medical mind in an unusual degree. Dr. Withers Moore, in addressing some few months ago the British Medical Congress, made the over-education of women his theme, and protested in set terms against the modern movement which in his own country is even more advanced than in ours. Sir T. Spencer Wells touched upon the same topic in his opening address at the Sanitary Congress, and pronounced an exactly opposite opinion. Dr. Richardson seems to steer a middle course, for while he allows that women can rival men in nearly every kind of work, intellectual and manual, that they choose to practise, he nevertheless does not approve of any such efforts on their part. He declares that every woman must decide in her own mind, and this presumably in her early girlhood, whether she will be a rival or a helpmeet. If the former, she is forthwith to give up feminine attire, allow herself to grow ugly or, at any rate, grotesque, and so far sacrifice her health as to be incapable of having healthy children. By these means she will develop into a kind of nondescript person, capable of doing any or almost any work she chooses. If, however, she prefers to train herself for the old-fashioned domestic duties, she is to remain beautiful and womanly, clothed in trailing skirts and enjoying tolerable health, but quite innocent of any intellectual effort. It is not at all surprising that Dr. Richardson closes his article with a kind-hearted warning against the first of these alternatives. The uninformed lady, 'hedged about with petti-coats and dragging long trains in the mire,' to quote the

Doctor's own expressive words, is not an enviable object. But even she is better than the abnormally developed person of neither sex who is to lose health and beauty in the pursuit of a profession. If Dr. Richardson's premises are true, his conclusion is perfectly correct, and the only wonder is that he has given it in such an apologetic whisper at the end of his story. It is with the object of relieving the minds of the compassionate public, who must be very much distressed at the miserable predicament in which women seem to be placed, that the present reply is written.

Dr. Richardson quotes examples to show that in manual labour and in intellectual work women may succeed at a certain cost to themselves and the world. Let us consider the two kinds of work quite separately. As regards manual labour such as that of whitesmiths, turners, and brass-finishers, it is no modern movement that has offered it to women. Anyone having the most elementary knowledge of the history of English industry can see the fallacy of naming such occupations as hitherto performed by men only. The tendency of our factory legislation for many years past has been in the opposite direction. The strong trade-unions of men have co-operated with philanthropists to shut women out of much work which formerly was undertaken by them. Whether it is right or wrong for women to use their muscles in earning a livelihood, those of the poorer classes have done it for so many generations that we have the results before us. We need not attempt to prophesy the strange evolution that will take place when women work like men, instead of staying at home to nurse their children. We have merely to look about to see what has already taken place under these very conditions. Mrs. Lynn Linton, writing in the *National Review*, falls into precisely the same error, and talks of women working at the pit-brow and in similar industries as if it were something new and of the period. This undeniable fact – namely, that women of the poorer classes have always undertaken hard manual work, and that the effect of modern legislation and public opinion is to lighten and not add to out-of-door occupations – disposes of a large portion of Dr. Richardson's argument as to what peculiar creatures women will become when they are allowed to earn a living by manual work.

One alteration in respect of female artisans has been threatened, and even partly accomplished, by those holding

advanced views on these subjects. Women are in some trades paid better than they used to be. There is a chance of cases of tyranny and injustice exercised by capitalists or overseers being inquired into and publicly exposed. Protective unions have been formed amongst them, and some higher interests than the daily struggle for bread have been introduced into their lives. In some few instances they have been admitted to share the benefits earned by those who are called the aristocracy of the labouring classes. For example, a few weeks ago a conference of delegates from printers' unions resolved that women should be admitted on equal terms to their organisations. These changes will not make women harder worked, but better paid, and it cannot be supposed that, even if they are the mothers of young families, that alteration will hurt them.

Having cleared away the mistake of assuming that manual labour is any new privilege for women, we are left to deal with the intellectual work which they are only now being permitted to undertake, and which Dr. Richardson considers they can succeed in accomplishing if they give up their feminine characteristics and become in fact a third sex. The experience we have of women doctors, women higher-grade teachers, and so forth, is so small, that it seems an absurdity to generalise; but so far as that experience has shown anything, it does not in the least carry out Dr. Richardson's suppositions. There are three main points that he has touched upon. The first, and least important, is dress. He considers that the modern costume of women must be very much altered before they can, as he calls it, 'rival men,' or, as others prefer to describe it, 'earn their living by congenial occupation.' Why should it be more necessary for women to discard petticoats than for barristers to discard wigs? Petticoats are a slight incumbrance if the wearer desires to walk quickly, and are troublesome if she is out of doors in wet weather. Wigs are extremely irksome, and even unhealthy, when worn in a heated court of justice, and during the performance of highly intellectual work. If our judges and counsel are to be forgiven the little weakness of preferring fashion to comfort, the same leniency may be extended to self-supporting women of the educated classes. Let the medical men who feel so acutely the disability of ladies' dress contrast themselves attired for ordinary professional work on a hot June morning with their sisters and daughters starting for college. The doctor is tightly inclosed in black or very dark-coloured

cloth, either leaving his chest comparatively exposed or giving it the benefit of double and treble layers of cloth, according to whether he favours the fashion of a shirt front or a buttoned-up frock-coat. A stiff collar surrounds his throat, and a tall black hat, inclosing a column of heated air, is on his head. This painful uniform of fashion has to be worn during the whole day, although his scientific training insures his knowing that his dark clothing absorbs the heat, and his tight collar, his braces, and his hat interfere with the healthy circulation of his blood. Now consider the pleasant summer costume of what is called the advanced woman. She wears a loose graceful dress of a light shade in colour and of flimsy woollen material. Her straw hat is ventilating throughout and is trimmed with white gauze, so that the sunheat is scarcely felt. Instead of an iron collar stiff with relentless starch, her throat is surrounded with a soft falling lace tucker, and in short her whole costume is exactly suitable to the weather, and because it is suitable it is beautiful. Contrasted with the black cloth, the tall hat, and the barrister's wig, it is the perfection of rational dress. Every unprejudiced person must agree that the medical men should begin with their own sex if they desire reform in dress. In winter it is true men's clothes are less unsightly, but those of sensible women are still not so absurd for winter wear as we have seen men's clothes to be for summer wear. The warm cloth jacket, the gracefully looped skirts, and the comfortable velvet or fur bonnets that ladies wear in winter are very healthy and tolerably convenient. They are certainly no serious hindrance to intellectual work of any kind at present attempted. I deny that women need change their fashions before they can work like men, for already the best of these fashions are much more suitable to work in than the fashions of men; and as men put up with the worse, women can put up with the better. If Dr. Richardson means that women cannot earn their bread in ball dresses, I agree with him. But do men go to business in court dress? Or would a judge carry his robes into the hunting field if he had a mind to follow the hounds?

The second point taken by Dr. Richardson is that personal beauty will be lost to women if they spend their lives in occupations commonly followed by men. With regard to manual occupations affecting the shape of the hands or the complexion we have already spoken. The thing has been tried for centuries. Our factory girls and gleaners and other rough

workers have always had their share of the love and reverence of their own class, and they will continue to have it in spite of all scientific prognostications to the contrary. With regard to the new openings for women in intellectual occupations, it seems impossible that these will leave any disagreeable traces in the appearance of those who follow them. There may be an exchange from an expression of unsatisfied wishes in the face of an untutored girl to that of happy complacency in that of one now well taught what she has a taste for; but I can think of no other probable alteration in appearance. The thousands of female teachers carefully trained for their profession, and now earning comfortable incomes under our school boards, form a class of comely young and middle-aged women, well dressed, and of pleasing, self-possessed manners. Our great singers and actresses, as highly trained and as hard-worked as the members of any profession, have never been noted for any oddity of appearance or for loss of feminine beauty. Dr. Richardson vaguely alludes to some instances in which 'beauty has died on the altar of female independence;' but those who have a very wide acquaintance among the English women, pioneers in the new movement, cannot recall a single instance which accords with his experience. Probably what has misled him is the fact that, whereas in the old days none but beautiful women would have been noticed at all in society, now even the plain have their chance if they are gifted with intellect. Mme. de Staël was not made plain by her literary work, but, being a plain woman, was yet noticed as an authoress. If a lady with red hair, harsh prominent features, and ungainly proportions, is introduced into society as a great lioness, it may be distasteful to the worshippers of a Griselda Grantley. Still, it is extremely illogical to assume that any particular avocation in life is the cause of the unpleasing appearance. It is not at all difficult for any social observer to test Dr. Richardson's accuracy on this point. Attendance at the annual prizegiving at one of the large public schools where nearly all the girls are trained to pass examinations; or at the annual ceremony of giving degrees at the University of London, in Burlington gardens; or at a tournament of lawn tennis, between two of our ladies' colleges – any of these easy experiments will decide at once whether systematic study has the effect of making young girls no longer beautiful in feature, form, and expression, or graceful in movement and manner.

Dr. Richardson's third point is, the danger for women, and more especially for those who are afterwards to bring up children, of overworking themselves in cramming for examinations. It is possible, without sharing his exclusive admiration for the system of the Scotch Universities, to endorse entirely his wise words as to the danger and folly of cramming. But he is altogether too narrow in defining the class he addresses. Not only women who after their studious years will marry and have children, but all women, should be mindful of their health, and should guard with jealous care the machine with which they must do their life's work, of whatever kind it may be. There is no need to divide women into two classes of wives and old maids on this account. We do not want a race of ailing mothers in England, nor do we want a race of ailing unmarried women. All the duties likely to be undertaken by women who, from want of inclination or opportunity, do not marry, had best be left alone unless the workers have sound health. Sick nursing in hospitals, teaching in schools, medical practice, business, art – every well-paying occupation demands good strong health; and she who attempts to earn her living after ruining her constitution by injudicious overwork will have but a poor success. Nor should Dr. Richardson have stopped at women. His warnings equally apply to men. To work oneself to the edge of brain disease is a foolish preparation for the hard competition of modern life, and the lesson is as necessary for young men as for young women. Instead of dividing his fellow-creatures into men and women, and subdividing the latter into those intending to lead single lives and those contemplating matrimony, and addressing to the last subdivision only the excellent advice to take care of that most precious possession, health, Dr. Richardson should have laid down the golden rule for the whole of mankind and womankind, with all the force of expression at his command.

Although none will deny that the reasonable precautions to preserve health during the period of school and college life are serious duties to be inculcated by teachers and observed by pupils, yet there are many, and these particularly among members of the medical profession, who consider it far more dangerous to society if women who afterwards become mothers break the laws of health than if others do so. But it will be seen by every ordinary observer of our times that such a selection of life as that suggested by Dr. Richardson is an

absolute impossibility. Our English girls do not as a rule have fixed notions of their future, and certainly do not conform to any which may exist in the minds of parents and guardians. The beautiful fiction of the princess sleeping until the prince arrives to awaken her expresses one of the great secrets of the purity and happiness of English homes. Whatever physical or intellectual training is good for those who are to become wives and mothers, that training must be given to all alike, and it must be left to the thousand chances of life how the knowledge acquired by a girl and the character developed in her will be afterwards used. Instead of teaching young women that they may decide for themselves whether they will marry or not, it is safer and happier to inculcate exactly the opposite. Let them store their minds with knowledge useful under any circumstances. Let them arm themselves with sensible, carefully formed opinions, and habits of self-reliance and self-control, and then, if they are blessed with a good constitution, they may earn an honest livelihood either as the heads of their husbands' households or as independent workers. Every sensible girl knows well enough that she cannot decide beforehand which position in life she will fill. What she can decide is that whatever work comes to her she will be prepared to do well.

If all cultured women are to receive the same kind of education, it becomes a very serious responsibility for any who believe they have influence to consider whether they are doing good or harm by encouraging close study and, in cases where girls desire it, a professional training. On the one hand we find a good deal of medical testimony against such study and training. A formidable band of eminent men, headed by Mr. Herbert Spencer, tells us that women, in order to do their natural work in the best possible manner, should only study with a view of being pleasing in society. On the other hand, we have the experience of many able women who have brought up girls and watched them in after life, and we have also the conclusions which our own reasoning powers enable us to draw from undoubted facts. Medical men, and, indeed, all who have devoted their best energies to the investigations of natural science, are almost entirely incapacitated for the correct solution of social problems. They have acquired a habit of studying objects through the microscope, or deadened by anæsthetics, or under the strict control and discipline of a hospital ward. To them men are as chess pawns, to be moved

here or left there, as science dictates. The friction introduced by the constant exercise of free will is forgotten, and thus their calculations as to human action are never realised. This is no doubt the reason why science, with all its modern progress, has affected so slightly the legislation of our country. Medical men are not politicians. They seldom take an active part in political contests, and are not found in high political places. They are satisfied to be indirectly represented in the legislature, and have so little influence upon its action that laws are passed, like those promoted by the anti-vivisectionists, actually hurtful to their most valuable investigations. If the doctors cannot solve their own social problems, and guide skilfully their own political course, it is not to be expected that they can do so any better for women. They regard all human beings as passive patients, who are to have their failings examined, diagnosed, and prescribed for. They forget that unruly patients will refuse the prescription.

Let us grant for the sake of argument that England would be a greater nation and the English a happier people if all English-women devoted their best energies to purely domestic concerns – if young girls learned as their sole technical acquirements the art of taking care of their own bodily health and that of their children; if all undue excitement were banished, and no risks were run of injuring in the slightest degree the physical strength of the next generation. How should we set about accomplishing this state of things? By denying to women higher education and the choice of professional work? Should we make our girls quiet in mind and healthy in body by leaving them untaught or by teaching them only the accomplishments supposed to be pleasing in society? Experience tells us that a good disposition and a contented mind are the essentials for a quiet life. Restless girls find an outlet in balls, private theatricals, fox-hunting, aimless imitation of young men, mischievous bohemianism, and in plenty of other ways, tedious to enumerate. Compared with the loss of health, temper, and personal dignity involved in the hare-brained race for such excitements as these, even a competitive examination after insufficient preparation is a harmless venture. The miserable condition of women who suffer from what they call 'nerves,' and which shows itself in fretfulness, depression of spirits, hysteria, and other specially ladylike maladies, is generally the consequence of mistaken management of health during the risky period for a few years

after leaving school. Some girls, having no aim in life, sacrifice their health by the painful performance of trivial duties of no importance in themselves, and which would never be insisted upon if there were any serious work to do. Others fall ill from sheer ignorance of the most elementary laws of health. Others, seeing no change of happiness but in a good marriage, risk everything to outshine their rivals in society. Others, from dullness and the carelessness bred of idleness, waste their strength in follies which they know are hurtful. Are any of these dangers incident to the newly discovered openings for women's work? Are any of them the probable condition of girls in careful training for professional careers? To those who have watched the upbringing of girls, it seems rather a preventive than a cause of delicacy of health to give them rational employment. For these reasons, it may be doubted whether medical men have hit upon the right cure for the evil of over-excitement and over-fatigue among women. Granting all that their physiological propositions establish, it is probable that their want of political skill may entirely prevent them from solving what is after all nothing but a social problem.

It should be remembered that the women who are sure to come within the doctor's purview are those who are ill. There are plenty of strong healthy girls, middle-aged women, and women considerably above middle age, who are fighting the battle of life without any injury to their constitutions, some of them remaining unmarried and some of them bringing up, wisely and well, healthy, happy children. But such women as these do not consult physicians. They have no occasion to. It is the unfortunate few who have been handicapped from the beginning with a bad constitution, some inherited weakness perhaps, or who have unwisely overstrained themselves, that come under the observation of the doctors. Now there is one cause of this occasional overstrain that might well be guarded against, and in this way the small number of women who break down from over-education might be made even less than it is.

The new openings for women are still little known among middle-class parents. A man with a large family to provide for invests money in teaching his boys money-getting pursuits, but leaves his daughters without technical knowledge. The consequence is that nearly all the girls, whose independence and originality of character prompt them to learn some congenial occupation, have to pay by interim work the cost of their own

training. Unless they are of age, with money of their own, they have to teach, or write, or act as lady companion, or in some way keep the pot boiling while they acquire and pay for the training which is to fit them ultimately for better work. It is only because serious-minded women have some great advantages over the generality of male students that this double strain of simultaneous earning and learning has not kept them far behind in the race. Women who are voluntary students in any art or profession have undoubtedly some great advantages over average male students. They have not been pressed into the work by conventional prejudice or family tradition. They have not the expensive and health-destroying habits learned by university men at college wines and in smoking saloons. They regard their work as a great privilege instead of a heavy task. In fact, they are necessarily in the state of mind of an enthusiastic lover of his profession. Any scholarships enabling women to carry on their students' work without the care of breadwinning at the same time will lessen the real causes of loss of health. The same good effect will be produced by enlightening the public, and gradually bringing home the truth to the somewhat darkened minds of parents. With the census returns before us we may see at once that a large number of Englishwomen must either remain unmarried and earn their own livings, or else emigrate to the New World. This fact must be recognised in its full significance before we can usefully reason about the wisest way of bringing up girls. Unless parents are prepared to send their girls abroad, they must furnish them with a good technical education such as will enable them to live independently. To count upon a girl being provided for by marriage, and to teach her nothing but the duties of a married woman, is about as foolish as it would be to count upon a boy becoming heir to a fortune and to teach him nothing but the duties of a landed gentleman. It is at least a comfort to know that, although all women without private fortunes must learn to earn their living, and a good proportion of them must actually use their knowledge and work, yet there is no occasion for the existence of the third sex, nor even for the startling change of the costume of women described by Dr. Richardson. We shall do well to take his warnings against overwork in good earnest and share them with our brothers. As to his prophecies of the Coming Race, they are more amusing than alarming.

MENTAL DIFFERENCES BETWEEN MEN AND WOMEN

The Nineteenth Century, Vol. 21 (1887)

George J. Romanes

In his *Descent of Man* Mr. Darwin has shown at length that what Hunter termed secondary sexual characters occur throughout the whole animal series, at least as far down in the zoological scale as the Articulata. The secondary sexual characters with which he is chiefly concerned are of a bodily kind, such as plumage of birds, horns of mammals, &c. But I think it is evident that secondary sexual characters of a mental kind are of no less general occurrence. Moreover, if we take a broad view of these psychological differences, it becomes instructively apparent that a general uniformity pervades them – that while within the limits of each species the male differs psychologically from the female, in the animal kingdom as a whole the males admit of being classified, as it were, in one psychological species and the females in another. By this, of course, I do not mean that there is usually a greater psychological difference between the two sexes of the same species than there is between the same sexes of different species: I mean only that the points wherein the two sexes differ psychologically are more or less similar wherever these differences occur.

It is probably due to a recognition of this fact that from the very earliest stages of culture mankind has been accustomed to read into all nature – inanimate as well as animate – differences of the same kind. Whether it be in the person of Maya, of the pagan goddesses, of the Virgin Mary, or in the personifications of sundry natural objects and processes, we uniformly encounter the conception of a feminine principle coexisting with a masculine in the general frame of the cosmos. And this fact, as I have said, is presumably due to a recognition by mankind of the uniformity as well as the generality of psychological distinction as determined by sex.

I will now briefly enumerate what appear to me the leading features of this distinction in the case of mankind, adopting the ordinary classification of mental faculties as those of intellect, emotion, and will.

Seeing that the average brain-weight of women is about five ounces less than that of men, on merely anatomical grounds we should be prepared to expect a marked inferiority of intellectual power in the former.[1] Moreover, as the general physique of women is less robust than that of men – and therefore less able to sustain the fatigue of serious or prolonged brain action – we should also on physiological grounds be prepared to entertain a similar anticipation. In actual fact we find that the inferiority displays itself most conspicuously in a comparative absence of originality, and this more especially in the higher levels of intellectual work. In her powers of acquisition the woman certainly stands nearer to the man than she does in her powers of creative thought, although even as regards the former there is a marked difference. The difference, however, is one which does not assert itself till the period of adolescence – young girls being, indeed, usually more acquisitive than boys of the same age, as is proved by recent educational experiences both in this country and in America. But as soon as the brain, and with it the organism as a whole, reaches the stage of full development, it becomes apparent that there is a greater power of amassing knowledge on the part of the male. Whether we look to the general average or to the intellectual giants of both sexes, we are similarly met with the general fact that a woman's information is less wide and deep and thorough than that of a man. What we regard as a highly cultured woman is usually one who has read largely but

1 This is proportionally a greater difference than that between the male and female organisms as a whole, and the amount of it is largely affected by grade of civilisation – being least in savages and most in ourselves. Moreover, Sir J. Crichton Browne informs me, as a result of many observations which he is now making upon the subject, that not only is the grey matter, or cortex, of the female brain shallower than that of the male, but also receives less than a proportional supply of blood. For these reasons, and also because the differences in question date from an embryonic period of life, he concludes that they constitute 'a fundamental sexual distinction, and not one that can be explained on the hypothesis that the educational advantages enjoyed either by the individual man or by the male sex generally through a long series of generations have stimulated the growth of the brain in the one sex more than in the other.'

superficially; and even in the few instances that can be quoted of extraordinary female industry – which on account of their rarity stand out as exceptions to prove the rule – we find a long distance between them and the much more numerous instances of profound erudition among men. As musical executants, however, I think that equality may be fairly asserted.

But it is in original work, as already observed, that the disparity is most conspicuous. For it is a matter of ordinary comment that in no one department of creative thought can women be said to have at all approached men, save in fiction. Yet in poetry, music, and painting, if not also in history, philosophy, and science, the field has always been open to both.[2] For, as I will presently show, the disabilities under which women have laboured with regard to education, social opinion, and so forth, have certainly not been sufficient to explain this general dearth among them of the products of creative genius.

Lastly, with regard to judgment, I think there can be no real question that the female mind stands considerably below the male. It is much more apt to take superficial views of circumstances calling for decision, and also to be guided by less impartiality. Undue influence is more frequently exercised from the side of the emotions; and, in general, all the elements which go to constitute what is understood by a characteristically judicial mind are of comparatively feeble development. Of course here, as elsewhere, I am speaking of average standards. It would be easy to find multitudes of instances where women display better judgment than men, just as in the analogous cases of learning and creative work. But that as a general rule the judgment of women is inferior to that of men has been a matter of universal recognition from the earliest times. The man has always been regarded as the rightful lord of the woman, to whom she is by nature subject, as both mentally and physically the weaker vessel; and when in individual cases these relations happen to be inverted, the accident becomes a

2 The disparity in question is especially suggestive in the case of poetry, seeing that this is the oldest of the fine arts which have come down to us in a high degree of development, that its exercise requires least special education or technical knowledge, that at no level of culture has such exercise been ostracised as unfeminine, that nearly all languages present several monuments of poetic genius of the first order, and yet that no one of these has been reared by a woman.

favourite theme for humorists – thus showing that in the general estimation such a state of matters is regarded as incongruous.

But if woman has been a loser in the intellectual race as regards acquisition, origination, and judgment, she has gained, even on the intellectual side, certain very conspicuous advantages. First among these we must place refinement of the senses, or higher evolution of sense-organs. Next we must place rapidity of perception, which no doubt in part arises from this higher evolution of the sense-organs – or, rather, both arise from a greater refinement of nervous organisation. Houdin, who paid special attention to the acquirement of rapidity in acts of complex perception, says he has known ladies who, while seeing another lady 'pass at full speed in a carriage, could analyse her toilette from her bonnet to her shoes, and be able to describe not only the fashion and quality of the stuffs, but also to say if the lace were real or only machine made.' Again, reading implies enormously intricate processes of perception, both of the sensuous and intellectual order; and I have tried a series of experiments, wherein reading was chosen as a test of the rapidity of perception in different persons. Having seated a number of well educated individuals round a table, I presented to them successively the same paragraph of a book, which they were each to read as rapidly as they could, ten seconds being allowed for twenty lines. As soon as time was up I removed the paragraph, immediately after which the reader wrote down all that he or she could remember of it. Now, in these experiments, where every one read the same paragraph as rapidly as possible, I found that the palm was usually carried off by the ladies. Moreover, besides being able to read quicker, they were better able to remember what they had just read – that is, to give a better account of the paragraph as a whole. One lady, for example, could read exactly four times as fast as her husband, and could then give a better account even of that portion of the paragraph which alone he had had time to get through. For the consolation of such husbands, however, I may add that rapidity of perception as thus tested is no evidence of what may be termed the deeper qualities of mind – some of my slowest readers being highly distinguished men.

Lastly, rapidity of perception leads to rapidity of thought, and this finds expression on the one hand in what is apt to appear as almost intuitive insight, and on the other hand in that

nimbleness of mother-wit which is usually so noticeable and often so brilliant an endowment of the feminine intelligence, whether it displays itself in tact, in repartee, or in the general alacrity of a vivacious mind.

Turning now to the emotions, we find that in woman, as contrasted with man, these are almost always less under control of the will – more apt to break away, as it were, from the restraint of reason, and to overwhelm the mental chariot in disaster. Whether this tendency displays itself in the overmastering form of hysteria, or in the more ordinary form of comparative childishness, ready annoyance, and a generally unreasonable temper – in whatever form this supremacy of emotion displays itself, we recognise it as more of a feminine than a masculine characteristic. The crying of a woman is not held to betray the same depth of feeling as the sobs of a man; and the petty forms of resentment which belong to what is known as a 'shrew,' or a 'scold,' are only to be met with among those daughters of Eve who prove themselves least agreeable to the sons of Adam. Coyness and caprice are very general peculiarities, and we may add, as kindred traits, personal vanity, fondness of display, and delight in the sunshine of admiration. There is also, as compared with the masculine mind, a greater desire for emotional excitement of all kinds, and hence a greater liking for society, pageants, and even for what are called 'scenes,' provided these are not of a kind to alarm her no less characteristic timidity. Again, in the opinion of Mr. Lecky, with which I partly concur:

> In the courage of endurance they are commonly superior; but their passive courage is not so much fortitude which bears and defies, as resignation which bears and bends. In the ethics of intellect they are decidedly inferior. They very rarely love truth, though they love passionately what the call 'the truth,' or opinions which they have derived from others, and hate vehemently those who differ from them. They are little capable of impartiality or doubt; their thinking is chiefly a mode of feeling; though very generous in their acts, they are rarely generous in their opinions or in their judgments. They persuade rather than convince, and value belief as a source of consolation rather than as a faithful expression of the reality of things.

But, of course, as expressed in the well-known lines from *Marmion*, there is another side to this picture, and, in now taking leave of all these elements of weakness, I must state my honest conviction that they are in chief part due to women as a class not having hitherto enjoyed the same educational advantages as men. Upon this great question of female education, however, I shall have more to say at the close of this paper, and only allude to the matter at the present stage in order to temper what I feel to be the almost brutal frankness of my remarks.

But now, the meritorious qualities wherein the female mind stands pre-eminent are, affection, sympathy, devotion, self-denial, modesty; long-suffering, or patience under pain, disappointment, and adversity; reverence, veneration, religious feeling, and general morality. In these virtues – which agree pretty closely with those against which the Apostle says there is no law – it will be noticed that the gentler predominate over the heroic; and it is observable in this connection that when heroism of any kind is displayed by a woman, the prompting emotions are almost certain to be of an unselfish kind.

All the æsthetic emotions are, as a rule, more strongly marked in women than in men – or, perhaps, I should rather say, they are much more generally present in women. This remark applies especially to the æsthetic emotions which depend upon refinement of perception. Hence feminine 'taste' is proverbially good in regard to the smaller matters of everyday life, although it becomes, as a rule, untrustworthy in proportion to the necessity for intellectual judgment. In the arrangement of flowers, the furnishing of rooms, the choice of combinations in apparel, and so forth, we generally find that we may be most safely guided by the taste of women; while in matters of artistic or literary criticism we turn instinctively to the judgment of men.

If we now look in somewhat more detail at the habitual display of these various feelings and virtues on the part of women, we may notice, with regard to affection, that, in a much larger measure than men, they derive pleasure from receiving as well as from bestowing: in both cases affection is felt by them to be, as it were, of more emotional value. The same remark applies to sympathy. It is very rare to find a woman who does not derive consolation from a display of sympathy, whether her sorrow be great or small; while it is by

no means an unusual thing to find a man who rejects all offers of the kind with a feeling of active aversion.

Touching devotion, we may note that it is directed by women pretty equally towards inferiors and superiors – spending and being spent in the tending of children; ministering to the poor, the afflicted, and the weak; clinging to husbands, parents, brothers, often without and even against reason.

Again, purity and religion are, as it were, the natural heritage of women in all but the lowest grades of culture. But it is within the limit of Christendom that both these characters are most strongly pronounced; as, indeed, may equally well be said of nearly all the other virtues which we have just been considering. And the reason is that Christianity, while crowning the virtue of chastity with an aureole of mysticism more awful than was ever conceived even by pagan Rome, likewise threw the vesture of sanctity over all the other virtues which belong by nature to the female mind. Until the rise of Christianity the gentler and domestic virtues were nowhere recognised as at all comparable, in point of ethical merit, with the heroic and the civic. But when the ideal was changed by Christ – when the highest place in the hierarchy of the virtues was assigned to faith, hope, and charity; to piety, patience, and long-suffering; to forgiveness, self-denial, and even self-abasement – we cannot wonder that, in so extraordinary a collision between the ideals of virtue, it should have been the women who first flocked in numbers around the standard of the Cross.

So much, then, for the intellect and emotions. Coming lastly to the will, I have already observed that this exercises less control over the emotions in women than in men. We rarely find in women that firm tenacity of purpose and determination to overcome obstacles which is characteristic of what we call a manly mind. When a woman is urged to any prolonged or powerful exercise of volition, the prompting cause is usually to be found in the emotional side of her nature, whereas in man we may generally observe that the intellectual is alone sufficient to supply the needed motive. Moreover, even in those lesser displays of volitional activity which are required in close reading, or in studious thought, we may note a similar deficiency. In other words, women are usually less able to concentrate their attention; their minds are more prone to what is called 'wandering,' and we seldom find that they have

specialised their studies or pursuits to the same extent as is usual among men. This comparative weakness of will is further manifested by the frequency among women of what is popularly termed indecision of character. The proverbial fickleness of *la donna mobile* is due quite as much to vacillation of will as to other unstable qualities of mental constitution. The ready firmness of decision which belongs by nature to the truly masculine mind is very rarely to be met with in the feminine; while it is not an unusual thing to find among women indecision of character so habitual and pronounced as to become highly painful to themselves – leading to timidity and diffidence in adopting almost any line of conduct where issues of importance are concerned, and therefore leaving them in the condition, as they graphically express it, of not knowing their own minds.

If, now, we take a general survey of all these mental differences, it becomes apparent that in the feminine type the characteristic virtues, like the characteristic failings, are those which are born of weakness; while in the masculine type the characteristic failings, like the characteristic virtues, are those which are born of strength. Which we are to consider the higher type will therefore depend on the value which we assign to mere force. Under one point of view, the magnificent spider of South America, which is large enough and strong enough to devour a humming-bird, deserves to be regarded as the superior creature. But under another point of view, there is no spectacle in nature more shockingly repulsive than the slow agonies of the most beautiful of created beings in the hairy limbs of a monster so far beneath it in the sentient as in the zoological scale. And although the contrast between man and woman is happily not so pronounced in degree, it is nevertheless a contrast the same in kind. The whole organisation of woman is formed on a plan of greater delicacy, and her mental structure is correspondingly more refined; it is further removed from the struggling instincts of the lower animals, and thus more nearly approaches our conception of the spiritual. For even the failings of weakness are less obnoxious than the vices of strength, and I think it is unquestionable that these vices are of quite as frequent occurrence on the part of men as are those failings on the part of women. The hobnailed boots may have given place to patent-pumps, and yet but small

improvement may have been made upon the overbearing temper of a navvy; the beer-shop may have been superseded by the whist-club, and yet the selfishness of pleasure-seeking may still habitually leave the solitary wife to brood over her lot through the small hours of the morning. Moreover, even when the mental hobnails have been removed, we generally find that there still remains what a member of the fairer sex has recently and aptly designated mental heavy-handedness. By this I understand the clumsy inability of a coarser nature to appreciate the feelings of a finer; and how often such is the case we must leave the sufferers to testify. In short, the vices of strength to which I allude are those which have been born of rivalry: the mental hide has been hardened, and the man carries into his home those qualities of insensibility, self-assertion, and self-seeking which have elsewhere led to success in his struggle for supremacy. Or, as Mr. Darwin says, 'Man is the rival of other men; he delights in competition, and this leads to ambition which passes too readily into selfishness. These latter qualities seem to be his natural and unfortunate birthright.'

Of course the greatest type of manhood, or the type wherein our ideal of manliness reaches its highest expression, is where the virtues of strength are purged from its vices. To be strong and yet tender, brave and yet kind, to combine in the same breast the temper of a hero with the sympathy of a maiden – this is to transform the ape and the tiger into what we know ought to constitute the man. And if in actual life we find that such an ideal is but seldom realised, this should make us more lenient in judging the frailties of the opposite sex. These frailties are for the most part the natural consequences of our own, and even where such is not the case, we do well to remember, as already observed, that they are less obnoxious than our own, and also that it is the privilege of strength to be tolerant. Now, it is a practical recognition of these things that leads to chivalry; and even those artificial courtesies which wear the mark of chivalry are of value, as showing what may be termed a conventional acquiescence in the truth that underlies them. This truth is, that the highest type of manhood can only then be reached when the heart and mind have been so far purified from the dross of a brutal ancestry as genuinely to appreciate, to admire, and to reverence the greatness, the beauty, and the strength which have been made perfect in the weakness of womanhood.

I will now pass on to consider the causes which have probably operated in producing all these mental differences between men and women. We have already seen that differences of the same kind occur throughout the whole mammalian series, and therefore we must begin by looking below the conditions of merely human life for the original causes of these differences in their most general form. Nor have we far to seek. The Darwinian principles of selection – both natural and sexual – if ever they have operated in any department of organic nature, must certainly have operated here. Thus, to quote Darwin himself:–

> Amongst the half-human progenitors of man, and amongst savages, there have been struggles between the males during many generations for the possession of the females. But mere bodily strength and size would do little for victory, unless associated with courage, perseverance, and determined energy. . . . To avoid enemies or to attack them with success, to capture wild animals, and to fashion weapons, requires reason, invention, or imagination. . . . These latter faculties, as well as the former, will have been developed in man partly through sexual selection – that is, through the contest of rival males – and partly through natural selection – that is, from success in the general struggle for life; and as in both cases the struggle will have been during maturity, the characters gained will have been transmitted more fully to the male than to the female offspring. . . . Thus man has ultimately become superior to woman. It is, indeed, fortunate that the law of the equal transmission of characters to both sexes prevails with mammals; otherwise it is probable that man would have become as superior in mental endowment to woman as the peacock is in ornamental plumage to the pea-hen.

Similarly, Mr. Francis Galton writes:–

> The fundamental and intrinsic differences of character that exist in individuals are well illustrated by those that distinguish the two sexes, and which begin to assert themselves even in the nursery, where all children are treated alike. One notable peculiarity in the woman is that she is capricious and coy, and has less straightforwardness than the man. It is the same with the female of every species. . . .

[Were it not so] the drama of courtship, with its prolonged strivings and doubtful success, would be cut quite short, and the race would degenerate through the absence of that sexual selection for which the protracted preliminaries of love-making give opportunity. The willy-nilly disposition of the female is as apparent in the butterfly as in the man, and must have been continually favoured from the earliest stages of animal evolution down to the present time. Coyness and caprice have in consequence become a heritage of the sex, together with a cohort of allied weaknesses and petty deceits, that men have come to think venial, and even amiable, in women, but which they would not tolerate among themselves.

We see, then, that the principles of selection have thus determined greater strength, both of body and mind, on the part of male animals throughout the whole mammalian series; and it would certainly have been a most unaccountable fact if any exception to this rule had occurred in the case of mankind. For, as regards natural selection, it is in the case of mankind that the highest premium has been placed upon the mental faculties – or, in other words, it is here that natural selection has been most busy in the evolution of intelligence – and therefore, as Mr. Darwin remarks, we can only regard it as a fortunate accident of inheritance that there is not now a greater difference between the intelligence of men and of women than we actually find. Again, as regards sexual selection, it is evident that here also the psychologically segregating influences must have been exceptionally strong in the case of our own species, seeing that in all the more advanced stages of civilisation – or in the stages where mental evolution is highest, and, therefore, mental differences most pronounced – marriages are deter-mined quite as much with reference to psychical as to physical endowments; and as men always admire in women what they regard as distinctively feminine qualities of mind, while women admire in men the distinctively masculine, sexual selection, by thus acting directly as well as indirectly on the mental qualities of both, is constantly engaged in moulding the minds of each upon a different pattern.

Such, then, I take to be the chief, or at least the original, causes of the mental differences in question. But besides these there are sundry other causes all working in the same direction.

For example, as the principles of selection have everywhere operated in the direction of endowing the weaker partner with that kind of physical beauty which comes from slenderness and grace, it follows that there has been everywhere a general tendency to impart to her a comparative refinement of organisation; and in no species has this been the case in so high a degree as in man. Now, it is evident from what has been said in an earlier part of this paper, that general refinement of this kind indirectly affects the mind in many ways. Again, as regards the analogous, though coarser, distinction of bodily strength, it is equally evident that their comparative inferiority in this respect, while itself one of the results of selection, becomes in turn the cause of their comparative timidity, sense of dependence, and distrust of their own powers on the part of women, considered as a class. Hence, also, their comparative feebleness of will and vacillation of purpose: they are always dimly conscious of lacking the muscular strength which, in the last resort, and especially in primitive stages of culture, is the measure of executive capacity. Hence, also, their resort to petty arts and pretty ways for the securing of their aims; and hence, in large measure, their strongly religious bias. The masculine character, being accustomed to rely upon its own strength, is self-central and self-contained: to it the need of external aid, even of a supernatural kind, is not felt to be so urgent as it is to the feminine character, whose only hope is in the stronger arm of another. 'The position of man is to stand, of woman to lean;' and although it may be hard for even a manly nature to contemplate the mystery of life and the approach of death with a really stoic calm, at least this is not so impossible as it is for the more shrinking and emotional nature of a woman. Lastly, from her abiding sense of weakness and consequent dependence, there also arises in woman that deeply-rooted desire to please the opposite sex which, beginning in the terror of a slave, has ended in the devotion of a wife.

We must next observe another psychological lever of enormous power in severing the mental structures of men and women. Alike in expanding all the tender emotions, in calling up from the deepest fountains of feeling the flow of purest affection, in imposing the duties of rigid self-denial, in arousing under its strongest form the consciousness of protecting the utterly weak and helpless consigned by nature to her charge, the maternal instincts are to woman perhaps the strongest of all

influences in the determination of character. And their influence in this respect continues to operate long after the child has ceased to be an infant. Constant association with her growing children – round all of whom her affections are closely twined, and in all of whom the purest emotions of humanity are as yet untouched by intellect – imparts to the mother a fulness of emotional life, the whole quality of which is distinctly feminine. It has been well remarked by Mr. Fiske that the prolonged period of infancy and childhood in the human species must from the first 'have gradually tended to strengthen the relations of the children to the mother,' and, we may add, also to strengthen the relations of the mother to the children – which implies an immense impetus to the growth in her of all the altruistic feelings most distinctive of woman. Thus, in accordance with the general law of inheritance as limited by sex, we can understand how these influences became, in successive generations, cumulative; while in the fondness of little girls for dolls we may note a somewhat interesting example in psychology of the law of inheritance at earlier periods of life, which Mr. Darwin has shown to be so prevalent in the case of bodily structures throughout the animal kingdom.

There remains, so far as I can see, but one other cause which can be assigned of the mental differences between men and women. This cause is education. Using the term in its largest sense, we may say that in all stages of culture the education of women has differed widely from that of men. The state of abject slavery to which woman is consigned in the lower levels of human evolution clearly tends to dwarf her mind *ab initio*. And as women gradually emerges from this her primitive and long-protracted condition of slavery, she still continues to be dominated by the man in numberless ways, which, although of a less brutal kind, are scarcely less effectual as mentally dwarfing influences. The stunting tendency upon the female mind of all polygamous institutions is notorious, and even in monogamous, or quasi-monogamous, communities so highly civilised as ancient Greece and pagan Rome, woman was still, as it were, an intellectual cipher – and this at a time when the intellect of man had attained an eminence which has never been equalled. Again, for a period of about 2,000 years after that time civilised woman was the victim of what I may term the ideal of domestic utility – a state of matters which still

continues in some of the continental nations of Europe. Lastly, even when woman began to escape from this ideal of domestic utility, it was only to fall a victim to the scarcely less deleterious ideal of ornamentalism. Thus Sydney Smith, writing in 1810, remarks: 'A century ago the prevailing taste in female education was for housewifery; now it is for accomplishments. The object now is to make women artists – to give them an excellence in drawing, music, and dancing.' It is almost needless to remark that this is still the prevailing taste: the ideal of female education still largely prevalent in the upper classes is not that of mental furnishing, but rather of mental decoration. For it was not until the middle of the present century that the first attempt was made to provide for the higher education of women, by the establishment of Queen's College and Bedford College in London. Twenty years later there followed Girton and Newnham at Cambridge; later still Lady Margaret and Somerville at Oxford, the foundation of the Girls' Public Day Schools Company, the opening of degrees to women at the University of London, and of the honour examinations at Cambridge and Oxford.

We see, then, that with advancing civilisation the theoretical equality of the sexes becomes more and more a matter of general recognition, but that the natural inequality continues to be forced upon the observation of the public mind; and chiefly on this account – although doubtless also on account of traditional usage – the education of women continues to be, as a general rule, widely different from that of men. And this difference is not merely in the positive direction of laying greater stress on psychological embellishment: it extends also in the negative direction of sheltering the female mind from all those influences of a striving and struggling kind, which constitute the practical schooling of the male intellect. Woman is still regarded by public opinion all the world over as a psychological plant of tender growth, which needs to be protected from the ruder blasts of social life in the conservatories of civilisation. And, from what has been said in the earlier part of this paper, it will be apparent that in this practical judgment I believe public opinion to be right. I am, of course, aware that there is a small section of the public – composed for the most part of persons who are not accustomed to the philosophical analysis of facts – which argues that the conspicuous absence of women in the field of intellectual work

is due to the artificial restraints imposed upon them by all the traditional forms of education; that if we could suddenly make a leap of progress in this respect, and allow women everywhere to compete on fair and equal terms with men, then, under these altered circumstances of social life, women would prove themselves the intellectual compeers of man.

But the answer to this argument is almost painfully obvious. Although it is usually a matter of much difficulty to distinguish between nature and nurture, or between the results of inborn faculty and those of acquired knowledge, in the present instance no such difficulty obtains. Without again recurring to the anatomical and physiological considerations which bar à priori any argument for the natural equality of the sexes, and without remarking that the human female would but illustrate her own deficiency of rational development by supposing that any exception to the general laws of evolution can have been made in her favour – without dwelling on any such antecedent considerations, it is enough to repeat that in many departments of intellectual work the field has been open, and equally open, to both sexes. If to this it is answered that the traditional usages of education lead to a higher average of culture among men, thus furnishing them with a better vantage-ground for the origin of individual genius, we have only to add that the strong passion of genius is not to be restrained by any such minor accidents of environment. Women by tens of thousands have enjoyed better educational as well as better social advantages than a Burns, or Keats, or a Faraday; and yet we have neither heard their voices nor seen their work.

If, again, to this it be rejoined that the female mind has been unjustly dealt with in the past, and cannot now be expected all at once to throw off the accumulated disabilities of ages – that the long course of shameful neglect to which the selfishness of man has subjected the culture of woman has necessarily left its mark upon the hereditary constitution of her mind – if this consideration be adduced, it obviously does not tend to prove the equality of the sexes: it merely accentuates the fact of inequality by indicating one of its causes. The treatment of women in the past may have been very wrong, very shameful, and very much to be regretted by the present advocates of women's rights; but proof of the ethical quality of this fact does not get rid of the fact itself, any more than a proof of the criminal nature of assassination can avail to restore to life a

murdered man. We must look the facts in the face. How long it may take the woman of the future to recover the ground which has been lost in the psychological race by the woman of the past, it is impossible to say; but we may predict with confidence that, even under the most favourable conditions as to culture, and even supposing the mind of man to remain stationary (and not, as is probable, to advance with a speed relatively accelerated by the momentum of its already acquired velocity), it must take many centuries for heredity to produce the missing five ounces of the female brain.

In conclusion, a few words may be added on the question of female education as this actually stands at the present time. Among all the features of progress which will cause the present century to be regarded by posterity as beyond comparison the most remarkable epoch in the history of our race, I believe that the inauguration of the so-called woman's movement in our own generation will be considered one of the most important. For I am persuaded that this movement is destined to grow; that with its growth the highest attributes of one half of the human race are destined to be widely influenced; that this influence will profoundly react upon the other half, not alone in the nursery and the drawing-room, but also in the study, the academy, the forum, and the senate; that this latest yet inevitable wave of mental evolution cannot be stayed until it has changed the whole aspect of civilisation. In an essay already alluded to, Sydney Smith has remarked, though not quite correctly, that up to his time there had been no woman who had produced a single notable work, either of reason or imagination, whether in English, French, German, or Italian literature. A few weeks ago Mrs. Fawcett was able to show us that since then there have been at least forty women who have left a permanent mark in English literature alone. Now, this fact becomes one of great significance when we remember that it is the result of but the earliest phase of the woman's movement. For, as already indicated, this movement, is now plainly of the nature of a ferment. When I was at Cambridge, the then newly established foundations of Girton and Newnham were to nearly all of us matters of amusement. But we have lived to alter our views; for we have lived to see that that was but the beginning of a great social change, which has since spread and is still spreading at so extraordinary a rate,

that we are now within measurable distance of the time when no English lady will be found to have escaped its influence. It is not merely that women's colleges are springing up like mushrooms in all quarters of the kingdom, or that the old type of young ladies' governess is being rapidly starved out of existence. It is of much more importance even than this that the immense reform in girls' education, which has been so recently introduced by the Day Schools Company working in conjunction with the University Board and Local examinations, has already shaken to its base the whole system and even the whole ideal of female education, so that there is scarcely a private school in the country which has not been more or less affected by the change. In a word, whether we like it or not, the woman's movement is upon us; and what we have now to do is to guide the flood into what seem likely to prove the most beneficial channels. What are these channels?

Of all the pricks against which it is hard to kick the hardest are those which are presented by Nature in the form of facts. Therefore we may begin by wholly disregarding those short-sighted enthusiasts who seek to overcome the natural and fundamental distinction of sex. No amount of female education can ever do this, nor is it desirable that it should. On this point I need not repeat what is now so often and so truly said, as to woman being the complement, not the rival, of man. But I should like to make one remark of another kind. The idea underlying the utterances of all these enthusiasts seems to be that the qualities wherein the male mind excels that of the female are, *sui generis*, the most exalted of human faculties: these good ladies fret and fume in a kind of jealousy that the minds, like the bodies, of men are stronger than those of women. Now, is not this a radically mistaken view? Mere strength, as I have already endeavoured to insinuate, is not the highest criterion of nobility. Human nature is a very complex thing, and among the many ingredients which go to make the greatness of it even intellectual power is but one, and not by any means the chief. The truest grandeur of that nature is revealed by that nature as a whole, and here I think there can be no doubt that the feminine type is fully equal to the masculine, if indeed it be not superior. For I believe that if we all go back in our memories to seek for the highest experience we have severally had in this respect, the character which will stand out as all in all the greatest we have ever known will be

the character of a woman. Or, if any of us have not been fortunate in this matter, where in fiction or in real life can we find a more glorious exhibition of all that is best – the mingled strength and beauty, tact, gaiety, devotion, wit, and consummate ability – where but in a woman can be find anything at once so tender, so noble, so lovable, and so altogether splendid as in the completely natural character of a Portia? A mere blue-stocking who looks with envy on the intellectual gifts of a Voltaire, while shutting her eyes to the gifts of a sister such as this, is simply unworthy of having such a sister: she is incapable of distinguishing the pearl of great price among the sundry other jewels of our common humanity.

Now, the suspicion, not to say the active hostility, with which the so-called woman's movement has been met in many quarters springs from a not unhealthy ground of public opinion. For there can be no real doubt that these things are but an expression of the value which that feeling attaches to all which is held distinctive of feminine character as it stands. Woman, as she has been bequeathed to us by the many and complex influences of the past, is recognised as too precious an inheritance lightly to be tampered with; and the dread lest any change in the conditions which have given us this inheritance should lead, as it were, to desecration, is in itself both wise and worthy. In this feeling we have the true safeguard of womanhood; and we can hope for nothing better than that the deep strong voice of social opinion will always be raised against any innovations of culture which may tend to spoil the sweetest efflorescence of evolution.

But, while we may hope that social opinion may ever continue opposed to the woman's movement in its most extravagant forms – or to those forms which endeavour to set up an unnatural, and therefore an impossible, rivalry with men in the struggles of practical life – we may also hope that social opinion will soon become unanimous in its encouragement of the higher education of women. Of the distinctively feminine qualities of mind which are admired as such by all, ignorance is certainly not one. Therefore learning, as learning, can never tend to deteriorate those qualities. On the contrary, it can only tend to refine the already refined, to beautify the already beautiful – 'when our daughters shall be as corner-stones, polished after the similitude of a palace.' It can only tend the better to equip a wife as the helpmeet of her husband, and, by

furthering a community of tastes, to weave another bond in the companionship of life. It can only tend the better to prepare a mother for the greatest of her duties – forming the tastes and guiding the minds of her children at a time of life when these are most pliable, and under circumstances of influence such as can never again be reproduced.

It is nearly eighty years ago since this view of the matter was thus presented by Sydney Smith:–

> If you educate women to attend to dignified and important subjects, you are multiplying beyond measure the chances of human improvement by preparing and medicating those early impressions which always come from the mother, and which, in the majority of instances, are quite decisive of genius. The instruction of women improves the stock of national talents, and employs more minds for the instruction and improvement of the world: it increases the pleasures of society by multiplying the topics upon which the two sexes take a common interest, and makes marriage an intercourse of understanding as well as of affection. The education of women favours public morals; it provides for every season of life, and leaves a woman when she is stricken by the hand of time, not as she now is, destitute of everything and neglected by all, but with the full power and the splendid attractions of knowledge – diffusing the elegance of polite literature, and receiving the homage of learned and accomplished men.

Since the days when this was written, the experiment of thus educating women to attend to dignified and important subjects has been tried on a scale of rapidly increasing magnitude, and the result has been to show that those apprehensions of public opinion were groundless which supposed that the effect of higher education upon women would be to deteriorate the highest qualities of womanhood. On this point I think it is sufficient to quote the opinion of a lady who has watched the whole course of this experiment, and who is so well qualified to give an opinion that it would be foolish presumption in anyone else to dispute what she has to say. The lady to whom I refer is Mrs. Sidgwick, and this is what she says:–

> The students that I have known have shown no inclination to adopt masculine sentiments or habits in any unnecessary or unseemly degree; they are disposed to imitate the methods

188 Gender and Science

of life and work of industrious undergraduates just as far as these appear to be means approved by experience to the end which both sets of students have in common, and nothing that I have seen of them, either at the University or afterwards, has tended in the smallest degree to support the view that the adaptation of women to domestic life is so artificial and conventional a thing that a few years of free unhampered study and varied companionship at the University has a tendency to impair it.

So far as I am aware, only one other argument has been, or can be, adduced on the opposite side. This argument is that the physique of young women as a class is not sufficiently robust to stand the strain of severe study, and therefore that many are likely to impair their health more or less seriously under the protracted effort and acute excitement which are necessarily incidental to our system of school and university examinations. Now, I may begin by remarking that with this argument I am in the fullest possible sympathy. Indeed, so much is this the case that I have taken the trouble to collect evidence from young girls of my own acquaintance who are now studying at various high schools with a view to subsequently competing for first classes in the Cambridge triposes. What I have found is that in some of these high schools – carefully observe, only in *some* – absolutely no check is put upon the ambition of young girls to distinguish themselves and to bring credit upon their establishments. The consequence is that in these schools the more promising pupils habitually undertake an amount of intellectual work which it is sheer madness to attempt. A single quotation from one of my correspondents – whom I have known from a child – will be enough to prove this statement.

I never begin work later than six o'clock, and never work less than ten or eleven hours a day. But within a fortnight or so of my examinations I work fifteen or sixteen hours. Most girls, however, stop at fourteen or fifteen hours, but some of them go on to eighteen hours. Of course, according to the school time-tables, none of us should work more than eight hours; but it is quite impossible for any one to get through the work in that time. For instance, in the time-tables ten minutes is put down for botany, whereas it takes the quickest girl an hour and a half to answer the questions set by the school lecturer.

These facts speak for themselves, and therefore I will only add that in many of those high schools for girls which are situated in large towns no adequate provision is made for bodily exercise, and this, of course, greatly aggravates the danger of over-work. In such a school there is probably no playground; the gymnasium, if there is one, is not attended by any of the harder students; drill is never thought of; and the only walking exercise is to and from the school. Let it not be supposed that I am attacking the high school system. On the contrary, I believe that this system represents the greatest single reform that has ever been made in the way of education. I am only pointing out certain grave abuses of the system which are to be met with in some of these schools, and against which I should like to see the full force of public opinion directed. There is no public school in the kingdom where a boy of sixteen would be permitted to work from eleven to eighteen hours a day, with no other exercise than a few minutes' walk. Is it not, then, simply monstrous that a girl should be allowed to do so? I must confess that I have met with wonderfully few cases of serious breakdown. All my informants tell me that, even under the operation of so insane an abuse as I have quoted, grave impairment of health but rarely occurs. This, however, only goes to show of what good stuff our English girls are made; and therefore may be taken to furnish about the strongest answer I can give to the argument which I am considering – viz. that the strength of an average English girl is not to be trusted for sustaining any reasonable amount of intellectual work. Upon this point, however, there is at the present time a conflict of medical authority, and as I have no space to give a number of quotations, it must suffice to make a few general remarks.

In the first place, the question is one of fact, and must therefore be answered by the results of the large and numerous experiments which are now in progress; not by any *à priori* reasoning of a physiological kind. In the next place, even as thus limited, the inquiry must take account of the wisdom or unwisdom with which female education is pursued in the particular cases investigated. As already remarked, I have been myself astonished to find so great an amount of prolonged endurance exhibited by young girls who are allowed to work at unreasonable pressure; but, all the same, I should of course regard statistics drawn from such cases as manifestly unfair.

And seeing that every case of health impaired is another occasion given to the enemies of female education, those who have the interests of such education at heart should before all things see to it that the teaching of girls be conducted with the most scrupulous precautions against over-pressure. Regarded merely as a matter of policy, it is at the present moment of far more importance that girls should not be over-strained than that they should prove themselves equal to young men in the class lists. For my own part, I believe that, with reasonable precautions against over-pressure, and with due provision for bodily exercise, the higher education of women would *ipso facto* silence the voice of medical opposition. But I am equally persuaded that this can never be the case until it becomes a matter of general recognition among those to whom such education is entrusted, that no girl should ever be allowed to work more than eight hours a day as a *maximum*; that even this will in a large proportional number of cases be found to prove excessive; that without abundant exercise higher education should never be attempted; and that, as a girl is more liable than a boy to insidiously undermine her constitution, every girl who aspires to any distinction in the way of learning should be warned to be constantly on the watch for the earliest symptoms of impairment. If these reasonable precautions were to become as universal in the observance as they now are in the breach, I believe it would soon stand upon the unquestionable evidence of experimental proof, that there is no reason in the nature of things why women should not admit of culture as wide and deep and thorough as our schools and universities are able to provide.

The channels, therefore, into which I should like to see the higher education of women directed are not those which run straight athwart the mental differences between men and women which we have been considering. These differences are all complementary to one another, fitly and beautifully joined together in the social organism. If we attempt to disregard them, or try artificially to make of woman an unnatural copy of man, we are certain to fail, and to turn out as our result a sorry and disappointed creature who is neither the one thing nor the other. But if, without expecting women as a class to enter into any professional or otherwise foolish rivalry with men, for which as a class they are neither physically nor mentally fitted, and if, as Mrs. Lynn Linton remarks, we do

not make the mistake of confusing mental development with intellectual specialisation – if, without doing either of these things, we encourage women in every way to obtain for themselves the intrinsic advantages of learning, it is as certain as anything can well be that posterity will bless us for our pains. For then all may equally enjoy the privilege of a real acquaintance with letters; ladies need no longer be shut out from a solid understanding of music or painting; lecturers on science will no longer be asked at the close of their lectures whether the cerebellum is inside or outside of the skull, how is it that astronomers have been able to find out the names of the stars, or whether one does not think that his diagram of a jelly-fish serves with admirable fidelity to illustrate the movements of the solar system. These, of course, I quote as extreme cases, and even as displaying the prettiness which belongs to a child-like simplicity. But simplicity of this kind ought to be put away with other childish things; and in whatever measure it is allowed to continue after childhood is over, the human being has failed to grasp the full privileges of human life. Therefore, in my opinion the days are past when any enlightened man ought seriously to suppose that in now again reaching forth her hand to eat of the tree of knowledge woman is preparing for the human race a second fall. In the person of her admirable representative, Mrs. Fawcett, she thus pleads: 'No one of those who care most for the woman's movement cares one jot to prove or to maintain that men's brains and women's brains are exactly alike or exactly equal. All we ask is that the social and legal status of women should be such as to foster, not to suppress, any gift for art, literature, learning, or goodness with which women may be endowed.' Then, I say, give her the apple, and see what comes of it. Unless I am greatly mistaken, the result will be that which is so philosophically as well as so poetically portrayed by the Laureate:–

> The woman's cause is man's: they rise or sink
> Together, dwarf'd or god-like, bond or free.
> . . .
> Then let her make herself her own
> To give or keep, to live and learn to be
> All that not harms distinctive womanhood.
> For woman is not undevelopt man,
> But diverse: could we make her as the man,

Sweet Love were slain: his dearest bond is this,
Not like to like, but like in difference.

Yet in the long years liker must they grow;
The man be more of woman, she of man;
He gain in sweetness and in moral height,
Nor lose the wrestling thews that throw the world;
She mental breadth, nor fail in childward care,
Nor lose the child-like in the larger mind;
Till at the last she set herself to man,
Like perfect music unto noble words.
. . .
Then comes the statelier Eden back to men:
Then reign the world's great bridals, chaste and calm:
Then springs the crowning race of human kind.
May these things be!

THE CAPACITY OF WOMEN
The Nineteenth Century, Vol. 22 (1887)

Edith Simcox

Mr. Romanes's article, published in the May number of this Review, is so excellent an example of the manner in which this subject should be treated, that it invites a few supplementary remarks and qualifications, which scarcely amount to criticism, as they in no way invalidate the general practical conclusions which he advocates.

Mr. Romanes is of opinion, for assignable and intelligible reasons, that 'in the animal kingdom as a whole the males admit of being classified, as it were, in one psychological species and the females in another.' And he is also persuaded that, among human beings, the course of history has resulted in bringing the minds of men and the morals of women respectively to a higher degree of development. The first of these propositions is no doubt true in the main; but so long as vague metaphysical notions about an *Ewigweibliche* continue to becloud the atmosphere, it is important and interesting to note that the psychological and other distinctions of sex are among the after-thoughts of the primæval mother nature.

Who would have ventured to predict, after comparing a rudimentary vertebrate in the undated past, say, with the common ancestor of ants and bees, that the future did not belong to the insects? There is a vast region of animal life in which existence seems renewed by transmigration rather than birth, where parentage is virtually unknown, and where the community is differentiated into castes rather than sexes. By an easy flight of the imagination, we can suppose ants and bees or butterflies to have developed on their own lines to a point as far removed in organisation, morals, and intelligence from the typical rudimentary insect as man is from the rudimentary vertebrate. The psychological distinctions of sex, noted by Mr. Romanes, would have no place in such a world. Even among

the vertebrates, it was not a foregone conclusion from the first that the mother bird or fish should hatch and protect the young: this function is shared or monopolised by the male so often that we can not be certain, if the rulers of the world had been developed from the races that swim or creep or fly, that intellectual birds or moralised reptiles would have noticed the same psychological sex distinctions as ourselves.

Of course it will be said that the existing distinction has emerged and survived because of its natural fitness; that is, that it has proved favourable to the life and development of the higher vertebrates; but there is a difference between things practically useful under given material conditions and things belonging to the eternal and immutable 'nature of things.' Science teaches that nature is eminently mutable, and that all elaborate qualities are the products of lengthy and complex processes of manufacture. Supposing the kind and degree of sex differentiation which was advantageous to mammoths to prove inconvenient to man, we shall find Nature as much open to the reasoning of facts now as in the days when she decided against the sociological experiments of insects and fishes. If the social life of men and women is not modelled upon that of seals or stags, any human propensities which are a mere survival from earlier stages of mammalian development will die out after a few ages of inappropriateness. This is in fact the conclusion at which Mr. Romanes's argument arrives, and we can only hope that it will not lose any of its force from being allowed to begin a stage further back.

With regard to the mental inferiority and moral elevation of women, there are one or two grounds for doubting whether either is quite as considerable as even Mr. Romanes is disposed to maintain. It may seem ungracious to disturb a complimentary consensus of opinion to the effect, as Mr. Romanes expresses it, that 'purity and religion are, as it were, the natural heritage of women in all but the lowest grades of culture.' But if the statement is not quite unassailable historically, its correction had best take the form of a modest disclaimer on the part of women themselves before some brutal misogynist demolishes the flattering illusion, and with it our last poor claim to some impartiality of judgment.

The exceptive clause, that women are devout and virtuous 'in all but the lowest grades of culture,' is not wide enough. The primitive saint, the primitive sage, and the primitive humourist

agree, it must be admitted, in taking a low view of feminine morality. The typical view of the typical woman is as a daughter of Eve, on intimate terms with the old serpent and given to the beguiling of men. The picture may have been – and to a certain extent was – unjust, but it was the one sketched by man while he monopolised the arts of portraiture. Indian rishis and mediæval monks took this view. Their ideal being ascetic, if a woman appeared on the horizon at all, it could only be as an ally of the lower nature they were endeavouring to subdue, and so, not unnaturally, from their point of view, they concluded every woman to be all 'lower nature.' This was unjust because the mass of men who were not ascetics had just as much 'lower nature' as the women, and it was not the fault of the latter that imperfect ascetics found their existence a trial or temptation.

Primitive philosophers have as a rule less to say about women than ascetics, and in place of moral disapprobation feel only a little mild contempt for their intelligence and want of moral elevation; but even in this there is a measure of injustice. The sage despises all women because they are ignorant of philosophy, but he does not despise all men, who are equally ignorant, because some men, he himself at least, have obtained knowledge. Later on, no doubt, cross divisions are established, and a 'religious' woman may be ranked as higher than a lay or lewd man; but from the earliest times even until now, I think, our comparative estimate of the virtue and intelligence of the average man and of the average woman is influenced by the fact that when we talk of men in general we mean all men, the great known to history and the small known to us in the flesh, and that when we speak of women in general we think of the ordinary known sort only.

The first thinkers of the first ages were taken from the class of gentlemen of leisure, rulers of men, possessed of whatever experience life then could teach; their leisure was secured by the industry of wives and slaves, and any latent aptitude their sisters might have had for religion or philosophy was sacrificed to the necessity for grinding corn or looking after the maids. The educational privileges, as one may call them, enjoyed by the favoured few, as a class, were utilised by the tiny cluster of individuals whose natural faculties allowed them to seize the happy moment. But from the prehistoric days when unknown sages translated the experience of primitive *Weltweisheit* into

the language of an ancient saw, from those days down to the last moment of our own degeneracy, it has been and remains true that the ruling minds of the ages have always been a *minority of a minority*, the units selected from a select few, the cream of the cream of the intelligence of their time.

The immortals whose names stand upon the brief list agreed upon by the whole civilised world were men who towered above the heads of a generation of great contemporaries, who as a rule had the way opened before them by an age of great precursors. In art, in literature, in philosophy, this is almost uniformly the case. Suggestive teaching, training that inspirits or provokes to growth, combine with the happy moments of historic and ethnic destiny to produce the cluster of eminent talent which all becomes articulate and effective at the same time. The great men of the great generations educate each other, and the greatest generations produce an immortal or two apiece. The thesis is almost too obvious to need illustration. Plato and Aristotle follow Socrates and the Sophists, as Raphael and Michelangelo succeed Giotto; Shakespeare, Chaucer; and Goethe, Klopstock *plus* Winckelmann, Lessing, and the vernacular *Reineke Fuchs*. So much will be conceded readily, but it is not so easy to understand what the immortals, whose features alone show clearly through the haze of time, may have owed to their long since forgotten contemporaries. Probably, since a heightened sensitiveness to all immaterial influences is a part of genius, the immortal owes even more than lesser men to all that is fortunate in his surroundings, and we can more easily imagine the wits of the 'Mermaid' without Shakespeare than a Shakespeare stranded on a realm of Hayleys. To drop into the familiar regions of modern literary biography, we know what Goethe owed to Schiller, and Coleridge and Wordsworth to each other, as well as to the lesser lights of their society; conscious and unconscious feelings of emulation drove Byron and Shelley to do their best work for each other, just as Thackeray was stirred by his admiration for *David Copperfield* to accomplish *Edmond* and prepare for Colonel Newcome.

If the fashion of the day causes all available talent or genius to be applied to some special branch of study, astronomy, theology, metaphysics, or whatever it may be, the result is of course still more obvious, and all Europe produces schoolmen as France of the Restoration produces romantic fiction in prose

and verse. Héloise and George Sand yield to the spirit of the age like Abelard or Victor Hugo – if they have learnt to read, and the chapter of accidents brings them into the current of intellectual life. But before we can form any opinion as to the fitness of their sex to produce half a dozen immortals in a millennium, we must first ask if historic and social influences have produced a generation of womanly precursors, and a group of women of talent, out of which the missing immortal might have emerged. It does not quite settle the question to say, what is no doubt true, that if women had had stronger brains they might have produced both. The brains both of men and women exercise themselves habitually upon such stuff as the customs of their age and race set before them. An enormous part of the brain power of mankind has been spent, or wasted, in smiting the Philistines hip and thigh: an enormous part of the brain power of womankind has been spent, or wasted, in cajoling Samson. But the victories of Samson pave the way for those of Saul, and the victories of Saul lay the foundations of the throne of Solomon. The daughters of Delilah found no dynasty, though they help to upset a good many. In other words, by following the fashion which required men to fight, the men on the winning side may drift into social and political relations favourable to the growth of civilisation; while the primitive division of labour, which confined women to the tent or homestead, cut them off, as a class, from the educational influences of power and free association with powerful equals. Here and there a woman of exceptional capacity and position might appear by chance among the rulers of men, but the opportunity would be owing to her connection by birth or marriage with the privileged class, and would make no opening for others of her sex.

Once the gulf was formed between the occupations and interests of men and women, it tended naturally to widen and perpetuate itself, until civilisation had made such progress that uncivilised wives went out of fashion, and women began to learn to read. If the workings of intelligence were quite unconditioned, we might ask why, when this first step was taken, women with some masterpieces of literature behind to help them did not develop intellectually, say, like men in and after the Homeric age. But the omission is perfectly intelligible if we are right in supposing that all intellectual movements, and especially such as culminate in the production of a world-

famed genius, originate when a whole class of persons are engaged together in occupations which suggest and stimulate fresh thought and action, under circumstances which allow the individual and the group to act and react upon each other, striking out fresh combinations, and multiplying suggestions and possibilities for those who come after.

Until the present day, even in the most civilised communities, it cannot be said that this social life of the intellect, as one may call it, has been open to women in appreciable numbers. The two above named reached their fame by chance; happily married or happily cloistered – and both had by nature as good a chance as other women of such a fate – both would have remained unknown to letters. Thrown by chance into the current of contemporary thought, their brains began to work to the same tune as their neighbours', and we find them to be made of the same intellectual paste as those able men of a period who, once in a way, find a genius to out-top them. While it is the exception for a woman to find herself in a position to produce anything, it is virtually inconceivable that she should produce immortal work. Nor is it altogether unscientific to hold our judgment in suspense as to what feminine brains may do, should circumstances ever become propitious to their productiveness; for we observe in the past that on the rare occasions when similar demands have been made upon the minds of men and women, chosen in the same way, the nature of the response has been surprisingly similar. Curiously enough, the demands thus made and met are such as the most ancient à priori theories of feminine frailty would have thought most inappropriate. Our primitive sage would certainly have been as ready to believe that women could write immortal poems as that they could discharge the higher functions of government or enter into the higher emotions of the religious life. We may not perhaps think very highly of the wisdom of crowned heads, or altogether endorse the mediæval ideal of saintliness, but we note that when public opinion has called upon women of high birth to rule, they have done so readily and with an amount of intelligence and good-will fully equal to that displayed on the average by masculine potentates.[1] Again, when opinion called men and women equally to embrace a life of religious devotion and asceticism,

[1] At one time in China a succession of able empress-mothers succeeded in establishing something like an irregular feminine dynasty.

women were found as able and willing as men both to follow and to lead, to organise and administer in the interests of the church on the one hand, and on the other to control the hostile forces of the world itself by purely spiritual influences. Here for the first time we find clever women, as a class, provided with a career, in the religious life, and much ability was shown by divers saints, abbesses, and founders or reformers of religious orders for women. Many of them were certainly quite clever enough to have addled their brains over the subtleties of the scholastic philosophy, but public opinion called on them to become saints and did not call on them to become theologians or metaphysicians, and then, as always, popular expectation fulfilled itself.

But, it will be said, men of genius or eminent talent have manifested themselves in social strata where intellectual eminence was neither looked for nor desired. The Ipswich butcher's son is called by his circumstances to be a butcher, not a cardinal, and the long list of 'self-made men' is quoted as a reproach to the other sex, as if women rich and poor had at least had no worse chances than the men who have triumphed over the difficulties of poverty alone. We may observe in passing that the inner circle of immortals is not recruited from the otherwise most justly honoured ranks of the self-taught. The non-existence of a phenomenon must not be mistaken for its impossibility; but we note that men who have had to fight for the rudiments of humane learning have not as a matter of fact ever subsequently reached the very topmost summits of human achievement. But there is a standing difference between the position of the boy or man who has to contend with adverse circumstances before his natural talents find fair play, and the position of girls or women even belonging to the leisured class. The difference is that the boy, if he escapes from the thrall of poverty at all, escapes into the surroundings to which he belongs by nature. The carpenter's boy with a turn for mathematics makes his way to Cambridge; the barber's lad with a taste for cuneiforms gets into the British Museum, and for all purposes of self-development and production the difficulties of birth and origin are left behind. Natural genius and cultivated talent meet on equal terms, and the education of comradeship and emulation is not less available to the poor man's son than to those with whom a kind of learned mediocrity is hereditary, or to those who inherit the means of

cultivating all their natural aptitudes to the utmost. Every age and every branch of thought has its first and second rate men, who rise above a crowd of fellow-workers as the rare immortal rises above a great generation. But first-rate achievement never crowns a lifetime of continuously solitary work, and in many, if not most cases, first-rate ability does not declare itself until promising natural faculties have been matured by exercise and polished by intercourse with other minds in the prime of their activity. Any intellectual coterie may serve to this extent the purpose of a university, and the debates and readings of Mill and the other young utilitarians in London were just as academic as the society in which Arthur Hallam was the leading figure.

It is needless to say that the most studiously disposed or gifted of young women in past generations have been cut off by custom as absolutely from the stimulus of such common intellectual life as from the advantages of university teaching in its stricter form. Middling abilities suffice to enable us to learn what we are taught, and we may agree that no youth is to be called exceptionally clever who cannot pick up, let us say, Greek or algebra without a teacher. But what clever man, who looks back upon the modicum of such learning acquired in or out of school, can imagine the cleverest youth proceeding to do any good with such acquirements amid the trivial occupations and mental solitude of the ordinary middle-class maiden? Youth insists on being amused, and clever youths find intellectual amusements the most fascinating of any; but, as children say, it is dull to play by oneself, and if the game is spoilt for want of school-fellows, the delightful play of young minds, instead of leading up to still more delightful work, gradually loses its charm, and one more of the clever girls, who might have grown into an able woman, drops out of the field altogether, and spends or wastes her brain power in some quite different direction.

Ruling minds, we began by saying, are a minority of a minority, but in fact we arrive at them by a process of winnowing indefinitely repeated and renewed. We have a senior wrangler at least every year; every university generation has its cluster of best men, but the best men of bad years soon drop out of sight, and even the best men of brilliant generations often fail to survive the rigorous tests of after life, and disappoint the hopes which centred on their future. The ability

believed in may have been real, but besides the accidents which may cause a man to obtain less success or reputation than his deeds or powers deserve, there are a thousand circumstances which may prevent powers from turning into achievement, may cause good work to produce less than its fair proportion of result, may make good qualities neutralise instead of reinforcing each other, and, as a result of these or countless other discouragements, may prevent the promises of youth from being fulfilled and leave the man of exceptional ability, who had every change at starting, after all as unproductive of great works as any woman. Then, again, the man in whom his contemporaries have seen the promise of immorality may, through some fault of merit in his character, become, womanlike, content to do something else with his mind. So Charles Austin, held to be the most brilliant man of a brilliant set, was content to spend his life in making a fortune at the Parliamentary bar. Brain force can spend itself on such work, and Charles Austin's cleverness still made itself felt in the narrow sphere he had chosen. But if men, who begin by dreaming of immortality and counting upon celebrity, are constantly found ready to subside into ordinary professional existence, can we wonder that women, who have never had so near a view of the tempting prizes of ambition, should be content to occupy their minds, even when these are really 'strong,' with the ordinary incidents of social and domestic life? Even supposing that there were at a given moment as many girls as boys naturally capable of attaining some degree of intellectual eminence, it would be natural, under all past conditions, for the girls to be choked off into contended obscurity in each case at an earlier stage of their intellectual development than would be the case with a boy of corresponding character, while of those who were not so finally choked off an overwhelmingly larger proportion would swell the ranks of comparative unsuccess, of those who apparently 'might have been' but are not exactly great.

It may even rest with circumstances to decide whether the flower of genius shall show itself or not upon the stock of natural talent. The extraordinary mathematical power of Mrs. Somerville is sometimes quoted as a proof that women at their best are without originality, since Mrs. Somerville at last had as much knowledge as men who do original work, and yet did none herself. But what are the facts? With ordinary teaching, it

will no doubt be admitted that such a born mathematician would have been senior wrangler at Cambridge at the usual age, but poor Miss Fairfax was eighteen before she could get hold of a Euclid, could then only read it in bed at night, and was deprived even of that resource by the confiscation of her candles. She was clever all round at the learning of schools, having taught herself some Greek and Latin as well as algebra, yet, human-like, she was led to go in the groove society prescribed, and submitted to marry, uncongenially, at twenty-four, and to spend her brain power in keeping house and minding babies on a small income. She was over thirty before she obtained possession of such a mathematical library as an undergraduate begins his college course with. When she was over forty she taught herself to stop in the middle of a calculation to receive morning callers, and to take it up where she had left off when they were gone. Can we wonder that no original work was done in a vocation thus cavalierly treated? The young mathematician of genius talks and thinks and dreams of formulæ; his very jokes are in their jargon; facility of manipulation reaches its highest point by constant exercise, and the constant familiarity with certain conceptions not only makes apprehension easier, but also keeps the whole field of mathematical thought so constantly present to the mind that discoveries, as it were, make themselves, in the recognition of new relations, on the suggestion of the known relations embraced in a single glance.

In such a science one sees clearly that genius is only talent carried to a higher power. In all cases, it is by the constant application of the mind to operations of the same character that intellectual work, of whatsoever nature, is made easy to those who are by nature able to perform it; and real mastery of this kind is seldom unrelieved by flashes of more or less brilliant inspiration, unless it is attained too late, after the first vigour of intellectual maturity is exhausted and worn out. But there is a further element of good fortune even in the productiveness of solid work. Circumstances determine whether there is room in this or that field for an epoch-making inspiration, and we cannot tell whether women will furnish their due proportion of original discoveries till we have a due proportion of them engaged in lifelong diligent day labour in the service of thought and knowledge. Probably most of us know venerable 'double-firsts' who have by no means set the

Thames on fire, and we must no more expect certain, prompt, and conspicuous eminence from every girl who takes a good degree than we do from men with the same record.

After all, the practical interest of the question is of the smallest. If women are to do any kind of literary or other intellectual work, however humble, it is for the interest of the community that they shall be taught and required to do it as well as their natural faculties will allow. This is the practical conclusion to which Mr. Romanes' argument points, and it is quite unnecessary for us to waste time and energy in guessing how good their best may prove in the ages which are to come. Reading women are no doubt interested in increasing the amount of good work of all sorts, and in the apparition of immortal works as often as niggard fate allows; but there is no room in the great republic of letters for the small jealousies of sex or nationality. If England has no immortal to produce, we shall be thankful to welcome one from France, and we should be sorry for the world to refrain from producing, if it could, an immortal man in the next decade, in order that an immortal woman – should the twentieth century give birth to such – might reign in more unrivalled eminence. The world and even its immortals exist after all for the many, not the few, and in the case of both men and women alike the main business of education must be to teach the many to understand and enjoy, while the very, very few who can originate or impart will educate each other, if we leave them free to do it and guard against having the light of any promising capacity snuffed out by discouragement in the tender years of youth with their irrecoverable treasures of vitality.

The intellectual capacity or women, then, is a problem – and not a very pressing one – for the future to decide, while their present moral capacity is a matter of observation. Granted that popular opinion may have somewhat underrated the powers which have as yet been imperfectly tested, there is no very apparent reason why it should have overrated the merits which could be proved and numbered, unless indeed there is somewhere hidden in the recesses of the public mind a conviction that after all men and women are 'pretty much of a muchness,' and that therefore, if for any reason we credit one or other of them with any special merit, we must in fairness discover or invent some counterbalancing merit or defect that will make the scales as even as our widest involuntary

generalisations declare them to be. We know of men incomparably wise, we know of women incomparably good, and so it seems natural when we want to generalise about the good qualities of the sexes to speak of men as naturally clever and women as naturally good. But are not the best of men really as good as the best of women? Have there not been in the world's history as many men as women eminent for goodness? We have endeavoured to show why the natural cleverness of women – assuming it to exist – has remained comparatively undeveloped and unproductive; but as regards both cleverness and goodness, is not any kind of eminence in either sex so far the exception as to make us hesitate in claiming either as a psychological sex characteristic?

The earliest comparative estimate of the sexes regards women as both morally and intellectually inferior to men.[2] Subsequently, public opinion has demanded some domestic virtues from women, and, with really commendable consistency, has to a certain extent supplied them with the means of cultivating the same. Accordingly the one virtue of which popular tradition formerly held women to be incapable is now ascribed to them as 'a natural heritage.' Is it not, however, historically certain that the superior chastity of civilised women is the product of sustained, deliberate pressure, legal, social, and religious, and in itself, so far as it exists, a proof of the extent to which the human race has power to realise its own ideals?

It is difficult to assign a date for the beginning of such pressure. Every community as it emerges from barbarism tries its own experiments, and if these are so far unsuccessful that culture and morals in the end break up together, the work has to begin again not very far from the beginning. The ideal of spiritual purity in mediæval Europe is embodied in the conception of a perfect knight, a Percival or Galahad, to whom we find no feminine counterpart or equivalent; the untamed maidenhood of Brunehild of course belonging to quite different and more archaic legendary cycle, without any moral significance. In the time of Boccaccio, it seems that ladies were required to disguise their amusement when very scandalously loose stories were told in their presence; but as they also tell such stories themselves, their protests are evidently more a

[2] 'A Mediæval Latin Poem,' reproduced in the *English Historical Review*, July 1887, may be referred to as a specimen of a copious kind of literature.

matter of manners than morals, and in the days of the *Decameron* the sex had evidently not yet entered upon the enjoyment of its heritage.

It is a long way from Boccaccio to the ladies' novelist of five centuries later, but our fastidiousness evidently grows at an accelerated rate, for Richardson himself appears to our present taste to pitch the standard of feminine virtue rather insolently low; at least he would be open to such a charge if we did not make allowance for the tone of feeling of the age, which was still a shade more barbaric than his own. As regards the particular virtue which poor Pamela was supposed to illustrate, our ideal has certainly been so far raised that she at least no longer satisfies it. But the whole duty of woman cannot be reduced to the single chapter, whether to marry – or not to marry – a rake. And it is an ethical blunder, nearly as offensive as any of Richardson's, to praise the virtuousness of women as a class merely on the assumption that they are all that Pamela was meant to be. Perhaps the assumption now current would add that they sometimes nurse in hospitals and are concerned for the happiness of dogs and cats; which is also in itself a good thing, and a sign of moral progress, since the natural woman is as prone as the natural man to enjoy bull fights and even gladiatorial shows. But civilised man is overtaking civilised woman in the distaste for bull fights, and even this acquired extension of the sympathetic sensibilities is not the whole of human duty.

If it is a damaging illusion to believe that all men are intelligent and well-informed because they are on an average better taught than women, it is not less damaging to assume that all women are fine moral agents because they are more chaste, and dislike the sight of pain more than men. As was argued long ago by an immortal moralist, wisdom and virtue, ignorance and vice, are inseparable, and it is a fact that our women would have been wiser, would have sought and seized knowledge and the means of obtaining it more resolutely for themselves, if their moral fibre had been of a finer and stronger cast than it could be while knowledge was still wanting. A secondary proof, if one is needed, that the intellectual superiority of mankind cannot be so marked as has been supposed, is supplied by the very fact that we do not find in men the marked moral superiority which should go with superior wisdom. But to suppose that superior virtue all round

can co-exist with inferior wisdom, is to suppose walls and towers to be raised without scaffolding and sustained without foundations. In fact, where the knowledge and practical experience of women are defective, so also is their sense of moral obligation. The intellect of women, as a class, has been concentrated and expended upon the incidents of private life and the domestic relations, and within these limits, as a natural consequence, their sense of moral obligation has been developed. Their participation in the public life of the community has been restricted, and hence their knowledge of the needs and duties arising from social and political relations is still very incomplete, while it is impossible alike with men and women for the conscience to speak concerning matters of which the mind has no consciousness at all.

If we are disposed to take a cheerful view of the moral future of the race – and all evolutionists are optimists at heart – we must look forward, not to a continued difference between the functions and ideals of the sexes, but to the evolution of an ideal of human character and duty combining the best elements in the two detached and incomplete ideals. Great men, we have seen, educate each other, and we shall never have both men and women at their best and greatest until we have the cream of the cream of both sexes educating each other towards the highest standard of all imaginable human excellence.

WHAT WOMAN IS FITTED FOR[1]

The Westminster Review, Vol. 127 (1887)

[Henrietta Müller]

There are women who have long held that even the physical incapacities of their sex are the result of circumstances; the frame adapting itself through ages of inheritance and natural selection to the surroundings that formed its destiny. But such opinions have been rather working underground than forcing their way to the surface, perhaps through the despair felt by their advocates of obtaining a hearing, since claims far less thorough-going have been denied with contempt and mockery, the time, seemingly, not being ripe for them. In spite of Darwin's great discovery, in spite of the word "Evolution" ringing in our ears on all sides and in connexion with every other topic, the same fruitless old ground has been gone over and over again in respect to the woman question, just as if no such thing as Evolution had ever been heard of! What are woman's qualities *now*? is she *now* man's equal, is she *now* capable of all that she aspires to be and to do?

Bebel, in his book on "Woman," says, "If a gardener or agriculturalist were to assert that a given plant could not be improved or perfected, although he had never given it a fair trial, or may be had even hindered its growth by wrong treatment, he would be regarded by his enlightened neighbours as a simpleton." Then, on the subject of genius, he says, "The amount of talent and genius in male humanity is certainly a thousand times greater than that which has hitherto been able to reveal itself; social conditions have crushed it just as they have crushed the capacities of the female sex, which has for centuries been oppressed, fettered, and crippled to a much higher degree." This far higher degree of fettering, then, has kept back the genius of women, in fact, often prevented it from

1 [Editor's note: For attribution of authorship see Lucy Bland, *Banishing the Beast: English Feminism and Sexual Morality, 1885-1914* (London, Penguin Books, 1995).]

arising at all, though the absence depends not on sex but on circumstances. Surely, it is impossible to live in the age which Darwin has enlightened, and refuse to believe that this *may be* and in all probability *is* the true view of the matter.

It would be a miracle indeed if the work which has been going on for ages among all things that have life should have passed over one-half the human race, suspending its influence over them alone, of all creatures on the earth's surface. If we admit this view, however, that women have become what they are by their circumstances, we have to admit that our present system of society is wrong and unjust, inasmuch as it still places one sex in a dependent and cramped position, and does its best to force all women, with their varied characters and powers, into the same kind of occupation. Women, after a long graduation in wrong and suffering, find themselves now, in the age of awakening, at an immense disadvantage in consequence of incapabilities which were *not* originally involved in their organization – a disadvantage which counteracts their efforts to advance, or worse still, which deprives them even of the desire of advancement itself.

"Man," it has been said, "is strictly his own creator, in that he makes himself and his conditions according to the tendencies he encourages. For tendencies encouraged for centuries cannot be cured in a single life-time, but may require ages for their cure."[2]

A little knowledge of the history of woman from the earliest times will show how her conditions were made and encouraged *for* her by men, who, through the circumstance of her motherhood (the *curse* might one not say, looking back along the terrible vista of the ages?), were able to enslave her to their will. But the fact of this long adverse race-education is invariably forgotten, when some back-movement towards her hereditary self, some little feminine weakness, overtakes the harassed footsteps of her who is striving to drag her weakened limbs out of the morasses of the past.

At such a lapse what smiles, what head-shakings from the unconvinced, what sighs from fellow-strugglers! How much nobler, how much more knightly would be the attitude of man at this crisis, if instead of standing cynically on the watch for these little womanly failings, he would hold out a brotherly

2 "The Perfect Way," by Anna Kingsford and Edward Maitland. [Vol. CXXVII. No. CCLIII.] – New Series, Vol. LXXI. No. 1.

hand to the sister who, after all, is only inspired by aspirations which in a man are held among the best and noblest of his nature – the love of freedom and the desire of development. For the honour of humanity it can be said that there *are* a few such men, and for their liberality of thought and generosity of sentiment women owe and feel towards them the deepest gratitude and reverence.

With regard to that old and favourite argument: the smaller weight and size of the woman's brain, of course there is the theory of evolution to account for it, but there is also this consideration, not generally allowed for. Certain parts of the brain, we are told, are employed, not in thought, but in directing the bodily machinery; that is to say, the entire brain is not a thinking organ. Therefore, man's larger frame requires a larger brain; but the extra size does not indicate extra thinking power in proportion. Moreover it appears that the weight of the brain varies enormously among intellectual persons of the same sex, and Bebel[3] suggests that the mere cerebral mass and weight (after a certain point) may not be a measure of mental strength, any more than bodily size is a measure of bodily strength. The organization, he thinks, is probably of more importance.[4] Possibly, therefore, women, even in their present state, are not so far behind in respect of thought-machinery as our methods of brain measurement seem to indicate. Be this as it may, however, no one has a right to prejudge the question of woman's future possibilities, and this is unfortunately exactly what every one does. Too many are inclined to view the whole question from the personal stand-point; one can generally discover what sort of women a man has associated with by his opinions on this movement. This is natural, but it is not fair. It throws too heavy a burden on the shoulders of women who are only fighting their way to freedom, and who have upon them still the impress of their former life, and of the lives of their mothers for countless generations.

To satisfy their judges such women must show themselves absolutely consistent, absolutely fair, absolutely logical, or

3 Bebel, who quotes Professor Redam.
4 Bebel would probably admit that, *other things being equal*, size *is* a measure of strength, whether of the brain or of the muscles. Without guarding against the false impressions that are given by his assertion, he draws attention to the fact that size of brain and quality of brain substance (or organization) do not appear to have any necessary connection. He warns us to beware of judging a question without taking all the data into account.

their cause, in the judges' estimation, suffers with themselves. Are *they* fair and logical in attaching it thus to a personality? It is in vain for women to plead that these qualities are not considered imperative in man; this only embitters their opponents and foredooms themselves as one-sided controversialists. Though lacking a man's infinite advantages of training, health, absence of nervous susceptibility and keenness of feeling, a woman must out-Herod Herod in her logic and her "sweet reasonableness," keeping herself unspotted from all false, doubtful or even untimely argument. If she speaks the truth too soon – the truth that men themselves come to acknowledge a little later – she damages her cause in the present. Those who might have been willing to listen to mild half-claims and assertions are frightened off by the bold and simple whole. This may be good discipline, but it is very severe upon the new pupil. She must be panoplied with strength and tact and gentleness; her logic and her temper should be flawless; she must be prepared to listen with a smile to the most tumble-down old arguments; she must hold back the bitter answer that rises to her lips at some suave taunt or insult offered to her and to her sex, perhaps by some foolish young man who knows nothing of the hard places of her life, or the deep and stirring tragedies of womanhood. More pathetic still, it may be, she must listen to the arguments of some sister, steeped in the old traditions, and holding on with the fervour of ignorance to the solidities of the present which she fears to exchange for the unknown possibilities of the future. And what *are* these solidities of the present to which so many women cling? They are simply the remnants of the original savage state, wherein (as Leslie Stephens puts it) "a man obtained his wife by knocking her down."

> To him, therefore [he continues], the ideal feminine character must have included a readiness to be knocked down, or at least unreadiness to strike again; and as some of the forms of marriage recall the early system, so in the sentiments with which it is regarded, there may still linger something of the early instinct associated with striking and being struck.

Who can doubt that it does linger? Even in the higher kind of fiction the acme of female excellence seems always to be reached by a patient submission to the most detestable

ill-treatment and tyranny on the part of a husband. The more abominable the man, the more perfect the woman who endures his ill-conduct without rebellion. And so all women, and alas! most easily women of the nobler kind, are preached into a moral suicide which makes it harder and always harder for those that come after them; their own well-endured sufferings piling stone on stone to the torture-houses of the future.

But side by side with all this there exists at the present moment a deep-seated, wide-spreading dissent from the old modes of feeling. Women are written about, and thought about as they have never been written about and thought about before; there are few thinkers who do not feel called upon to take some view of the matter, though it may be the strange unmodern one of Lecky, who sees a solution for the necessity of so many women to earn their living, in a return to the monastic system of the Middle Ages. Had he suggested the painless extinction of these inconvenient clamourers for their daily bread, his proposal would really have been more merciful. How does it happen that from men to women (between whom as individuals the greatest human love is supposed to be possible) there should be so little mercy, so little justice or sympathy?

Women are generally said to have concrete ways of thinking, while men deal with abstractions. But man appears unable to be just and merciful to *woman*, though he may be loving and tender enough to *one* woman who has pleased his fancy or won his affection. Does this show an abstract mind? That men do not know anything about the sufferings of women is not surprising, for the latter have been trained to conceal them from their male relatives lest the knowledge should give them pain. This care was scarcely necessary, as men are not quick at seeing the hardships from which their own lives and organization protect them, and they could have borne the knowledge of their existence, we may safely conclude, without unmanly wincing. But in fact no one is eloquent enough to bring before the minds of those to whom nature and circumstances for ever make such suffering impossible, a true picture of an average woman's life, with its thousand weary little burdens, its fretting anxieties and cares and pains, made doubly hard to bear by the flaw that will be almost invariably found in a woman's health, a flaw surely indicating some evil condition, whether inflicted on the sufferer by herself or others. Bebel affirms that experienced doctors assure us that the greater number of

married women, especially in towns, are in a more or less abnormal condition. That one fact alone speaks volumes.

The want of refreshing congenial work goes hand in hand with unremitting claims upon the time and thought, ceaseless small duties, unrelieved by any space of time when the work is done and the mind is free to throw aside its worries, and recruit itself with study or recreation. There is no change, no alternate stringing and unstringing; the bow is always bent, and who shall say that this fact alone is not enough to account for the rapid exhaustion of their youthful energies now regarded as natural to women? Anyhow the normal woman's life – supporting as she does an elaborately cumbrous domestic machine upon her shoulders – is full of care and weariness with very little compensation, and when she also bears the burden of motherhood and the rearing of children, the position is one of severe and unremitting strain. What wonder that the health suffers, that the freshness of life is utterly gone, and that its good things are missed? In the beautiful "Story of Avis," by Elizabeth Stuart Phelps, this subject is pathetically worked out in the history of a girl who has resolved not to marry because she fears that marriage will make her false to her art, to which she has devoted herself ardently. Unfortunately her warm, enthusiastic nature, with its wide sympathies and strong feelings, cannot escape the passion of love. She does struggle, but she finally gives in, on her lover's strong assurances of understanding and sympathy. But after marriage he forgets his sympathies and his promises, anxieties accumulate and the result that Avis dreaded takes place. Domestic trifles encroach one by one.

> It was not much, perhaps [says the author], to set herself to conquer this little occasion, not much to descend from the Sphinx to the drain-pipe at one fell swoop, not much to watch the potatoes while Julia went to market; to sit wondering how the ironing was to get done, while her husband talked of Greek sculpture: to bring creation out of chaos, law out of disorder, and a clear head out of wasted nerves. Life is made up of such little strains, and the artistic temperament is only more sensitive to but can never hope to escape them. It was not much, but let us not forget that it is under friction of such atoms that women, far simpler and so for that yoke far stronger than Avis, have yielded their lives as a burden too heavy to be borne.

Looking at this picture in the light of evolution, we can see before our eyes the more immediate process under which the womanly character has been formed; we can see the non-domestic proclivities being stifled, health undermined, nerves fretted, and the power of happiness teased out of existence. The system is one of combined starving and irritation. Happiness is partly a matter of habit, and if every minute that passes brings with it some little arrow of trouble, the mind losses its healthy tone, and the condition of distress and worry becomes ingrained. How this takes the sunshine out of existence, not only for the victim, but for her associates, any one can see for himself who looks around him. One of the causes of this burdensome home life in certain classes, is the absurdly elaborate style of living which these classes think it necessary to keep up, apparently as a voucher of gentility, for it certainly has no other effect except that of making the lives of its supporters miserable.

Again, the absolute banishment of the idea of co-operation in domestic life causes an incalculable waste of energy, as well as the evil of thrusting upon so many human beings work which is unsuited and uncongenial to them.

From all evils which affect humanity at large, women being of course handicapped by acquired weakness, suffer more severely than others. In the wage-earning class this is evident at first sight, while in the richer classes the evil is hidden under a cloak of luxury; but it is always there, wearing and corroding the heart. "The tyranny of times and laws is heavy upon them to the end." How these closely knitted evils are to be banished can only be seen, as, one by one, they are attacked from different sides and in different ways. But clearly the A B C of right and justice to women (to say nothing of right and justice to the whole race) is to open the gates of life to all and let them enter in and find their place there by direct experiment. That there are great difficulties to be encountered must be admitted. The present state of our society makes it hard indeed for women to go out into the world of savage competition and force their way among the strugglers. Still the removal of social and legal disabilities is demanded by justice and is a step in the direction of progress. The consequences must be faced. History is continuous, and doubtless what women have endured in the past will haunt them and their descendants for many a generation to come,

but we must face the spectres and live them down;[5] there will be pain and failure to endure: the moment is terrible with birth-pangs of the new order, but its coming is now certain.

It is constantly being pointed out to women – even by those who are ready to admit their possibilities of a high development – that the real woman's kingdom is in the home and, above all, in the nursery, and that the "mother's love and care" should still, and for ever, be a woman's "crowning joy and ambition." But this again is prejudging the case, for surely it is for women to find out what their crowning "joy and ambition" is to be, and if many in the future refuse to regard the mother's love and care in that light, the mere resulting variation in individual types of character will be a distinct gain to society. On the other hand, there is something more in prospect for women and for the race than would be achieved by a mere successful competing with men for the prizes of life, important as that step would be with its attendant improvement in position, and training, and independence. The real woman has yet to be born – the truly womanly woman who develops the power that is within her freely and without reference to artificial ideals. A cramped and distorted nature can be neither manly nor womanly, nor even quite human in the broadest sense. Real womanhood is a thing of the future. What it will be must of course depend upon the form of society, and that social form reciprocally will be influenced by the new standing that women take in it. So that their qualities will be in a certain sense in their own hands to determine. Mankind is tied to the wheel of evolution, but man can and does more and more as he develops in intelligence consciously make it run in the direction he may choose. What he *cannot* do is to make it stand still. All thoughts and acts of ours trace out the path of our development.

Certain qualities peculiar to women have been evoked in the past; for instance, delicacy of perception, quickness of insight, grace, gentleness, and a self-control wonderful to think of in connexion with their susceptible physical temperament. These qualities are valuable: they have been dearly bought, and it is a pity to let them go. If women do not preserve the sweeter, more picturesque, and graceful aspects

[5] See "Ghosts" by Ibsen, translated by Francis Lord.

of life, what a sunless world we should have! And there is not enough sunshine as it is; it should be made brighter, nor more grey and bleak. Surely there is something far better to be done than to offer to humanity a mere repetition of manhood, however perfect the imitation might be. This would be very "stale, flat, and unprofitable." Sympathy, not antagonism between the sexes should be the watchword of the future order, and indeed there is every sign that the new womanhood will have much closer sympathies with masculine nature than have the women of the older type; but the personality will perhaps differ still more from that of man, because the woman of the future will follow the lead of her own nature and not that of a deadening convention. For the same reason, too, the future will produce a multitude of types of womanhood, increasing the changes of making a happy choice in marriage, and opening a wide field for variety in the conception of married life itself. Then will be offered all possible range for individual taste and character, in place of the present cramped ideal, which demands that all who enter the gates of matrimony shall bring themselves into precisely the same attitude towards it as is held, or supposed to be held, by every other married person. Then, perhaps, the old fancy of the soul finding its other half may be actually realized. There is something very fascinating to the human mind in this idea of the two sexes being necessary complements of one another; it has always been a favourite apology of conservative thinkers for upholding the present position of women. But while the woman was not free it was an idea impossible to carry out: men and women were then *different*, but not truly *complementary*: to make them that must be the work of the future. This generation cannot conceive the inspiring beauty that must come to pass in the relations between men and women when the woman shall have explored her own possibilities, and man has made the tremendous gain which this development must inevitably bring to him also. The world cannot afford to lose the best powers of half its people. In this crippled state it has been struggling miserably for ages. What will happen when the whole of those human powers become co-operative? What will happen when men and women are *spiritually* united? A new humanity will have arisen![6] If the development of the future should tend

6 One remarkable saying, attributed to Christ by Clement of Alexandria, is
 sometimes quoted – for instance, in "The Perfect Way," before alluded to in

to make women on the average less engrossed with maternal cares than they have been, the result will be a glad prospect for mankind. For at present children suffer miserably through the blind, unthinking self-immolation of their mothers. Mothers deprive themselves of efficiency, of health, knowledge and enjoyment of life, for their children's sake, and their children share the penalty. They are loaded with cares and caresses, and deprived all their days and nights of fresh air and rational clothing. Mothers stunt their own humanity in their children's service, and in revenge the children are stunted too; their minds are clothed with false ideas and petty prejudices, original growths are lopped off, and thus human beings grow up to perpetuate the mistakes and wrongs of which they have been the victims, and to hand them down as heirlooms to the next generation.

A more general intelligent sympathy and enlightened love of humanity, with less violent motherliness, would be a universal blessing to the community, though our devotion to the old idea makes this one difficult to admit. There are many who would rather have women in the old way, motherly, than that the children of the future should be wisely tended. If there were less maternal *instinct* and more human love, half the cruelties that children now suffer under the loving care of devoted mothers would undoubtedly be spared them.

How all these powerful citadels of error ever came to be attacked at all is one of the mysteries of our life, for the more rounded and complete the system of evil the less chance one might suppose would there be to get outside it and view it apart from the self that has been formed under its influence. That is probably why reforms do almost invariably come from without and not from within the circle of oppression. It is to human genius – the power of standing *without*, and bringing, as it were, an intelligence from another sphere to bear upon the problems of this one – that we for ever owe our salvation. Once the word from above has been spoken, the seed of reform has been sown. For the injured and the insulted the deliverer has come. "The spirit of the times, this secret but elementary force of Nature, the origin of all the material and spiritual currents in humanity, comes to their assistance."[7] But if this is to be our

these pages. Christ declares that "the kingdom of God can only come when 'two shall be one, and the man as the woman.' "

7 Bebel, "On Woman."

ideal – the free development of womanhood, and through it a larger development for all humanity – our present problem becomes a very difficult one.

How is the existing crisis to be got over without injury to women and the race from the too great strain of competition upon their undeveloped systems? without also the sacrifice of those feminine qualities which are good to keep, and without the artificial division of women into two ranks – the one to remain single and to devote themselves to work outside the home, and the other to be relegated to the fireside and the nursery? To be satisfied with this last solution would be to abandon our brightest hopes and ideals, and probably to court defeat by the antagonism which it would set up between the intelligent and the affectional sides of woman's nature – an antagonism which should be avoided at all hazards, as it would tend to create two somewhat gruesome types of womanhood, the one all mind and no heart, and the other all heart and no mind. In the long run, too, heart would even tend to disappear altogether in favour of a stupid instinct; for, after all, it is really at the touch of intelligence that the higher kinds of love arise to beautify human life. Perhaps the simplest way of arriving at a solution of the problem is to find out what principally stands in its way, and to try little by little to overcome it. First and foremost among the obstacles are the cramped ideals of life that are so general, and especially the ideals of married life. It comes to this: that a woman has to purchase the gratification of her affections at the expense of her whole nature, and very often the man has much to suffer also from the narrowing influences of a conventionally arranged marriage.

The more love there is in the world, the better for the world, provided it does not confine the sympathies within the circle of the home. Two sides of the nature require to be satisfied and developed: the intellectual and the emotional; but the present world offers a stern alternative: One or the other, which will you have? The woman of to-day should answer "both." Thus an entirely new ideal of marriage will be a condition of the new order, if that new order is to embrace the best reforms that can be made, and yet to conserve the best qualities that the past has brought forth. In this new ideal the words "duty" and "right" would give place to "freedom" and "equality," while (almost as a consequence)

a large family would be regarded as a bitter wrong, above all to the woman, but also to the children and to society. Little is to be hoped while the majority of women are doomed to this burden of incessant child-bearing, a system which, if it were not so common and therefore so unconsidered, would be seen to be the cruelest and most degrading bondage under which a human being can suffer; one which makes motherhood into a blight and a curse, and stands in the way of all hand-in-hand advancement for men and women. On these points of course arises a network of questions and problems, each requiring separate discussion; though they should not be discussed without regard to the intimate way in which they hang together and affect each other, the difficulty of the solution of one generally being the chaotic state of all the rest.

But of this we may be assured: that every step we take in the improvement of our general social condition, makes just that much easier the question of the future activities of women, and *vice verse*.

The spread of education, while conducing to the solution of that question, will aid in the dispersion of prejudice, and in effecting such a fundamental improvement in our social arrangements as shall remove from the shoulders of the worker, be he in what so-called "class" he may, the burden of excessive labour for inadequate payment.

Such a state of affairs may be hard to attain, but surely with the help of goodwill, knowledge and patient experiment it is not unattainable; and if it *were* attained, if the present crazy race for wealth were slackened by the removal of the fear of poverty and the absurd mammon-worship of the century, women, married or single, might then safely take their part in the outside work of the then more brotherly and gentler world, which their presence would tend always to make *more* brotherly and *more* gentle. Such is the ideal to be worked for and hoped for. Meanwhile many women and the larger-hearted men will strive to realize it, and in the process, a nearer and nearer approach must always be made to the type of the ennobled humanity of the future.

All can make some effort towards the ideal, even if their own lot is cast in the deepest of the old dungeons; their cries may be faint but they will be heard and caught up by those who are more happily placed, those who are moving forward

to the front of the battle and conquering by endurance and sacrifice new ground for themselves and their sisters. Such women will sow the good seed which will ripen into a harvest of well-being to be reaped hereafter, and the day is coming when their spiritual children of future generations will rise up with one accord and call them blessed.

THE HIGHER EDUCATION OF WOMEN
The Westminster Review, Vol. 129 (1888)

It has often been remarked that men and women after middle age, and sometimes before that period, are much averse to change of any sort. They share Montaigne's aversion to novelty. "Je suis desgouté de nouvelleté quelque visage qu'elle porte," remarks that genial old philosopher. Without perhaps actually stating the opinion that "Whatever is, is right," we may yet say that deep down in the hearts of men and women who have passed their first youth is the firm conviction that whatever was good enough for them and their fathers is good enough for the growing generation. But as an able woman, one who herself felt acutely the cramping and narrowing influences that so fetter the lives of women, has said, "To delight in doing things because our fathers did them is good if it shuts out nothing better; it enlarges the range of affection – and affection is the broadest basis of good in life." And it is because one believes that by the opposition to the movement for the Higher Education of Women much good will be shut out, that one is much dismayed by the antagonism displayed towards it. Many and various have been the opinions expressed on this subject, and so general has been the bulk of publicly expressed opinion against this higher education, as almost to justify the head of one of the best of our colleges for women in her complaint that "public opinion is very much against our work." But to those who believe in the truth of their cause, opposition, however general, can never damp their ardour; and they are further comforted by the reflection that "in human affairs no extension of belief, however widespread, is *per se* evidence of truth."

The objections that have been urged against this movement may be shortly summarized as follows:- The opponents of higher education for women tell us that it will so tax and enfeeble the energies of women that their constitutions will prove unequal to the strain. Nay, with a cool assumption of the

point at issue, characteristic, one regrets to say, of the opponents of this movement, they tell us that "women, though they may give up every thought of matrimony, *are* unequal to the strain, and had better remain unequal." Further, however, probably with an uncomfortable conviction that women, by virtue of this fatal higher education, have already accomplished a good deal, it is argued that, even should they succeed in rivalling men in work hitherto confined to men, the women's strength will be so exhausted that they will prove unequal to the further stain entailed by the duties of matrimony with its consequent motherhood. The result of this enfeeblement will be that the children of such highly educated women will be weak and immature, and so there will be perpetuated, not only fewer children – not certainly an unmixed evil – but that these children will, in the natural course of events, bring forth descendants unable to survive in the battle of life. And we learn from a woman, herself of considerable ability, that this evil result and more has already ensued, short as is the time during which this higher education has been in operation. Mrs. Lynn Linton asserts that "the number of women who cannot nurse their own children is yearly increasing in the educated and well-conditioned classes, and coincident with this special failure is the increase of uterine disease. This I have," adds Mrs. Linton, "from one of our most famous specialists." One may remark on this, in passing, that the above assertion is an interesting example of *non sequitur*. There are many features of social life also coincident with this higher education, but they are not by any means necessarily due to this education. Further, Miss F. P. Cobbe, in an extremely interesting paper on the "Little Health of Ladies," in the *Contemporary Review*, 1878, holds a view that differs widely from that of Mrs. Linton. Miss Cobbe points out that it is especially among the wealthy and well-conditioned classes that there is so much illness, but she ascribes its prevalence to causes none of which can be described as in the remotest degree connected with excessive exercise of the brain.

It is further argued that to be successful in the race some women wish to run – *i.e.*, to reach a slightly higher intellectual level than they at present occupy – they must remain a class apart; they must, in fact, be celibates. As it has been very frankly, if not very intelligently, asserted: "To justify the cost of her education a woman ought to devote herself to its use,

else does it come under the head of waste; and to devote herself to its use, she ought to make herself celibate by philosophy and for the utilization of her material." She must, in short, give up all thoughts of domestic pleasures save and except those that are enjoyed by bachelors. And, it being assumed that higher education is only compatible with celibacy, and that only the better class of women will go in for it, we are told that only inferior women would be left to perpetuate the race, to the great detriment of society. And other disabilities that are prophesied for those women who are rash enough to wish to cultivate their brains, one finds that they must discard petticoats, which hamper their movements, and so hinder them from competing effectually with men in men's occupations. "Whatever," says Dr. Richardson, "therefore, there is of elegance in the present form of female attire, that must be sacrificed to the necessities of competition with men in the work common to men;" and then he adds this highly instructive, and, one ventures to think, highly original, view of the importance of woman's dress, and which may possibly cause some women to reconsider their determination:– "The dress she wears under the *régime* of woman, the mother of men and women, is the sign of the destiny which holds her from the active work of men, and which affords her the opportunity for bedecking herself so as to fulfil her destiny with elegance and fascination." Surely the gospel of clothes could no further go. It is also maintained that this fulfilling of her destiny with elegance and fascination, or otherwise, will be seriously interfered with by leading to a modification of the present mode of dress, concerning the beauty of which opinions differ. But should woman be so ill-advised as to enter the ranks with men she will find that, just as men's occupations stamp themselves in repression of visage, in tone of voice, in carriage of body, and in size and shape of hands, so must she not hope to escape this supposed degradation of elegance and beauty entailed by these modifications. Finally – this time also an æsthetic argument, and therefore supposed to be peculiarly adapted to convince female intellects, and those who believe that there is, after all, something higher for woman to do than simply to bedeck herself for the fulfilling of her destiny with elegance and fascination – woman is warned that, should she persist in her ill-advised course, the awful result will ensue that her forehead will become slightly larger, as a necessary

consequence of the increase of brain power; and it seems that some æsthetic genius has laid it down, apparently for all time, that in woman "a large forehead is felt to derogate from beauty."

The value of this æsthetic peculiarity of woman's forehead can be properly appreciated only when we learn that "the frontal regions, which correspond to the non-excitable region of the brain of the monkey, are small or rudimentary in the lower animals, *and their intelligence and powers of reflective thought correspond.*"[1] And from his researches, Professor Ferrier sees reason to believe that "development of the frontal lobes is greatest in men with the highest intellectual powers, and, taking one man with another, the greatest intellectual power is characteristic of the one with the greatest frontal development." When we thus turn to science, we get small encouragement for our admiration of small foreheads – an admiration that is very analogous to the complacency with which the Chinese regard the distorted and unnatural feet of their women. The foregoing objections form a list of disabilities, social, physical, and moral, that is sufficiently appalling to minds accustomed to accept all *ex cathedrá* statements as gospel, and to receive assertions as established facts, and we know that women's minds are peculiarly susceptible to such influences.

But through all the objections there run two assumptions, neither of which is warranted by anything much beyond the dictum of some more or less trustworthy authority, and a few cases of injury produced by injudicious and excessive study, probably conjoined with a delicate constitution. These assumptions are – 1, that this higher education of women, as carried out, say, at Girton and Newnham, is inconsistent with physical health; and 2, it is implied and assumed that the physical health of the women of the present day is of an extremely satisfactory character. Before proceeding to examine these points, we may remark as rather a melancholy fact that most of the opposition to this movement comes, not from the uneducated and illiterate, but from the learned and from those who, with more knowledge, ought to know better; particularly is it in the medical profession that the most bitter opposition is met with. The attitude of this profession towards women who have

[1] Ferrier, "Functions of the Brain."

endeavoured to enter medicine, in which there is a great sphere for them, has been, one regrets to say it, one of uncompromising hostility; so much so as to pretty nearly justify Miss F. P. Cobbe when she says that the wisdom of the medical profession on this subject may be thus summed up: "Women, beware!" it cries; "beware! You are on the brink of destruction. You have hitherto been engaged only in crushing your waists; now you are attempting to cultivate your minds! You have been merely dancing all night in the foul air of ball-rooms; now you are beginning to spend your mornings in study. You have been incessantly stimulating your emotions with concerts and operas, with French plays and French novels; now you are exerting your understanding to learn Greek and solve propositions in Euclid! Beware, oh beware! Science pronounces that the woman who *studies* – is lost!" To those who know anything of the opposition manifested by the medical profession towards this movement, such a description as the foregoing, though severe, must appear accurate. But, as was remarked, it has been too readily implied that the health of those women who are most likely to go in for this higher education is at present good – an assumption which any one on very short consideration can contradict from his own experience.

Where do we find grown girls whose physical health and nervous energy are such that they would go a long walk for the sake of the physical exercise it gives them? But we do find too many girls who, at the age when the bodily condition should be most vigorous, and their nervous energy most active, find their strength and nervous energy quite exhausted by the labour required for dressing and going for a solemn walk into town, whence they return exhausted and fagged out, instead of benefited. And can be wonder at this, when we see the methods invented by fashion to so attire our women that their arms and legs are so hampered, and their bodies so compressed, that free active exercise is impossible? No wonder then that woman should find it such a trouble to dress, and that, being such a trouble, it is as often as possible avoided, until her exercise is pretty much as limited as that of the model woman in Socrates, where the good husband "advises his wife to take exercise by folding up and putting by clothes, so obtaining what she ought to have obtained by walking out."[2]

2 J. P. Mahaffy, "Social Life in Greece."

Such meagre exercise as our women take is quite inconsistent, not only with health, but with beauty. Any one who knows anything of gynæcology is aware that many feminine troubles are due solely to want of exercise, with consequent weak and defective health; and more cases come under the notice of specialists, famous or otherwise, from this defective and weak state of health of our women, than have ever come, or are ever likely to come, from the injurious effects of this higher education. So prevalent is the general weak physical condition of women that one cannot but agree with Miss Cobbe's reflection – "that the Creator should have planned a whole sex of patients, that the normal condition of the female of the human species should be to have legs which walk not, and brains which can only work on pain of disturbing the rest of the ill-adjusted machine – this is to me simply incredible."

With a higher intellectual training, and the mind consequently more actively employed, one can safely say that specialists in women's diseases would lose many of their most profitable patients, many of whom come under their care from that fruitful source of feminine ills – an unoccupied mind and the consequent *ennui*. Were a doctor to lose his female patients he would lose a considerable part of his practice, depending, as it does to so great an extent, on the many ailments so certain to affect any creature so "cribbed, cabined, and confined" as are most of our women. For one case of woman's disease that comes under the care of a medical man, due to the injurious effects of this higher education, there are a score of women that come under his care for similar diseases that have no such explanation as over-exercise of brain to offer as the cause of their ailment. To assume, therefore, that the present or past health of our women is anything approaching the standard of physical excellence is an assumption indeed. What women have already done in mechanical work Dr. Richardson has told us. As editors of papers, and as managers of business houses, women have proved their capacity. As clerks in the Post Office, which can only be entered by competitive examination, the Postmaster-General has announced that they have proved their competency. And it is a sign of good omen that, at a meeting of compositors and printers in London a short time ago, there was passed a resolution on this subject, in which, while expressing a strong opinion that "women are not physically capable of

performing the duties of a compositor," the conference recommended the admission of female compositors into the Union, "upon the same conditions as journeymen, provided always the females are paid strictly in accordance with the scale."[3]

When one proceeds to more purely intellectual work, one finds that in the examinations for the Triposes held at Girton and Newnham, as well as in the ordinary B.A. Degree Examination, and at London University, women have proved themselves the equals of men; while the list of appointments subsequently held by those who have so successfully passed their examinations – appointments as medical officers at home and abroad, as well as to educational positions entailing onerous and fatiguing duties – sufficiently demonstrates, one would imagine, that there are, at any rate, very many women who, besides having been capable of the physical and mental strain necessary to pass such examinations, are yet further able to undertake and fulfil the duties of posts that necessarily involve much mental and physical work. But though this is so, one cannot, and one need not, ignore the fact that occasionally cases do undoubtedly occur of serious injury to the health of women from over-exercise of brain; nor is this result to be wondered at. We know that when a low type of civilization comes into contact and competition with one of a higher grade, an evil result to the lower type will ensue. The law of survival of the fittest will come into operation, the weaker will suffer, and those that survive will be those most suitable for the stages of evolution necessary in the progress of a lower to a higher type. So, though to a much more limited extent, will mischief ensue when a lower type of, or a less highly developed, brain endeavours, without previous careful training, to undertake tasks easy to the more highly trained intellect of man.

Through many generations, women have been kept intellectually in swaddling clothes. Just as the Chinese cramp up the feet of their girls and get ridiculed for their pains, so do we, with more enlightenment, and therefore with more sin,

3 It is worthy of note that the late Dr. Pusey, in advertisement of a "Commentary on the Minor Prophets," says that all the printing has been done by women at the press of the Devonport society; and he, after many years' experience, sees reason to believe that "there is no kind of printing which women cannot execute as skilfully, remuneratively to themselves, and less expensively."

circumscribe the mental growth of our girls, thereby earning, if not receiving, the ridicule that is properly our due. From the earliest years this cramping and paralysing influence begins. At an age when physiologically there is little difference between the sexes, the boy expends his surplus nervous energy on his rough but healthy games, untrammelled by clinging garments; while the girl is taught, even thus early, that it is improper and unbecoming to romp about as her nervous energy would dictate; and, as if still further to hamper the natural, healthy movements of the body, we dress our girls in materials readily soiled, with pinafores and ribbons, which they are carefully enjoined – dear little souls! – to keep scrupulously clean. Later on, this difference in training, while still continuing and increasing as regards the physical education, is extended to the mental culture, and various subjects – for example, Euclid and algebra – are excluded, for some occult reason, from the curriculum for girls, the male brain alone being evidently considered capable of tackling such studies. So that by the time girls are fully grown we find that, from want of proper exercise in their earlier days, their bodies are weaker than those of boys, and, from the starving system adopted in the mental training, the woman's brain is necessarily very imperfectly developed. And thus, as a consequence, woman is incapable of much healthy exercise, as walking, and quite incapable of running – whoever saw a young lady run? – while her highest intellectual aspirations are usually fully satisfied by a perusal of the fashion-column of the newspaper, supplemented by social studies, gathered from novels, say, by the late Mrs. Henry Wood. Even now, when much progress has been made, when Oxford and Cambridge teachers accept fees from the students of Girton and Newnham, and examine them as they do the students at the Universities, we find a curious survival of this circumscribing process, because, while the girls undergo examinations for the degree of B.A., this degree is withheld from them. It is laid down thus: "To all women who pass any one or more of the Triposes, certificates are now formally granted by the University, declaring that they have attained to the standard of first, second, or third class in an honours examination for the B.A. degree; *but this degree, for various reasons, is not conferred upon them.*" For the same curious but unaccountable reason one may suppose it is that we are familiar now with the spectacle of a girl being allowed to

compete for a scholarship, but, on gaining the first place, the prize is denied to the successful student because she happens to be a girl.

The intellectual features that characterize women correspond to what one would expect from human beings confined and hampered, bodily and mentally, as women are. The development of a girl into a woman is much more rapid than that of a boy to a fully grown man. This early development is one of the most characteristic features of all simple and lowly developed organisms, which are developed slower the more complex and highly organized they are. Further, women are very impulsive and prone to act on and trust to what they call their instincts, which are only their imperfectly trained powers. They are extremely credulous, a feature that renders them peculiarly open to anything that assumes the appearance of authority. Finally, they are characterized by great emotional excitability, partly due, of course, to physiological peculiarities, but more due to the want of development of any controlling power, which is only to be attained by education of the higher brain-centres. "In proportion," says Professor Ferrier, "to the development and degree of education of the centres of inhibition do acts of volition lose their impulsive character and acquire the aspect of deliberation. . . . If the centres of inhibition, and thereby the faculty of attention, are weak, or present impulses unusually strong, volition is impulsive rather than deliberate." And Professor Ferrier comes to the conclusion that "the centres of inhibition being thus the essential factors of attention, constitute the organic basis of all the higher intellectual faculties, and in proportion to their development we should expect a corresponding intellectual power." In fact, in woman it is undoubtedly true that, owing to the want of any counteracting influence, "the emotional is at its maximum, and the intellectual or discrimination is at its minimum." This being so, is it at all wonderful if, when these women or their children are set to unwonted intellectual tasks, there should ensue some evil results? But let us attribute the evil results to their true cause, which is found in our old vicious social customs, which, by hindering the full physical development of our girls, render them weak and delicate in body, and, by limiting their studies in school, necessarily unfit them for undertaking higher intellectual work. The reports by some inspectors of schools, which are so often brought forward for

the discomfiture of those who believe implicitly in statistics, are anything but conclusive against the higher education of woman. The reports, at least as quoted, are devoted mainly to pointing out that there exists much headache among the children, which may easily be. But to attribute this headache to higher education alone is surely a very unscientific proceeding; more especially when we hear nothing about the state of ventilation of the schools, the amount of time devoted to exercise, and whether there is any irregular and improper feeding, all of which factors have been proved to produce headaches and other evils. In children's schools, too, there is often too much expected from the pupils, and they are crammed instead of being instructed for the examinations, on their passing of which depends unfortunately the teacher's result-fees. With less cram, more outdoor exercise, and good and regular feeding, little headache is to be found. In the *Lancet* the other day was a note of a report on myopia by Dr. Widmach, who carried out an investigation on the effect produced by study on the eyesight among the young people of the more important schools of Stockholm; and he found that in more advanced pupils myopia was much more common and more marked amongst girls, which circumstance Dr. Widmach very properly considers is accounted for mainly by "the great inferiority of physical education and opportunities for outdoor games in girls' schools, and by the needlework and music, which are there so frequently the employment of out of school hours." Were all our school reports written out with the scientific discrimination that characterizes that of Dr. Widmach, we should hear less of the direful results of the higher education of women. But, to listen to the fearful indictment brought against this movement, one would imagine that both the hours of study and the curriculum were very exacting. What are the facts? In Girton and Newnham, which may fairly be taken as representative of the best features of this movement, it is found, in the first place, that the average age of the students is twenty years, so that they are not raw girls, but have reached their full physical growth, except perhaps in bulk. Further, the intending student must pass an entrance examination, which is a guarantee that they must have at least some capacity for profiting by the course of study. The number of hours of study averages 768, including time spent in hearing lectures, which would make the actual hours spent in hard

reading four to six, not surely a very trying day's work. The time for meals is from two to three hours. All studying soon after meals is rigidly discouraged. And yet, in spite of the severe mental training that the passing of such examinations entails, and which should, if the objections have any value, produce such physical exhaustion that there would be small inclination for exercise beyond a gentle stroll, we find, on the contrary, that there is manifested by the students an extremely healthy aptitude for such athletic games as lawn tennis and racquets; while the course of training is so carefully regulated by the able women at the head of these colleges, that the general health of the students is extremely good, cases of break-down from overwork being very rare. Such testimony is, one would imagine, worth bushels of reports about headaches found among pupils of lower schools where cram prevails, and where there is little attention paid to physical education. The argument that, in order to make proper use of her education, a woman should remain unmarried, has no value when we find that the outcry about the injury done by the higher education is founded on very insufficient premisses. Were it, however, necessary that some highly educated women, like many others not so cultured, should remain celibate, they would be in good company, seeing that Handel, Beethoven, Reynolds, Turner, Michael Angelo, and Raphael all belonged to the honourable order of bachelors.

It is always assumed that the destiny of every woman, which she is to fulfil with elegance and fascination, if possible, is marriage. But, considering that the number of women in excess of men in these islands has been estimated at about 1,000,000, it is obvious that many must lead solitary lives, and must, therefore, make homes for themselves. But as none can tell beforehand which girls are to be married and which to be celibate, such things, like kissing, going by favour, it is essential that the education should be such as will qualify all women for making their own way in the world. Even should a woman marry, it is surely a most extraordinary thing to say that her education is lost and of no value, or that the expenditure on her education is thereby thrown away. A man now-a-days wants something more than a good housewife and mother of his children. Time was when the education of men generally being very indifferent, they were not particularly sensible of any great deficiency of education in their spouses,

and were content when her erudition extended no deeper than her prayer-book and a receipt-book – which seems to have been its extent, according to Macaulay, in the latter half of the seventeenth century. But with the progress of education and learning comes a longing for a companion, and for one whose face does not assume a blank appearance when anything more subtle than baby-clothes forms the subject of conversation. A man now is not likely to be so easily satisfied as was that Prince of whom Montaigne tells us, who, on being told that the lady he was about to marry was not very learned, replied: "Qu'il l'en aymoit mieulx, et qu'une femme estoit assez sçavante quand elle sçavoit mettre difference entre la chemise et le pourpoinet de son mary." Now such knowledge, though desirable, not to say necessary, in the wife of one's bosom, would hardly suffice to make a very intelligent companion. One of the most important results, however, that will accrue to society from the further extension of higher education of women, will be the beneficial effect it will have over the character of the children borne by such cultured women. If there is one law in Nature more certain than another it is that the mental, no less than the bodily, characteristics are transmitted to the offspring. This being so, it is, to say the least, advisable that our future mothers, as well as the fathers, should have as much culture and education as is attainable without injury to health. Had the higher education been in vogue when Goethe lived, perhaps he had married some other woman than his servant, and his son might have been another, possibly a better, Goethe, instead of being so deficient in intellectual capacity that his father always spoke of him, with grimly sarcastic truth, as "der Sohn der Magd."

It is quite probable, as Mr. Spencer very properly points out, that Edwin is not, as a rule, brought to Angelina's feet by her German. But surely it is as equally true that, unless Edwin is an absolute idiot, the knowledge that Angelina can whisper soft nothings in his ear in that learned but slightly guttural language will not be a very fatal obstacle to his declaration. Rosy cheeks, laughing eyes, and a finely rounded form are no doubt great attractions, and very desirable. But if one's wife has only these physical attractions, without a corresponding mental development, she may prove a very good nursemaid, but not a very intelligent helpmeet. It is also worth remembering, as Professor Mahaffy very properly says, that "it is only when mental

refinement is added to physical beauty . . . that love rises from an appetite to a sentiment." And when those laughing eyes grow dim, and the rosy cheeks assume the contour of the full moon, while the finely rounded form has reached those proportions that roused so much the susceptibilities of Nathaniel Hawthorne, then will one find out, if not before, the advantages of having some mental as well as physical health and beauty. And such education will not render women the less capable of undertaking one of the most important tasks that fall to the lot of any, viz., the care and training of the growth and development of a child's mind. Finally, we should recognize a fact, too often ignored, that, after all, woman has a life of her own to lead. There are many problems in life that a woman has to solve for herself with such light as she may derive from her education, and on the proper solution of some of these problems will depend much for good or for evil, both to herself and to those with whom she may be connected. It is, therefore, very desirable that she should have as much help as may be given by a highly trained intellect, and, in proportion to her previous mental training, will be her capacity for judging and living rightly.

In conclusion, one cannot but feel that this movement will not only be of advantage to women themselves, whom it will raise socially and mentally, but that it will also be of service to the race, by giving us mothers whose cerebral development will be such that their children will be more easily taught, and capable of much more than the children of less able mothers. Further, by giving otherwise inadequately occupied women healthy occupation for their minds, it will get rid of that *ennui* which is so fruitful of much evil, and so prolific of patients that fill the consulting rooms of medical men.

Tennyson's ideal –

"She with all the charm of woman,
She with all the breadth of man" –

may be only an ideal, but it is one, at least, that is worth striving for. And if, with our narrow and limited methods of education, we do meet with some women who come up to this ideal, what may we not expect when a fuller and more gracious life is opened out to woman?

The movement may be marked by extravagances, and the methods adopted for the attainment of the end may not be the

best possible, but this is, after all, only another mode of saying that the movement is directed by human beings. George Macdonald says truly: "The tide of action in these later years flows more swiftly in the hearts of women, whence has resulted so much that is nobler, so much that is paltry, according to the nature of the heart in which it swells."

Let us then recognize generously that there is such a tide, and that although we may, by our opposition, delay the progress of the current, yet we can no more arrest it than could Dame Partington with her mop stop the progress of the Atlantic.

FEMALE POACHING ON MALE PRESERVES
The Westminster Review, Vol. 129 (1888)

For years, now, the Woman Question has been before the public woman's rights discussed, her wrongs proclaimed, and the sphinx of futurity consulted as to her final sphere and destiny; yet far from being talked out, the question is to-day as burning as ever, and, on a continually widening basis, remains the topic of the times. The narrow footing contested for at first has long been won; the riddle, after the manner of such riddles, has been reading itself, and the puzzle has been opening to the key of experiment. Wrongs have been righted, rights have been reached; but, notwithstanding, so vast is the subject, that not even yet have all its bearings and details ever been fairly marshalled on the platform of common justice, that ground which should be the first, but is generally the last, upon which claims are considered and decided.

It is clear that women are in a time of transition. Transitions must come, but woe unto them to whom they come! They must ever be seasons of trial. As environment changes, the organism adapts itself or perishes. The change may be gradual and adaptation easy, or it may be swift and out of step with surrounding evolution – when the adaptation will be attended with effort and pain. How woman's environment has changed, research and observation tell us; how the change must be met, it is the work of deduction and experiment to show.

From the starting-point of history, and all along its path, woman figures as the complement of man, his hinder- or his help-meet – his worse or his better half. She has ever followed his evolution, albeit in the rear, and in a sort of tandem arrangement, with, we fear, many a kick from the leader and more than her share of the load. The functions of primitive man were mainly *physical*. The female reared her offspring, the male brought them food. As man ascends, labour complicates and undergoes division, and to woman fall the duties which interfere least with those of maternity – cooking, "mending,"

housekeeping generally. And so on, through the centuries –
man gaining, woman losing, might and muscle; until, in the
case of the latter, we arrive at Medici waists and Chinese
feet. And men, having gained power, use and abuse it; ever
further they encroach upon the woman half of humanity,
curtailing its rights and activities, and limiting it at last to a
share in their lower functions alone. The relation of the sexes
may vary with varying peoples, but woman has acquiesced in
her destiny and is always last. Thought, at first concrete, was
determined by *individual* surroundings, and woman's
diverged from man's, only, however, to meet it again on a
common *impersonal* platform, when, through a larger
environment, the mind had mounted up to general and
abstract ideas. Here again, from his larger life, man is first;
but this time in degree and not in kind. A little widening of
woman's environment, a little spirit on her part, and she is
easily alongside. Emotionally, woman, as a rule, takes
precedence. Her passions, though less controlled by thought
and less disputed by other activities, have, far from overrun-
ning her nature, undergone such purification from the
predominance of the maternal instinct, that it is through
them she earns her greatest title to respect. And when the
poet tells us that

"Woman's love to man's love is as 'water unto wine,' "

he speaks truth beyond his intention. Woman's love is
wholesome, pure and vivifying; man's, too often, the wine
which is a mocker, and the strong drink which is raging.

To review carefully the evolutionary path of woman would
be instructive, but in a short paper like this is obviously
impossible. We must pass with a bound to the present day, and
consider how it finds us. Surveying this wondrous world of
1888, only an optimist would rejoice, only a pessimist despair;
we, who stand between, do neither; we sorrow indeed, but not
"as others which have no hope." To begin with, the women of
our land and time might be excused for thanking the Lord with
pharisaic fervour, that they are not as other women. Standing
on the pinnacle of evolution, in the forefront of the Aryan race,
compounded from its higher branches, the Latin and the
Gothic, they have all things in their favour, and, remembering
that *noblesse oblige*, must look upon themselves as the
champions of their sex. It is they who must envirage the times,

and try, if they can, to find the causes that for so long now, and to so many women, have made the world seem out of joint.

The first and greatest fact that meets one, is that rapid change of environment already mentioned, to which the organism has not yet fully adapted itself. Hitherto man and woman, interdependent, have been affected in a fixed ratio by outward change; but the change of to-day affects that ratio. The numerical proportion of the sexes has not always, of course, been exact. Men have been in the majority, as in the case of the Benjaminites and the early Latins, when adjustment has been tried; but now that the other scale dips down, and we have far fewer men than women, how shall we seek to equalize? Polygamy, suttee, female infanticide – none of these venerable methods commend themselves to the Western mind. Women must accept their surplus condition and adapt themselves to its consequences. And this, however unwomanly, is surely not quite so bad as reversing the Sabine story, and pouncing down upon other lands for stray superfluous males! From a high ethical standpoint, unappropriated women should doubtless perish. Their room is so evidently better than their company that they should have the good sense to go. But the going is the rub, and "the undiscovered country from whose bourne no traveller returns," is for them a puzzle, as for every one. Alas for elective affinities, and for the biune form, by circumstance sawn in sunder! Alas for the lonely half, at work on some primeval forest, or bleaching on some distant battlefield! And alas for the "severed self," seeking in vain the domestic environment for which the ages have adapted it! Its case is, of course, deplorable, but we can hardly blame it for preferring a half life to no life at all, and striving to hold to the little it has; nor can be wonder that, when opposed and jeered at, like Wisdom "in the city it uttereth its words, saying, How long ye simple ones will ye love simplicity, and the scorners delight in their scorning?"

It is the law of evolution that many shall be called and few chosen; each vacancy has a dozen candidates whose claims, in our days, are decided by competition, and to this decision, at present, woman, like man, must yield. Matrimony is, of course, an exception, and far above the vulgar jostle. There, as we know, nothing but perfect affinity determines choice. Never does finesse or intrigue or worldly interest turn the groping hand aside, nor unworthy allurements lower its direction! But

after creation's lords have chosen the best of creation's ladies (best in what, we will not ask), and creation's ladies, as many of them as numerically could, have accepted the lead of their several lords into the higher and biune existence (perish such poems as Locksley Hall, and all who would shatter the dream!), it is left for the crowd of the unclaimed to review their position and to make the best of it. Only a fraction of them are of independent means, and the bulk of them, unless kept "womanly" by individual generosity, public subscription, or national taxation, will have to wound æsthetic sensibilities and work for a living. And as hard work neither softens outlines nor heightens complexion, from being a plain fact they may become a plain-looking fact, and so offer still further outrage to artistic taste. But, as it is pleasanter to have a sentiment than to pay for it, even this worthy one, which would keep women true to a vanished environment, everywhere gives way. The avenues through which money flows – trades, handicrafts, art, literature, professions, learned and unlearned – are all held by men who do battle there for the enchanted dust, and bear to their women at home the spoils of war. But those who are not their women – what is to become of them? Shall they perish for the lack of food? Reluctantly they arise, and, unarmed, go forth. The poor, who can least afford sentiment, launch their tens of thousands, and the middle classes, who would fain afford it but cannot, their thousands. Mill girls come pouring from the slums, and governesses crowd the school-rooms. The first calling may be unwomanly, but it pays; the second may be womanly, but it does not pay. And so, in the middle classes, want sharpens wit; higher-class women seek higher-class work, and the hungry hordes advance; through defeat and failure, poor attempts and paltry successes, till, daily wiser in the tactics of war, they assail the male strongholds of the professions themselves. Great is the outcry and dire the dismay! And, most scandalous feature of all, that knowledge of business and culture of intellect, which woman sought from necessity, she now pursues *con amore*, and with no further aim than that of developing her powers and serving her kind!

And so more and more does the light of her broadening faculties shine before men, who, seeing her good deeds, far from glorifying their Father which is in heaven, seem rather inclined to blame Him for thus including woman in the evolutionary plan, and so chasing away that mental darkness

which so many men would have had retained as the only medium in which their farthing rushlight of wisdom had any chance of showing.

She has made her way through school and college up to some of the foremost educational posts, through the ordeal of ward and dissecting-room to honourable places on the medical staff; and now, through legal lore and Divinity Hall, she approaches the sanctuaries of the Law and the Church – nay, is already within the portals. American Portias are called to the bar, and American clergy-woman exhort unto righteousness from the vantage ground of the pulpit. Although the utterances of St. Paul, persistently torn from the context of time and nation, will cause much grating of ecclesiastical hinges, the doors are already swinging, and will soon stand wide. Woman's fitness must in the end prevail. Physical objections there are none; her voice is as flexible, as penetrating, as man's; her oratory as graceful, her earnestness is as real. In the Church, if anywhere, the mind and heart should be the measure of the man. As regards mind, we are sure she would raise the average; and for heart – none will dispute her that. Her gift of language is proverbial, and there are many Dinahs amongst us, whose eloquence, unencouraged by stipend, is, in promiscuous religious meetings, outpoured in the service of God. Women can, do, may preach, only it seems they must not be paid for it! Whether any one at all should be paid is, of course, a disputed point; but in the Church, as it is, women should have an authorized place. They succeed abroad as missionaries, where the post is more arduous; why should they fail at home? The path of the pioneer is not a smooth one, and not often sought by those who are doubtful of the goal. As for the Law, there is not even a St. Paul against it. If quotations must be made, Shakespeare comes first, and in his unerring hands Portia is her own justification, just as, doubtless, her American followers already are, and as the women of this land soon shall be!

And now let us review objections. The commonplace man expresses his frankly. In the first place, he resents woman's rivalship, and complains that it lessens his respect for her. From the respect that would see one die of hunger rather than share with one chances of wealth, may we all be preserved! He fears, too, that his chops may suffer, and his wife have a mind of her own. But surely he has the world to choose from, and culture, even if, as is foolishly imagined, it be out of sympathy

with the kitchen, is not yet universal. If the wife of his choice prefer Plato to puddings, he has himself to thank. He should have known what he wanted, and waited till he got it.

The beauty lover mourns that these higher occupations are spoiling women's looks. For long the Hellenism of the world has been represented by her, created as she seemed to call forth expression, not to show it. There is no doubt that her higher brow, her stronger mouth, her greater animation, her deeper, stronger moods – all are changing the old ideal. Junos are rare, Venuses the exception; Minervas only remain. But we can already picture the time when the three will be merged in one, and to the charm of Teutonic expression will be added the grace of Grecian feature.

Much unworthy opposition comes, alas! from woman herself. We hear of "man's inhumanity to man." Woman's inhumanity to woman is worse. The self-righteous woman of to-day seems to be transferring her wrath from the vicious to the advanced. She bewails their lack of modesty, and their growing tendency to push themselves forward; not that there is any harm in this, when the object sought is within the legitimate range of womanly desire, such as ball-room reputation, promenade renown. It is seeking things beyond her sphere – an honest livelihood, influence over the higher moods of others, that all true women should shun! To inert to strive for better things herself, she scouts at those who do, and sets about proving that their labour is in vain. "Men hate advanced women," says the flirt and the coquette; and this is partly true. They may hate the name – it has become synonymous with so much silly swagger, such paltry pretence. As, in national changes, hundreds have flocked to the new banner only because unfit for the old! They may hate the name, but the best men in the end must come to love the reality. For the truly advanced are those who, foremost of the old, have but added the new; who having fairly trod each step of evolution, now rightly lead the van. The really womanly before are more really womanly now; and the energy not all grace that sometimes marks them now is natural from the sharpness of the struggle, and when peace is proclaimed will vanish,

"Oh! wasteful woman, she who may
On her sweet self set her own price,
Knowing he cannot choose but pay;

How hath she cheapened paradise!
How given for nought the choicest gift,
How spoilt the bread and spilt the wine,
Which, spent with due respective thrift,
Had made brutes men and man divine!"

Outbid on all sides, as are those who would raise the price, they will nevertheless in the end prevail. "We needs must love the highest when we see it," but men must have time to see. Those were good old times for silly women when the mixing of a posset made them virtuous, and skill in antimacassars an ornament to their sex; when the rouge-pot and the milliner paved the way to man's heart, and the kitchen and the cupboard to his esteem; when lack of logic was their privilege, and lack of learning their duty; when to be unworthy was often to be womanly; when they were brought up to believe and not to reason, as Napoleon I. is said to have advised, and so became open to all sorts of error; when empty of culture, they were full of caprice, and void of mind were replete with malice; for, as the French say, "La méchanceté vient non pas de ce qu'on a d'esprit mais de ce qu'on n'en a pas assez."

And now we come to the mass of intelligent men and women who have a "*sentiment*" against this "Woman Question," who admire justice but shrink from its consequences; whose womanly ideal, soft-voiced and tender-hearted, is too precious to be willingly given over to change. Woman is to them too high, too pure for contact with the work-a-day world. They would put her in a shrine and worship her. They would have her alight as a ministering angel, but gingerly, for fear of soiling her wings. It is from them we hear so much about woman's true mission: the tending of the sick, the holy charge of childhood; and we agree with them in every point. Were it necessary to sacrifice this ideal to advancement, we should be the first to pause.

But such sentiment, beautiful in itself, is wrongly directed, and is opposed not to a reality, but to a popular caricature. Those who hold it picture advanced women with instincts warped, with brutalized physique; but are out lady-doctors, our school-board members, our high-school teachers brutal and unsexed? We see no sign of it. Over-education is an evil from which boys suffer as well as girls, and the gymnastic training which is now being extended to their sisters has alone

saved them. Where the essentials of success are intelligence, energy, perseverance, may not woman shine as well as man, and without risk of deterioration? If such qualities are unwomanly, it is time she was unsexed. To equal man she need not ape him, nor, by copying his unessentials, grow mannish. Her voice is softer at a sick-bed, and a martial stride adds nothing to the dignity of a surplice. And how the higher essentials, not of relative but of absolute life, success – truth, purity, gentleness, justice – will be lessened by a larger and more public sphere, it is difficult to imagine. Truth will grow stronger with strength, purity become positive instead of negative, gentleness be purged of weakness, and justice grow possible from the judicial power which is indispensable for deciding claims, and which trained intellect and knowledge of facts alone can give. "We should be delighted," say many, "for women to enter the professions, were they only fitted for them. But think of their physique, their prejudice, how they reason in a circle, how jump to conclusions; the public would be sacrificed to persons, and principles to pique." But we have heard of men doing good work who were not very robust. King Alfred was not a giant, nor the poet Pope a miracle of health, and the pillars of the Church and Law themselves are not always mighty men of valour. Men have been known to betray preference for the circular route in reasoning and short-cuts to conclusions, and we have heard of politicians to whom Gladstone was more than their principles. So we see that man falls short of perfection. Yet he is not without hope of himself, and why should woman despair? Must she alone stand aside from the march of progress and be as she has been? Such *à priori* judgments are unworthy of a scientific age. We want an *à posteriori* verdict, and claim the right of experiment. Let us not read failure as a whole from individual *fiasco*, and remember that failure is a shadow that haunts the sun of success.

And now for the last objection. "What is the good of all this higher education?" say some. "No sooner is a woman ready for a career than she marries: forgets her high calling, or, at most, passes it on to her children."

Advanced women cannot do better than marry. They will inaugurate a higher domestic tone, and hand on their own acquired adaptation to the new environment. Their technical training may be lost in domestic duties, but with a truer civilization, which shall retain only the essentials of home and

social life, with smaller families, and with the labour-saving methods acquired through business-like habits, marriage will not always mean for them, as it too often does now, the end of development. There is nothing incongruous between "mending" and mathematics, cooking and chemistry, and, as Howells in one of his novels, says, "Lofty ideals, when not indulged in at the expense of lowly realities, he had never found hurtful to any one." And there is no reason why, if fashion permitted, she should not even clothe her household in scarlet, like the virtuous woman of Proverbs, and so put herself beyond reproach for ever!

And if woman would be man's real helpmeet, she must advance. "Women govern us," writes a Frenchman. "Let us render them perfect; the more they are enlightened, so much the more shall we be. On the cultivation of the mind of women depends the wisdom of men. It is by women that Nature wins on the hearts of men." By sharing the more material part of man's life woman increases its attractiveness, for what she shares is alone complete. But when intellectual interests are partaken in as well, the joy of completeness in the higher will far outweigh the loss of energy in the lower functions. With double strides instead of single, the two will advance together until the twain are indeed one.

So out of seeming evil good has come. The numerical inequality of the sexes, by changing the environment of woman, and forcing her on to higher effort, has advanced the cause of humanity. Men alone have done well; but, looking round on the corrupt laws which the best of them sanction, on the lowness of professional and commercial aims, on their apologetic attitude towards much that is good, and their satisfaction with more that is bad, we cannot help hoping that, with women, they may do better still. "And, after all, the true measure of a woman's right of knowledge is her capacity for receiving it," and of her fitness for work, the way in which she does it; not any thoughts or theories of ours. The wave of progress is stealing on – over blame, abuse, contempt; and not one of us is stronger than Canute of old to arrest the rising tide.

THE TALENT OF MOTHERHOOD
The National Review, Vol. 16 (1890)

Arabella Kenealy

Some years ago, when I first established myself in medical practice, it happened that I had two patients, a consideration of whose cases, bearing as they do impressively upon the question of woman's education, will, I am sure, be interesting to the psychological reader.

I was sitting in my consulting-room, spending the morning in some literary work, and awaiting the advent of patients with that delighted expectation which characterizes the hopeful young practitioner, when a lady, whom I will call Mrs. Graham, was announced.

An extraordinarily handsome woman of about twenty-five, with a broad intellectual brow, and bright intelligent eyes, entered. She came in with a firm quick tread, her head erect; strength, decision, and activity in every movement of her tall figure. A fine health glanced from her eyes, and lay in the clear red and white of her cheeks. Her features were straight and beautifully formed, her firm, well-cut lips showing considerable strength of will and self-control. She did not look much like a patient; and, indeed, before she had time to speak, I had had time to experience some qualms of conscience with regard to my impending obligation of mixing with the healthy current of her blood some potion of my pharmacœpia.

She soon relieved my mind of its premature misgivings. After we had exchanged greetings, she plunged at once *in media res*.

"I have come to you," she said in a clear, concise way, and her strong resonant voice betokened its source in a healthful, ample pair of lungs; "I have come to you because you are a woman, and I am an upholder of my sex. We live in an age – a glorious age – which is seeing, and will see still more fully, the emancipation of woman, her development and the ultimate maturing of her powers, which have been so long in a crude

and rudimentary state. I look forward to the time – and it is not far distant – when woman shall be in every way the equal of man, physically as well as mentally. Her mind shall be as free and vigorous as her unfettered limbs. She shall throw off the intellectual yoke as she shall throw off her corsets, allowing herself to develop strong and active. From mother to daughter her powers shall descend, evoluting and reaching farther until she stands by man, her name beside his in scientific, political, and all other attainment."

Much more she said in the same strain, anticipating with glowing eagerness the future of her sex, speaking with the utmost enthusiasm, the clearest intelligence. The definiteness of her views, and the remarkable powers of expression, interested me greatly.

She has been a year married, and was now looking forward to motherhood to complete her life.

"I consider," she went on, her clear, deep eyes looking into mine, "that my child should be a fine type of humanity. I myself have splendid health, and I have developed and cultivated my powers to the utmost. I was originally a delicate and – I am ashamed now to confess it – a sentimental girl, but by chance some paper dealing with woman's higher education and her rights fell into my hands and roused me from my lethargy. At sixteen I was hard at work at one of the first high schools. I adopted a rational dress. I played tennis and cricket with my brothers. I rowed with them and ran with them. I gradually straightened up my sentimental wits, and strengthened, by effort, my delicate frame. Later I was at Girton, while my brothers were at Trinity; and I may say without vanity, for I worked incessantly while they worked dilettante fashion, I far outstripped them when tested by examination. I have tried in every way to show, and I think I have shown successfully, that there is nothing a man can do in the direction of physical or mental effort which is not equally possible to a woman. My frame is as vigorous as a man's I can walk farther and endure more fatigue than my husband, who is strong and healthy; and I am never ill. Since I have adopted a more energetic life, I have had no illness whatsoever. Before then I was considered delicate, and an hour's tennis tired me more than four hours of the same exercise would affect me now. When I left college I found in my father's office – he is a banker – ready use for my

developed energies. I can work as long as he, and he tells me I can work as well. I was quite contended with life, but I consider it a duty to marry, and when I met my husband I found him the most cultivated and interesting man of my acquaintance. The liking was reciprocal, and we were married. Since then I have transferred my energies from my father's to my husband's office. I employ a housekeeper to manage my home, and I can afford to do so, as my work in the office repays me tenfold her salary. I am perfectly happy. I have no time for all the forebodings and fancies which make miserable the lives of most of my women friends. I only wish all women could be brought to see the advantages, the superiority, of a life full of purpose and effort, in comparison with the aimless, dreary existences so many of them lead."

This story of her life was not told to me all at once, but from time to time as I saw her. I observed her with much attention. Her well-knit frame and steadfast nervous system never once drooped beneath that strain of another life drawing upon her health-resources. Active of body and full of intellectual energy, she never once flagged, or if she felt the need of mental or physical relaxation succumbed to the sense of her necessity.

She rode, and walked, and played tennis.

"Let my child's limbs," she said, "be well developed and strong, its frame muscular, and full of vitality."

She read, and wrote, and conducted her business.

"Let its mind," she said, "be active and clear; its faculties good, its talents quickened."

As her medical adviser, I urged upon my beautiful strong-minded patient some misgivings I felt. I might as well have confided them to the winds.

"So long," she replied, "as my own health is good, so long as I do not tire in body or brain, how can you tell me I do too much. The child must inherit the mother's health; from her energies it derives its strength."

I suggested in answer an idea which I had not in those days, as I now have, been able to prove by experience, viz., that the continuance of so energetic and active a course of life under the circumstances of her condition, might draw upon the child's resources.

But she would not listen. She laughed her clear, strong laugh. "That can be only a baseless fancy," she said. "I

believe in the fact of my own health, the evidence of my capability. While I am full of energy, physical and mental, my child must have out of my abundant vitality more than enough for its needs."

My second patient, whom I will call Mrs. Eden, came to me two mornings after Mrs. Graham's first visit, and the similarity of condition and striking differences of their character and feeling suggested to my inquiring mind an interesting sequel.

Mrs. Eden came into my room, a quiet, delicate-looking girl, of about the same age as my other patient, with a pale sensitive face, and grey wistful eyes. As she entered nervously, her slight figure seeming to shrink from observation, her soft mouth unsteady with feeling, I mentally contrasted her with the woman who had two days before come to consult me. The fine strength and self-confidence of the former stood out in bold contrast with the timid diffidence of my present visitor.

Mrs. Graham, with her muscular frame and assertive bearing, was a creature of essentially different fibre from that of the slender, emotional girl who now stood before me. She was well, though delicately made. Her slight figure was erect; the pose and carriage graceful, but just now there was an atmosphere of timidity about it, expressive of indecision. Her eyes were bright and full, and the pallor of her complexion was not unhealthy, though sensitive and nervous.

As I rose to receive her, she quickened her steps, and laying a clinging hand upon mine, she looked into my face. Bright tears stood in her eyes, and they shone with a moist lustre.

"I am to be a mother," she said with tremulous lips, "and will you tell me how I can do the best for my little baby?" The tears overfilled her lids, and ran through the thick lashes on to her cheeks.

"I am very foolish," she continued, smiling as she wiped them with her handkerchief, "but it is all so wonderful, and I am so afraid!"

I tried to reassure and cheer her.

"Oh, it is not for myself I fear," she answered; "but it is such a sacred trust, such a mighty wonder, and I am afraid I may do wrong – afraid I may hurt the tender, growing life. I have been amongst the children of the poor, and have seen the crippled limbs and carious spines, the idiot heads, and eyes that are blind, and I have felt we cannot do a greater wrong than put

such an inheritance of disease upon our children. Surely it can be helped! Surely, if the mother give out of her health and love and tenderness, these little ones would not be born so!"

"But suppose," I replied, "as if often the case, the mother have neither health nor tenderness to give?"

"It is terrible," she said, "for motherhood to be so undertaken."

I was much attracted by my new patient, and persuaded her to talk further. Comparing her with Mrs. Graham, and wondering if their views were as dissimilar as themselves, I tried to draw from her her ideas upon this subject of motherhood.

She was not a talker, and had no very definite views to propound. She had formulated no theories, and had not considered the question until the knowledge of her approaching responsibility had filled her with a serious sense of its gravity.

She had always been what is called "delicate," though no illness or definite symptom of disease had developed itself. I was inclined to look upon her delicacy as having no origin in nor likeness to ill-health; it was only that her nervous system was highly-strung and sensitive, and, vibrating to touches which less highly-pitched organizations do not feel, exercised and exhausted itself on planes other than practical. Her sympathies and emotions, more fully developed, took cognisance of and responded to things of which less imaginative natures are unconscious.

In contrasting her with Mrs. Graham, I found that the latter could walk for three hours without tiring, while an hour's continuous walking induced fatigue in Mrs. Eden; but while the former walked in the pride of her strength, keenly enjoying the freedom of movement and sustained activity, though her powers of observation were acute, and nothing on the road failed to arouse her attention, yet the sympathetic sense with nature was entirely absent.

For Mrs. Eden, the beauty of blossom, the tints and grouping of a bunch of leaves, the grey-green lichen on a cottage roof, the sedge and bulrush by a pool, a lightning-blasted lonely oak, the rush of the wind across a field of barley, the shimmer and light and shadow of the waking world, all these struck on her listening sense, thrilling and sounding a thousand echoes to which the other's ears were deaf.

Her sympathies were so attuned as to be like another set of senses. Beyond the lens which gathered the rays of the actual world there seemed to be another power of sight, where all images were thrown upon the retina of her emotions and there broke up in a play of colour and light.

When Mrs. Graham perceived a fact standing out clear and sharp-edged in an atmosphere of reason, Mrs. Eden saw it with ever-shifting boundary lines, dissolving and wavering with the expansive vibratile motion of summer-laden air. I wondered, in those days, which was the higher power of vision.

Surely, I told myself, Mrs. Graham's clear, rational mind, wherein all things stand out in definite view with sharp-cut edge, is evidence of a strong and perfect sight. Surely Mrs. Eden suffers from a kind of mental shortsightedness – an astigmatism of the mind. But misgivings would come. Is it not, I would ask myself, the perception of a little beyond which blurs the clearness of outline? Is it not the very seeing into distance which obscures the edge of that which is near? Do things in reality stand out in the clear, definite fashion of Mrs. Graham's mind?

Is not the boundary line of what *is* ever fading and dissolving into the misty light of *what will be*? As men, by looking only into objects near them, grow shortsighted, does not the mind, so treated, also lose the power of seeing into distance? Has not Mrs. Graham, by so sharpening up her power of focus, blunted her power of higher sight?

With this notion in my mind, I questioned her. I found her practically without imagination, practically without emotion. She had a stern, definite recognition of duty; she had a steadfast, definite feeling of affection, and these were firmly interwoven with and inter-dependent upon her knowledge and her reason. But into those higher realms of emotion, where the soul rushes with a cry in indefinite yearnings and hopes, where the bruised heart distils sweet essence in the subtle air, where the spirit of human love and aspiration trembles on the threshold of heaven, into these rarer planes of feeling her rational sense could not penetrate.

"Woman," she said, "has too long been the slave of sentiment, and in consequence the slave of man. Let her cultivate the activity of her mind and clear out all these fancies, let her develop the healthy muscles and energy of her body and exorcise the demon hysteria. Unrestrained emotion – all

emotion which is not entirely under control – is a weed that chokes the mind. We need pruning and clearing and lopping, lest our intelligence become a wilderness."

"Would you trim us like the old-fashioned yew trees – clip us to definite shape."

"Rather that than the old-fashioned garden where there is no order."

"But, remember, in the too well-kept garden you reap there only what you sow. In the wilder garden, where nature runs a little riot, the winds of the air, the bird and the bee scatter seeds from many quarters, and the old wild garden brings forth abundantly."

I myself had no very decided views on the subject, and only threw out stray objections that struck me. But my objections had little weight with her, and, indeed, partaking as they did of the nature of theories, they would not have been likely to move her who asked proof and logical showing for all that her creed admitted.

She was firmly convinced of the excellence of that educational system which demands that all the faculty and capability of an individual be developed to the utmost, brought entirely under the volition and control. She permitted no lounging, physical or mental, no dreaming or wandering of wits. "Change of occupation," she said, "is rest. When my mind is weary of work, I relax the strain, and alter the direction of fatigue by physical exertion. I will not allow one speck of dust to dim the clearness of my mind. At school and college, I formed these good habits. There was scarcely a moment of my day which was not guided by definite intention. By thus constantly directing the channels of faculty, we bring them under complete control, increase our capacity, and strengthen immeasurably our powers. Recognizing this, we can only infinitely regret how the wealth of woman's talent, which has lain dormant through the ages, has been lost to the world. Hitherto one half of the talent and power of humanity has been silent for the want of opportunity and education to develop it. The race might have advanced – evolution would have gone on – at just twice the rate of its past progress, had things been otherwise. The cultivated, active-limbed, fully-developed woman must have produced children of larger growth, and man would not have been so long in leaving the cradle."

I had not then, nor have I since, met with a woman possessed of so remarkable an intellect, yet withal she gave the impression, as clever women often will, of some faculty missing, and that the faculty of sympathy. With all her beauty and talent, one never grew to love her. Armed *cap-à-pie* in the strength of her self-confidence, she made no appeal to the affections.

Mrs. Eden was an artist. She possessed considerable artistic appreciation and feeling, but she was somewhat deficient in the power of execution. She felt the glow and fervour of a great artistic conception, her feeling clothed it round with light and colour, but her hands failed in the expression. Like most true women, her nature was essentially artistic; like most true women, she was deficient in large executive power. The conception leapt from her brain, strong in outline and colour; the expression fell on the canvas somewhat feebly, only a shadow as it were of the fancy it reflected. Her talent was uncertain, and, at best, nothing remarkable. She made graceful drawings and pretty studies. She illustrated books very charmingly, but the power of sustained idea and fully-grappled talent necessary to the production of great work was not hers. "It seems as if," she said, "the thought were lost somewhere in my nature before it reaches my fingers, as if some mesmeric touch of the outer world puts a languor on my hands." And so it was. Her nervous system was so sensitive that it answered to the least vibration of the atmosphere. The ripple of a bird's wing, the cry of a wounded creature, the laugh of a child, the rumble of a distant wheel, the rustle of the trees, each and every eddy that stirred the current of the air, broke on her listening sense in little wavelets of emotion. Yet she was not unpractical. Her house was well ordered, and was a charming home. After her marriage she gave up her profession, continuing her artistic work an as interest only, and a means of amusement.

During the period preceding her child's birth, it was curious how all her mental creative power seemed to have deserted her. I have known her to sit for an hour with pencil in hand, before her blank paper, but no inspiration would come. It was as if there were some intimate relation between the mental and physical creative power, and that while this latter was being drawn upon for motherhood, its corresponding faculty on the mental plane was in abeyance.

On one occasion, she, by a strong effort, constrained her forces, compelled her fancy to produce, her pencil to express; but the reactionary impulse showed itself in so violent an emotional depression, that I strongly forbade such another attempt.

The reaction, she assured me, was a sympathetic correspondence with her unborn infant's condition, this having suffered temporarily from her forced exertions. "All my strength," she said, "seems drawn into the little life; all my powers silent that the little sense may hear. My heart beats softly, that it may beat with the baby heart. The very breath I take seems an inspiration of God's air into the baby lungs. I cannot touch the little hands or kiss the little face, but I love it – I love it ere ever it is born."

Comparing my two patients in their great dissimilarity, which, I asked myself, is the higher, truer type of woman? What, indeed, is the essential of womanhood – what the crucial test? To this latter query there came ringing up on all sides the answer, Motherhood – motherhood, that function *propter quod est mulier.* It was useless to combat by little specious falsehoods of to-day's philosophy that truth upon which the world stands, to deny this, the hinge of human progress, the pivot of education.

I came back to the incontrovertible axiom. Motherhood is the true test of womanhood. That education and training, therefore, which best fit her for this function are for her true development. The best mother is the best woman. She who is able best to bring her faculties to the focus of motherhood is the most highly-developed of her sex; she it is who has travelled along the right lines of progress; she it is whose education has been the highest. Though her nature never undergo the test, she who is most fitted for this marvellous function is the fittest of women in all life's other womanly functions. Upon the best motherhood must the progress of nations depend; upon the proper performance of this duty the evolution of humanity turn. Woman it is who assimilates the spirit of the age, and interprets it in the capacity of her children.

I resolved, then, to leave the solution of the problem as to which of my patients was the higher feminine type to be determined by results. She whose child should prove to be the better human type, physically, mentally, and morally; she it was whom I would adjudge the true model of her sex.

And surely, thought I, Mrs. Graham, with her fully-developed physique and intellect, with all her powers quickened into bright and rare activity – surely, she it is who must best know and can best interpret the spirit of the age; surely the child of her who is in the van of womankind must lead humanity's march. As she has quickened her executive and productive powers on all planes, certainly on this also must her capacity be greater.

Some few years later I am in a position to answer the question I then asked myself. I am able also to bring to the solution of the problem the results of subsequent similar experiences. The first-born of my two patients are of strikingly dissimilar type, as dissimilar as are their mothers. There is no mediocrity about them; none of that averageness – if I may use the word – which makes the comparison of individuals so difficult.

The child of the one – the woman whose intellectual and physical powers are abnormally superior to those of the rest of her sex – her child is as far below the average of mankind as Mrs. Eden's is superior to it. I can still recall the cry of horror and disappointment that broke from Mrs. Graham's lips at the first sight of her baby. It was the only occasion upon which I knew her well-disciplined nervous system to be startled out of its control. It was a bitter, terrible moment. And, indeed, the poor infant might easily have disappointed a far less ambitious mother. As the nurse held it to her, clad in its long white frock, the light fell full upon its face, and then she broke out in that bitter cry. The wasted, puny frame, the low-browed, ill-developed head, the sunken, vacant eyes – the wretched baby was such a horrible contrast to its strong-limbed, vigorous, brilliant mother. The infant's sickliness, and a habit it had of moaning constantly as if in pain, though no reason could be found for its complaint, seemed like a piteous, feeble protest against some wrong done it.

It was only with the utmost care the child was reared. The disappointed mother, with her strict sense of duty, bestows much attention upon him, but he remains a backward, fretful, unhealthy boy, far behind his fellows in intelligence as he is in health. He is stunted and ill-developed, with a narrow bulging forehead, sunken cunning eyes, and sensual mouth.

His intellect is of a very inferior calibre, shallow, quick and selfish, and he has a marked deficiency of moral perception.

His health is bad, his temper morose. He is a source of continual vexation and chagrin to his handsome, clever mother; the deficiencies of his mind and heavy indolence of his nature irritating and annoying her at every turn.

The first-born of my other patient is of a very different type. A bright, healthy, strong-limbed boy, he shows a remarkable intelligence; he is gifted, indeed, with extraordinary talent, and promises to be a man of great attainment.

He has a beautiful intellectual head and face, a well-built sturdy physique and fine nervous energy. Though so young, he shows himself steady of purpose, loving and generous of heart, and his brain-power, approaching in no way to precocity, is most exceptional.

A greater contrast it is difficult to imagine than exists between the children of the two mothers.

That of the one is so essentially foremost in the ranks of humanity, that of the other is as if in him evolution had taken a backward step, so inferior is he to the average of his kind.

No one seeing this degenerate child of eminently superior parents could but be struck by the thought that some cause more potent and forceful than chance must have determined his striking inferiority.

Overcome by the seriousness of the truth involved, I set myself to explain the marvel.

Could it be, I asked myself, that Mrs. Graham's rare physical and mental capability was drawn from the reserve force of her offspring? Can it be that nature stores in the undifferentiated faculty of one generation the capacity of the next, and that Mrs. Graham had artificially forced into activity, and for her own use, the latent power of her son?

Was she in her extraordinary and abnormal efforts drawing upon a naturally dormant evolutionary store, wherein lay her child's human inheritance?

Is the extreme reading of woman's rights a record of her children's wrongs?

Does the blunting of her fibre in the treadmill of over-training make it incapable of those delicate mind-vibrations which, too fine to move the hand or guide the pen, are the echoes of a distant higher plane, that are registered and gathered in the mother's heart, to heighten the pitch and raise the keynote of her children's voices?

Had Mrs. Graham, in attuning and controlling to definite purpose each iota of her powers, spoilt their assonance with the faint, vague call of progress sounding from the hill-tops? Whatsoever the method of her error, it is certain that in her child evolution had slipped backwards, the strong, beautiful, assertive amazon had mothered a pigmy.

The sensitive, fine-souled nature of the other had answered to a higher touch, and in her child evolution seemed to take almost two steps onward. Her artistic mind, allowed free play, idealized the image of man, and her child was born a hero. Her physical powers, unexhausted by effort, had produced a fine nervous health in her offspring.

My two first patients are typical and extreme cases, but since their cases suggested to me an all-important truth, I have been able to bring the weight of many subsequent experiences to establish in my mind the conviction that an education which develops up and cultivates the faculties to the full, leaving no reserve of undifferentiated power, can but have an injurious effect upon the next generation, whose resources are thereby exhausted. That the continuous strain of business or professional pursuits, as also of great social exertions, during the periods preceding the birth of a child must of necessity show itself in the inferiority, physical, mental, or moral of that child, interfering, as it must, with the physical and mental composure of the mother, and spending the nervous forces essential to the proper growth and evolution of the embryo.

It has been shown that the embryo curiously and marvellously, in its development, passes through the various phases of evolution by which mankind has come up; that in its earlier stages it is impossible to determine to which of the animal kingdom it will eventually belong.

By analogy we may conclude that the child passes later through the stages of development man has assumed since he became distinctly human. *It is not difficult then to imagine, supposing the maternal power to fail, that the child's evolution may stop short, its human development be arrested on a lower plane, and an inferior type – anterior to the age in which it is born – may be brought into existence.*

We are too ready to consider that if a child be born of a strong constitution, the mother has fulfilled his duties; but, supposing the child to be a healthy specimen only of a type

lower than its parents, is there not, in fact, a further failure of parental responsibility than takes place when a child, more sickly in constitution, yet morally superior, is produced.

The relation between mother and child is far more intimate than is commonly believed. We see a striking evidence of this in those cases, by no means infrequent, in which a woman remains well and healthy so long as she brings forth only sickly infants, but the birth of a vigorous child is the date of her distinct constitutional deterioration. She is never afterwards equally strong. The effort of nature in the production of a healthy offspring seems to have sapped the very foundations of her vigour. She has given, it appears, a portion of her life-power in the putting forth of a higher human blossom.

The motherhood of a complex race is not at all the insignificant function we are in the habit of considering it. Every fibre of the woman's nature is strung to the tension of a higher note, her faculties strained to the effort. She may not suffer from any definite disease, but her strength is devoted to the needs of the developing life; her soul is faint, her limbs are languid, because in her nature is making an onward stride.

It is untenable that during so trying and important a period she should be weighted by the cares of bread-winning. No woman undergoing the trial of motherhood should be engaged in any pursuit which absorbs her best energies and strains her attention. She should, so far as she is able, limit her efforts and conserve her strength, in order that this may be expended in the fulfilling of that maternal responsibility she has undertaken.

The fact that this is in some instances an automatic and more or less mechanical condition, which does not at all detract from a woman's health and energies, but allows her to perform with ease other arduous obligations, shows only that in such the bond of sympathy between mother and child is missing, that she is insensitive to or careless of its needs.

The faculty of good motherhood – the possession of great mother-power – which shows itself not in quantity but in the finer quality of the offspring, is a distinct talent; and surely, when we consider that upon it the vital question of humanity's evolution turns, we may regard this talent as not the least to which woman may aspire.

Suitable general education and freedom are necessary for the development of this wonderful talent, but during that epoch in

which it is seeking expression all other faculties must perforce be more or less silent.

Let no woman be compelled to seek marriage as a means of livelihood; no position can be more demoralising. Let her education be such that it will enable her to support herself till love – if this happen – tempt her from her independence. But let her then recognise marriage and motherhood as gateways of self-sacrifice, entering which she must be content to give up in a measure her material independence, and to spend her powers – at least for a time – in another direction.

The education and training she has undergone – unless, as is unfortunately too often the case in these days of forced cultivation, they have been so extreme as to warp her nature and spoil her woman-power – will make her the better wife and mother. But the utmost care is needed in the training of women – the possible mothers of the race – that their delicate physical sensitiveness should not be blunted by extremes of exercise, their special intellectual and moral characteristics distorted and deformed by mental strain;

> For woman is not undevelopt man
> But diverse.

This is no call for the relegation of woman to the position she held in those days when, uneducated and undeveloped, she was pitiably and to a demoralising extent dependent upon the other sex for all the advantages she possessed. All I advance is a protest, lest in the keen excitement of her new independence, the rush and activity of her new interests, she shall be forgetful of that grave trust the welfare of her children, and, through them, of the progress of the race.

Dr. Weir Mitchell, perhaps the greatest of all authorities on the subject of nervous diseases, tells us that only about one American woman in a hundred is physically fit for motherhood, and we who, from the restlessness and overwork of our lives to-day sit with the spectre of nerve exhaustion ever at our board, are rapidly approximating to the physical condition of our American cousins.

The type given in Mrs. Graham, of a woman who has, without injuring her health, diverted into the vortex of her self-assertiveness and self-expression the current of her mother-power – not, unfortunately, her power of producing children, but that capability which every true woman possesses of

adding her quotum to the improvement of the race – is certainly less common than is that of the woman whose health is broken and her mind deformed by physical or mental overstrain.

I met the other morning some fifty or sixty girls trooping out of a high school, and observing these with attention – through my physiological glasses, as it were – I stood aghast at the picture of womanhood projected.

The girls ranged in age from twelve to sixteen, and the sallow skins, nerveless faces, sexless look, lustreless or spectacled eyes, and heavy anæmic lips of the greater number– a small proportion being bright-eyed, eager neurotics – told a pitiable story of constitutions being wrecked between two forces: on the one hand, nature struggling to develop a healthy efficient womanhood; on the other, over-education exhausting the nerve power and demagnetizing the blood by long, close hours of study and arduous application.

Just at the most trying epoch of her existence, when the future of her constitution trembles in the balance, the woman-child is taxed to the utmost, and generally with the worst possible results. The beautiful health of body and mind are irrevocably lost; the spontaneity and originality trodden out of the tender unformed nature on the treadwheel of high pressure.

It is in the conservation of character that woman retains her inherent talent of motherhood; in that education which develops and cultivates her natural faculties, instead of substituting for these masculine, or, to speak more truly, neuter attributes artificially formed by the immaturity and dwarfing of her womanhood.

In our modern fashion we do honour to her whom nature has endowed with a lovely talent of singing, but we give small credit to her who has so kept holy and watered with "the rain of deep feeling," in this arid, dusty highway of civilization's march, the sanctuary of her nature that it shall bring forth beautiful human blossoms. We honour the Christ-child, and the pure Virgin heart of the Mother who bare Him. For nineteen hundred years we have set before us as a model the sacred life and teaching of the Nazarene, but we have been deaf to the teaching of the Virgin-Mother, which is a marvellous message to woman, putting before her the ideal motherhood of the Holy Son.

Some day I do not doubt but that the function of motherhood, which woman is sneeringly, in modern parlance,

said to possess "in common with the cow," will be highly esteemed and held to be immeasurably superior to those small talents of tongue and hand which are now considered as of so much greater worth. Instead of being regarded as the sign of her inferiority, the power of expressing the inherent beauty and wealth of her nature by the bringing forth of a lovely human type will be a talent most coveted by woman, and most honoured by man.

Happy he
With such a mother! faith in womankind
Beats with his blood, and trust in all things high
Comes easy to him, and tho' he trip and fall,
He shall not blind his soul with clay.

THE EMANCIPATION OF WOMEN[1]
The Fortnightly Review, Vol. 50 (1891)
Frederic Harrison

To those of us meeting here, on the thirty-fourth anniversary of his death, who knew Auguste Comte in life and have made his teaching the work of our lives, he is neither infallible authority and unique prophet on the one hand, nor, on the other, is he merely a great thinker and founder of a school of philosophy. To us he is really the founder of a Religion: but that religion is neither mystical, nor incomprehensible, nor absolute. It is simply a scheme of rational knowledge, enlarged into a practical rule of earthly life. We are no "Comtists," as some still perversely call us; for we do not base our faith on Comte's words, example, or precept. We base them on the sum of Positive knowledge. This sum of Positive knowledge was neither discovered nor collected – much less revealed by Auguste Comte. It was in part arranged and co-ordinated, connected and illustrated by him – and that (I say it most reverently, but most definitely) with constant errors, much premature generalisation, and not a little defective knowledge. It no more disturbs me to have to admit mistakes, fallacies, ignorance in the philosophy of Comte than to admit them in Aristotle and Descartes. And as I am neither Aristotelian nor Cartesian, so I am not Comtist. The only authority I can recognise is the sum of man's Positive knowledge; and the only interpreter of that knowledge is the final judgment of the most competent minds. The very suggestion of any man having closed the progress of knowledge at once amazes and disgusts me.

But on the other hand, though Auguste Comte is to us one of the great teachers of mankind, having no indisputable authority such as we shrink from giving to other great teachers, he

[1] An address given at Newton Hall, on 5th September, the anniversary of the death of Auguste Comte.

is no mere philosopher, head of a school of science, and intellectual reformer. He is the founder of a Religion – but there again not the inventor of a religion – much less the revealer or Prophet of a new religion. The religion of Humanity is not new: it was not a discovery of Auguste Comte: he was not the first even to introduce it to our age. The religion of Humanity is as old as Humanity: all other kinds of religions are merely parts of it, germs of it, strivings after it, forecasts and types of it. The religion of Humanity began with civilisation and with human nature. It has been a constant living force – disguised now as the worship of nature, or of many gods, now as the worship of one God, or of the Infinite and the Unknowable. It was always and everywhere the living bond which held together the family, which formed nations, and stirred men to all that was good and great. We meet here to-day, not to acknowledge our faith in a new Religion: we meet to submit our consciences to the oldest religion known to this planet; to go back to human nature in its primæval simplicity. We rest in a religious faith of which the Judaisms, the Buddhisms, the Romanisms of East and West are but late perversions.

Of this Religion – the essential and primitive bond of Human Nature – Auguste Comte never was, and never professed to be the inventor. But he professed to be – and he was – to use his own word, the "institutor," or founder. That is to say, he put on a solid foundation, made intelligible, plain, coherent, forms of belief and of feeling which for ages had been living and working indeed, but were indistinctly seen, vague, misunderstood, without any scientific ground, perpetually covered by a mass of accumulated and superincumbent *débris*. Comte did not discover the Religion of Love and of Faith in Human Nature – which was there already. He did discover that it was the real religion, and that it was ample in itself without supernatural and superterrestrial ideas about religion. And by his wonderful sketch of sociology as a science (*ébauche* he loved to call it) Comte gave this religion of Human Nature a basis of demonstrative reality, and thus closed the long warfare between Science and Religion, Philosophy and Devotion. This was not to invent a new Religion – I can hardy say how much the idea of such a new "Tower of Babel" disgusts me – but it was to found the Old Religion, which arrogance and vanity had long buried under so much dogma and so many dreams.

This difference between "inventing" a new thing, and "founding," or giving permanent foundation to an old thing which had been obscured, misunderstood, and mis-used, is so important that I will try to illustrate it by a figure. When Watt discovered the steam-engine, or Wheatstone the electric telegraph, they "invented" new instruments of enormous power, of which certainly the inorganic materials existed, but of which the idea, construction, and use had never before been known on this earth. When Columbus or Cook discovered unknown continents and islands across the ocean, they found lands, peoples, minerals, vegetables, and animals – a flora and a fauna, which had, indeed, been there for ages – but which were so completely new at the time of discovery that, though only on the other side of this planet, they no more affected Europe, Asia, and Africa than if they had been placed on Mars.

Comte never was, and never claimed to be, the "inventor" or "discoverer" of a new Religion in this sense. What he did say was this: "Mankind has for ages persistently sought for a permanent religion in all kinds of form. Now, a scientific study of history and sound anthropology show that the essence of all these efforts lies in a combination of Hope in Man's Future with veneration for Man's higher nature, knowledge of Man's past history, his actual resources and limits. This is the essence of religion; and hopes of an eternal Heaven and assertions about the Universe and its origin are not religion at all, but hindrances of religion. Your old love and faith in Human Nature itself, *is* your religion. And all that you need is to clear it from the clouds, grave on your minds its scientific certainty, and allow yourselves to see it in its true beauty!"

The change which this involves is, no doubt, very great – deep, wide, and startling. But it is not a change from the old to something new and unknown, it is not a leap in the dark. It is a clearing off of the new to come down to the old foundation, to abandon ambitious dreams for solid good. It is unquestionably a new Era; but it is a simple and a continuous development. It is as when Julius and his successors in the Empire said to the Romans – "Peace is your real glory: not war. Your dreams of perpetual warfare and universal dominion are cruel superstitions and degrading phantoms. Your mission, Romans, is to civilise in peace the nations you have incorporated. The true greatness of the Roman Republic is to count all Southern Europe amongst her citizens." Or, as when St. Paul said to the

Jews – "Cease your ambitious dreams of a conquering Messiah. The true Messiah bears a message of Faith, Hope, Charity which the Prophets and Priests used to utter to the stricken remnant of Israel, and which, I tell you, is to be offered to every son of Man, who is, every one of them, a son of God." Or, as when wise and peaceful statesmen slowly taught the people of Europe that industry, not war, was the true business of civilised man – that Peace hath her victories far more renowned than war. Or, as if an English statesman were to arise and tell the democratic agitators of to-day that England is now a democratic Republic if we choose to act like citizens, that good government is a more urgent want than an ideally-perfect machine for taking votes, and that Home rule, in the true sense, is a far nobler ideal than any Imperial Federation of the English race. Or, just as we here tell the Socialists around us, that the essence of Socialism is a moral, social, and religious education of the people – without which, to confiscate the wealth of the actual capitalists, and to put hungry and angry workmen to direct the capital of society, would be a disaster to all; for true Socialism consists in the spread of a religion of social duty, and not in social wars, proscriptions, and confiscations. All of these are examples of a New Era being founded by a return to, or the development of, old and living forces, which have been thrust aside or misunderstood, under the spur of ambition, arrogance, and vanity.

This is the meaning of the underlying maxim of Positive Philosophy – *Progress is the development of Order*. That is to say, our true hopes for the future lie, not in destroying the institutions and products of the Past, but in cultivating them to their normal issue and purpose. There is nothing *new* in Positivism, except in making new use of our old resources. On the other hand, there is nothing in positivism absolutely *old*, in the sense of returning to anything in the Past as it used to be. We can neither stand still, nor can we go back. We *must* go forward. We can recall nothing, no more than the old man can recall his youth, or the youth his childhood. We must change everything. But we can create, invent, originate, in an absolute sense, nothing. Whatever pretends to be absolutely new, without parentage or preparation, is a manifest imposture. Everything must be *developed*, *i.e.*, evolved by normal growth out of the conditions and germs of the Past. There are infinite

meanings and inexhaustible applications in the maxim: *Progress is the development of order.*

Thus, with all its daring ideal of a New Era in every sphere of human life, Positivism is, in the true and noble sense of that term, profoundly conservative. It traces the growth of the great institutions of Humanity back for tens of thousands of years to the very dawn of civilised society, and it finds them all and everywhere living forces, working for human good: the Family, Marriage, the Domestic education, Political Government, Nations, the appropriation of capital, the differentiation of social functions, the influence of a spiritual authority, the transmission of ideas, of materials, of memories, the diverse offices of the sexes, the tendency to continual differentiation, along with a collateral tendency to union and organisation by common beliefs and venerations. Our Positive Religion finds these institutions, habits, and tendencies, with a history of a hundred centuries, ever more and more definitely marked, and it aims at developing these diversities to their normal issue – not at assimilation and uniformity. It seeks to purify and spiritualise the great social institutions – not to materialise them or annihilate them.

In nothing is this character more conspicuous than in Comte's teaching as to the social Future of Women. It is intensely conservative as to the distinctive quality with which civilisation has ever invested women, whilst it is ardently progressive in its aim to purify and spiritualise the social function of women. It holds firmly the middle ground between the base apathy which is satisfied with the actual condition of woman as it is, and the restless materialism which would assimilate, as far as possible, the distinctive functions of women to those of men, which would "equalise the sexes" in the spirit of justice, as they phrase it, and would pulverise the social groups of families, sexes, and professions into individuals organised, if at all, by unlimited resort to the ballot-box. Herein Positivism is truly conservative in holding society to be made up of *families*, not of individuals, and in developing, not in annihilating, the differences of sex, age, and relation between individuals.

But first, let us get rid of the unworthy suspicion that Positivism is content with the condition of women as we see it, even in the advanced populations of the West to-day. As M. Laffitte has so well put it, the "test of civilisation is the place

which it affords to women." In a rudimentary state we find women treated with brutal oppression, little better than slaves or beasts of burden, where the conditions of existence make such tasks almost a cruel necessity for all. In many societies of a high civilisation, from the point of view of intellectual activity or military organisation, the condition of women is often found to be one of seclusion, neglect, or humiliation, moral, physical, and intellectual. Even to-day, under the most favourable conditions – conditions, perhaps, more often found in some sections of the labouring classes of cities rather than amongst the spoiled daughters of wealth and power – it is shocking to see how backward is the education of women as a sex, how much their lives are over-burdened by labour, anxiety, and unwomanly fatigues, by frivolous excitement and undue domestic responsibility, by the fever of public ambitions and cynical defiance of all womanly ideals.

No! we can never rest satisfied with the current prejudice that assigns to woman, even to those with ample leisure and resources, an education different in kind and degree and avowedly inferior to that of men, which supposes that even a superior education for girls should be limited to a moderate knowledge of a few modern languages, and a few elegant accomplishments. This truly Mahometan or Hindoo view of woman's education is no longer openly avowed by cultured people of our own generation. But it is too obviously still the practice in fact throughout the whole Western world, even for nine-tenths of the rich. And as to the education which is officially provided for the poor, it is in this country, as least, almost too slight to deserve the name at all. For this most dreadful neglect Positivism calls aloud for radical relief. It calls aloud for an education for women in the same line as that of men, to be given by the same teachers, and covering the same ground, though not at all necessarily to be worked out in common or in the same form and with the same practical detail. It must be an education, essentially in scientific basis, the same as that of men, conducted by the same, and those the best attainable, instructors – an education certainly not inferior, rather superior to that of men, inasmuch as it can easily be freed from the drudgery incidental to the practice of special trades, and also because it is adapted to the more sympathetic, more alert, more tractable, more imaginative intelligence of women.

So, also, we look to the good feeling of the future to relieve women from the agonizing wear and tear of families far too large to be reared by one mother – a burden which crushes down the best years of life for so many mothers, sisters, and daughters – a burden which, whilst it exists, makes all expectation of superior education or greater moral elevation in the masses of women mere idle talk – a burden which would never be borne at all, were it not that the cry of the market for more child labour produces an artificial bounty on excessively large families. And to the future we look to set women free from the crushing factory labour which is the real slave-trade of the Nineteenth Century, one of the most retrograde changes in social order ever made since Feudalism and Church together extinguished the slavery of the ancient world. In many ways this slavery of modern Industrialism is quite as demoralising to men and women, and in some ways as injurious to society, as ever was the mitigated slavery of the Roman Empire, though its evils are not quite so startling and so cruel.

These are the wants which, in our eyes, press with greatest urgency on the condition of women, and not their admission to all the severe labours and engrossing professions of men, the assimilation of the life of women to the life of men, and especially to a share in all public duties and privileges. The root of the matter is that the social function of women is essentially and increasingly different from that of men. What is this function? It is personal, direct, domestic; working rather through sympathy than through action, equally intellectual as that of men, but acting more through the imagination, and less through logic. We start from this – neither exaggerating the difference, nor denying it, but resting in the organic difference between woman and man. It is proved by all sound biology, by the biology both of man and of the entire animal series. It is proved also by the history of civilisation, and the entire course of human evolution. It is brought home to us every hour of the day, by the instinctive practice of every family. And it is illustrated and idealised by the noblest poetry of the world, whether it be the great epics of the past or the sum of modern romance.

It is a difference of nature, I say, an organic difference, alike in body, in mind, in feeling, and in character – a difference which it is the part of evolution to develope and not to destroy, as it is always the part of evolution to develope organic

differences and not to produce their artificial assimilation. A difference, I have said; but not a scale of superiority or inferiority. No theory can more deeply repudiate the brutal egoism of past ages, and of too many present men of the world, which classes women as the inferiors of men, and the cheap sophistry of the vicious and the overbearing that the part of women in the life of humanity is a lower, a less intellectual, or less active part. Such a view is the refuge of coarse natures and stunted brains. Who can say whether it is nobler to be husband or to be wife, to be mother or to be son? Is it more blessed to love or be loved, to form a character or to write a poem? Enough of these idle conundrums, which are as cynical as they are senseless. Everything depends on how the part is played, how near each one of us comes to the higher ideal – *how* our life is worked out, not whether we be born man or woman, in the first half of the century or in the second. The thing which concerns us is to hold fast by the organic difference implanted by Nature between Man and Woman, in body, in mind, in feeling, and in energy, without any possibility of talking of higher and lower, of better or of worse.

Fully to work out the whole meaning of this difference in all its details, would involve a complete education in Anthropology and Ethics, and nothing but the bare heads of the subject can here be noticed. It begins with the difference in physical organisation – the condition, and, no doubt in one sense, the antecedent (I do not say the *cause*) of every other difference. The physical organisation of women differs from that of men in many ways: it is more rapidly matured, and yet, possibly, more *viable* (as the French say), more likely to live, and to live longer; it is more delicate, in all senses of the word, more sympathetic, more elastic, more liable to shock and to change; it is obviously less in weight, in mass, in physical force, but above all in muscular persistence. It is not true to say that the feminine organisation is, on the whole, weaker, because there are certain forms of fatigue, such as those of nursing the sick or the infant, minute care of domestic details, agility to resist the wear and tear of anxiety on the body, in which women certainly at present much surpass men. But there is one feature in the feminine organisation which, for industrial and political purposes, is more important than all. It is subject to functional interruption absolutely incompatible with the highest forms of continuous pressure. With mothers, this

interruption amounts to seasons of prostration during many of the best years of life: with all women (but a small exception not worth considering) it involves some interruption to the maximum working capacity. A normal perfectly healthy man works from childhood to old age, marries and brings up a family of children, without knowing one hour of any one day when he was not "quite fit." No woman could say the same; and of course no mother could deny that, for months she had been a simple invalid. Now, for all the really severe strains of industrial, professional, and public careers, the first condition of success is the power to endure long continuous pressure at the highest point, without the risk of sudden collapse, even for an hour.

Supposing all other forces equal, it is just the five per cent. of periodical unfitness which makes the whole difference between the working capacity of the sexes. Imagine an army in the field or a fleet at sea, composed of women. In the course of nature, on the day of battle or in a storm, a percentage of every regiment and of every crew would be in child-bed, and a much larger percentage would be, if not in hospital, below the mark or liable to contract severe disease if subject to the strain of battle or storm. Of course it will be said that civil life is not war, and that mothers are not intended to take part. But all women may become mothers; and though industry, the professions, and politics are not war, they do, and they ought to, call forth qualities of endurance, readiness, and indomitable vigour quite as truly as war.

Either the theory of opening all occupations to women means opening them to an unsexed minority of women, or it means a diminution and speedy end to the human race, or it means that the severer occupations are to be carried on in a fashion far more desultory and amateurish than ever has yet been known. It is owing to a very natural shrinking from hard facts, and a somewhat misplaced conventionality, that this fundamental point has been kept out of sight, whilst androgynous ignorance has gone about claiming for women a life of toil, pain, and danger, for which every husband, every biologist, every physician, every mother – every true woman – knows that women are, by the law of nature, unfit.

This is, as I said, merely a preliminary part of the question. It is decisive and fundamental, no doubt, and it lies at the root of the matter. It is a plain organic fact, that ought to be treated

frankly, and which I have touched on as an incident only but with entire directness. But I feel it to be after all, a material, and not an intellectual or spiritual ground, and to belong to the lower aspects of the question. We must notice it, for it cannot be disregarded; but it is by no means the heart of the matter. The heart of the matter is the greater power of affection in Woman, or, it is better to say, the greater degree in which the nature of Woman is stimulated and controlled by affection. It is a stigma on our generation that so obvious a commonplace should need one word to support it. Happily there is one trait in humanity which the most cynical sophistry has hardly ventured to deny – the devotion of the mother to her offspring. This is the universal and paramount aspect of the matter. For the life of every man or woman now alive, or that ever lived, has depended on the mother's love, or that of some woman who played a mother's part. It is a fact so transcendent that we are wont to call it an animal instinct. It is, however, the central and most perfect form of human feeling. It is possessed by all women: it is the dominant instinct of all women; it possesses women, whether mothers or not, from the cradle to the grave. The most degraded woman is in this superior to the most heroic man (abnormal cases apart). It is the earliest, most organic, most universal of all the innate forces of mankind. And it still remains the supreme glory of Humanity. In this central feature of human nature, Women are always and everywhere incontestably pre-eminent. And round this central feature of human nature, all human civilisation is, and ought to be organised, and to perfecting it all human institutions do, and ought to converge.

I am very far from limiting this glorious part of maternity in woman to the breeding and nurture of infants; nor do I mean to concentrate civilisation on the propagation of the human species. I have taken the mother's care for the infant as the most conspicuous and fundamental part of the whole. But this is simply a type of the affection which in all its forms woman is perpetually offering to man and to woman – to the weak, the suffering, the careworn, the vicious, the dull, and the over-burdened, as mother, as wife, as sister, as daughter, as friend, as nurse, as teacher, as servant, as counsellor, as purifier, as example, in a word – as woman. The true function of woman is to educate, not children only, but men, to train to a higher civilisation, not the rising generation, but the actual society.

And to do this by diffusing the spirit of affection, of self-restraint, self sacrifice, fidelity, and purity. And this is to be effected, not by writing books about these things in the closet, nor by preaching sermons about them in the congregation, but by manifesting them hour by hour in each home by the magic of the voice, look, word, an all the incommunicable graces of woman's tenderness.

All this has become so completely a commonplace that the very repeating it sounds almost like a jest. But it has to be repeated now that coarse sophistry has begun, not only to forget it, but to deny it. And we will repeat it; for we have nothing to add to all that has been said on this cardinal fact of human nature by poets, from Homer to Tennyson, by moralists and preachers, by common sense and pure minds, since the world began. We have nothing to add to it save this – which, perhaps, is really important – that this function of woman, the purifying, spiritualising, humanising of society, by humanising each family and by influencing every husband, father, son, or brother, in daily contact and in unspoken language, is itself the highest of all human functions, and is nobler than anything which art, philosophy, genius, or statesmanship can produce.

The spontaneous and inexhaustible fountain of love, the secret springs whereof are the mystery of womanhood, this is indeed the grand and central difference between the sexes. But the difference of function is quite as real, if less in degree, when we regard the intellect and the character. Plainly, the intellect of woman on the whole is more early mature, more rapid, more delicate, more agile than that of men; more imaginative, more in touch with emotion, more sensitive, more individual, more teachable, whilst it is less capable of prolonged tension, of intense abstraction, of wide range, and of extraordinary complication. It may be that this is resolvable into the obvious fact of smaller cerebral masses and less nervous energy, rather than any inferiority of quality. The fact remains that no woman has ever approached Aristotle and Archimedes, Shakespeare and Descartes, Raphael and Mozart, or has ever shown even a kindred sum of powers. On the other hand, not one man in ten can compare with the average women in tact, subtlety of observation, in refinement of mental habit, in rapidity, agility, and sympathetic touch. To ask whether the occasional outbursts of genius in the male sex are higher than the almost

universal quickness and fineness of mind in the female sex, is to ask an idle question. To destroy either out of human nature would be to arrest civilisation and to plunge us into barbarism. And the earliest steps out of barbarism would have to begin again in each wigwam with the quick observation and the flexible mind, and not with the profound genius.

As with the intellect – so with the powers of action. The character or energy of women is very different from that of men; though here again it is impossible to say which is the superior, and far less easy to make the contrast. Certainly the world has never seen a female Alexander, Julius Cæsar, Charlemagne, or Cromwell. And in mass, endurance, intensity, variety, and majesty of will no women ever approach the greatest men, and no doubt, from the same reason, smaller cerebral mass and slighter nervous organisation. Yet in qualities of constant movement, in perseverance, in passive endurance, in rapidity of change, in keenness of pursuit (up to a certain range and within a given time), in adaptability, agility, and elasticity of nature, in industriousness, in love of creating rather than destroying, of being busy rather than idle, of dealing with the minutest surroundings of comfort, grace, and convenience, it is a commonplace to acknowledge women to be our superiors. And if a million housewives do not equal one Cromwell, they no doubt add more to the happiness of their own generation.

We come back to this – that in body, in mind, in feeling, in character, women are by Nature designed to play a different part from men. And all these differences combine to point to a part personal not general, domestic not public, working by direct contact not by remote suggestion, through the imagination more than through the reason, by the heart more than by the head. There is in women a like intelligence, activity, passion; like and co-ordinate, but not identical; equally valuable, but not equal by measure; and this all works best in the Home. That is to say, the sphere in which women act at their highest is the Family, and the side where they are strongest is Affection. The sphere where men act at their highest is in public, in industry, in the service of the State; and the side where men are the strongest, is Activity. Intelligence is common to both, capable in men of more sustained strain, apt in women for more delicate and mobile service. That is to say,

the normal and natural work of women is by personal influence within the Home.

All this is so obvious, it has been so completely the universal and instinctive practice of mankind since civilisation began, that to repeat it would be wearisome if the modern spirit of social anarchy were not now eager to throw it all aside. And we Positivists have only to repeat the old saws on the matter, together with this – that such a part is the noblest which civilisation can confer, and was never more urgently needed than it is to-day. In accepting it graciously and in filling it worthily, women are placing themselves as a true spiritual force in the vanguard of human evolution, and are performing the holiest and most beautiful of all the duties which Humanity has reserved for her best-beloved children. The source of the outcry we hear for the Emancipation of Women – their emancipation from their noblest duty – is that in this materialist age men are prone to despise what is pure, lofty, and tender, and to exalt what is coarse, vulgar, and vainglorious.

When we say that we would see the typical work of women centred in her personal influence in the Home, we are not asking for arbitrary and rigid limitations. We are not not calling out for any new legislation or urging public opinion to close any womanly employment for women. There are a thousand ways in which the activity of women may be of peculiar value to the community, and many of these necessarily carry women outside their own houses and into more or less public institutions. The practice of the ladies connected with this Hall alone would satisfy us how great is the part which women have to play in teaching, in directing moral and social institutions, in organising the higher standard of opinion, in inspiring enthusiasm in young and old. We are heartily with such invaluable work; and we find that modern civilisation offers to women as many careers as it offers to men.

All that we ask is that such work and such careers shall be founded on *womanly* ideals, and shall recognise the essential difference in the social functions of men and of women. We know that in a disorganised condition of society there are terrible accumulations of exceptional and distressing personal hardship. Of course millions of women have, and can have, no husbands; hundreds of thousands have no parents, no brother, no true family. No one pretends that society is without

abundant room for unmarried women, and has not a mass of work for women who by circumstances have been deprived of their natural family and are without any normal home. Many of such women we know to be amongst the noblest of their sex, the very salt of the earth. But their activity still retains its home-like beauty, and is still womanly and not mannish. All that we ask is that women, whether married or unmarried, whether with families of their own or not, shall never cease to feel like women, to work as women should, to make us all feel that they are true women amongst us and not imitation men.

We are not now discussing any practical remedy for a temporary difficulty; we are only seeking to assert a paramount law of human nature. We are defending the principle of the womanliness of woman against the anarchic assertors of the manliness of woman. There is a passionate party of so-called reformers, both men and women, who are crying out for absolute assimilation as a principle; and such is the weakness of politicians and leaders that this coarse and ignorant sophism is becoming a sort of badge of Radical energy and freedom from prejudice. With all practical remedies for admitted social diseases we are ever ready to sympathise, and I venture to claim for this body which meets here, that not a public question of importance ever finds us dull to listen or slow to act. In the name of mercy let us all do our best with the practical dilemmas which society throws up. But let us not attempt to cure them by pulling society down from its foundations and uprooting the very first ideas of social order. Exceptions and painful cases we have by the thousand. Let us struggle to help or to mend them, as exceptions, and not commit the folly of asserting that the exception is the rule.

We all know that there are more women in these kingdoms than men, and not a little perplexity arises therefrom. But since more males are born than females, the inequality is the result of abnormal causes – the emigration, wandering habits, danger-ous trades, overwork and intemperance of men. It is the first and most urgent duty of society to remedy this social disease, and not to turn society upside down in order to palliate a temporary want. Certainly not, when the so-called remedy can only increase the disease by "debasing the moral currency" and desecrating the noblest duties of woman. Certainly, no reformers whatever can be more eager than we are to do our best to help in any reasonable remedy for our social maladies,

be they what they may. But the extent and acuteness of social maladies makes us only more anxious to defend the first principles of human society – and to us none is so sacred as the inherent and inalienable womanliness of all women's work.

The prevalent sophistry calls out for complete freedom to every individual, male or female, and the abolition of all restraints, legal, conventional, or customary, which prevent any adult from living his or her own life at his and her private will. It is specious; but, except in an age of nihilism, such anarchic cries would never be heard. It involves the destruction of every social institution together. The Family, the State, the Church, the Nation, Industry, social organisation, law, all rest on fixed rules, which are the standing contradiction of this claim of universal personal liberty from restraint. Society implies the control of absolute individual licence; and this is the claim for absolute individual licence. It is perfectly easy to find objections and personal hardship in every example of social institution. Begin with marriage. Many married people would be happier and, perhaps, more useful, if they could separate at will. *Therefore* (the cry is) let all men and women be always free to live together or apart, when they choose, and as long as they choose, without priests, registrars, law-courts, or scandal. Many parents are unworthy to bring up their children. *Therefore*, let no parent have any control over his child. Many women would be more at ease and perhaps more able to work in their own way, if they wore men's clothes. And some men, especially the old and the delicate, might be more comfortable in skirts. *Therefore*, abolish the foolish restrictions about Male and Female dress. And this our reformers, it seems, are preparing to do. Many men and more women are, at 20, better fitted to "come of age" than some men at 30. *Therefore*, let everyone "come of age" when he or she thinks fit. Many a man who, through hunger, steals a turnip is an angel of light compared with a millionaire who speculates. *Therefore*, abolish all laws against stealing. Many a foreigner living in England knows far more of politics than most native electors. *Therefore*, abolish all restrictions applying to "aliens" as such. Many a layman can preach a better sermon than most priests, can cure disease better than some doctors, can argue a case better than certain barristers, could keep deposits better than some bankers, find a thief quicker than most policemen, and drive a "hansom" better than some cabmen. *Therefore* – it is

argued – let every man, woman, and child live with whomsoever he or she like, wear breeches or petticoats as he or she prefer, put their vote in a ballot-box whenever they see one at hand, conduct divine service, treat the sick, plead causes, coin money, carry letters, drive cabs, and arrest their neighbours, as they like, and as long as they like, and so far as they can get others to consent. And thus we shall get rid of all personal hardships, all restrictions as to age, sex, and competence, and all public registration; we shall abolish monopolies, male tyranny, and social oppression generally.

The claim for the complete "emancipation" of women stands or falls along with these other examples of emancipation. And the answer to it is the same. The restriction, which in a few cases is needless, hard, even unjust, is of infinite social usefulness in the vast majority of cases, and "to free" the few would be to inflict permanent injury on the mass. To make marriage a mere arrangement of two persons at will would be to introduce a subtle source of misery into every home. To leave women free to go about in men's clothes and men free to adopt women's clothes, would be to introduce unimaginable coarseness, vice, and brutalisation. To leave everyone free to fill any public office, with or without public guarantee or professional training, would open the door to continual fraud, imposture, disputes, uncertainty, and confusion. It is to prevent all these evils that monopolies, laws, conventions, registers and other restrictions on personal licence exist. And the first and most fundamental of all these restrictions are those which distinguish the life of women from that of men.

Not very many reformers consciously intend the "emancipation" of women to go as far as this. There is a great deal of playing with the question, more or less honest, more or less serious, as there is much playing with Socialism, Agnosticism, and so forth, by people who perhaps, in their hearts, merely wish to see women more active and better taught, or some of the worst hardships of workmen redressed, or the dogmas of Orthodoxy somewhat relaxed. But when a great social institution is seriously threatened we must deal with the real revolutionists who have a consistent aim and mean what they say. And the real revolutionists aim at the total "emancipation" of women, and by this they mean that law, custom, convention, and public opinion shall leave every adult woman free to do whatever any adult man is free to do, and without let or

reproach, to live in any way, adopt any habit, follow any pursuit, and undertake any duty, public or private, which is open to or reserved to men.

Now I deliberately say that this result would be the most disastrous to human civilisation of any which could afflict it – worse than to return to slavery and Polytheism. If only a small minority of women availed themselves of their "freedom," the beauty of womanliness would be darkened in every home. Just as if but a few married people accepted the legalised liberty of parting by consent, every husband and every wife would feel their married life sensibly precarious and unsettled. There is nothing that I know of but law and convention to hinder a fair percentage of women from being active members of parliament and useful ministers of the Crown, learned professors of Hebrew and anatomy, very fair priests, advocates, surgeons, nay, tailors, joiners, cab-drivers, or soldiers, if they gave their minds to it. The shouting which takes place when a woman passes a good examination, makes a clever speech, manages well an institution, or climbs up a mountain, or makes a perilous journey of discovery, always struck me as very foolish and most inconsistent. I have so high an opinion of the brains and energy, the courage and resource of women, that I should be indeed surprised if a fair percentage of women could not achieve all in these lines which is expected of the average man. My estimate of women's powers is so real and so great that, if all occupations were entirely open to women, I believe that a great many women would distinguish themselves in all but the highest range, and that, in a corrupted state of public opinion, a very large number of women would waste their lives in struggling after distinction.

Would waste their lives, I say. For they would be striving, with pain and toil and the sacrifice of all true womanly joys, to obtain a lower prize for which they are not best fitted, in lieu of a loftier prize for which they are pre-eminently fit. A lower prize, although possibly one richer in money, in fame, or in power, but essentially a coarser and more material aim. And in an age like this there is too much reason to fear that ambition, and the thirst for gain and supremacy, would tempt into the unnatural competition many a fine and womanly nature. Our daughters would be continually longing to see their names in newspapers, to display the cheap glories of academic or

professional honours, to contemplate their bankers' passbooks in private, and to advertise in public their athletic record.

Let us teach them that this specious agitation must ultimately degrade them, sterilize them, unsex them. The glory of woman is to be tender, loving, pure, inspiring in her home; it is to raise the moral tone of every household, to refine every man with whom, as wife, daughter, sister, or friend she has intimate converse; to form the young, to stimulate society, to mitigate the harshness and cruelty and vulgarity of life everywhere. And it is no glory to woman to forsake all this and to read for honours with towelled head in a college study, to fight with her own brother for a good "practice," to spend the day in offices and the night in the "House." These things have to be done – and men have to do them; it is their nature. But the other, the higher duties of love, beauty, patience, and compassion, can only be performed by women, and by women only so long as it is recognised to be their true and essential field.

It is impossible to do both together. Women must choose to be either women or abortive men. They cannot be both women and men. When men and women are one started as competitors in the same fierce race, as rivals and opponents, instead of companions and help mates, with the same habits, the same ambitions, the same engrossing toil and the same public lives, Woman will have disappeared, society will consist of individuals distinguished physiologically, as are horses or dogs, into male and female specimens. Family will mean groups of men and women who live in common, and Home will mean the place where the group collects for shelter.

The Family is the real social unit, and what society has to do is to promote the good of the Family. And in the Family woman is as completely supreme as is man in the State. And for all moral purposes the Family is more vital, more beautiful, more universal than the State. To keep the Family true, refined, affectionate, faithful, is a grander task than to govern the State; it is a task which needs the whole energies, the entire life of Woman. To mix up her sacred duty with the coarser occupations of politics and trade is to unfit her for it as completely as if a priest were to embark in the business of a money-lender. That such primary social truths were ever forgotten at all is one of the portents of this age of scepticism, mammon-worship, and false glory. Whilst the embers of the older Chivalry and Religion retained their warmth, no decent

man, much less woman, could be found to throw ridicule on the chivalrous and saintly ideal of woman as man's guardian angel and queen of the home. But the ideals of Religion of old are grown faint and out of fashion, and the priest of to-day is too often willing to go with the times. Is it to be left to the Religion of Humanity to defend the primeval institutions of society? Let us then honour the old-world image of Woman as being relieved by man from the harder tasks of industry, from the defence and management of the State, in order that she may set herself to train up each generation to be worthier than the last, and may make each home in some sense a heaven of peace on earth.

THE EMANCIPATION OF WOMEN
The Fortnightly Review, Vol. 50 (1891)
Millicent Garrett Fawcett

Mr. Frederic Harrison's interesting paper, entitled "The Emancipation of Women," in last month's *Fortnightly*, invites a few words of comment and criticism from those who are not able to share the conclusions at which he seems to arrive. There is very much, however, in his paper with which the advocates of the emancipation of women will find themselves in sympathy, and to these points I propose in the first instance to draw attention.

Mr. F. Harrison's position as to the claim of women to the highest kind of education and training, his exalted estimate of the value to the world of the work in it that can only be done by women, his claim for women, not only of equality but of supremacy, in the home, with all the changes this would imply in domestic life, differentiate his position completely from the position as regards the relation of women to men, of which Milton is the worthiest and ablest exponent, namely, that women are essentially inferior and subordinate to men, that man is the final cause of God's creation, and that woman was made to minister to him and serve him. Mr. Harrison's tone throughout is as far as possible from this: he, indeed, expressly repudiates it; he speaks in his eloquent way of "the brutal egoism of past ages and of too many present men of the world which classes women as the inferiors of men"; he calls this view "the cheap sophistry of the vicious and overbearing," and maintains that "such a view is the refuge of coarse natures and stunted brains." He refers to the "base apathy which is satisfied with the actual condition of woman as it is."

In the matter of education, speaking, it must be assumed on behalf of the Positivists who meet in Fetter Lane, if not for the whole body, he says that Positivism "calls aloud" for radical improvement. Mr. Harrison, in claiming that Positivism "calls

aloud" for scientific education for women, does not refer to the fact that there are people, such as Professor and Mrs. Sidgwick, Miss Clough, Miss Davies, Mrs. William Grey, and Miss Shirreff, who have done better than "call aloud", and have quietly done the work of providing improved education for girls and women. Positivism ought to be grateful to them, though they are for that emancipation of women which Positivism denounces. To call aloud for a good thing is good, as far as it goes; but to provide it is better. So far from being contented with the present or past position of women, Mr. Harrison scorns "the brutal oppression" with which women have been treated in the past, and says that in the present, even among the advanced populations of the West, the practice in regard to women's education is on a par with that of the Mohammedan and Hindoo peoples. He advocates "an education for women on the same lines as that of men, to be given by the same teachers and covering the same ground, though not necessarily to be worked out in common, or in the same form and with the same practical detail. It must be an education, essentially in scientific basis, the same as that of men, conducted by the same, and those the best attainable, instructors – an education certainly not inferior, rather superior, to that of men." In the next paragraph, in order still more thoroughly to emphasise his repudiation of the old view of women's sphere, he says: "We look forward to the good feeling of the future to relieve women from the agonizing wear and tear of families too large to be reared by one mother," and also anticipates that this good feeling of the future "will set women free" from factory labour.

The foregoing brief survey is enough to show how little Mr. F. Harrison is in sympathy with the ordinary view of those who oppose the emancipation of women; indeed, his essay, although in form it is a protest against women's emancipation, is in great part a product of the movement of this century for their emancipation.

But while those who are frankly in sympathy with the evolution of the independence of women find much to agree with in Mr. Harrison's premises, they will find little or nothing to agree with in the conclusions he draws from them; and I think they can fairly charge him with misrepresentation (doubtless unconscious) of their views and objects, and also of their methods of working for them. They will also charge him

with a remarkable and almost ludicrous degree of unpracticality, both with regard to his hopes for the future and his knowledge of the present; and, lastly, with this: that with all his repudiation of the old theory that woman is essentially the inferior of man, and only of importance in proportion as she ministers to his comfort and enjoyment, and his fine phrases about "the chivalrous and saintly ideal of woman as man's guardian angel and queen of the home," he really wishes to give women no freedom for the development of individual powers and gifts: he wishes to tie them down to one career and one only – that of housewives.

I will deal with these points one by one. First, I charge Mr. Harrison with misrepresentation: and here I say again that I know enough of Mr. Harrison, as a friend and as a writer, to be quite sure he is not guilty of intentional misrepresentation; he never misrepresents except when he does not know, or when his rhetorical high horse runs away with him. But with this reservation I maintain that he does misrepresent in the article I am criticising, and that rather badly. By implication, if not by direct assertion, he seeks to identify the movement of anarchy and revolution with the movement for developing the social and political independence of women. No misrepresentation can be more unfounded. There are people who are in rebellion against all order in society; who think marriages should be dissolvable at will; that parents ought to have no control over their children; that no harm would be done if women wore men's clothes, and men women's; that all laws against theft and other offences against property ought to be abolished; that all distinctions of nationality ought to be swept away; that any quack or impostor who chooses to put a brass plate on his door calling himself a physician, a lawyer, or what not, should occupy exactly the same position as those who have entered the various professions after complying with the constituted educational tests of fitness. Everybody who reads the newspapers, and keeps his ears and eyes open, knows that people of this kind exist: whatever they may call themselves, they are in effect anarchists, against all order and against all authority. But they are not the people who have had anything whatever to do with the movement for the emancipation of women. Many of them are actively hostile to it. I ask Mr. Harrison to produce one bit of work done by these people that has helped in any way to procure better education for women,

to open employments to them, or to obtain a recognition of their claim to civil rights and just laws. To identify, or, rather, attempt to identify, them with the workers for women's emancipation as Mr. Harrison does, will only mislead those who are entirely ignorant of the matter in hand. None of the leaders of the women's rights movement in England have ever countenanced for a moment anarchic methods or anarchic aims. Many of them, on the contrary, recognising women's instinctive leanings towards morality and order, look upon their more active participation in public affairs, and especially their admission to the Parliamentary suffrage, as a valuable reinforcement of the party of order against the attacks of the anarchists whom Mr. Harrison so justly denounces. A lady long resident among members of the Greek Orthodox Church told me that she had received a letter from one of them in which the phrase "the Pope and all other Protestants" occurred. Mr. Harrison gives an example of a similar depth of ignorance, but with less excuse for it, when he identifies the movement for social anarchy with the movement for the emancipation of women.

But this misrepresentation does not stand alone. We come now to a second. Mr. Harrison speaks of the "brutal egoism" of past ages in their estimate of women; he himself shows another kind of egoism; it is not at all brutal, it is amusing. He cannot free himself from the masculine egoism that, because many of us wish women to have greater freedom in the matter of education, employments, and civil and political rights, we therefore wish them to be like men. Those who are still in bondage to this idea have not shaken off the superstition of the innate inferiority of women. To acknowledge superiority is to acknowledge a desire, latent or open, to resemble the superior being. We recognise the difference between men and women, and maintain just as strongly as Mr. Harrison does, that this difference is not one of inferiority or superiority, but one that influences character, conduct, methods of looking at things, and modes of action in innumerable and infinitely complex ways. Make a woman queen of the greatest empire in the world, place on her shoulders political responsibilities from early girlhood to old age of the weightiest kind, she remains a woman "for a' that." Make her a doctor, put her through the mental discipline and the physical toil of the profession; charge her, as doctors so often are charged, with the health of mind

and body of scores of patients, she remains womanly to her finger-tips, and a good doctor in proportion as the truly womanly qualities in her are strongly developed. Poor women are very quick to find this out as patients. Not only from the immediate neighbourhood of the New Hospital for women, where all the staff are women doctors, but also from the far east of London, do they come, because "the ladies," as they call them, are ladies, and show their poor patients womanly sympathy, gentleness and patience, womanly insight and thoughtfulness in little things, and consideration for their home troubles and necessities. It is not too much to say that a woman can never hope to be a good doctor unless she is truly and really a womanly woman. And much the same thing may be said with regard to fields of activity not yet open to women. Take one where Mr. Harrison has ranged himself with our opponents – the share of women in political activity. We do not advocate the representation of women because there is no difference between men and women; but rather because of the difference between them. We want women's special experience as women, their special knowledge of the home and home wants, of child life and the conditions conducive to the formation of character to be brought to bear on legislation. By giving women greater freedom we believe that the truly womanly qualities in them will grow in strength and power, and we hold this belief, not merely as a pious opinion, but as a fact that is proved by a comparison of the various civilisations of various countries. Where women are practically the slaves of men, they have the defects of slaves: they "speak with men's voices," they flatter men's vices, and thereby often manage by cajolery to achieve their own little objects; they neglect the truly womanly qualities, the protecting motherly instincts, the mercy, fidelity, purity, and love of a truly womanly nature. The emancipation of women has probably gone further in England and America at the present time than in any other countries. We are not afraid to compare the womanliness of the women of these countries, as practically shown in the care of children, in endeavours to save and prevent human wreckage, with the womanliness of the women, say of Spain, Egypt or Dahomey. Give a rose good soil and a sunny aspect; let its branches shoot out so that it makes plenty of young wood; do not try to bend and twist it into a too rigorous formality of shape, and you will get the best out of your tree that it is capable of; by giving it a

good chance, do not be afraid that you will turn it into an oak or a fuchsia.

There is no wish whatever on the part of the women's rights party to "annihilate," as Mr. Harrison says, "the difference of sex." But this silly cry of doing the impossible thing of annihilating the difference of sex is set up regularly, step by step, whenever women wish to avail themselves of any of the things which men have tried and found good. In the time of Mrs. Hannah Moore, it was unwomanly to learn Latin; Sidney Smith tried to reassure the readers of the *Edinburgh* eighty years ago that the womanly qualities in a woman did not really depend on her ignorance of Greek and Latin, and that a woman might even learn mathematics without "forsaking her infant for a quadratic equation." Later it was unwomanly to write a book, and within my own memory it was unwomanly to skate or ride in a hansom cab. More lately still, when the Albemarle Club was about to be started, the most gloomy forebodings as to its effect "on the foundations of society" and the womanliness of women were indulged in. A highly cultivated lady, a member of the Positivist Society, said to me *à propos* of the Club: "But do you wish *every* distinction between men and women to be abolished?" She joined the club soon after its formation, and has certainly not neglected her opportunities of frequenting it; but I have not heard either from herself or her friends that she has been "unsexed" thereby.

One more misrepresentation is the charge, implied rather than distinctly formulated, that those who favour the emancipation of women have a low estimate of the value and importance of women's domestic work. Mr. Harrison speaks of "debasing the moral currency," and "desecrating the noblest duties of women"; and it can only be supposed from the context that this means that those who favour the emancipation of women take a low view of women's work in the home as mothers of families. Again no assumption can be more entirely unfounded. From Mary Wollstonecraft and Miss Martineau, the spokeswomen for women's freedom have always held in the highest esteem the value and importance of women's work in the home. The fact that to the mother in nearly all classes is consigned the training of children in their most impressionable years, in itself is one of the strongest claims that has ever been put forward for raising the education and social status of women. The woman who brings up a family well does work of

inestimable value to the State. She is contributing to the greatness of her country in its highest sense if she provides it, not only with so many head of human beings, whose worth may be reckoned like that of cattle, but with men and women "true in word and deed, brave, sober, temperate, chaste." To argue that because this work is so invaluable and requires so many fine qualities of heart and brain, therefore all women shall be given the Hobson's choice of marriage or nothing else in the way of a satisfactory career, appears to me an error rather similar to that which so long maintained religious tests at the universities. Reverence was supposed to be shown to religious teaching, as embodied in the tenets of the Church of England, by making every aspirant for a university degree or a college fellowship declare his allegiance to the thirty-nine articles. In some colleges no one was admitted to a fellowship who had not previously partaken of the Holy Communion. Men of deeply religious mind who were either troubled by doubt, or were members of other church bodies, were thereby excluded from university life; but Gallios of all types took the tests gaily, and even joined in the sacrament, scoffing in their hearts and with a jest of their lips. This is now universally recognised as a poor way of honouring religion; and it appears to those who favour the emancipation of women, but a poor way of honouring marriage to give girls practically no choice between marriage and a life of perpetual childhood.

Many of the shipwrecks of domestic happiness which most people can call to mind, have been caused either by the wife having no real vocation for the duties and responsibilities of marriage, or from her having married without deep affection for her husband, simply because she felt it was a chance she ought not to miss of what is euphemistically called "settling herself in life." Such a marriage is as much a sale as the grosser institutions of the East can provide. It is a desecration of holy things; a wrong to the man, and a wrong to the children who may be born of the marriage. A girl I know was saved the other day from one of these wretched marriages that do so much to cause the names of the victims to them to reappear in the newspapers under the heading of "Probate and Divorce." She was in a position in society in which it would require abnormal force of character for a young woman to take up any professional pursuit or absorbing occupation. A man of wealth and position had paid her great attention, and every one

supposed they were on the point of an engagement, when she heard that he was engaged to some one else. Her pride was wounded, but not her heart. She said to her mother, "I am sorry in a way; I should have accepted him if he had asked me, for I don't think anything better was likely to offer; but I don't care for him in the least, and I don't think I ever should." I mention this incident because most people will recognise it as a type; a type which George Eliot portrayed in literature when she described the marriage of Rosamond and Lydgate. Of course it is possible that the heroine of my tale was not speaking the truth; but supposing that she was, what she contemplated doing was on a par with what goes on between twelve and two every morning in the Haymarket and Piccadilly Circus. It is to sell what should never be sold: sensual and materialising, it is this and things like it, which really "debase the moral currency," and "desecrate the noblest duties of woman," not factory or any other honest labour, nor any claim on the part of women for a fuller recognition of their citizenship.

I come now to what I conceive to be the unpractical character of Mr. Harrison's paper. In two or three lines he says that he looks "to the future to set women free from the crushing factory labour, which is the real slave trade of the Nineteenth Century"; in other passages he appears to be averse to women engaging in any remunerative work, professional or industrial, and has a little sneer (that, I take it, of a rich man who has never had to work for a living) at the professional woman contemplating her banker's pass-book with satisfaction. In reply to all this we would ask him how he proposes to provide for the millions of women who earn their own living in various forms of industry? The new census returns are not yet obtainable in full detail; but the census of 1881 showed that three and a-half millions of women in Great Britain and Ireland were earning weekly wages. Mr. Harrison proposes to "set them free from factory labour"; but he must know that in innumerable cases this would be setting them free to starve. One of the nail and chain-making women, when threatened last summer with legislative interference with her labour, was asked if her hard work did not hurt her. She replied, "My work didn't hurt me: if I hadn't done it, what my mouth missed would have hurt me." Mr. Harrison makes no attempt to grapple with the practical problem of women's work, and

makes no suggestion as to how best to help to make the hours and wages of their work more conducive to a satisfactory life for the workers as human beings. Here, as elsewhere, in his paper, rhetoric and fancy take the place of solid practical good sense. He, no doubt, feels that each woman ought to be provided for in superintending and beautifying the home of some man, presumably as his wife and the mother of his children. His lamentations that this is impossible, because there are more women than men in this country, furnish one of the most curious passages that I have read for a long time, even on this most discussed subject of the whole duty of women. To him the unmarried woman is a blighted being, and his feeling heart bleeds for her, and he "calls aloud" to proclaim his distress and sympathy. "We know," he says, "that in a disorganized condition of society there are *terrible accumulations of exceptional and distressing personal hardship. Of course, millions of women have, and can have, no husbands!*" It would, perhaps, be hypercritical to remark that the rhetorical "millions" ought to be changed for "nearly a million." But what is far more striking is, that when Mr. Harrison speaks of "terrible accumulations of exceptional and distressing personal hardship," the first image that rises in his sympathizing mind is that of "women who have, and can have, no husbands." He must surely dwell in a kingdom of fancy and imagination, or the first sentence would have been followed by a second much more closely in touch with the tragedies of common life. It is not the women who have no husbands, but the women who have bad husbands, who are most deserving of compassion – women, whose stories appear week by week in the newspapers, who are driven to suicide by the nameless and hideous brutalities to which they have been subjected; women who are driven on the streets that their husbands may loaf in idleness on their earnings; women who live in daily and hourly terror of their lives from their husband's personal violence; and cases worse even than any of these that recall and exceed the worst horrors of the story of the Cenci. Mr. Harrison must live in a world where he never hears or knows these things, or surely he would not be so lachrymose over the supposed woes of women "who have, and can have, no husbands"; it is true that in the next part of the same sentence he extends his compassion to women who are not well provided with other relatives, "women who have no parents, no brother, no true

family." If I am not misinformed, the Positivist theory is that every women should be maintained in the home, without herself earning money, by the exertions of either father, husband, son, brother, or some other male relative. People who have never been, since childhood, in absolute pecuniary dependence on others, can with difficulty measure the bitterness of the position, otherwise they would not need to often to be reminded –

> "come sa di sale
> Lo pane altrui, e com' é duro calle
> Lo scendere e il salir per l'altrui scale."

But whatever the value of the theory that every woman ought to be dependent upon some man for food, clothing, books, amusements, and all the other necessaries and amenities of life, it is becoming year by year less in correspondence with the facts of our national life. Speaking roughly, all working-class women and many middle-class women work for wages up to the time of their marriage, and many of them work after their marriage. Miss Clara Collett, in her chapter on women's industries in Mr. Charles Booth's book, *Life and Labour of the People*, says that in London young women working as tailoresses prefer to work for strangers rather than for their fathers, even when their fathers are in the same trade and able to employ them. The reason is very simple: in the first case they get wages, in the second they do not. It is hardly too much to say that it is not till women have had an opportunity of working for wages outside the home that the value of their work in the home has received the recognition it deserves. Economic independence has paved the way for that wider emancipation which Mr. Harrison is opposing. That the movement for women's emancipation has an economic foundation, based on the changes in methods of production utilising the labour of women, affords strong ground for believing in its durability; it also suggests an explanation of the fact that the movement is furthest advanced in England and America, the countries where this industrial change is more developed than elsewhere; and lastly, why symptoms of this movement towards freedom on the part of women are observable in every country in the world which has shared in the industrial changes of modern times. Mr. Harrison, and many others, often attribute the women's rights movement to the fact that there

are more women than men in England, and therefore the supply of men is not sufficient to provide every woman with a husband; but this simple explanation ceases to be applicable when we look at the women's rights movement in America; for there men are in a majority, almost exactly equal to the majority of women in England. In New Zealand and the Australian colonies generally men largely outnumber the women, but there, in many respects, the emancipation of women has gone further than elsewhere.

There are signs in Mr. Harrison's paper that he has hardly kept himself acquainted with the industrial change that has taken place in the position of women. He runs into one sentence his belief that there is nothing but the trifles of "law and convention" to prevent women being members of Parliament, professors of Hebrew and anatomy, *"surgeons, nay, tailors*, joiners, cabdrivers, or soldiers, if they gave their minds to it." The words I have italicised show how little he knows of the actual world of women's work: a few women are surgeons; that, perhaps, he could not be expected to know; but thousands of women are tailors – the clothes of the British army are made by women. To quote Miss Clara Collett again, her article on "Women's Work in Leeds"[1] shows that the number of women employed in tailoring is rapidly increasing:–

CENSUS RETURNS OF THE TAILORING AND MACHINING IN LEEDS

	Women	Men	Total
1861	131	1,323	1,454
1881	2,740	2,148	4,888

Miss Collett is unable, like the rest of us, to give the figures for 1891, but she estimates the number of women and girls now employed in this trade in Leeds at 10,000. Thus, while Mr. Harrison was exclaiming that there was nothing but law and convention to prevent women engaging in the masculine pursuit of making clothes, he must have been unaware that law and convention had nothing to say in the matter, and that probably more than half the men in England are wearing clothes made by women.

But while Mr. Harrison is unpractical in his ignorance of what is actually taking place under his very eyes, he is equally unpractical where he most assumes the wisdom of the practical

[1] *Economic Journal*, September, 1891.

man. How can he suppose that the work of working women gets itself done if it were true, as he asserts, that every mother was "for months a simple invalid?" The robust way in which the working woman, as a rule, goes through the child-bearing period of her life, tempts one to hope that some women who enjoy ill health on these occasions would be more robust if they were less idle. A nail and chain-making woman, who joined the deputation to Mr. Matthews in June, was asked by him to describe the nature of her work. She answered in a way that was more to the point than might at first sight appear: "I ha' had fourteen children, sir, and I never was better in my life." Her well-developed frame, bright complexion, and hearty voice, corroborated her words; and yet here is Mr. Harrison saying that women are physically unfitted by the law of nature for hard work, and that if they undertake it either the work will be done by "an unsexed minority of women, or it means a diminution and speedy end to the human race." The arrow of facts is all against Mr. Harrison. The present century is the time, speaking roughly, in which women have entered the field of industry otherwise than in domestic work. It took between four hundred and five hundred years for the population to double itself between 1448 (before the black death) and 1800; but in the ninety years since 1801, it has been multiplied by four-and-a-half, that is, from less than nine millions to nearly forty millions. Of all arguments against women's emancipation, that based on the "end of the human race" theory has, in the presence of the census tables, the least power to alarm us. Mr. Harrison does not confine what he has to say in this so-called biological objection to women's work to women as mothers. He says that "all women," with very few exceptions, are "subject to functional interruption absolutely incompatible with the highest forms of continuous pressure." This assertion I venture most emphatically to deny. The actual period of child-birth apart, the ordinarily healthy woman is as fit for work every day of her life as the ordinarily healthy man. Fresh air, exercise, suitable clothing, and nourishing food, added to the habitual temperance of women in eating and drinking, have brought about a marvellously good result in improving their average health. Mr. Harrison indulges his readers with the well-worn old joke about an army composed of women, a certain percentage of whom will always be unable to take the field from being in childbed. It might be retorted that a

percentage of the actual army is invalided from a less reputable cause; but it is undesirable to vie with Mr. Harrison in irrelevant observations. No one wishes women to serve in the army, or to be dock-labourers or butchers, because they are physically unfit for the work involved; but they are not physically or mentally unfit to vote, or to engage in a large number of industrial, scientific, and professional pursuits, and these privileges and occupations therefore we wish to see opened to them.

Mr. Harrison appears to me to be misled by a desire too much to map out the whole of human life with tape measure and ruler, and to carry the idea of division of labour into fields where it has no true application. To woman he assigns the affections; to man, activity. He is tempted sometimes into speaking as if he believed men were incapable of affection, and as if it were only abnormal men who have the strong clinging affection for their children that most women have. This is not true of human nature as I have observed it. At least, I have never considered those men abnormal or "unsexed" in whom family affection was strongly developed. The side where women are strongest, says Mr. Harrison, is affection. The side where men are strongest is activity. Intelligence, he is good enough to add, is common to both, as if activity and affection were not also common to both. A man incapable of affection, a woman incapable of practical activity, would be monstrosities, fit only for the gaol or the asylum. How beside the mark all this mapping out of qualities according to fixed rules appears to those who approach the subject from the practical side, and find themselves in contact with the infinite complexities of the actual characters of men and women or boys and girls in the nursery!

Let us try by another practical test the value of Mr. Harrison's efforts to contribute to the solution of difficulties and problems as they arise in real life. Take the case of a family consisting of half-a-dozen daughters. There is sufficient work perhaps at home for one of them; if they have neither beauty nor wealth they are very likely not to marry. What are they to do? Mr. Harrison's reply is that their "function is to educate, not children only, but men"; and also to "keep the family true, refined, affectionate, and faithful." This is all very well; but my six healthy young women would retort, "What men? Whose family? Papa wouldn't like it at all if we tried to educate him, and we think our family is fairly refined and affectionate, and

would not be less so if there were rather fewer of us in it."
Again, take another practical case. A girl comes and says,
some years ago her father lost his health, then his business
went to pieces; her brother tried to carry it on, and he, too,
failed, and has now gone to try his fortunes in Australia.
What would I advise her to do? She is not well educated
enough to teach; her friends are kind, but not rich, and she
has been staying with them a long time, and then follows a
free rendering into English of "come sa di sale," &c. The
answer is hard enough any way; but as the emancipation of
women goes on, and more occupations and pursuits are
open, it becomes easier. If Mr. Harrison had his way it would
be impossible to give any answer at all, except to tell the girl
that she was one of the "unsexed minority," or was a
specimen of "exceptional and distressing personal hardship."
For I imagine that no one, in reply to such an applicant,
would have the impertinence to tell her that her "function
was to educate men" and to keep the family refined and
affectionate, that this task must absorb "her whole energies,
her entire life," and that it would be degrading, therefore, for
her to mix this "sacred duty with the coarse occupations" of
earning a living.

My last charge against Mr. Harrison is, that while in words
he repudiates the subordination of women to men, and the
notion that the woman is of value only in so far as she ministers
to the comfort and enjoyment of the man, he cannot really
divest himself of it. It comes round to this: the emancipation of
women, the giving to women a full choice of a large number of
useful and honourable occupations other than marriage would,
in Mr. Harrison's view, be "worse than a return to slavery and
polytheism. If only a small minority of women," he says,
"availed themselves of their freedom, the beauty of woman-
liness would be darkened in every home." To translate this
from the general to the particular, it might run thus: "If only a
small minority of women smoked and rode astride, the
sentiment of many men and women as to what was fitting
would be wounded." This is absolutely undeniable, but it is
surely overdoing it to say it would be worse than a return to
polytheism and slavery. J. K. S., author of *Lapsus Calami*, has
put his thoughts on this subject in a verse which I think
embodies a good deal of the true inwardness of Mr. Harrison's
reasoning:–

TO ONE THAT SMOKES
"Spare us the hint of slightest desecration
 Spotless preserve us an untainted shrine;
Not for thy sake, oh goddess of creation,
 Nor for thy sake, oh woman, but for mine."

A great deal of Mr. Harrison's wish to confine women practically to domesticities, to prevent them from having the opportunities of earning a living, to force them into marriage whether they have a real vocation for it or not, is explained when we remember that it is "not for thy sake, oh woman, but for mine." The theory that the woman is not so much the friend and comrade of the man as a goddess to be set in a shrine and worshipped, receives a shock when brought in contact with the realities of life. Hence, also, Mr. Harrison's weeping and wailing over this "materialistic age," where men "despise what is pure, lofty, and tender, and exalt what is coarse, vulgar, and vainglorious," "an age of nihilism," of "disorganization," of "scepticism, mammon worship, and false glory." This railing against the evolution of society which is taking place before us, is probably to be accounted for by the fact that it does not closely correspond to Positivist ideals, and in fact seems going further and further from them. Therefore, in Mr. Harrison's view, the times are out of joint, and he really believes that it rests with the Positivist Society to set them right. He says, "We," i.e. the Positivists, "are defending the principle of the womanliness of women." There has been nothing showing such a want of the sense of proportion since the Bishops of Winchester and Gloucester rose in convocation "to defend the honour of their Lord's Godhead." The womanliness of women is one of those great facts of nature which do not require the exertions of the Positivist Society to buttress it: but this is what Mr. Harrison cannot bring himself to believe. The saying, "The sun will rise to-morrow – subject to the constitution of the United States," finds a parallel in several passages of this remarkable paper. To give another example: "Is it," Mr. Harrison exclaims, "to be left to the religion of humanity to defend the primæval institution of society?" To this absurd question there can be but one answer – when the supply of negatives provided by the English language appears inadequate to their demands, schoolboys substitute the word "scarcely;" we are tempted to employ the same word on this occasion.

Whatever may be the special periods and difficulties of the present time, our case is not as desperate as that. Positivism claims to be a religion of faith in human nature; but its professors exhibit a pitiable want of faith, a practical infidelity, when they talk as if the womanliness of women existed only in virtue of their exertions, and appear to think that if thirty or forty people meeting in Fetter Lane relaxed their endeavours "the primæval institutions of society" would collapse.